MICRO-BIONIC
RADICAL ELECTRONIC MUSIC AND SOUND ART
IN THE 21st CENTURY
Thomas Bey William Bailey

MICRO-BIONIC
RADICAL ELECTRONIC MUSIC AND SOUND ART IN THE 21st CENTURY
Thomas Bey William Bailey
isbn 978-1-84068-153-6
Published by Creation Books 2009
© 2008 Thomas Bey William Bailey
All rights reserved
www.creationbooks.com

CONTENTS

ACKNOWLEDGEMENTS

In the 2½ years required to bring this book to a satisfactory level of completion, much has changed in my life, including the loss of some irreplaceable friends. Koji Tano, Tokyo's relentless proselytizer of ecstatic noise, passed away shortly just before the first informal conversations that would become the germ of this whole project took place. I hope that this book will introduce readers to at least some of the music that Koji otherwise would have championed, although I cannot rightly claim to be half the laser-sharp enthusiast that Koji was. My friend and former co-worker Akitake Kato will also be missed; his forthcoming nature and infectious optimism could light up even the sterile tower block full of identikit office drones where we spent our weekdays. Finally I must pay my respects to the inspiring diligence and vitality of Racquel 'Zuzu' Stewart, who I presume dead after 5 years' time as a missing person – although I will be overjoyed to learn any information to the contrary. With such unhappy partings behind me, I am definitely blessed to still have a support network of exceedingly intelligent, diversified, and talented individuals. Among these are Petr Ferenc and Tom Novak, who are responsible for the Czech translation of this book, and many more good times besides. Times have been lean since the first words in this book were put to page, with erratic employment and global economic uncertainty, so anyone who shared freely of their food, drink, and lodging is well worthy of praise here: thanks to Joseph Stearns, Tim Doe, Anna Linder, Jeff Bell, Nigel Staley, Hidenori Fujiwara, Kazuya Ishigami, Brandon Hocura, Naomi Okabe, Jason Funk, Silvia Hromadkova, Jeffrey T. Atkins, Jeff Crawford and Jackleen Leary for their selfless efforts in this department. Any of the individuals in this list would be excellent people on their own merits, but get extra credit for all the sustaining shots in the arm that they provided this author during terminal streaks of bad luck. The artists who were interviewed for this book deserve credit both for making music that challenged and shaped key aspects of my personal worldview, and for taking time out of busy schedules to field questions. Thanks are also due to the artists who took the extra time to comb through the text for historical inaccuracies and embellishments. The list of interviewees and sonic consultants includes (in no particular order) William Bennett, Andrew McKenzie, Bob Ostertag, Dave Phillips, Frans de Waard, Zbigniew Karkowski, Peter Rehberg, Francisco López, Leif Elggren, Carl Michael von Hausswolff, Lasse Marhaug, John Duncan and Peter Christopherson. Other figures from the world of music promotion and criticism provided invaluable input; Satoru Higashiseto and Massimo Ricci are among them. Finally, I tip my hat to the more prudish and conservative elements of the 'modern music' critical community, whose negligence and narrow scope all but necessitated the writing of books like this one – with hopefully more to follow.

INTRODUCTION

In January of 2006, while on one of my routine walks through the Shibuya district of Tokyo, I was struck "again, for the first time" by the chilled hyper-modernism of the city while listening to the wild and abrasive abstractions of 'extreme computer musician' Peter Rehberg on a portable MP3 player. I had an idea to compose a book about electronic music that would comment on the same hyper-modernism I noticed around me in Tokyo, a very vague concept that was, in the beginning, no more than a flurry of mental images and sounds with no real thesis statement riveting it into place. Once I sat down to begin writing in earnest, though, this project miraculously evolved from what would have been a book-length exclamation point into a cohesive catalog of ideas and insights. One thing was for certain, in a book treating technologically-oriented music, I wanted to be not too celebratory of technology or too damning. In my readings and personal discussions on topics like techno, noise, and sound art, I noticed people basing their support of, or antipathy to, these forms of music based only on the kind of technology that the music was made with, discussing this to the detriment of the life experiences, philosophies and external factors that really informed the music. At the same time there was not, and still isn't, that much writing on this kind of music that didn't stray into academic obscurantism or thinly veiled attempts to prove how many records the respective authors had accumulated. I wanted to convey my excitement about this culture to an audience that, while not being spoon-fed morons, had no patience for the rarified atmospheres and self-congratulatory, discursive muscle-flexing of journalistic elitists –either elite by means of academic credentials, or by the amount of money they had pumped back into the 'scene' – who were hoping to remake the world in their dry and authoritarian likenesses.

When my friend, the composer Zbigniew Karkowski, laughingly told me in conversation that "all writing about music is bullshit", I knew at this point that I had my work cut out for me, taking his aside as a direct challenge to pen something that was *not*, well, bullshit. But how to avoid this supposedly omnipresent "bullshit" factor? In Karkowski's reckoning, music writing and reviews fail to accurately convey the illogical and spiritual feeling behind music, since the relative perception of that music from one listener to the next will be too varied for any one writer's viewpoint to really encapsulate *all* of these listener reactions. Music and sound can accurately simulate events, although their ability to conjure a perfect mental reproduction of one *specific* event is almost nil, given the divergence in memories, experiences, and personal prejudices of each individual listener. With music of the kind reviewed in this book, which relies on heavy amounts of abstraction and non-didactic techniques like pure noise and temporal/spatial distortions, the spectrum of subjective interpretations will probably be wider than ever. So, naturally, I decided to de-emphasize poetic descriptions of the music's visceral effect upon me (although some of this sneaks in here and there), instead suggesting ways in which these sound works are symptomatic of larger socio-cultural trends and problems. I especially hope to convey that the spirit of interpretive flexibility animating this music is part of a larger movement towards de-centralization as a survival mechanism, especially as concerns marginalized artists.

I coined the term *Micro Bionic* as the title of this book, because of the way in which the term neatly applies to this music's definitive features. I am taken by the increasing amount of music which is characterized by superhuman intensity, speed, efficacy, etc., yet is produced with a bare minimum of physical exertion, sound equipment, and financial resources. In addition to these factors, makers of 'micro bionic' music often operate using a tiny 'cell structure', in comparison to the huge entourages marshaled by major record companies and entertainment conglomerates. A single person making this music might act as an entire 'record label', handling every aspect of the music from artwork design to recording to distribution. Again, it is a 'more than human' amount of responsibility for those single cells who are willing to take it all upon themselves – and many do so

gladly.

On a less positive note, the audiences for much of this music remain in the 'micro' range compared to the millions of fans courted by conventional music entertainers. Even here, though, there are advantages to be found: these 'micro' niche markets can remain fiercely loyal to those who deliver them the goods, and are infinitely more participatory – often being inclined to spread the ideas of their favorite artists through music of their own making. Their numbers may be inferior, but they are a long-term and deeply entrenched support structure rather than a fickle, fleeting fanbase.

+++++++

Upon looking back on the full title of this book, I was, like any parent, proud of my humble attempt at coining a genre name, despite the fact that this will probably never make it into common parlance in the same way that zesty terms like "intelligent dance music" or Simon Reynolds' "post-rock" have become the coin of the realm. The subtitle was another story altogether, one which could be misinterpreted as being contrary to the very aims of this book. So, before sending my mutant daughter of a creation out into the world to be judged (and hopefully liked) by all, I should make some cursory attempt at delineating the boundaries of these terms as I am personally using them.

"Radical"?

"Radical" is not a word that I use lightly, or as an indicator of fashionable, darkside cool (lest we forget the one-time popularity of 'radical' as a slang term used by American skateboard punks in the 1980s.) In a time when the actions of politicized, militant radicals have caused serious collateral damage (to borrow the sanitized military jargon equivalent to 'mass murder') and swept thousands of innocent bystanders into bloody conflicts, and when desperate attempts to re-organize the world have caused innumerable disasters, a term like this seems as inappropriate and outdated as calling a guitar-wielding noise musician a "guitar terrorist."

Yet one can be radically destructive, or radically creative, and the difference between the two may come down to a question of intent. In the history of avant-garde music, activities like John Cage's visit to an anechoic chamber, where he learned that there is no such thing as pure biological silence (he claimed to hear the sounds of his own blood circulation within the chamber), have had radical effects on the nature of composition, to the point where it would be impossible to "un-learn" them. But the effect, in this case, was not something that was deliberately sought out. Many of the artists in this book simply 'followed their own star' and resisted cultural mediation to such a degree that radical and irreversible results were achieved, even if this was not the explicit desire of those artists. Like Cage's fable of the anechoic chamber, many of the discoveries outlined in this book have not had the radical and utopian effect of 'changing the world' at all, but have revealed the way the world has always been, even while this reality was obscured from our sensory perception in the age of mass media.

My own belief is that human history is a cyclical series of advancements and retreats, and that 'revolutionary' overthrow of one *ancien régime* is soon followed by the ascendancy of another, as brutal and draconian than the previous one, or moreso. I am very suspicious of certain strains of 'revolutionary' thought and their promises of a definite endpoint in human history –either Apocalypse or Utopia – as well as their ignoring the fact that nature is ultimately indifferent to our efforts. In a creative milieu where, more often than not, the revolutionary impulse and the "will to significance" is common, certain strains of creativity –like the "noise" music of Merzbow, or the unmediated swathes of natural sound recorded by Francisco Lopez – are radical for their *refusal* to promise or herald human progress. Seeing things for 'what they are', or finding value in the way that things have always worked rather than for what they may eventually become, is, to me, one of the quintessential radical actions in an epoch where warring factions violently flail towards progress

or change, only succeeding in creating something *cosmetically* different from the old order.

"21st Century"?

Right away, this is another term that is not going to be universally accepted: the "21st century" is an exclusive product of Western calendars and subsequent Western media domination, even though plenty of other timetables are still in existence and widely used. For a book that will try to convince people that Western tradition isn't the only valid wellspring of creativity, it may seem preposterous to insist that we are all linked together by a common religious tradition. So "21st century" is admittedly an empty term in absence of anything more personally satisfying. Still, the variety of other terms on hand seemed equally vague. Contemporary? Modern? 'New Music'? All of these terms seemed very limiting, in that they suggested the present is the only point in time worth considering. In composing this book, I wanted to deal with music that certainly is *happening* or at least relevant at the time of writing, but which also, through any number of different techniques, *transcends* the immediate. I submit that a common factor of most interesting '21st century music' is its refusal to deal only with that point in time which we can immediately perceive or engage in a tactile manner.

Much of the more interesting electronic music I've encountered has, if anything, a pronounced streak of atavism running through it: it brings submerged memories of the distant past –sometimes even a pre-human stage in the past – to the surface, in order to make more accurate projections about the future (again, often without promising that the future will be markedly more 'progressive' than the past.) "Back to the future," as it were. The same process can occur in reverse, of course, with state-of-the-art technology being used in an anti-progressive manner; breaking down the complex organizational structures and programmatic behaviors that are supposedly necessary for us to reach loftier plateaus of existence and understanding. Whichever strategy is being implemented, I find it personally far more interesting and worthy of discussion than music and sound that is 'living for today' or trapped in a kind of 'pastless present.'

Also, a great deal of the music in this book comes from musicians who have begun their careers well before the 21st century began, yet are creating something which encapsulates the 'big questions' that we now have to deal with. Many have been active since the 1970s or 1980s, but are just now being recognized for their work, or have been creating work that projected those 'big questions' onto our ears before those questions ever became the topic *du jour* – or before those questions became amplified to a level of panic that was distinctly "21st century."

In the end, the term "21st century", as used by this book, is just shorthand for the unique set of socio-cultural issues that have marked the years since 2000 in the Western "common era". These include globalization of both market forces and of such counter forces as asymmetrical warfare/"terror", and the numerous "unpredictables" which can come from having a globe saturated with humans as never before, e.g. a Malthusian catastrophe arising from scarcity of basic resources. These include also the unparalleled amount of mankind now connected to the Internet and with hourly access to personal computers, and all the issues which spin off from this situation: the glut of digital pornography and desire manufacturing, the increased experimentation and interaction with cultures outside of one's physical reach, the vast underground of peer-to-peer file sharing networks consuming huge amounts of audio-visual information (often illegally) without paying a cent for it. Naturally, the "21st century" is also marked by movements in direct revolt against any of these developments.

"Electronic Music"? "Sound Art"?

This book's subtitle claims that it is about 'electronic' music and sound art, but the meaning of this should be clarified as well. Anyone with experience in the audio field will testify that virtually all music recorded or performed today incorporates some electronic element or another. We hardly think of the electric guitar or a turntable as an 'electronic' instrument on par with a synthesizer,

although both feature some component –the guitar's vibrating strings, and the vibrations of the turntable's stylus – which is amplified electronically. Even a completely un-effected human voice being heard over the radio involves the introduction of electronic equipment into the system. So, what exactly is so special about the handful of artists being recognized by this book?

For one, the artists who I've chosen to focus on in this book are ones who actively confront the human relationship with our steadily accumulating masses of consumer technology. That relationship is, as it has always been, fraught with tension – and if the sound surveyed in this book does not provide a satisfying resolution to that tension, then it should at least get us to think in a new way free from absolutist opinions of technology (i.e., that it is 'good' or 'evil'.) These artists generally do not occupy the extreme polarities of technophobia or technophilia; most of them simply work from the pragmatic standpoint of using whatever tools are available, without any concern for where they might fit into an eventual convergence of man and machine, or that takeover of humanity by artificial intelligence called the "Singularity" by the inventor Ray Kurzweil.

When all is said and done, the artists herein have been selected because of their ability to seek unknowns in themselves and in an audience, rather than to merely proclaim known facts. The 'electronic music' in this book is made by individuals who are actively engaging in a kind of dialogue with their tools in order to answer questions that they would otherwise not know the answers to, as opposed to musicians and composers who believe the 'big questions' of life have already been answered, and who thus use electronic devices and recording techniques as just a kind of ornamental flourish.

The same criteria could also be used for the examples of 'sound art' listed in this book. This may be an even more contentious term than 'electronic music', yet it is necessary to include since the distribution networks of sound art do not always perfectly overlap with those of radical electronic music, even though the boundaries are becoming more Gaussian-blurred by the day: sound art, owing to its frequent mixed-media presentation and its emphasis on being exhibited through public installations, occasionally differs from an electronic music which favors 'static' media (compact discs, MP3s etc.) Even here, though, limited *objet d'art* editions of LPs and CDs have elevated the musical artifact to the level of a mixed-media presentation, giving listeners a tactile accompaniment – a small-scale *Gesamtkunstwerk* akin to a 'private installation.' Live performances are another story entirely – when the focus on the presence of a human performer is de-emphasized, and various combinations of sound-heavy sensory information take place of pride instead, are we dealing with a *concert* or an *installation*? The relative ease of one's own entry and exit from an installation, as compared to a concert, used to be the deciding factor, but these days concerts of electronic music –especially ones set up in a festival atmosphere – are less restrictive.

Whether sound art is *synonymous* with electronic music is open to debate; and some of the rationales for deciding whether one is an electronic musician as opposed to a sound artist –such as adopting a 'project name' for their CD releases rather than using a given birth name – border on the irrelevant. Whatever yardstick we attempt to use for determining one's allegiance to electronic music or sound art, exceptions rise up to challenge the absolute validity of the rule. "Some, but not all" seems to be the answer to almost any inquiry we make about whether an electronic musician differs from or is equivalent to a sound artist. Therefore, claiming that this book was about "electronic music" *and* "sound art" at least allowed me to let readers draw their own personal conclusions from the many examples within, whereas a book about *either* "electronic music" or "sound art" would be insisting to readers that one or the other is more commercially viable, or perhaps more intellectually and emotionally stimulating – and none of this is easily quantifiable.

Et cetera...

Please note that the chapters in this book do not need to be read in sequential order, although they may occasionally refer back to one another – after a certain point much of the activity discussed did not happen in any linear historical sequence; many artists reached the same conclusions simultaneously within different geographic confines. To borrow a concept from Gilles Deleuze and

Felix Guattari's *Mille Plateaux*, the book could be seen as a kind of 'toolkit' with certain discussions and ideas being more useful to the individual reader than others. While I would recommend at least beginning with the opening chapter on Industrial music (which I feel puts a decent 'primer coat' of paint onto this finished work) even this is not mandatory, and many readers may already be familiar with this brief 'pre-history' of 21st century musical tactics.

To borrow another statement from an influential book – in this case, Douglas Kahn and Gregory Whitehead's anthology *Wireless Imagination: Sound, Radio and The Avant-Garde* – these writings should not be taken as the "last word" on any of these musical phenomena. We are poised on the brink of technological and cultural developments which, while they may not exactly cause seismic disruptions in human nature, will change the sonic landscape more quickly than any of us can perfectly imagine or predict. Therefore, the music discussed here is not "the last word" either, and merely braces us for what may be even more unexpected and dynamic outbreaks of creative force. While finishing up this book I had the distinct, nagging feeling of packing a suitcase for a long journey and knowing that, despite my best efforts and notes to myself, some useful item or another would be forgotten – and even if I remembered it, it would probably put my suitcase over the 'weight limit' enforced at the local airport and would force me to pay a heavy fine or carefully re-arrange all the items that I *had* remembered to pack.

With all this in mind, future volumes of this book would not be inconceivable, let alone dozens of other qualified reports on this subject. If this volume stimulates interest in conducting the research that would facilitate the writing of those future works, then my work here is done.

"Passion can create drama out of inert stone."
-Le Corbusier

1.
RESISTANCE OF THE CELL:
INDUSTRIAL MUSIC VS. THE "CONTROL MACHINE"

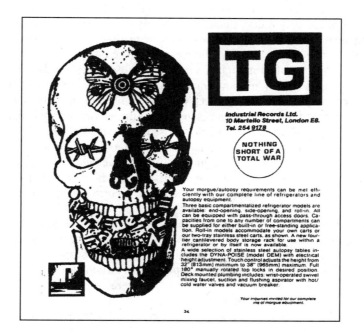

This book is an introduction to 21st century sound artists whose works reflect, and sometimes transcend, their temporal and spatial confines. That is to say, artists who make informed critiques of human nature (and post-human development) in an era where the overwhelming amount of extraneous noise makes it increasingly difficult to do so; smothering unique and distinct signals wherever they arise with slick media flak. To build a convincing argument as to why these artists are successful in their activities, and worthy of further consideration, we first have to zoom out to the broadest possible view of our planet's condition, to see exactly what these temporal and spatial confines are which form the framework for their creative endeavors. At the moment, attempting a run-down of current events that would still be relevant at the time of this book's publication seems futile and downright silly, given the demented velocity at which these events are progressing. All the same, a very broad overview of the human condition at the opening of this millennium seems like a necessary formality here.

Much has been made of the so-called 'population bomb' (or, in the words of 'Gaia Hypothesis' formulator James Lovelock, "*Disseminated Primatemaia*") which is at the epicenter of most 21st century crises. History shows that ideological disputes and feudal wars for the recognition of sovereignty would likely still rage on if our planet were at a tenth of its current population, but that is most definitely not the case now, and instead we have intensifying struggles over resource management, population dynamics, and wealth distribution – which in turn fuel the seemingly unquenchable fires of war, poverty and xenophobia. The biosphere seems incapable of sustaining a species which is doubling its numbers in record time, and debates about the scientific veracity of global warming pale in comparison to the fact that, even as natural disasters and warfare diminish our numbers significantly, we will re-populate at such a rate that the survivors of these tragedies will not even be able to enjoy the dubious reward of having more 'breathing room'. To start this

journey on such a grim note may seem counter-productive to some, but neither do we do ourselves any favors by denying the gravity of this situation. The shift in population dynamics alone, let alone the strain that a mushrooming population will have on the planet's resources, provides case enough for alarm. In developed countries that are widely believed to have "grown out of" their intense martial phase (see especially Western Europe and Japan) birth rates are dropping below replacement levels, and a significantly older population will be left to shape the future politics of those countries. In the meantime, a whole host of developing, increasingly militarized nations are growing rapidly in both population and discontent, while maintaining a median age somewhere in the mid-20s. Impartial students of population dynamics are clearly not the only ones to seize on the possibility for disastrous conflict here, when an aging, shrinking, secular, post-martial world collides with a youthful, expanding, passionately religious, militaristic one. The ultra-rightist, nationalistic parties of the developed countries are seizing on deeply ingrained phobias to up their recruitment efforts considerably, sensing that those contingencies in their countries who *are* still young and combative may be willing to forget the past failures of fascist control in the face of immigration-related anxiety. The potential for such conflicts to explode in the streets at any given moment has provided an easy rationale for local governments to increase their surveillance efforts, disregard numerous civil liberties, and conveniently deploy more brutal methods of policing, while an immense military/industrial/prison complex turns the desire for security into a tremendously lucrative enterprise.

Difficult situations such as these are almost guaranteed to produce more intense artistic expression among those who can find the time for it. This is not to belittle those who, ill-equipped to find solutions for such catastrophes, resort to more gentle, escapist and 'classical' modes of expression. But this is a book about engaging complex issues through artistic expression, not beating a temporary retreat from them until they become more tolerable. So, with this in mind, we turn to Genesis P. Orridge, one of the past century's most celebrated (or reviled, depending on who you consult) counter-cultural provocateurs, for some more opening thoughts on the present state of humanity:

"It seems to me that our species is in a multiple crisis. Ecologically we are the most efficient locusts ever known. Judging by our disinterest in the CONSEQUENCES of our actions, one might conclude we are also as stupid as locusts, in that we allow ourselves to be led down a locust path. Financially we are in the throes of hottest passion. Everyone is doing everyone else in a corporate parody of a bacchanalian orgy, complete with intrigues and perversions. We would do well to recall the last daze [sic] of Rome when everything was possible, and the sacred and profane unified in power."[1]

However, the 'locust swarm' effects of the population explosion are only one side of the rapidly unfolding story of the new millennium. It is indeed a 'saturation society' where everything apparently needs to operate at the maximum possible level in order to remain useful for such an expansive global population, and the dissemination of information has been one of the few things capable of satiating the population's needs in a time of general scarcity. In fact, it has been so successful as to *surpass* the population's needs, with plenty of people noticing that information now comes down the pipeline at too quick a rate to even be properly digested.

In/Formation: The 'Terror Guards' of Industrial

Genesis P. Orridge, as a founding member of Throbbing Gristle and consequently the musical genre known as Industrial music, is partially responsible for a good deal of the artists profiled in this book. While he remains as controversial a figure today as in the Industrial heyday of the late '70s-early '80s (thanks to a recent proselytizing of 'pandrogeny', or the spiritual implications of hermaphroditic nature) his seminal group's influence on the current generation of sound artists can be perceived far and wide – from the 'extreme computer music' of the Austrian Mego record label to the paint-peeling synthetic pulse of the Finnish duo Pan Sonic. Throbbing Gristle were, for a brief period, the flagship of a small but impressively varied fleet of sonic activists converging under the Industrial

music banner – originally this applied only to the roster of Throbbing Gristle's Industrial Records label (TG, S.P.K., Cabaret Voltaire, Clock DVA, Monte Cazazza) although the core group of 'original Industrialists' was expanded somewhat with the publication of the Re/Search *Industrial Culture Handbook*: shamanistic metal drummer Z'ev, 'machine theater' collective Survival Research Laboratories and pure noise magus Boyd Rice were also named among the aggressive and prolific aggregate of multi-media artists that constituted the first Industrial wave.

Throbbing Gristle, before being recognized as the spearhead of Industrial music, were originally an outgrowth of an earlier multi-media art troupe called COUM Transmissions (named after a nonsense word heard in an out-of-body vision that P. Orridge experienced on a family drive through the countryside.) Capitalizing on the new thrust towards collaborative/group-based art dawning in the 1960s, COUM produced a wide and varied body of work including sculpture built from recycled materials, film-making, guerrilla theater and (most relevant to their future incarnation as Throbbing Gristle) live, improvisational musical spectacles. The highly anti-professional, willfully naïve and open participatory nature of the group's output is stylistically indebted to the other major rumblings 20th century art based around a group identity – primarily Dada, Fluxus, and Viennese Aktionism – infusing these mainly Continental movements with a more uniquely British vocabulary and sensibility. COUM activities were essentially a means of questioning and eliminating social divisions: they were apolitical and anti-materialistic, favoring direct experience as the real means to cultural epiphany and social change, rather than the hoarding and appraisal of art objects. They were as populist as could be expected for the time, often bringing local criminals and Hell's Angels into their orbit – a fact which heightened the police attention given to the collective, and eventually forced them to move from their native Hull to London in 1972.

In a 1970s performance art world whose visual extremity and cathartic nature were embodied by pieces like Chris Burden's car-top crucifixion and Paul McCarthy's unsettling play with food and bodily fluids, COUM were not an isolated curiosity – but their residence in a comparatively smaller nation, and their status as recipients of Arts Council funding there, arguably made them more notorious more quickly than either of these Stateside artists. All of the most potentially offensive aspects of COUM united into one raging current at 'Prostitution,' the group's 1976 exhibit at the ICA – an exhibit with a three-fold significance. Firstly, it was intended as a retrospective/overview of COUM's work to date, then as a parting shot to the art world, and thirdly, the exhibit at which the group would transition to its musical incarnation as Throbbing Gristle (TG's first official performance was at the 'Prostitution' opening party.) COUM, to their credit, had never participated in the kind of rarified culture that typified so much of traditional gallery art; in which creators were rarely on hand to discuss their creations, or to interact with an 'audience' beyond dealers, curators, and prospective buyers. Each of the four COUM members who would become Throbbing Gristle were in agreement that music would provide more of an indelible imprint on the psyche of a younger, more diversified public. And just as COUM had attempted to wrest control of art from a limited establishment, Throbbing Gristle aimed to do the same with electronic music. The U.K. had a fascinating recent history of involvement with electronic music innovation, with such successes as the BBC Radiophonic Workshop – but again, it was confined to a hermetically-sealed studio atmosphere, not likely to be breached by untrained youth in desperate need of personal expression.

More than Throbbing Gristle's influence on the actual sonic structure of modern electronic music, though, the band's influence comes from the way they interacted with the information overload that was just beginning to manifest itself during their existence. The band's primary focus was the 'information war' (as proposed by Marshall McLuhan in *The Medium Is The Message*) rather than, as many have supposed, the dehumanizing potential of factories – dehumanization through factory automation was an issue which had ample time to enter the public discourse *well* before the late 1970s, and was surely touched upon already by a number of politicized folk singers, Beat provocateurs and hippie collectives. Thus the term 'Industrial' was a kind of misnomer to begin with, although later groups would adopt a more explicitly 'heavy industry' nomenclature and symbology

rife with cogwheels, metallic clamor and lyrical allusions to hard labor. Attributed to Throbbing Gristle cohort and like-minded San Francisco performance artist Monte Cazazza (who coined the slogan "Industrial Music for Industrial People"), the term was not so much an attempt to open the public's eyes to the bleakness of regimented factory life as it was an attempt to mock the then-prevalent desire for things to be 'real', spontaneous, or 'from the heart' as opposed to pre-meditated and manufactured.

There was a bitter irony to all this: namely, that many artists of the day claiming to have a sincere, 'from the heart' product were, more often than not, completely fabricated by the entertainment business – it took contrarian performance artists like Throbbing Gristle to actually *admit* to the degree of mechanization and reproduction which really took place in the commercial music world, and to be far more straightforward about their intentions than the rest of the 1970s musical elite. For people duped by the cult of ersatz authenticity, Industrial music was, on face value at least, a conscious inversion of supposed universal values of organic/natural living, liberal democracy and spiritual questing. The trends of increasing species homogeneity and of 'branding' were thrown back in the face of the public in an uncomfortable but irrefutable statement on the old 1960s subculture's powerlessness relative to the massive military-industrial complex: distinct, flashy stage gear and flowing tresses were swapped for camouflage uniforms and short utilitarian haircuts, while some Industrial record albums came wrapped in interchangeable, artless packaging, sometimes bearing nothing other than a parody of a corporate logo and some descriptive text on a plain white background. Lyrical poetry was ditched in favor of lobotomized, spoken or shrieked accounts of traumatizing experiences (see 'Hamburger Lady', dealing with a hospital burn ward nightmare.) Or, taking it one step further, the 'vocals' on a track might be no more than an appropriated instructional tape meant to familiarize soldiers with the noises made by different types of artillery fire ('Weapon Training.') Metronomic, programmed rhythm-box beats and looped sound fragments rounded out the sonic program – serving to discipline and punish (one of Throbbing Gristle's most recognizable songs is, indeed, titled 'Discipline') rather than to warm and console.

Yet 'Industrial' music was not a wholesale capitulation to, or endorsement of, superior forces of bureaucracy, war and mass production – far from it. It simply proposed a different way of engaging these hostile powers: outright protest, street skirmishes and on-campus proclamation of one's anti-authoritarian position were obsolete, if not downright foolhardy, especially when the authorities were now so huge and bloated as to be undermined in more subtle, stealthy ways. The bohemian drop-outs of the recent past had achieved all that they likely would with sit-ins, moratoriums and attempts to levitate the Pentagon: the new youth subculture would be one composed of highly organized, paramilitary 'control agents' and (in a play on the initials T.G.) 'terror guards' – all of whom would find some means of borrowing the establishment's most prized commodity in order to weaken or destroy it. As P. Orridge described in 1980:

"Basically the power in this world rests with the people who have access to the most information and also control that information. Most of the paranoia concerned with politics is about what is really going on, what is secret, what we are not being told about...these [information] systems are very expensive and cumbersome, requiring capital equipment which can't be utilized the whole time. So to cover costs and keep equipment running, these systems have to be made available to the rest of us to keep them financially viable. That's why you can get access to cable TV, to computer time, instant printing and cassette recorders, even the mail, Polaroids too, and video...they develop these systems for their own reasons, but they are so expensive they have to mass produce them to finance them. So we all get easier and easier ways to multiply our ideas and information, it's a parallel progression."[2]

Genesis' statements will almost certainly cause some to think of that most omnipresent example of the 'beating swords into ploughshares' strategy, the Internet. In its earlier incarnation as the Arpanet, computer-to-computer communication was something only to be used in the event of fallout from a nuclear strike, while nowadays the prospect of limited access to online communication seems unfathomable, at least for the moment. While the gradual transformation of

clandestine military technology into everyday consumer technology has certainly been empowering for many inquisitive and creative souls, this has not yet led to total counter-culture victory through re-appropriation of the nebulous 'control machine's' information. While the Internet and all its attendant innovations have forced some governments and multi-national corporations into a position where they can be more easily monitored and criticized, the same has held true for those governing bodies' subjects. The potential for vacuuming up data about possible dissidents via the Internet has now become so great as to make P-Orridge change the above opinion (which was, after all, voiced on the cusp of the 1980s) a full 180 degrees:

"I myself am absolutely on the side of an immense skeptical suspicion of the 'World Wide Web'. What a horrible title. Are we all the innocent little insects unwittingly trapped in a gluey binary Armageddon of telephone lines? Who is the spider? Well, control of course. Corporations of course, increasingly insipid and acceleratingly effective bureaucratic governments."[3]

Genesis continues in even more damning terms:

"Mobility of labor is the capitalist dream, and computers realize the ultimate exploitative nightmare. All labor can now travel anywhere, without physically moving. Much cheaper and more efficient. Everything piped down a phone wire. Perfect! I don't think so. Count me out. I unplugged my modem ages ago. Best thing I ever did for my creative mind. Unplug yours too."[4]

Recent evidence shows an about-face on this issue: Genesis P. Orridge does indeed have a regularly updated online presence, and has tempered his warnings on the Internet with Gnosticism-tinged suggestions that it could accelerate humanity's re-combination with the 'divine'. Still, another essay, circa 1998, better illuminates his personal fear of this medium's potential to turn humanity into a horrifically indistinct and pliant mass (also expanding on the opening statements about the population crisis):

"There may be an environmental issue here too. As the climate gets more and more unstable through the unrecyclable waste of our species of performing (and occasionally clever) rats, we will be forced to live in more and more controlled, indoor environments. What better solution than to have all the 'drone' workers at home. Out of the deadly rays cutting through the orgone. Out of the polluted air. Unable to see the ongoing death of nature. More and more content with virtuality, processed food. Infinite options of televisual, Internet experience and distraction. Even content to reduce their investment in direct sexuality. Thus slowly being weaned from the replication disaster that is biological breeding."[5]

The Sound of Muzak/The Electronic Revolution

In the new millennium, the sort of soft tyranny that Genesis predicts above is not being carried out by means of telecommunication alone. Whereas the computer-initiated information age of the 1990s may have simultaneously liberated and enslaved, so too did the boom in other emerging fields, such as behavior-modifying neuropharmacology. Pharmaceutical firms such as Novartis (formerly Ciba-Geigy), Pfizer, Eli Lilly and Glaxo Smith-Kline have become almost synonymous with mind control and 'social engineering' in circles of autonomous thinkers – meanwhile, their soporific products have been embraced by millions upon millions of consumers throughout the world. While some may see the steady advancement of such 'social engineering' anti-depressant chemicals such as Prozac and Ritalin as a godsend, other more skeptical individuals see them as little more than unnecessary 'cures' for universal human problems that were meant to be experienced as a means to further evolution – in the case of anti-depressants like Prozac or Paxil, which release acceptable amounts of serotonin in brains starved of such, thus 'curing' sadness and nervous tensions, the question constantly arises: are these medicines simply a way to postpone public awareness of a disintegrating geo-political situation, rather than allowing the populace to be agitated into altering the situation themselves? It is something worth considering, especially when one of the most effective soporific 'drugs' is free and accessible twenty-four hours a day in the form of television (a medium whose major broadcasting networks are, incidentally, owned by some of the most

successful international war profiteers.) As Neil Postman suggests in his 1986 jeremiad *Amusing Ourselves To Death*, the omniscient 'Big Brother' of Orwell's *1984* can't feasibly exist in a world where normal individuals have an unprecedented amount of access to information – but a similar power could very well exist in a world where people are too drugged, pacified, and otherwise distracted through a deluge of entertainment media to even *attempt* uncovering information detrimental to his activities. An inept governing body would have great ease in controlling its subjects when they mostly exist in comfortable mindsets free of emotional peaks or valleys, having absolutely *no* opinion on anything from ecological destruction to the failing educational system.

Not long ago, before either the advent of the Internet, 24-hour "news" networks, or the revolutions in neuropharmacology, this 'soft' social engineering within the Western world (as opposed to the 'hard' application of military and police force) still had to be largely carried out through the various forms of mass entertainment then on hand. Television, of course, has had a host of neurological effects comparable to those of mass-marketed pharmaceuticals – but, in the audio realm, perhaps no better example of "social engineering through entertainment" exists than the Muzak of the late 1970s and 1980s. It was a music which, by today's music production standards, was laughably quaint and inoffensive – the characteristic muted horns, the subdued, even submerged flutes and the lightly-brushed percussion of Muzak melted together into an insidious beige soundscape; an aural tranquilizer meant to dull the alien sensation of spending time in antiseptic offices or hospital waiting rooms. Whereas today's legally available tranquilizers aim to free people from the wild, raging passions which define humanity, so too did Muzak attempt to strip all the emotional, soul-stirring 'peaks and troughs' from music and to replace them with something just 'human' enough not to unnerve people, but too vague to arouse the emotional surges of conventional forms of music – passions which would be serious obstacles to meeting quotas of production or consumption. Marc Almond, of the subversive synth-pop act Soft Cell, had this to say on the subject of Muzak:

"When I was doing the soundtrack for the film *Decoder* with [Genesis P. Orridge], we were doing some experiments with Muzak tapes, which we shouldn't have had but we got hold of, and we analysed them on a spectrum analyzer and the levels all stayed the same – just straight. With normal background music, the LEDs were just going up and down. Muzak is just straight across, it didn't move. Basically it's just totally compressed because it's music put together by scientists."[6]

Muzak was, at one time, such an effective audio security blanket that it pitched itself to America's swelling network of fast food franchises and supermarkets as "the security system of the 1970s." This was a point not lost on Klaus Maeck, the Berlin-based owner of the 'Rip Off' punk record shop/distributor, and writer of the aforementioned film *Decoder*. In this illuminating 1983 film, which features Industrial culture luminaries Genesis P. Orridge and F.M. Einheit in acting roles (alongside a cameo by William Burroughs as the proprietor of a junk electronics store), Muzak represents the control machine which pacifies an entire city and keeps them completely focused on their leisure hours in 'H-Burger' franchises ("H" here being a wordplay on heroin.) Another amusing pun is in the movie's working title, *Burger Krieg* ('burger' being both the fast food favorite and the German word for 'citizen', thus giving the title a meaning of 'civil war.') The film is a case study in what would eventually become the defining characteristic of Industrial music: manipulating and re-appropriating consumer technologies, especially those intended to have a behavior-modifying or pacifying effect, so that they will instead agitate individuals and once again stimulate them into a state of free, non-compliant thought. As Klaus Maeck says:

"Being in the music business and participating in the punk and new wave explosion, I became more interested in music. Muzak was one thing that I found. Subliminal music to influence people's moods, to make them function better, or buy more. So my conclusion was similar to that of 'bands' like Throbbing Gristle; by turning around the motivation, by cutting up the sounds, by distorting them etc. one should be able to provoke different reactions. Make people puke instead of feeling well, make people disobey instead of following, provoke riots."[7]

Genesis P. Orridge (who had already transitioned into the Psychic TV project by the time of

Decoder's filming), appearing in a clerical collar and listed in the film's credits as *Höhepriester* [High Priest], hints at the aggressive and tactical nature of Industrial music when he states, in a monologue halfway through the film, that 'information is like a bank' and that it is the duty of inquiring minds to 'rob the bank' and to 'destroy everybody' who withholds free access to information. It's an unrepentant, easily-grasped sentiment, and one which at least identified a true enemy to be dealt with – it should come as no surprise that the vague, scattershot "DESTROY" of latter-day punk rockers, with no clear target in mind, has become a more suitable slogan to be mass-marketed on t-shirt designs than the ideas of the original Industrialists. While Genesis P. Orridge, Throbbing Gristle and their ilk may have been among the first to present the 'information war' within a 'pop culture' context, the anarchic writings of Beat author William S. Burroughs provided the raw schematic for these ideas in the first place. Burroughs' *Electronic Revolution*, while one of his shortest texts, has also become one of the most widely cited and appreciated amongst members of the Industrial music community and beyond, thanks to its radical proposition that consumer electronic devices (in this case, tape recorders) could be used as magical tools, empowering the otherwise disenfranchised through a sustained program of juxtaposing sharply contrasting information samples: pig squeals mixed with prayer calls, for example. This technique has been incorporated into the paranoiac drone of early Cabaret Voltaire and Clock DVA records, in the early voice experiments of Z'ev, and in countless others besides. *Electronic Revolution* not only offered practical examples for how anyone could short-circuit the "lines of association" laid down by the mass media, but also offered emboldening statements such as the following:

"No, 'They' are not God or super technicians from outer space. Just technicians operating with well-known equipment and using techniques that can be duplicated by anyone else who can buy and operate this equipment."[8]

Such blunt dismissals of impregnable authority were an exciting stimulus for the Industrial movement of the 1970s and 1980s. And, better yet, not only did the anti-authoritarian re-appropriation of technology 'level the playing field' but in some cases it made the insurgent elements *more* powerful than their oppressors:

"You have an advantage which your opposing player does not have. *He must conceal his manipulations. You are under no such necessity* [italics mine]. In fact, you can advertise the fact that you are writing the news in advance and trying to make it happen by techniques which anybody can use. And that makes you NEWS. And TV personality as well, if you play it right. You want the widest possible circulation for your cut/up video tapes. Cut/up techniques could swamp the mass media with total illusion."[9]

Throbbing Gristle and company took the preceding advice and ran with it – layering sounds, images, and attitudes with surgical skill. It was helpful, of course, that the individual members came from very different disciplines, all with some direct connection to mass media or communications apparatus: Genesis P. Orridge was an expert on contemporary art movements, Peter "Sleazy" Christopherson was an accomplished graphic designer, Cosey Fanni Tutti modeled for pornographic magazines, and Chris Carter was savvy with do-it-yourself electronics, stage lighting, and circuitry. Admittedly, no one in the band had any formal musical training (and most of the band even made a conscious decision to play the musical instrument they most hated), but the arsenal of non-musical maneuvers that they collectively developed made for something more resonant than much music of the day. Many of the new breed of Angry Young Men were willing to shake their fists at the all-enveloping communications media and information technology being used against them, but surprisingly few ever thought of using it as a weapon against itself.

To Be Done With The Judgment Of Punk

"I'd heard The Damned, I'd heard The Clash, and I just thought they were rock crap – I was never interested in rock 'n roll. And Throbbing Gristle, although they used guitars, and bass, and originally drums, the whole aesthetic of it reflected the way my life was – I lived on really boring estates and R.A.F. council blocks. What they put into their music lyrically and soundwise was so relevant to me,

it blew punk out the window – it really did. They were confronting issues the other bands weren't doing – the other bands were being dressed by Jasper Conran, the clothes designer... The Clash were... and it was all clothes-oriented, and 'The London Scene,' and it was horrific. [Throbbing Gristle's] art was life, and life was art – there wasn't a difference."[10] (John Balance, of Coil)

Industrial music had the misfortune to emerge concurrent with the UK punk rock scene, which led to occasional confusion of the former with the latter, and to an occasional complete indifference to Industrial efforts – or, more insulting to Industrial musicians, the claim that punk had 'enabled' the very existence of Industrial music and that it was an umbrella under which all marginalized and antagonistic artists could now find some safety. This fallacy is easily dismissed, considering that the first wave of Industrial musicians had been experimenting with weird, spontaneous music since at least the early 1970s. In a milieu as incestuous as British pop music, though, there was bound to be some crossover and cooperation between the genres from time to time – Peter Christopherson was responsible for some of the controversial shop window displays of the punk fashion temple SEX (most notably a display in which it looked like a real punk rocker had been detonated, and his charred remains placed on display.) Both had a penchant for using archetypal symbols of totalitarian order to different ends: the punks donned swastika armbands and t-shirts, suggesting that they could regard even the greatest horrors of the 20th century with sneering apathy, and Throbbing Gristle utilized the lightning flash logo of Oswald Mosley's British Union Of Fascists, broadening that symbol's meaning of "action and unity" to a variety of other more personal contexts. Post-punk staples like Joy Division, by naming themselves after a Nazi brothel, and featuring old Hitler Jugend imagery as sleeve artwork, delved into this subject matter in yet more uncomfortable detail, while their label (Factory) shared the austere design schemes and motivations of Throbbing Gristle's Industrial Records (Joy Division's frontman Ian Curtis was allegedly a close friend of Genesis P. Orridge.) And, of course, there were the requisite concert bills shared by punks and Industrial musicians, which generated a full spectrum of reactions from forced ennui to all-out violence. Several key differences between the two movements should also be noted, in spite of occasional efforts to link the two in their ultimate goals. Chiefly among these differences is the reactionary, Luddite panic that the nascent punks sometimes espoused in the face of new technology. Sound artist Francisco López noted the pitfalls inherent in this attitude when he stated:

"I once read an interview with [Clash guitarist] Joe Strummer, in which he was criticizing technology in music. He said something like 'I am a musician, I don't want to be a fucking computer operator'. Surprising to see he didn't realize about the fucking guitar operator in front of him."[11]

Peter Christopherson, when posed a question about the moral ambiguity of technology, also answers in a non-alarmist fashion disappointingly lacking in the punks of the time:

"I do not see a causal relationship between a hammer and playwright Joe Orton's boyfriend Kenneth Halliwell, who killed him with one. He could have used a rock... or even a pen. No matter what tools are available, it is still always the responsibility of us to use them wisely and generously, rather than to hurt others. If you are asking 'would the world be a better place without tanks and land mines?' the answer would obviously be yes, but this is an abstract and non-realistic question – we have them, just as we have iPods and cell phones. Your question also infers that technology may inevitably lead to the destruction of mankind, but I believe that it is mankind itself (rather than technology) that will do this."[12]

Although this is certainly not the case with every participant in the punk community, punks regularly voiced their fears of automation and computerization in song, in a way that smacked more of its antithetical "hippie" consciousness than they'd care to admit. While it was, from the outset, a multi-media subculture (the pre-TG performance art collective COUM Transmissions referred to their happenings as 'transmedia', and de-emphasized artistic specialization), the Industrial movement would often be judged using purely sonic criteria.

Punk rock, for all its anarchist yearnings, did indeed build itself on a capitalistic rock'n roll chassis. Punk concerts were still very much a means to selling records: on the whole they didn't manage to escape from the ironic cycle of making records to preserve a performance, then having

a performance which is only successful insofar as it duplicates the record. Industrial performances were usually events which could not be replicated twice, which might have absolutely nothing in common with any pre-recorded work, and which replaced the usual technical skill exhibition expected of a music concert with a more generalized dissemination of information. Which is not to say that Industrial events were tantamount to academic lectures – the sensory overload of these showcases comprised high volume ultrasound and sub-bass frequencies, high powered floodlights turned on the audience, disorienting collages of taped conversations or news feeds, home-built electronic devices emitting previously unheard types of modulation and oscillation, and also film backdrops of an alien or uncomfortable nature. It was a panoply of sights, sounds, and occasionally smells (Survival Research Laboratories are particularly famous for incorporating nausea-inducing compounds into their shows) which, unlike most other popular music, struck on a physical *and* intellectual level – assailing the body with high decibel blows while the brain attempted to decode the bizarre, scrambled crosstalk coming from multiple cassette machines.

The psychological effects of droning, continually escalating monotony were also put to use in place of traditional pop music's appeals to sentimentality. Despite the sheer unavoidable force of these presentations – something like a more brutal take on Warhol's 'Exploding Plastic Inevitable' concept – many period journalists and punk sympathizers walked away with the impression that it was no more than willful dilettante-ism from middle-class "art students". Unfortunately for these critics, history has proven the inverse to be true – only one member of Throbbing Gristle had a formal art education (Peter Christopherson, at SUNY, Buffalo) whereas many of the punks did. Members of Throbbing Gristle were certainly aware of the 20th century artistic avant-garde's accomplishments, having concretized or built upon the ideas of everyone from Kurt Schwitters to Günter Brus to John Cage – and they had a vested interest in distilling these atavistic ideals into amplified music, at the time the most popular and immediate art medium. Yet most of the 'art education' of these individuals was a matter of personal questing after information, not of any formal training within an accredited institution. Many of the art-school educated punk rockers, who should have had a more thorough and applicable knowledge of experimental technique by dint of their education, were the first to run to the aid of musical tradition.

D.I.Y. Or Die

Another difference between the Industrialists and their musical contemporaries was the degree of autonomy with which they operated. Punk, again, owing to the relative ease with which the public could digest it in comparison to Industrial music, was given precedence over music which people didn't even have the vocabulary to describe – and today's nostalgic puff pieces on the punk era almost invariably celebrate how the punk movement re-asserted the right of the individual in society. Genesis P-Orridge, however, is quick to counter those who would give punks all the glory for a work that he was also instrumental in achieving, claiming that "the difference between Punk and Throbbing Gristle was that Punk was trying to change the nature of Rock & Roll; Throbbing Gristle was trying to change the nature of music."[13] Punk has, by this time, been associated with the Situationist movement of Guy DeBord an incalculable number of times – in his "Theory Of The *Dérive* ", DeBord states:

"One can *dérive* alone, but all indications are that the most fruitful numerical arrangement consists of several small groups of two or three people who have reached the same level of awareness, since cross-checking these different groups' impressions makes it possible to arrive at more objective conclusions."[14]

The *dérive*, as per DeBord, translates to "drifting" and is an aimless walk or journey through an urban area, so as to break hold of routine patterns of movement and assign one's own 'psychogeographical' meaning to any given space – simply put, to control the spatial boundaries one finds oneself in, rather than to be controlled by them. Just like the Industrial employment of Burroughs' cut-up techniques using jarring tape collages, it was an attempt at negating control simply by refusing to believe that one park, building etc. had only one pre-set purpose. Some

Industrial musicians, however, would probably disagree with DeBord's suggestion that small groups of people were the "most fruitful" – in fact, many Industrial musicians in the wake of the first TG-led wave operated using a 'lone wolf' cell structure almost completely independent of any peer group or support network. While even the most radical and politically active punks, such as Crass, worked as a collective, individuals like Nigel Ayers (of Nocturnal Emissions) would become one-man industries comprising publishing, music production, graphic design and more. While the 'publishing' in question may have been just a matter of having access to a photocopy machine, and the 'graphic design' may have been little more than haphazardly cutting and pasting monochromatic images into maddening, cluttered montages, it was still a striking level of autonomy for a single working-class person to have, one which pre-dated the 'information consolidation' potential of web pages by some 15 years. Individual cells in the early 1980s rose up in virtually every country where cheap mass-production techniques could be accessed by everyday consumers: there was Minus Delta T in Germany, Club Moral in Belgium, Merzbow in Japan and a host of others – in all cases, at least two of the above criteria for autonomous production were being taken care of by a single ambitious personality. The processes of printing, layout, mail distribution etc. were just one part of the story, though – the actual recording of music had become, thanks to cheaper home recording devices and to highly versatile electronic instruments like the Korg MS-20 synthesizer, something which could be achieved in record time – without the anxiety of running up astronomical bills for studio time (provided a studio could even be found whose engineers would condescend to recording this kind of music), and without the need to get the consensus approval of a 'band' before one's musical visions could be realized. Waxing nostalgic over the revelatory introduction of new musical equipment, Moritz R. (of Germany's absurdist electro-pop group Der Plan, who developed concurrently with the British Industrial movement) states:

"A real watershed moment for me was an encounter with a machine: Pyrolator [a.ka. Kurt Dahlke, also of Der Plan] had a Korg MS-20. And I got a chance to play around with it a little. The thing looked like a little telephone switchboard. And if you wrangled with it long enough, it didn't sound like an instrument anymore, but like wind, water, a helicopter, or an air raid siren. And I had this definite feeling of 'finally, now I can make some music soon, too.' Without the MS-20 and a little bit of Japanese technology, none of that would have been able to transpire. And from that point on, the whole development of music was also a technological development."[15]

The MS-20, as well as other period synthesizers such as the EMS Synthi A, were excellent tools for simulating the sounds of the information war – the palette of electronic sounds produced by these instruments went beyond the confines of tonal music and reminded the listener of a great deal of other elements within the sonic landscape of the late 20th century: television static, automatic weapons, and humming of electric pylons being just a few examples that come to mind. Their ability to emulate deep percussive sounds also provided a convenient way to make rhythmic music without needing a full battery of acoustic drums. New instruments such as these provided the perfect sonic component for a multi-media art form hellbent on becoming, as per one Throbbing Gristle review, "...a means to radicalize the listener into abandoning bourgeois romanticism for a realistic view of life."[16] Such romanticism and sentimentality was comfortably couched in the familiar sounds of guitar groups and pop vocal ballads, which may have dealt with modernity in a lyrical sense, but balked at using the actual technological innovations of modernity – because, again, it was considered as counter-productive to creating an aura of "authenticity." In situations where Industrial artists did resort to conventional instrumentation, it was modified to the point of sacrilege – the 'wings' were sawed off of the guitar of Cosey Fanni Tutti, in order to make it more lightweight, portable and practical for use as a "ladies' guitar" – the placement of practical considerations before 'tradition for tradition's sake' seemed to offend almost as many serious music fans as Throbbing Gristle's unrepentantly harsh subject matter. And they were not alone in this respect – Boyd Rice of NON took the blasphemy of the rock-n-roll Holy Grail one step further by mounting spinning fan blades on top of the strings and pickups, turning it into a "roto-guitar" capable of generating ferocious, fatiguing walls of solid noise (Rice's early experiments with

turntables also mark one of the first uses of that particular playback device as an instrument, outside of the *musique concréte* tradition.) Elsewhere, Blixa Bargeld of the Berlin 'scrapheap music' ensemble Einstürzende Neubauten used sparse, rusted, and atonal guitar sounds as little more than a complement to his bandmates' primal pummeling on metallic implements. In all these cases, the wielders of the instruments probably had no knowledge of how to read or score sheet music, let alone the nimbleness of finger required to play the instrument properly – this in spite of the fallacious rock-'n-roll mantra that "anyone can play guitar". The use of instruments both novel and traditional, or electronic and acoustic, to produce specific psychological/physiological effects (rather than as tools through which to channel virtuosity), is an idea which came into its own with Industrial music – an action which Genesis P. Orridge defends by saying "in the end, music is popular culture and art is divine."[x17]

New Collectivism

"Art is noble mission that demands fanaticism, and Laibach is an organism whose goals, life and means are higher – in their power and duration – than the goals, lives and means of its individual members."[18] (Laibach)

Industrial music did return music to an exciting zero point where the only limitations on creation were the artist's own resourcefulness – yet, in a testament to the genre's fluid boundaries, the 'lone wolf' cell structure was not the only strategy embraced by all of its constituents. The leftist politics of the London metal-bashing group Test Dept., for example, demanded that strength in numbers be deployed against a corrupt and monolithic State: the individual names of the band's members were not widely known or listed on album credits, and their functions within the band were also assumed to be interchangeable. To do otherwise would have been a concession to the "star system" of popular music, in which a procession of 'unique' personalities supposedly performed a function (virtuosity with a musical instrument, athletic dancing skill) that could not be replicated or imitated by other mere mortals, making them objects onto which the masses could project fantasies about what *they* would do with such exclusive talents. The end result of this is easy enough to see: a large-scale de-personalization brought about by the industrialization of common dreams. These dreams are dictated to the masses by stars who stop short of truly giving the masses the means to realize these dreams themselves.

In a purely tactical sense, the development of a personality cult around the individual members of Test Dept. would also be foolish – groups agitating against a much more powerful State (Test Dept. supported the South Wales miners' strikes in the mid-'80s, among other causes) can hardly afford to disclose their positions or to offer up the same kind of candid personal details that pop musicians offer to appease their fans.

This collectivist take on Industrial was made more interesting when it headed East to Slovenia, to be taken up by an intellectually advanced group of artists known as Laibach. If Throbbing Gristle, with their camouflaged uniforms and homemade sonic weapons, appeared like partisan fighters aligned against a monolithic regime, then Laibach looked and sounded like the regime itself. Both proposed discipline as an aesthetic and lifestyle, although Laibach did not share Throbbing Gristle's means of enlightening people through highly disorienting and confusing music. Rather, their music switched out the elements which seemed to pride themselves on their alienation – the white noise 'wall of sound' – for 'militant classical' touches like soaring strings and rolls of military snare. Industrial rhythms, samples, and brooding electronics also figured into the picture, but were hardly the meat of the presentation itself. In person, Laibach wore vintage uniforms with officers' caps and leather riding boots, while dressing their concert stage with atavistic elements like antlers, Malevich crosses (a vague, black symbol more akin to the 'Red Cross' logo than the elongated Christian cross), cog wheels and a good deal of related 'power' imagery. At least one swastika figured into the band's album cover artwork, but the irony of its use was lost on many: the swastika in question was appropriated from a design by anti-Nazi artist John Heartfield, and was formed from four interconnected hatchets. In its original context, the swastika warned of the

conclusive effects that fascist ideology brought about – a brutal 'chopping down' of humanity. Yet Laibach refused to condescend to the people by pointing out such things, allowing them to draw whatever conclusions they liked – and thus calling into question whether they were 'dictators' in the traditional sense of the word.

The band's name itself was the Germanized form of the Slovenian capital Ljubljana – just one out of many scandal-provoking points in the band's career – and they were, like Throbbing Gristle, originally an offshoot of a complex multi-media enterprise. The parent group of Laibach was NSK (short for *Neue Slowenische Kunst,* or New Slovenian Art.) NSK and Laibach were known for visual and audio works that were almost infuriating in their ambiguity, offering no clear explanations (public statements about the art tended to encrypt the meaning even further) or explicit indications of the individual members' beliefs and ideals – rather this ambiguous presentation was used in a way that drew out the latent fanaticism and irrationality of the viewer/listener. The result was, as can be guessed, an art that set both fascists and socialists against them for blaspheming the icons of those respective political affiliations. An early Zagreb concert, in which the face of respected Yugoslav leader Josip Broz Tito was superimposed on pornographic film images, was abruptly curtailed by the police. Within June of the same year (1983), the group appeared on the nationally broadcast television program *TV Tednik* [TV Weekly], in a live interview with presenter Jure Pengov. Footage of the interview is now enshrined in the Modern Gallery of Ljubljana, and in it Laibach appeared like a paramilitary version of the British artists Gilbert & George – known for their comically flat, deadpan affectation and their habit of answering questions in unison. Pengov goaded the band into making outrageous statements, while condemning their use of their former occupiers' German language (which figured into their name, lyrics, and poster art actions.) Although Laibach had been operating for a few years before the TV incident, only after the TV appearance would official censorship be directed at them: there was a 4-year ban on the usage of the name 'Laibach' (it was said that there was "no legal basis" for the name), which was said to needlessly stir painful memories of the nation's period of Nazi occupation. The incident could have been dismissed as a rude, punk-ish provocation for its own sake – yet, as NSK biographer Alexei Monroe writes, something was wrong with the picture:

"All the evidence necessary to condemn was present, except... Laibach's 'fascistic' statements actually sampled self-management texts [the social policy initiated by Tito deputy Edvard Karelj], their uniforms were Yugoslav army fatigues, and so on. All the elements used to prove the group's guilt also 'prove' their innocence. This is the paradoxical position from which Laibach respond to the 'eternal question' about if they are really fascist: *isn't it evident?'*"[19]

The joke was, of course, that it was *not* evident, and that the longer Laibach stayed in the public eye, the more questions they raised, without offering a single satisfactory answer to the multiplying number of inquiries.

Monroe is wise to note that the 'retro' fascistic elements utilized by Laibach – uniforms, banners, rigid discipline and Wagnerian symphonic clarity – are, paradoxically, the same elements which distance it from more modern (post World War II) emanations of fascism. Leading ultra-rightist politicians like Jean Marie LePen and David Duke have made it a habit to court mainstream respectability, opting for crisp business suits and jeans instead of military uniforms, and insisting, at least publicly, that their followers claim power through the ballot box rather than through guerrilla actions and violent intimidation. While their speeches given to already 'converted' or 'awakened' racialists can still approach the fiery sloganeering of the Third Reich's leaders, their publicly voiced concern has shifted to more universally cherished institutions like the family unit, away from the imperialist concepts of *lebensraum* and *endlösung*. Had Laibach employed a similar aesthetic at a time when the Nazis actually were ravaging Europe, their aims could hardly be viewed as anything but another rote exercise in heroic propaganda. As it stands, though, a Mosleyan "England Awake!" lightning flash being used on Throbbing Gristle regalia, or a Slovenian band singing martial anthems in German, actually manage to work *against* the post-war efforts to make fascist ideals palatable in the 'politically correct' media landscape. Monroe suggests that, in such an overtly 'PC' climate,

the resurgence of archetypal fascist symbology is the *last* thing on the minds of neo-fascist organizers:

"...these Germanic signifiers are, to those who have been exposed to the group's work, indelibly associated with the underground, taboo nature of Laibach, so it could be argued that Laibach's use of them takes them *away* from the boundaries of acceptability."[20]

Moreover, the musical content of Industrial itself does not sit well with the fascist political program. Even those who fail to do the minimal research on the alternative lifestyles of Industrial's founding fathers (see the homosexuality and drug use of William Burroughs, for starters) may have difficulty making any sense of the anarchic and asymmetrical sonic onslaught. As per Alexei Monroe:

"Fascism is, in practice, suspicious of – if not outright hostile to – avant-garde and experimental approaches to music or culture, and Nazi musicology always condemned atonal and avant-garde music. Fascism is also suspicious of ambiguity, contradiction and paradox, the elements that maintain uncertainty and suspicion around Laibach."[21]

Along with the above, the embrace of technology-driven music is, to many on the extreme right, another step into the abyss of decadence. This is puzzling, given the tendency of white supremacists in particular to boast of the white race's global lead in scientific and technological advancements – but all the same, most fascistic music groups rely on a 'folkish' acoustic sound, on neo-classical composition, or guitar-based excursions into punk and metal. The focus away from harmony, and into pure sonic texture, is too much of a theoretical leap for many ultra-right shock troops to make.

While Laibach shares with other Industrial artists the tendency towards exploration of mass psychology and mass manipulation, their critique of Industrial's leading lights has been anything but simple praise. Concerning Throbbing Gristle, Laibach say that

"The engagement of these groups, in terms of their programs, has remained at the level of romantic existentialism. LAIBACH, on the other hand, stands in the midst of life and is pragmatic. Our motto is based in reality, truth, and life. From this standpoint, every comparison of LAIBACH with the specified groups is meaningless."[22]

In making this statement, Laibach are not alone: the quasi-mystical elements of Genesis P. Orridge's undertakings (especially his later efforts in Psychic TV) have alienated a number of would-be allies within the larger sphere of confrontational Industrial music. After the original formation of Throbbing Gristle dissolved, P. Orridge began to show a larger interest in the Promethean poses of rock gods who had, in his estimation, subverted the 'star system' of their time – delivering a purely spiritual and transcendent musical content via the Trojan Horse of commercial music. To this end, Jim Morrison and Lou Reed were among the personalities most frequently 'channeled' by P. Orridge in his Psychic TV project – unsurprising given his coming of age in the heady 1960s. In sharp contrast to such sincere efforts to carry on the would-be shamanistic tradition of these individuals, Laibach channeled archetypal rock gods of their own (The Beatles, Freddie Mercury of Queen) in order to expose the latent 'groupthink' and totalitarianism hidden behind their enticing aura of individuality. An act as simple as converting the lyrics of Queen's anthem "One Vision" into German, and retitling it as "Geburt Einer Nation [Birth of a Nation]" was enough to accomplish this. Hearing Mercury's optimistic/utopian lyrics twisted into *ein Fleisch, ein Blut, ein wahre Glaube* [one flesh, one blood, one true belief], and harnessed to a musical backdrop of marching rhythms, Wagnerian strings and uplifting brass, reveals the latent fascistic obsession with 'The One' and with central authority – slyly suggesting that the 'individualistic' charisma of performers like Mercury is merely a catalyzer of collective and conformist spirit, rather than an exemplar to lead people to a greater sense of their own individuality. 'The impossibility of originality', and consequently, individuality, is a theme returned to time and time again by Laibach – after hearing Laibach's militarized, highly de-personalized cover versions of famous pop songs (The Rolling Stones' 'Sympathy for the Devil', and the entirety of The Beatles' *Let It Be* album are also brought in for 'historical revision' by Laibach) it is difficult to see this music in the same way as before. At the very least, it is difficult to attend

another arena concert, in which an artist's face or logo is replicated on a veritable sea of t-shirts and merchandise, and to *not* draw a parallel with totalitarian political systems.

The existence of groups like Laibach and Test Dept. make it more difficult to call Industrial a movement carried out exclusively by resourceful 'individuals' – but neither the 'partisan' information warfare of Throbbing Gristle or the 'regime' metaphor of Laibach constitute the sole, 'proper' form of Industrial culture. The two respective methods attacked whatever manifestation of Control was most prevalent in the daily lives of the groups' members. In an corporate-controlled environment like the United Kingdom, it was more suitable for Throbbing Gristle to individualize the technological tools of conformity. In the socialist Yugoslavia of Tito, Laibach was required to adopt their extreme image in order to confront both the forces of Western cultural colonization *and* the false 'autonomy' preached by the Yugoslav authorities themselves. For all the ideological differences between the two factions, Laibach make statements about the nature of art which are remarkably similar to the above proclamations of Genesis P. Orridge:

"The aim of art is to give immortality to everyday practical behavior and work, which is necessary if life is to provide us with a ladder leading to divinity."[23]

"We Have Ways Of Making You Laugh"

Despite all the deathly serious socio-political issues which Industrial music was often mired in, it would be erroneous to say that it was without a sense of humor. All of the more respectable Industrial units, as opposed to the massed ranks of copyists and also-rans, seem to have cultivated this capacity – and not merely as a necessary release valve when the overall presentation became too oppressive, but as an essential component of the 'cultural camouflaging' technique. The degree to which this humor is effective, though, might depend on how great one's capacity is for irony, or for recognizing the very fine line between a cleverly crafted parody and the 'genuine article'.

Laibach again deserve special mention for making a caricature of totalitarian mystique so convincing, so much *more* marked by formal pomp and archaic nobility than real-life totalitarianism, that it becomes downright hilarious for those who notice the subtle distinctions. A good idea of this can be grasped by watching footage of the band's vintage live performances: the group's lead singer stands so stock-still, only occasionally tossing out a grandiose sweep of the arm, that anyone not already offended by the band's pseudo-'Nuremberg rally' stage set or seduced by the martial *sturm und drang* of the music will likely find this choreographed inaction to be a very funny negation of energetic, faux-shamanistic 'rock god' performance. At other points in the show, a pair of drummers at the front of the stage mime trumpet parts which are obviously being played on backing tape, and a lone woodcutter appears as an 'opening act'. The whole performance is so stripped of warmth and audience-performer rapport, the absurdity and sheer discomfort of the situation can force laughter where even a seasoned comedian couldn't. In the same way that groups like SPK turned floodlights on their audience to make them the 'focal point' of the performance, the more ridiculous elements of Laibach's performance made audience members the brunt of their joke: if the band's mock-militarism was something to laugh at, then even more laughable were the Third Reich nostalgics in the audience who convinced themselves this performance was a *real* fascistic political rally.

When not active in the public sphere through concert performance, Laibach were articulate interview subjects whose official statements regularly contradicted each other, adding another level of humor to the proceedings. While referring to themselves in the 3rd person rather than the 1st, the band flavored their speech with eloquent aphorisms and adopted a condescending tone which seemed equally dismissive of everything. The humorous element to this aspect of their presentation was, in fact, its arch humorlessness itself: the band seemed very cognizant of Western stereotypes relating to Slavic Easterners, and proceeded to amplify these stereotypical characteristics to an unreal extreme: these characteristics being coldness, incomprehensibility, and denunciation of individualism. Nowhere is this more evident than when Laibach calls into question the 'problem' of humor itself, saying

"According to Darwin, *laughter* is an expression mostly common to idiots, and according to English psychologist M.W. Brody, it represents the concluding part of aggressive usurpation. It is well-known that the word *humor* springs from England and the English are proud of it; however, it is also well known that England has nothing left to laugh at. Its humor is a leftover of narcissoid hedonism, its weapon against the outer world and a proof of its pseudo-domination over the actual situation. In art, we appreciate humor that can't take a joke."[24]

Throbbing Gristle, meanwhile, milked a great amount of humor from the weird juxtapositions of tastes which they unironically enjoyed. For one, the band members were fascinated with the kitschy, light-hearted 'exotica' music of composers like Martin Denny and Les Baxter – a music associated more closely with wholesome, innocent leisure time in 1950s America than with the cruel realities of a crumbling British empire. Throbbing Gristle went so far as to be photographed in the "Hawaiian" outfits that characterized Denny's band, and the cover design for their *20 Jazz Funk Greats* album was also a case study in this kind of mimicry. According to P. Orridge, the record sleeve

"...was drenched in ironic parody... we mimicked the print layout of Simon & Garfunkel as well, to give the impression of classic pop archetypes of design and consumer friendliness [...] The sickly pink lilac colour of the back sleeve was as close as we could get to Simon & Garfunkel's *Bookends* album."[25]

This was really not a humorous act in and of itself, but it becomes somewhat funnier when weighed against the actual musical output of the band: it is almost impossible for the layman to reconcile this with audio selections from the TG canon: see the harrowing audio suicide note "Weeping" or the murky, sinister fog of numbers like "Slug Bait." In this way Industrial music re-integrated the listener with life outside of the unrealistically smooth transitions, edits, 'wipe' effects and segues that were part and parcel of TV programming: in street-level reality a moment of giddy laughter really could be followed a second later by one of terror or unexpected embarrassment, and vice versa. Awkward moments of inter-personal contact were something that had to happen from time to time in order for individuals to understand if their life strategies were working or not, and Throbbing Gristle set an example by bypassing the rock club circuit and agreeing to perform virtually anywhere that would have them (one shining example being their riotous performance for an all-boys' boarding school.)

An advanced appreciation of pure mischief as a transformative tool would also be necessary to enjoy Industrial's more amusing side – take, for example, Boyd Rice's infamous vinyl record with multiple center holes bored into it, or his vast back catalog of conceptual pranks – making obnoxious calls to radio call-in shows, placing a row of eggplants on spikes outside a shopping center, or presenting a skinned sheep's head to First Lady Betty Ford. Rice's propensity for mischief eventually earned him a place of honor in the Re/Search publication *Pranks!*, along with fellow Industrial culture alumnus Mark Pauline of Survival Research Laboratories. When confessing to the above actions, Rice makes a case for outlandish pranks being yet another way to dismantle the 'control machine' – a proposal that Re/Search interviewer Andrea Juno obviously lauds:

"[The police] know how to deal with real criminals, but somebody who puts eggplants on sticks – you're making a mockery of their social order, and that's worse than what most criminals are capable of doing. By doing something incomprehensible, you place yourself outside their magic, and then they lose control."[26]

A series of live radio 'showdowns' with Christian talk show host Bob Larson have also provided a perfect glimpse into the eccentric Industrial sense of humor. Hoping to skewer Rice on air for his connections to the Church of Satan, and to goad him into unleashing some mean-spirited tirades, precisely the opposite happens: Rice's unnerving calm and middle-American affability forces Larson into a series of rabid ranting fits. Although Rice quotes from Social Darwinist scribes like Ragnar Redbeard, scoffs at liberal humanism and generally comes off like a pop culture avatar of Oswald Spengler, he also admits a fondness for the bubblegum pop of Little Peggy March and invites his incensed host out for 'a beer' after being verbally pilloried by him for an hour (Larson replies to the invitation by saying "make mine a Perrier".) Going by the logic that the funniest things are the

most unexpected, this particular show is side-splittingly funny – it's difficult to stifle a laugh when Rice's favoring of animals over humans prompts Larson to angrily blurt *"Christ did not die... for a PLATYPUS!!!"*

Rice's 50/50 personality split between Nordic berserker and 'space age bachelor' is also another example of how Industrial culture's camouflaging techniques work not only to obscure the true intentions of their practitioner, but to *reveal* the true nature of an adversary: while Rice tempers his misanthropy with just enough ebullience to make himself seem likeable, while his debate partner is reduced to an embittered, seething caricature of himself. The majority of on-air callers to the program even voice open support for Rice's fire-breathing ideals. Boyd Rice's method of enlightenment through enhanced irritation – also evident on his "playable at any speed" record of lock grooves (*Pagan Muzak*) – is not that far removed from the comic disruptions of period comedians like Andy Kaufmann, or from the tortuous boredom of select Warhol pieces. However, in the case of Rice and several others like him, there is a clear spiritual aim to even the most ridiculous of antics – Rice is a student of Gnosticism, citing the Gnostic deity Abraxas as a kind of tutelary divinity for his ability to "stand in two circles at once" or erase the fundamental contradictions arising from the duality inherent in human nature.

The glorification of quotidian artifacts is another humorous, occasionally agitating ploy used by the 'control agents' of Industrial culture – one of the most obvious cultural precedents for this being Marcel Duchamp's "readymades" or mundane, mostly unmodified modern objects which earn their elevated status merely because the artist (rather than the public or the critical community) wills it so. Whereas Marcel Duchamp may have exhibited urinals and snow shovels 'as is,' with little extra embellishment beyond an artist's signature, Throbbing Gristle would release a series of 24 cassettes in a plain suitcase – in spite of the demonstrated skill of Peter Christopherson as a designer of lush album sleeves (Christopherson was employed by the 'Hipgnosis' design firm, which provided covers for such progressive rock titans as Yes and Genesis.) Other artists, such as Berlin's Die Tödliche Doris (whose *Geniale Diletannten* movement could be seen as a German sister movement to Industrial), released a set of 2" records meant for playback within a talking doll's battery-powered voicebox (these were undoubtedly 'found' rather than manufactured at the band's request.) The constantly nagging refrain of "the medium is the message" is never far behind when such things are employed as the framing devices for the audio works within – the message, in this case, being that the age of mass production and, to some extent, of collectivist ideology, favors easily-directed human ciphers instead of a messy tangle of diversified individuals: hordes of briefcase-wielding businessmen heading off to work in sterile, climatized office buildings, while their children receive sage advice from such laughable surrogate 'role models' as lifeless plastic dolls.

This concept is one that has recently come full-circle back to the 'recognized' art world, up from the grotto of Industrial culture: there is 'Young British Artist' Tracy Emin's Turner Prize-winning *My Bed*, a tableau whose inclusion of menstrual-stained underwear easily invites comparison to the infamous 'Prostitution' exhibit of COUM Transmissions in 1976, in which Cosey Fanni Tutti exhibited used tampons alongside the framed pages from pornographic magazines for which she modeled. Another pair of Turner Prize-winning artists, Jake and Dinos Chapman, largely constructed their panoramic war-scape *Hell* from untold numbers of toy figurines, either in Nazi uniform or naked and dismembered. While the painstaking amount of time needed to assemble this piece might not qualify it as a 'pure' readymade, its gallows humor places it firmly in a tradition previously occupied by artists such as Throbbing Gristle. Nothing seems so much like an extension of TG's presentation as a detail from *Hell,* in which an artillery-damaged McDonald's franchise becomes a scene of hideous carnage and rape. It's telling indeed, then, that the Chapmans would select TG as one of the star performers at the All Tomorrow's Parties festival, which they curated in 2004. This has been one of only a few select concerts played by a "reunited" Throbbing Gristle, who otherwise ceased to exist in 1981 – in keeping with their career-long assessment of life's inexhaustible irony, the band split up to *avoid* what seemed to be a coming breakthrough in commercial success and critical acclaim. In a fitting (although not pre-meditated) end to the Industrial era proper, the final record released

by the band's Industrial Records imprint was not a Throbbing Gristle release, but *Nothing Here Now But The Recordings*, by none other than William Burroughs.

+++++++

The idiom of Industrial music, as we'll see in later chapters, has since been absorbed into the works of countless electronic musicians and performers (to say nothing of the other arts), but the real triumph of this music has always been its refusal to let records and live concerts be its sole cultural end product. Industrial musicians used music as a metaphor for a fully integrated lifestyle of radical autonomy and 'psychic self-defense' – unlike many other music-related subcultures, the music merely acted as the *frisson* to redirect the individual listeners' behavior, rather than claiming that attendance at a concert or ownership of a record was the absolute pinnacle of the cultural experience – the music was no more than the starting point in the struggle for realizing one's ideal self. Andrew McKenzie, who has left his own mark on this musical aggregate through the strange, evanescent gestures of his project The Hafler Trio, is worth quoting at length on the impact of Industrial music:

"At the time of the arising of all 'this stuff' (whichever label is put onto it), there was nothing. World-wide, perhaps an audience of 3000 – and that's a very generous estimate – people, most of whom were active in producing material themselves. Selling 1000 copies of a record was a feat that was envied. but through it all, what emerged was a sort of movement – not in any organised form, or label, or name – but what was there was a blending and intermixing of film, music, literature, religion, art and many other things; something that really had not existed before. *This* was what drove people on. It was the beginning of seeing *outside* of 'just making music', and the glimpsing of something greater. Now it is so that many people deny this now, but the artifacts contradict them, and indeed, their careers would not have come into being had it not been so."[27]

Musical genres and sub-genres come and go, but full-blown cultural memes tend to mutate in a rather tenacious matter, and refuse to die as easily as isolated musical trends. For this reason, it's fitting to close this chapter with some of the dialogue from one of Genesis P. Orridge's favorite books, *Conversations with Marcel Duchamp* – in which Duchamp defends the Surrealist movement in terms that could apply perfectly to the Industrial movement as well:

DUCHAMP: Fundamentally, the reason Surrealism survived is that it wasn't a school of painting. It isn't a school of visual art, like the others. It isn't an ordinary "ism," because it goes as far as philosophy, sociology, literature etc.

CABANNE: It was a state of mind.

DUCHAMP: It's like existentialism. There isn't any existential painting.

CABANNE: It's a question of behavior.

DUCHAMP: That's it.

2.
LIBERTINES OR ASCETICISTS?
A QUARTER-CENTURY OF WHITEHOUSE

Prologue : Resurgent *Rumori*

After the official dissolution of Throbbing Gristle in 1981, the chthonic beast known as Industrial music splintered into a variety of sub-genres, each of them expanding upon some key element of the founding quartet's radical agenda of cultural de-programming. Not the least of these phenotypes were the follow-up projects formed by the actual members of TG themselves, although the influence of the factory foursome was, come the mid-'80s, just one piece in an increasingly complex puzzle of creative approaches. Newer artists at this time, already emancipated by TG's suggestion that it was the whole nature of music which needed re-assessing, and *not* just rock 'n roll, were free to tap the potentialities of non-linear noise, new technologies and a much broader palette of subject matter than courtship rituals. Few have ever succeeded on the same level as TG did – and despite the anarchic encouragement for others do whatever they pleased sound-wise, a certain amount of homogeneity and cloning was bound to become a contagion in the nascent genre. One of the most heavily borrowed elements of the Throbbing Gristle program was the predilection for fetishizing the universally ugly, dutifully following Genet's sage advice *"to escape the horror, bury yourself in it".* This particular quote was appropriated by Industrial arch-transgressor Monte Cazazza, a man who, with his sneering anti-music and faked snuff films, created more than his fair share of aesthetic horror for people to immerse themselves in. A survey of the young, restless, post-TG cadre of noisemakers shows that they largely did not have the same grounding in media theory or as varied an aesthetic sensibility as their forebears, and attempted to compensate with a pure lust for negation. This tendency is best exemplified by the exhausting sleeve notes of the New Blockaders 7" single *'Epater Les Bourgeois'* [Flatten The Bourgeoisie]:

"Let us demolish these fetid blocks of security, of tradition, of certainty, of unquestioning worship... let us be murderors [sic] of the past! The obscene progression of regression shall be halted by us, The New Blockaders! Let us be anonymous. O brothers and sisters, let us work in subtle ways, and then at dawn our hour of glory shall come! Let us be chameleons, let us enter their ranks unnoticed... only attacks from behind ever succeed! Let us sever this parasite called history, it has nothing to do with us...this is the future! This is now!"[1]

The New Blockaders were not alone among the noise community in their insistence that the 'future', whatever that was imagined to be, would come about by spontaneous, atavistic acts of destruction – although their official statements were some of the most hyperbolic (and consequently, some of the most entertaining.) The New Blockaders would bolster their claims that "even anti-art is art...that is why we reject it!" with a shopping list of negation, again to be found on the notes to their *'Epater...'* single. Sparing virtually no communications or entertainment apparatus, the Blockaders claim to be "anti-books, anti-newspapers, anti-magazines, anti-poetry, anti-music, anti-clubs, anti communications!",[2] then delivering the blackly funny *coup de grace:* "we will make anti-statements about everything....we will make a point of being pointless!"[3] Only the previous *enfants terribles* of the European art world, Throbbing Gristle's spiritual predecessors in the Viennese Aktionists, trumpeted nihilism to such all-pervasive levels: provocateurs like Otto Mühl stated that his 'ZOCK' order "has no dread of chaos... rather it fears forgetting to annihilate something,"[4] and laid out a brusque 5-point plan for ZOCK culminating in blowing up the Earth from space, with a subsequent "attempt to cave in the universe".

With such attitudes of cultural leveling running strongly through it, the rising noise

underground of the '80s seemed to be heir apparent to the Italian Futurists of the 1920s, who exhibited plenty of their own destructive streaks in a concerted effort to clear away the sentimental debris of history. The open support that some noise-based acts voiced for the Futurists would not make it any easier for them to repudiate claims that they also glorified fascism, an allegation that dogged them throughout the genre's halcyon days of the 1980s. Whether they were aware of it or not, The New Blockaders were endorsing a type of 'rebuilding by leveling' which had led to the rise of fascism in the first place: take, for example, the actions of April 15, 1919, when the Italian socialist newspaper *Avanti!* had its offices and its communications apparatus (linotype machinery) wrecked by an unholy alliance of Futurists and *arditi* [the former frontline soldiers who would become so useful in furthering fascist policies of the '20s]. The poet/figurehead F.T. Marinetti and his Futurist coterie would become disillusioned with fascist politics soon enough, while Benito Mussolini would eventually seek an artistic movement that better combined Italian traditionalism with more progressive tendencies (and, of course, would find armed marauders like the *arditi* infinitely more useful in accomplishing his aims than the abstractions of poets and cultural theorists.) Marinetti's true acceptance by the overlords of the fascist political system was also called into question when Adolf Hitler, hosting an exhibit of Nazi-denounced 'degenerate art' in 1938, included a selection of Italian Futurist works in the show.

Truth be told, though, Marinetti's influence on the noise movement, despite his founding of the Futurists and subsequent penning of *The Futurist Manifesto,* is not as widely felt today as that of another Futurist luminary, Luigi Russolo – and his own seminal manifesto *The Art Of Noise.* No educational narrative on radical modern sound, let alone an assessment of post-Industrial musicians, can be totally complete without some acknowledgement of Russolo. His short but essential broadside against traditionalism is reverently quoted in at least one crucial CD retrospective of post-Industrial sound (Z'ev's *One Foot In The Grave* compilation, released on Touch in 1991) and the number of sound artists now paying homage to Russolo, whether aware of it or not, is manifold. Marinetti's insistence that extreme violence was an aesthetic device (since, after all, life and art were indistinct concepts) was taken to heart by more than a few of the genre's more confrontational performers: early live performances could devolve into chaotic situations requiring police intervention, while the demanding physicality of performances by Z'ev and Einstürzende Neubauten localized this violence to within the performers' own bodies. Still, the credit for truly drafting up any kind of a sonic blueprint for a more apolitical kind of Futurist music belongs to Russolo (even though he does quote at length from Marinetti's battlefield poetry in *The Art Of Noise.*) And it is also worth noting that Russolo considered himself a Futurist painter with some novel ideas about music, not a trained musician or composer in any sense of the word – through this alone he has a special kinship with the 'non-specialist', artistically omnivorous tradition of Throbbing Gristle and beyond.

One quote from *The Art Of Noise* stands out as not only relevant to the makers of post-Industrial and noise music, but to many of the transient musicians of the 21st century who would attempt to compact a huge, dynamic sound into a small box operated by just a single person:

"It is hardly possible to consider the enormous mobilization of energy that a modern orchestra requires without concluding that the acoustic results are pitiful. Is there anything more ridiculous in the world than twenty men slaving to increase the plaintive meowing of violins?"[5]

It may have taken seven decades for a street-level, non-academic movement to finally create an economical live music more pleasing to Russolo's sensibilities – but with the post-Industrial avant-garde, Russolo's wishes were made flesh in a dramatic, unequivocal way. Giant stacks of amplification equipment were already *de rigueur* for the arena rock-n-roll of the 1970s, but it could still be argued that the personnel required to prepare these lumbering dinosaurs for performance was at least equal to the 'mobilization of energy' spent on an orchestra in Russolo's day. An entourage of stagehands, instrument 'techs' and 'doctors', drivers, caterers and other assorted hangers-on, all arriving in town with extravagant contract rider demands, did not make for an economical music show. It would take the dawn of the digital age, and all its attendant innovations

(ADAT machines, laptops etc.) before the ratio of human input to instrumental output could truly be maximized, but Russolo should still be lauded for his early attempts to help this process along. His invention of the *intonarumori* – basically waist-high acoustic boxes connected to bullhorns and operated by hand-cranks or electric buttons – was a step in the direction of making a transducer that didn't require athleticism or extreme agility to operate. The *intonarumori* had only about a one-octave range, adjustable in tones or semi-tones, but 27 different types were created according to the type of sound they were meant to generate: there were howlers, cracklers, exploders, thunderers, crumplers etc. The instruments were built in collaboration with another painter, Ugo Piatti, confirming that Russolo was not the only artist looking to liberate organized sound from 'musicians' – reining music back into the organic whole of art and life.

Music For Monochrome Men

The voluntary termination of Throbbing Gristle in the early '80s may have prevented the band from being pinned to the 'pop' status which it abhorred, but the template they created had already become quite useful to other marginalized individuals in dire need of catharsis. Genesis P. Orridge lamented the waning days of Throbbing Gristle, and the rise of their 'stereotypical Industrial fan', as follows:

"They wear Doctor Martens and military trousers and black leather jackets, semi-Nazi regalia, skinhead hair cuts or black hair, they are mainly male. They make cassette tapes of their Industrial music, which are mostly just feedback, and they bemoan the non-existence of TG. They feel that we betrayed something wonderful."[6]

Other members of Throbbing Gristle would be less dismissive of their successors – both Cosey Fanni Tutti and Peter "Sleazy" Christopherson insisted that the 'scene' was formed out of (in Christopherson's reckoning) "the lack of a response by the music business to the changing needs of the audience"[7], rather than as a blanket emulation of TG. Still, P. Orridge continued, naming names this time:

"We'd left a rather unhealthy residue of people and ideas, albeit because people had chosen to misunderstand what we were saying. It got into this thing of who could shock each other the most, SPK doing videos of dead bodies [and] Whitehouse for example, who I instantly and totally despised. Making a hole for those people to crawl through was quite scary."[8]

The people who were 'instantly and totally despised' by P. Orridge are best described as 'power electronics' artists, the coinage of the group Whitehouse: this was a markedly sinister, cauterizing offshoot of Industrial music characterized by its apparent glorification of anti-social behavior, pathology and the nihilistic fringe elements within post-industrial society, with no shortage of disregard for that society's plethora of sexual inhibitions. For the literary-minded music consumer, the 'power' prefix instantly brings to mind Friedrich Nietzsche's famous proclamation of the 'will to power' – and while no members of any power electronics act have attained any degree of political power, they did try to make good on attaining some of the more easily attainable qualities of Nietzsche's *übermensch:* liberal democratic and/or Christian values of humility and charity were mocked, while these systems' egalitarian trappings were unceremoniously swept aside – neither was there any place for, say, Rousseau's Enlightenment admission of the 'good in man'. The 'libertinage' of the Marquis De Sade was a vastly more influential idea from *that* period in European history (Juliette, the anti-heroine in Sade's similarly-titled novel, is even suspected to be a parody of Rousseau's heroine Julie.)

The songs of Throbbing Gristle, which covered every aspect of social deviance from voyeuristic obsession ("Persuasion,") to serial killing ("Urge To Kill," "Dead Ed") gave the power electronics generation a potent cocktail to imbibe – although, as P. Orridge has already touched upon, one of the intoxicating effects of this cocktail was a propensity for creating art totally devoid of subtlety and variance. Cheap cassette reproduction provided an outlet for the power electronics market to become immediately flooded with artists who reveled in Thanatos, discarding TG's

concessions to popular music forms (subversive as they might have been), and unloading a deluge of recorded material onto a comparatively limited audience – it would not be unheard of for a housebound power electronics artist to release 5-10 tapes in a year to match a professional studio recording artist's single album. In this respect, at least, the patronizing declaration of "my week beats your year", on Lou Reed's feted noise album *Metal Machine Music,* held true. And while it may not have been intended as such, the endless underground flow of brutal power electronics releases was something of an indirect comment on such modern institutions as the evening news – could power electronics artists really be counted on to produce wildly varying and constantly innovative releases, in a culture which seemed to be stagnating as a whole? Local news reports from the period were virtually no different than the ones being broadcast now, with their blank, clinical assessments of extreme social mayhem and their inability to really convey any message more cogent than 'it's dangerous out there.' Much of the power electronics genre simply transposed the indifferent reportage of televised news onto an audio format, occasionally even using unaltered snatches of nightly news monologues to drive home the point of otherwise abstract and anonymous noise assaults. These noise assaults themselves were like the significantly more bloody-minded cousin of minimalist composition, featuring single notes on a synthesizer held down for indeterminate periods of time while being oscillated, modulated and tonally mangled. This would form the backdrop for similarly modulated, heavily effected shrieks, shouts and vocal tantrums, all coming together in an effort to simulate the deranged thought processes of an incurable sociopath.

Ironically, the most well-publicized mass slayers have shown a taste for music considerably gentler than power electronics – British serial killer Dennis 'Monochrome Man' Nilsen, to whom the *pièce de résistance* of power electronics (Whitehouse' 1983 LP *Right To Kill*) is dedicated, enjoyed more contemplative electronic music – Laurie Anderson's 'O Superman' in particular. Charles Manson, whose influence is felt in all areas of the post-industrial music community (his friendship with Boyd Rice of NON, and the inclusion of his song 'Always Is Always' on Psychic TV's *Dreams Less Sweet* LP are just two of the more obvious examples), has always preferred and even performed American folk music, and sharply refuted allegations that the influence of the Beatles influenced his 'Family' to kill – "*Bing Crosby* was my idol",[9] he protests.

For all its flirtation with the aesthetics of fascism and *lustmord*/thrill killing, the power electronics genre has turned out to be, on average, fairly conservative in the subjects it chooses to portray. One of the major shortcomings of the genre is its tendency to cherry-pick only those controversial subjects which are already firmly entrenched in the mass consciousness: most power electronics bands would be just resourceful enough to dig up a Heinrich Himmler speech to use as an intro to one of their electrified acid baths, yet would sidestep the activities of the Croatian *Ustase,* who revulsed even Himmler's elite S.S. troops with their gleeful throat-slitting contests. It also doesn't look as if any contemporary power electronics artists have delved into the grisly specifics of the more recent genocides in Bosnia, Rwanda, Darfur etc. – making one wonder if these purveyors of brutality truly have a sense of history beyond Anglophone and Western European spheres of influence. By wielding such utter predictability, there is a vast underground which sadly commits the cardinal sin of any subversive art movement: failing to move an audience beyond a purely neutral reaction. Yet we have to remember that this genre was effectively birthed by a band that sent even Genesis P. Orridge reeling. This was, after all, the man whose performances in COUM Transmissions involved public displays of ritualized self-mutilation and endurance-testing play with bodily fluids – any band whose transgressions could arouse the ire of a moral relativist like P. Orridge must be worthy of some further examination.

"Deliver The Goods...That People Want To Receive"

Whitehouse was formed on the cusp of the 1980s by a teenaged William Bennett: a soft-spoken, Edinburgh-based *bon vivant* and classically trained guitarist. The band's moniker was meant as an ironic jab at puritanical anti-pornography crusader Mary Whitehouse, who happened to share a surname with a particularly low-brow porn magazine. William Bennett served a brief stint in the

new wave outfit Essential Logic before the dawn of Industrial music sparked a musical reassessment – he envisioned a corrosive musical maelstrom that could "bludgeon audiences into submission." Before this dream could manifest itself, though, Bennett played guitar in a transitional group called Come, an angular 'garage electronics' combo matching Bennett's inventively skewed chord progressions with a jittery synthetic pulse (provided partially by Mute Records boss and Normal founder Daniel Miller, recording under a pseudonym.) While that band would sadly be relegated to a footnote in the annals of new wave, their namesake was used as the label for releasing future Whitehouse records – under the 'Come Organisation' banner, there were 9 Whitehouse albums released over a period of 5 years, as well as a house organ entitled *Kata* (a Greek prefix meaning 'downward') – a skeletal, but intriguing fanzine which mythologized the activities of Whitehouse as well as providing readers with some of the more interesting facts related to modernity's aberrant monsters and anti-heroes. As commonplace as such writing may be in the 'blogosphere' of the age, there are few other things to compare it with from that era – only Throbbing Gristle's *Industrial News* dispatch surfaces as an immediate point of comparison. Bennett's undeniable impatience with the shortcomings and of pop culture (and worse yet, the stylistic compromises of the 'underground') especially shows through in the *Kata* reviews section, where record reviews are more often than not venomous 2-sentence put-downs.

Whitehouse released the idiosyncratic *Birthdeath Experience* in 1980, unveiling their trademark sound of simple, pulverizing synthesizer bass tones, twinned with skull-shearing high frequencies bordering on ultrasonic. These were wrung out of otherwise unfashionable, unreliable instruments like the battery-powered EDP Wasp mini synthesizer. The fundamental sound was just one of the many unsettling juxtapositions the band incorporated into their final presentation – and the degree to which this technique is used in contemporary sound is a testament to its having 'stuck'. Make no mistake, it is and always has been as far from an easy and passive 'entertainment' product as could be imagined, yet the act of trying to make sense of the catastrophic frenzy has had the potential to appeal to a broad cross-section of people beyond the realm of music fandom. The act of listening to Whitehouse as a non-initiate (the author bought his first Whitehouse album on a total whim, with no advance knowledge of the band's sound or intentions) is indeed an 'active' one, not unlike driving by some horrific accident and attempting to create closure on the scenario by projecting a personal 'back story' onto the accident victims: the vague elements and buried clues hidden within the overall violent foundation of the early records almost force one to engage their imagination with it in order to endure it. Even in a music as LOUD and engulfing as this, not everything is merely handed to the listener with a satisfying explanation: and as such, the band's sound could seem like wide-eyed, instinctual savagery bashing heads with avant-garde sophistication. And all of the above impressions occur *before* William Bennett's vocals kick in. His is one of the most immediately recognizable voices within the last several decades of difficult music: his signature being focused, crystalline screams rising and falling in a smooth arc over an extended number of measures, if Whitehouse' music could be said to work on such traditional musical principles as 'measures'.

Whitehouse caught on quickly through a program of relentless releasing (their second album *Erector* was being recorded before the first had even begun to circulate), as well as the relative ease of getting in touch with the band – Bennett has stated that printing his contact address on the back of LP sleeves was, for the time, a publicity coup which surprisingly few others had thought of: even if no LP had been purchased, many might still write requesting further information. Total refusal to 'outsource' the Whitehouse sound as a tool to advance others' projects was another hallmark of the band: to this day, no Whitehouse pieces have been released on third parties' compilation albums, nor have they been used as incidental music for film scores – although numerous offers to do these things have come and gone.

This simple, but still novel promotional strategy brought many of the band's key players into its orbit: there was the 14-year old Philip Best, who ran away from home in order to attend a show by the band, and who used Whitehouse as the template for the similarly unyielding Consumer

Electronics, the Iphar cassette label, and the magazine *Intolerance* – which delivers exactly what the title promises. Another notable contact, from 1982 on, was Chicago writer Peter Sotos (still the band's most contentious point despite his departure in 2002) whose criticism of pornography and exploitative 'true crime' literature occupies a unique place in the literary netherworld. Although a full overview of Sotos' work (much of it recycled into lyrics for Whitehouse songs) reveals a scything critique of mass media's hypocritical portrayal of predators and their victims, it is difficult for casual, piecemeal readers to see it as anything but sadistic pornography in and of itself – Sotos' early '80s magazine *Pure*, printed during his studies at the Art Institute of Chicago, is especially hard to swallow given the mocking and condescending tone with which it treats abuse and murder victims – yet later efforts like *Parasite* begin to shift the critical ire from the victimized towards the shock dealers in the major media; they who attempt to cover the most prurient information in a thin veneer of morality, all the while presenting it as lurid entertainment. Whatever his motivations, Sotos' stint as a Whitehouse contributor was severely overshadowed by his status as a convicted criminal: possession of a magazine featuring child pornography (photocopied for the 2nd issue of *Pure*) led to a controversial trial in which Sotos would become the first person in the U.S. to be charged with possession, rather than distribution of, such material. Other early supporters did not carry with them Sotos' unenviable reputation, but would become well-known for their own musical confrontations nonetheless: these included surrealist-about-town Steven Stapleton of Nurse With Wound (whose vast archives of recorded music offered valuable inspiration to William Bennett), as well as the Hafler Trio's Andrew McKenzie.

Actually, it was both Stapleton and McKenzie who would aid Bennett in bringing his vision to a viewing public for the first time in 1982: both were participants in the first Whitehouse "live aktion", a more than subtle nod to the same Viennese Aktionism that had prefigured COUM Transmissions and Throbbing Gristle. While the public aktions of Nitsch, Mühl, Brus et al. occasionally took the form of music performances or "psycho-motorik noise aktions," they were still grounded in an ethos of taking paintings beyond the 2-dimensional boundaries of the canvas – so 'body art' and irreverent misuse of raw materials (often confusing aktions with the less aggressive 'Happenings' of the 1960s) was the central component of the presentation, rather than the sound. For Whitehouse aktions, this formula was inverted – the jarring and unequivocal blasts of power electronics were the catalyst for the theatrical exhibitions of delighted rapport and utter hostility which rapidly unfolded between performer and audience. Only the effect on the viewing audience – involving no end of literally dangerous confrontation (some of it inflicted by audience members upon themselves) and ecstatic convulsion – was the same between the two different takes on 'aktion' art.

The particulars of past live aktions are compiled in the band's official 'live aktion dossier' online. Such occurrences as *"Steve Stapleton gets arm cut after flying glass during Whitehouse performance/police raid in large numbers midway through 'Anal American'/many arrested in chaos/Whitehouse manager Jordi Valls spends night at police station for barring access to police"* are cataloged in the dossier in an almost humorously understated way, beside other attempts at audience participation like *"two guys with pants around their ankles make out near the front of the stage during performance"*. Also humorous was the band's former habit of (in the best Industrial tradition of camouflaging) disguising their sound during pre-concert soundchecks in an effort to convince wary promoters that they were a "Human League"-style synth-pop band. Some individuals decided, however, that the joke had gone too far when, at a 1983 Newcastle performance, William Bennett *"lightly [slapped] a girl in the face in ritualistic fashion"*, subsequently causing a disinformation campaign to be launched against Whitehouse from another corner of the post-Industrial milieu. According to said campaigner, the slap prompted a mass audience walkout and a decline in the number of U.K. record shops willing to stock their albums, although Bennett contends "the only knock-on effect was that the local Newcastle independent record store (sorry, can't recall its name) stopped selling our stuff."[10] Such inflation of minor offenses into urban legends was not – and still is not – uncommon, prompting Andrew McKenzie to state that

"This is worthy of a book in itself. Truly. I seriously doubt that book will be written, unfortunately, as it would have the most effect. The problem is that we go into *Rashomon* territory – each with his own version. And that leads to useless and destructive insistences on 'proof'. History is gossip, and not facts, as someone wiser than I once said."[11]

The 'classic' Come Organisation period of the band lasted until 1985, when the band released its genre-defining *Great White Death* LP, played a pair of wildly successful live aktions in Spain, and subsequently claimed it had achieved all that was possible within the confines of its chosen media. The official press release famously stated that Whitehouse' participants were now ready to turn to "a life of crime" in order to sate their appetites. This was, of course, one of many media-baiting proclamations accepted by the print media as gospel truth. The various performers in Whitehouse' milieu were notorious for such claims, and for exposing the tendency of people to believe practically anything they hear from a dubious 'authority' such as a performing artist: many people still believe, thanks to Steven Stapleton, that Aktionist artist Rudolf Schwarzkogler committed suicide by gradually slicing off his own penis – needless to say, an undocumented event easily disproved with minimal research. The sensationalism whirling around the band would be helped along further thanks to disinformation spread by bands unreceptive to their aesthetic. Musicians like Nigel Ayers (of Nocturnal Emissions) would even make claims that Bennett shouted racist invective from on stage – however, within the huge catalog of documented Whitehouse live performances from the era, there is as much evidence to back these accusations as there is to prove Schwarzkogler's suicide by self-mutilation.

Do You Believe In Rock N Roll?

Whitehouse is a project that will, in most reviews of the band's work, invariably be referred to as "dark". This is a more fitting term than many, but is somewhat misleading when the term has been used as the heraldic banner by so many other music-based subcultures. To most latter-day industrial and Gothic rockers, for example, "dark" is merely subculture shorthand for a set of escapist leisure time activities, which involve an above average focus on paranormal subjects, and on either idealized times past or times yet to be realized (sometimes both occupying the same storyline – Japanese role-playing video games provide a fine encapsulation of this.) In other words, it is a subculture concerned more with fantasy and elaborate fictions than in, say, altering the social landscape through direct confrontation – very much a full 180-degree turn from the stoic, unromantic, survival-oriented atmosphere generated by the seminal Industrial groups, to say nothing of the atmospheres conjured by the music of Whitehouse. And as much as it irritates Goths who claim to have woven together an exclusive and inimitable social scene, the maligned hippie culture of yesteryear contains striking parallels to Goth culture. Recreational drug use is usually not frowned on. Pageantry, and being seen in public as exaggeratedly 'other', is more important than in most subcultures. Magical experimentation and eclectic spirituality is encouraged. Even the same *scents* are handed down from the flower children to the creatures of the night: sandalwood incense and patchouli oil being two that immediately spring to mind. If this light-hearted, ethereal bill of fare can be called "darkness", then perhaps the world is a better place than the daily news briefs would have us think.

The Gothic rock/Industrial rock alliance's collective fixation on death imagery is usually the deal-breaker which causes other culture tribes to label them as ideologically "dark": but they are still as prone to as much escapism, daydreaming, and stylized languishing as their distant hippie cousins. Thanatos, as envisioned by Goth culture, rarely walks without Eros by its side: just witness 'Death' as an attractively rendered young girl (in the comic of the same name) by *Sandman* author Neil Gaiman. This (to borrow the coinage of a group of Chaos Magicians) 'Thanaterotic' fusion is the crucial distinction between the Goth fantasist and the utilitarian, "assume all communications are tapped" ethos of the Industrial paranoiac. Which is not to say that either culture is completely free of turgid cartoon caricatures, or that the more 'serious' Industrialists are 100% committed to 'smashing the control machine' without occasionally looking over their shoulders in a moment of

bittersweet nostalgia. One of the most vocal opponents of such Industrial nostalgia is Whitehouse' William Bennett, who calls them stuck in a "1983 time warp" and just as sentimental for a bygone era than any of their rock culture forebears. Fear not, though, as Bennett has plenty of choice words for *those* people, too–

"There's so much incredible amazing music in the world, why be so limiting? [Rock music is] a musical fast food chain. It's so horribly conservative, so co-opted (ever since Elvis and its mainstream marketing), so full of embarrassingly fake rebels, it's like seeing your dad at a disco. It's more than flogging a dead horse, there's nothing left to flog, and there's nothing left to flog it with."[12]

Whitehouse, although they have delineated the boundaries of musical extremity for over a quarter-century now (and have even curated a series of other artists' music titled "Extreme Music From..."), do not refer to themselves by the term 'extreme' (like 'dark', another term which has been de-fanged through overuse.) William Bennett states that it supposes an 'outmost limit' without stating in what direction an artist must travel to reach that limit. In the place of simple 'extremity', Bennett believes the band's success comes from working on levels "both esoteric and exoteric" and that some will experience the band's music on a "purely visceral" level, while others encounter "unexperienced depths."

Whitehouse also exists a world apart from musical scores, notation and the like – and William Bennett is also hesitant to include Whitehouse in any grand tradition of outré musical development, rejecting the terms (like 'improvisation') that have come to characterize any music too complex or alien in its structure to immediately perceived by the listener:

"The word 'improvisation' doesn't sit easily in my musical vocabulary, since I don't see what we do as part of an established musical language or culture. It reminds me as a teenager of reading interviews of rock bands 'writing' songs – as if they were sitting down in candlelight to compose with some music notation like Mozart or Beethoven might have done. It's more of a process of 'sculpture' from an internally represented idea, which then has to be transformed somehow into tangible sound. That's the challenge, and any number of ways are available to achieve that goal."[13]

Just as 'improvisation' is a kind of misnomer for the work of Whitehouse, so too is the term 'anti-music', proclaimed with zeal by contemporaries like The New Blockaders. Bennett, who seemingly enjoys a much broader variety of music than many of his peers (he has written approvingly, and surprisingly, of everything from Italo Disco's giddy naiveté to the French progressive rock of Magma), could hardly be called a spokesperson for the final destruction of the musical form. Yet, as a confessed connoisseur of all the arts, he is happy to criticize *musicians* for their failure to present relevant work with a passable shelf life. He voices his disappointment with the bulk of modern musicians as such:

"So many musicians at an early stage in their careers will find themselves in a comfort zone where they no longer feel the need to come up with anything new, and will happily just sit back and do the retreads until the end, even when they're obviously failing. In the realms of literature and art for example, I see the fires burning bright into old age, even at times increasing in intensity. I'm not quite sure why that's the case, other than the theory that music attracts participants for a lot more reasons than the mere opportunity to create."[14]

Lest we forget, Whitehouse was partially formed as a reaction to what Bennett perceived as the quickly faded promise of The Sex Pistols, Throbbing Gristle, et. al.: as an attempt to the nullify the perceived ironic poses of these artists with something of unmistakable, almost elemental, purity. Whitehouse, in sharp contrast to Throbbing Gristle, do not entertain any ideas of having an 'mission', nor is public image an integral part of their work.

By the time Whitehouse' debut exploded onto the scene, the kind of single-minded sonic wrath it contained wasn't completely without precedent in the annals of electronic music. Gordon Mumma's *Megaton for William Burroughs* or Alvin Lucier's *Bird and Person Dyning* shared similar techniques of electronic swarming and 'feedback-as-instrument', respectively. Yet while these pieces are visceral in their own right, they still remain appreciated by a largely academic and isolated

audience; their composers are largely respected as theoreticians and innovators within this university-educated community. Whitehouse, on the other hand, has had a much more heterogeneous following throughout their existence (although they remain notoriously at odds with Genesis P. Orridge, they have shared a similar strategy of playing at any venue which would have them) and has guaranteed an equally mixed critical reception: Messrs. Mumma and Lucier, to this writer's knowledge, have never had death threats directed at venues where they were scheduled to perform, have never been physically attacked by militant feminists, and have been spared the endless string of chaotic incidents which once dogged Whitehouse' public appearances.

Psychopathia Sexualis

Whitehouse, due to their raw atonality and reliance on extreme frequencies, are more likely to be accepted by the sound art community than the more mid-range friendly alternative music community, although both have admitted (with varying degrees of hesitation and enthusiasm) to borrowing components of Whitehouse' presentation. Sonic Youth guitarist and relentless noise advocate Thurston Moore has dropped the band's name on more than one occasion, as well as more left-field figures like Peter 'Pita' Rehberg and multi-disciplinary artist Russell Haswell. The band has marshaled an impressive array of cultural backers, yet most of these artists are well aware of the band's notoriety, and are usually compelled to temper their admiration for Whitehouse' sound with an assortment of disclaimers and carefully worded rationales. Sound artist and bio-acoustic researcher Francisco López, another highly influential figure as far as his chosen fields are concerned, accurately exemplifies the cautious approach to the band:

"In the industrial culture, the term 'Industrial' was more related to an aesthetic of violence (images and references to genocide, murders, etc.) than to machines. The sex and violence discourse of Whitehouse, for example (so 'catchy' for many people), is absolutely uninteresting for me, whereas I always have found their sound work extremely appealing (and a true overlooked landmark in the experimental underground.)"[15]

No discussion of Whitehouse' influence could be complete by excising their sound from their thematic interests, though, and it is precisely this subject matter which has led to the inexhaustible hostilities aimed at the band, and their (only recently lifted) blackout on openly discussing their ideas on the air and in other public forums. Whitehouse texts have become something of a litmus test to see if one really adheres to the accommodating, "anything goes!" philosophy of the art world or not: they have been revered as holy writ by the type of genuine outcasts who hound imprisoned serial killers for correspondence and autographs, and in fact the Whitehouse albums of the '80s constitute some of the first ever items of serial killer memorabilia. In Whitehouse, prolific slayers and sadists like Dennis Nilsen, Peter Kürten, and Gilles de Rais all have their first-ever commercially released songs devoted to them, to say nothing of porn luminaries like Chuck Traynor (the band's Great White Death LP is largely inspired by Deep Throat actress Linda Lovelace's confessional biography Ordeal, based on her degradation at the hands of co-star Traynor.) Whitehouse' interest in human sexuality was what really set them apart from much of the Industrial milieu, though – many of whom were quite contented with thorough examinations of violence, but were made uncomfortable by any mention whatsoever of sex. Bennett, in his weblog, goes after this one-sided thematic approach as follows:

"It's noticeable that the legions of noise copycats are far more comfortable with murder and destruction, or just general total abstractness, than they are with filthy, explicit, juicy sex. It still amazes me now that, as a band within any genre, we seem to almost have an unchallenged monopoly on the use of the word 'cunt'. Well, the men don't know but the little girls do indeed understand."[16]

If nothing else, the reactions towards Whitehouse' flagrant sexuality shore up the failures of the supposedly all-inclusive 'sexual revolution' of the 1960s: just as homosexual musicians like Coil were laughably taken to task for records deemed to be 'misogynist' (because they claimed to enhance "male sexuality"), Whitehouse were seen as lending their endorsement to cruel and abusive

sex practices even when combining gender-neutral titles like 'Coitus', 'Total Sex', and 'On Top' with the lashing harshness of their music. Ironically, through this same juxtaposition of elements, the would-be titillating quality of the truly sinister entries in Whitehouse' catalog (see 'Rapemaster,' 'Tit Pulp' and 'Bloodfucking') is blunted somewhat: for most listeners, the Whitehouse sound is simply too alien to fit comfortably into any musical vocabulary of seduction and sexiness. Bennett's electro-shock vocals, for one, have little in common with the smooth whispered intimacy of sexual 'come ons', and the instrumentation is as far removed as possible from the repetitive 4/4 pulse that is widely seen as being a simulation of coital rhythm. The musical content, by standing outside comfortable human points of reference, hardly seems to lend any credence to the activities mentioned in the songs, nor do the songs seem like 'simulations' or documentary dramas. Combined with the raw sexual imperatives of Whitehouse' minimal lyric sheets (most 1980s Whitehouse pieces consist of about 5-6 lines of text) it becomes something of a sonic 'double bind' – the more a listener consciously *tries* to become sexualized by an unfamiliar and unrepentantly vicious sound, the more he/she reveals the lack of desire to do something that must come naturally. The music is more complex than a quick scanning of lyrics will let on, and – like the writings of Peter Sotos – is more than just a grinning salute to those dominating individuals who leave a trail of broken victims in their wake. The criticism hurled at Whitehouse for their supposed lionization of sexual predators, murderers etc. is, again, more appropriately directed at their sheepish imitators – and shows an inability on reviewers' part to separate propaganda from commentary. William Bennett clarifies his stance on the predator-victim dynamic in a 2004 interview on London's Resonance FM:

INTERVIEWER: A major theme on the [*Cruise*] LP seems to be the world of women's magazines and obsessions with health and food. Is this album in any way a critique of that outlook? What [unintelligible] are you actually expressing that from? It's a very dark recording, isn't it?

BENNETT: A lot of bands that have tried to imitate Whitehouse, they focus on this very authoritarian element of this 'sadist', you know, this archetype sadist – but I think they're completely missing the point, because really all Whitehouse is about – and again, people might be surprised to hear this – is that it wouldn't work if there wasn't an incredible sensitivity to the people – in this case – suffering, and understanding them at their level. The understanding *is* at their level, it's not at the level of the person dishing out the punishment, or the treatment, or...whatever. That's why it's so powerful, and that's why it can touch people – so...in this sense, I wouldn't call it a critique of the outlook, but it's exploring those vulnerabilities and those sensitivities to an extent where I think you can actually feel that, you can feel uncomfortable.[17]

Peter Sotos, writing in his *Parasite* journal, also comes to the conclusion that Whitehouse' most blunt transgressions are in the imagination of the listener, rather than the stated intent of the creators:

"Whitehouse don't seek to comment on the need for an 'alternative,' just as they don't seek to comment on entertainment, or sadism, or man's inhumanity or hypocrisy, or sexual mores, morals or meanings. That erudite concerns and statements can be extracted from their work is in the motivations (however justified) of their fans. Whitehouse's concerns are their understanding of their tastes. And the band stands alone in their ability to apply these tastes without exploiting or mimicking them. Whitehouse remain as pure as their impulses. But their history and their reputation seems to be fostered largely by those who misunderstand it."[18]

Yet none of these explanations have been satisfactory for a decent slice of the critical community – Whitehouse' music still has been interpreted as a flat-out endorsement of violent compulsion, and has mobilized reviewers like John Gill to come to the rescue – writing a review of the *Great White Death* LP, he seethes that "their output puts the lie to the 'ignore them and they'll go away theory', and I want to stop them. One individual tainted by their ideas is one far too many."

For every John Gill, though, there is a counterweight, and maybe another listener whose opinions fall in some grey area between the extremes of repulsion and adoration – this diversity in reactions was, at one point, the stated objective of Whitehouse: *"the listeners of these records will always enjoy the most intense reactions of all, because they are the most repulsive records ever*

made". With this sentiment in mind, few people working in sound art hope for, let alone *advocate* outright polarization of their audience as Whitehouse does. Press releases for new Whitehouse releases often warn longtime supporters in advance of stylistic deviations, and most CDs on the band's post-Come Organization record label, Susan Lawly, come printed with a stentorian inversion of the "play at maximum volume" disclaimer: *"warning: extreme electronic music – acquire with due caution."* William Bennett, as an interview subject, comes across to the uninformed as something of an anti-publicist for his own work, frankly stating that many people just will not have the ability to appreciate it. Yet he doesn't discourage adversity, stating that

"Polarization is desirable because it's more likely to make people reveal their true selves, it reveals more of their truth even if it says little about the work in question. While for some this is a wholly positive experience, for others it exposes the enemy in the mirror."[19]

Screams in Favor of De Sade

Since Whitehouse eludes most of the familiar musical points of reference, and claims to find much music 'enjoyable, but not inspiring', it's better to look for their roots in the literary realm: especially within the more scathing forms of socio-political satire, and written musings on the depths of human obsession and interpersonal manipulation. The Marquis de Sade is the obvious starting point for understanding Whitehouse' shameless breaches of lyrical 'no-go zones': a younger William Bennett saw a great many of his ideas fleshed out in the Grove Press translations of Sade, with their almost laughably exaggerated scenes of orgiastic sex and sacrificial violence, and their underlying premise that man is merely a more highly evolved animal with no real moral advantage over the rest of nature. From *Justine:* "No, there is no god, Nature sufficeth unto herself; in no wise hath she need of an author."[20] Curiously for critics of Whitehouse' (and de Sade's) alleged misogyny, de Sade was an author whose heroines, such as the imposing Madame de Clairwil, often tower over passive males in an atomization of the conflict between nature and supposedly 'superior' man – and while the lust-fueled transgressions committed by these women have little documented parallel in reality, literary critic Camille Paglia suggests that de Sade has built them up for another reason:

"Sade has spectacularly enlarged the female character. The barbarism of Madame de Clairwil, orgasmically rending her victims limb from limb, is the sign of her greater *conceptual* power."[21]

20th-century admirers of de Sade, like the reluctant French philosopher Georges Bataille, also figure into the Whitehouse pantheon. As for books penned during William Bennett's lifetime, Whitehouse' music sits comfortably alongside such works as Bret Easton Ellis' *American Psycho,* his acidic satirical drama which binds together the twin 1980s obsessions of serial killing and vain, conspicuous yuppie consumption (echoed in Whitehouse tracks like "Now Is The Time" and "Asking For It".) J.G. Ballard's *Crash* and *The Atrocity Exhibition* are other possible influences, if only for their exploratory quality in regards to obsession. Yet while almost nobody would confuse the above authors with the characters in their works, myriad elements of the listening public have assumed that Whitehouse are inseparable from their songs – that they truly aspire to be the heirs apparent to the bloody-minded legacy of Caligula and Nero, despite the very limited resources necessary to do this. William Bennett is not blind to this preconception, having occasionally launched Whitehouse performances with a 'thumbs up' salute and march inspired by Malcolm McDowell's film portrayal of the demented emperor Caligula – Current 93 frontman David Tibet, an occasional collaborator of the band, has also hailed Bennett as "an expert on Roman decadence." However, the black humor of Bennett's Caligula poses, and indeed most of Whitehouse' lyrical content (to say nothing of their deliberately misleading and misinforming the more gullible elements of the music press) are completely lost on a music audience which is used to having every aspect of their music rigorously dictated to them (note the shouts of *"why don't you stand up for what you believe in!"* on the vintage Whitehouse track 'Rock 'n Roll' – a biting parody of the dictatorial inter-song banter bleated out by Kiss frontman Paul Stanley.)

Stewart Home, author of *The Assault on Culture*, perpetrator of various conceptual art

pranks, and self-styled scourge of the bourgeoisie, seems like a natural enemy of Whitehouse given his somewhat utopian leanings, and indeed he is. With the 'violent sex' outrage perhaps covered too well by journalists like John Gill, Home instead goes after them because

"Whitehouse commodify terror and mass murder as an entertaining spectacle, and the consumption of this as 'art' mimics the fascist obliteration of private space. This tendency is manifested most obviously on the Whitehouse album *New Britain*, which features the tracks 'Movement 1982', 'Roman Strength', 'Will To Power', 'New Britain', 'Ravensbruck', 'Kriegserklarung', 'Viking Section' and 'Active Force'".[22]

Admittedly the alarmism and knee-jerk Situationist critique is disappointing coming from someone like Home, who seems to have a thorough knowledge of art's use in creating elaborate hoaxes, and its function of forcing Bennett's "enemy in the mirror" to reveal itself through self-righteous expression of moral outrage. Home's critique would have some weight to it, were it not for the fact that *New Britain* is an album packaged (like the similarly controversial *Buchenwald* LP) in a totally unadorned sleeve, with no published lyrics, nor anything even approaching the political in the musical content. Bennett's vocals throughout the 1982 release are disorienting, indecipherable shrieks heard as if underwater, audio Rorschach blots unlikely to stir the patriotic and nationalist sentiments common to garden-variety fascists. By the logic Home applies to this record – that song titles are necessarily a microcosm of one's ideology – should a listener to 'Mars, Bringer of War' from Holst's *Planets* suite interpret this as an encouragement to make war?

A survey of Whitehouse interviews over the years shows that the quest for converts is the last thing on the band's mind, and as Bataille says of Sade,

"His characters do not speak to man in general, as literature does even in the apparent discretion of the private journal. If they speak at all, it is to someone of their own kind."[23]

Bataille is also careful to note that de Sade wrote one of his most incendiary works from a lowly victim position – his excessive *120 Nights of Sodom*, though it has a wealthy, aristocratic quartet of fiends at the center of its erotic atrocities, was written by a victim of overzealous state prosecution: de Sade was held under lock and key after narrowly escaping the death sentence for sodomy. Bataille suggests that the furious quality of that particular manuscript came from de Sade's desire to judge those who had meted out the harsh punishment for this trivial crime, and to "[sit] in judgement on the man who condemned him, upon God, and generally upon the limits set to ardent sensuality."[24] Sade, writing the bulk of his influential work in this condition, could not have honestly believed that his fantasies would come true in his own lifetime. In the same way, the accusations that Whitehouse wanted to use their music as a sort of recruiting tool to attain fascistic power are ludicrous, as is the accusation that they may have been actual initiators of 'ultraviolence' in their free time – you'd wonder how deliriously stupid a criminal, in any frame of mind, would have to be in order to telegraph his desires for pathological behavior in such a visible profession. Only recently, within certain enclaves of the 'gangsta' rap community and the Black Metal underground, have recording artists been able to use a genuine life of crime as a P.R. boost for their careers as entertainers. Otherwise, the number of historical precedents for the 'killer entertainer' archetype is slim. Shoko Asahara and Charles Manson, to wit, were both cult leaders whose ideologies influenced highly publicized murders, and they were self-styled musicians as well – yet their music contains no overt references to their planned actions, or celebrations of the same.

The Internet has once again served as the great debunker regarding this issue, though. A recent incident involving Bennett's injury at a 2007 concert (after falling off a high stage) served as the unlikely fuse for an explosive debate on the many assumptions made about Bennett's character over the years. On one side of the dividing line were the sympathetic well-wishers, and on the other were a squad of "old school noise" aficionados, who saw these tender expressions of sympathy as the last straw in an ongoing program to "soften" and "humanize" their idealized image of Whitehouse: lust murderers moonlighting as a music group. A feud beginning on the band's official web forum spilled over into other more loosely moderated arenas – like the 'Chondritic Sound' power electronics message board-where conjecture was piled on top of conjecture in an attempt to

humble Whitehouse once and for all. The accusations levied at Bennett's extracurricular activities, however, are condemnations of pursuits that would appear to all but the disgruntled power electronics buff as creative and constructive acts – once again, the band's music had served as a tool to expose the more peculiar quirks of certain individuals: in this case, the sobering fact that people's lives were sustained by daydreams of a new breed of heroic ultra-sadist *cum* avant-garde aesthete, who would fight their dirtiest battles in their stead. When said artist failed irrevocably to live up to his role as antisocial hate-object (or, ironically, to make good on the 'fascist' accusations of Stewart Home and others) the disenchanted went after him with the passion of a lover scorned.

The Second Coming

The 1990's, defined by a desperate and flailing need to provide 'closure' on every touchy issue of the foregoing century, were almost guaranteed to spawn a sideshow industry of theatrical extremism as a caricature of those issues. The American daytime talk show circuit became one such release valve for those helpless to explain or adapt to the pre-millenial spasms of genocide, technological instability (the 'Y2K bug'), general decline in work ethic and 'value for money', *ad nauseam*. Just the first few years of the decade alone provide a whole cornucopia of lurid examples: on TV staples like *The Jerry Springer Show* and *Geraldo,* America's raging id was trotted out before it in the guise of 'shock rock' mainstay G.G. Allin, who appeared on the show clad in jockstrap, crudely etched prison tattoos and *Wehrmacht* helmet to hurl all the anticipated affronts at "the pigs" while boasting of raping female fans at his concerts and heaving his freshly deposited fecal matter at gaping onlookers as a holy "communion" (his body was, after all, the "rock-n-roll temple" in his estimation.) The eager nosedive of 'trash TV' into the world of *panem et circenses* was only the most obvious exponent of all this: the world of print media was also rife with its pariahs of 'extreme' culture. Mike Diana, a Florida cartoonist and elementary school janitor known for his amateur comic *Boiled Angel,* was taken to court and placed on a 3-year probation in which he was banned from further cartooning. Diana's ghoulish depictions of sexual molestation and blood-soaked sacrilege may not have even registered a blip on the radar had one *Boiled Angel* not been discovered at the scene of a Floridian murder, but whatever the case, the unalloyed ugliness of his child molestation scenarios made him the temporary face of the cyclical 'freedom of expression' debate. Elsewhere, the lacerating, Portland-based 'zine scribe and satirist Jim Goad, in a misfired attempt to throw the self-congratulatory, disaffected edginess of his own readers back in their faces, published a 'rape'-themed issue of his journal *Answer Me!* (Goad is, for the record, the first publisher to collect all of Peter Sotos' early writings into one volume, entitled *Total Abuse.*) The result was another obscenity trial, although the outcry came this time from the politically left and more secularized regions of society. The cases of Diana and Goad, among other cases involving less artistically-inclined criminals, finally pushed the envelope to the point where America's aggressive moralists took up sexual abuse as their new *cause célèbre,* having so dramatically failed in their hunt for "Satanic covens" in the 1980s.

The Hollywood-based pornography industry, naturally, also responded to – and eventually epitomized – the 'provocative is better' media trend of the '90s by inventing (or at least mainstreaming) whole new genres of porn. These newer sub-genres were based less and less on depictions of consensual love-making and more and more on sexual endurance tests with mobs of faceless, grunting males servicing a single 'actress', showcases of freakishly huge (to the point of useless) genitalia, and decidedly un-sexy encounters with robotic 'fucking machines'. Meanwhile the industry, already far out of step with the culture of political correctness, resurrected all the available ethnic and cultural stereotypes in order to give an extra shot of naughtiness to their program of titillation through degradation. All that remained, after exhausting every conceivable kink and fetish, was to attain digital market saturation via the Internet – a cakewalk if ever there was one. The 24-hour omnipresence of porn has only recently led to critical backlash, collective guilty 'soul-searching', and a parallel recovery industry aided by porn experts such as Luke Ford outing it as "fast food for the soul," and by author Pamela Paul (*Pornified*) writing well-intentioned but inconclusive

jeremiads on the subject of porn addiction. The fast food comparison was an apt one, anyway, since both industries, over the course of the 1990s, continually rolled out new products which baited consumers with the word 'extreme' as a selling point.

As garish and prurient as '90s-style extremism may have been, though, its bluntness should not always be confused with an ability to shake modern society to its foundations. Performers like G.G. Allin were an extension of the entertainment tradition of the carnival geek show, not to the simultaneously horrific and introspective "abreaction plays" of the Viennese Aktionists. Both attendance at a G.G. Allin show or at a Nitsch action carried with it risks to one's physical or psychological well-being, and while both the participants in Nitsch' blood orgies and victims of Allin's scatological mayhem have claimed them to be epiphanies, it was Allin who reflected his era while the Aktionists transcended theirs. Allin's self-immolating antics merely reflected the very 1990s trend towards accepting any and all superlatives as worthy of attention, if not respect – at the very least, he elicited gasps betraying a sense of simultaneous disgust and awe. With becoming the most outrageous performer ever (the "public animal #1") as his stated agenda, Allin limited himself to a situation where he would be defined solely by his interaction with a public, whereas the Aktionists often performed their art as a clandestine ritual, behind closed doors and with no corresponding documentation other than whispered hearsay after the fact. In this sense, Whitehouse is much closer in spirit to the Aktionists: both their *Right to Kill and Psychopathia Sexualis* LPs, after being pressed in near-private editions, have been refused re-issue on the grounds that being made available to a larger public would nullify their impact (both have been bootlegged into oblivion, however.) And despite the occasionally charismatic stage presence of both Whitehouse and the Aktionist performers, both have down-played the relevance of their public personae as being secondary to the understanding of their art: both the direct intensity of a William Bennett scream and of a Günter Brus self-mutilation had a mediumistic quality to them, relinquishing power and even accepting a role as 'lightning rod' rather than imagining themselves as the centripetal force Allin must have thought himself to be. Whitehouse' entrance into the 1990s was more than just an attempt to capitalize on the growing acceptance of 'shock' techniques, or to make a bid for 'influential' status in the new circus of excess – but their continued existence did illuminate the hollowness at the heart of the extremist gestures perpetuated by Generation X, and the inverse relationship between their empty embrace of shock tactics and a knowledge of what truly ignited humanity's more furious passions.

When Whitehouse resumed record-releasing activity in the 1990s, this time releasing their material under their Susan Lawly imprint, they joined forces with Chicago's highly articulate and highly irascible Steve Albini – a producer and independent music journalist known throughout Chicago just as much for his willful belligerence as for the superb quality of his studio recordings, and for his encyclopedic knowledge of microphone techniques. Press updates of Albini's musical activities virtually always contain some variation on the sentiment "love him or hate him, he gets the job done", and it is becoming something of a tedious cliché to note how he has never aborted any of his promises, despite his apparent bottomless cynicism. Such a man would seem like a natural for helping to transmit William Bennett's uncompromising vision, and so he was. Despite Albini's firm grounding in the rock world, the two have overlapping interests that shouldn't be ignored. During his tenure as the frontman of the scathing post-punk combo Big Black, Albini's subject matter for songs could be every bit as difficult as those guiding Whitehouse' songs – perhaps not as terse and with much more of a narrative element, but still not at all recommended for the sheltered and oblivious. Like Whitehouse, Big Black commits the grievous sin of stripping the fantasy element from stylized "darkness". Take as an example "Jordan, Minnesota" off Big Black's *Atomizer* LP, which could almost qualify as a rock revision of certain Whitehouse numbers. If you were to excerpt just the last, rhythm-free 90 seconds or so of "Jordan..." the parallels would become even more clear: the stinging, quivering feedback drawn out over an extended period, the distressed vocals that sound eerily like a desperate plea and a spat order at the same time. This is to say nothing of *Atomizer's* lyrical strip-mining of all possible forms of social decay: topics such as wife-beating,

post-traumatic stress and the sexual thrill of arson all become grist for Steve Albini's topical mill, making one wonder why *Atomizer* and its companion pieces never met with the same indignant protests as Whitehouse releases. The liner notes to this album include, among the self-effacing notes about malfunctioning equipment and the string of obscure in-jokes, an Albini-penned statement that sounds like a Stateside approximation of Bennett: *"Our interests in death, force and domination can change the way we think. Make us seek out new forms of 'entertainment.' Ever been in a slaughterhouse?"* One last parallel worth noting: both Big Black and the Come Organisation-era Whitehouse dissolved at a time when they felt they were at their creative peak, and had reached some satisfactory level of completion.

With Albini fine-tuning the band's sound, Whitehouse embarked on a far more idiosyncratic creative phase than before – if nothing else, the enveloping intimacy that is Albini's trademark makes some of the mid-'90s pieces exude a sense of genuine claustrophobia. The small room sound of the album centerpiece "Quality Time," for example, highlighting the sparse electrical crackles and the spastic, wounded nature of Bennett's vocal, is profoundly uncomfortable, almost cinematic in its evocative ability – the impatience, frustration and burning need of the track's narrator is a world away from easy portrayals of invincible libertines churned out by the bands generated in Whitehouse' wake. Elsewhere, the epic length (12 minute) "Halogen" features a lush introduction by way of interlacing feedback 'solos,' low-volume snatches of confectionery Thai pop music buried beneath a rolling noise tumult, unexpected interjections of silence, and a rabid, wrathful William Bennett shrieking lyrics that are as unsettling as they are cryptic. The voice anchoring these pieces is one which may itself be vulnerable to forces beyond its understanding, simultaneously victimizer and victimized – at least, without any obvious references as to the track's inspiration, this is one conclusion we can reach. This kind of perceptual ambiguity is what, once and for all, demarcates the boundaries between Whitehouse and the other musical shock merchants so typical of the era. That the aforementioned recordings of Whitehouse come packaged in stereotypically 'cute', airbrushed doll artwork by Trevor Brown only heightens the inability of critics or casual music consumers to 'pin down' the meaning of these songs. Whitehouse circa the mid-late 1990s is an outfit which truly has absorbed the major lessons of the avant-garde without having ever been absorbed by the avant-garde establishment in turn – but this, too, would change over time.

Animal Response Technicians

The 21st century incarnation of Whitehouse is not only an anomaly in the world of noise and power electronics, but in much of the sound art world, period. Their newer, heavily digitized sound is an object lesson in dynamic tension, and the sharp, ceaseless harangues of the William Bennett/Philip Best vocal duo defy the listener to fixate attention on anything other than their hectoring voices. The 'new' Whitehouse also benefits from incorporating the techniques of linguistic pseudo-sciences such as neuro-linguistic programming (NLP) and Scientology auditing into the mix; reassessing the ability of each individual word to severely alter listeners' emotional and psychological composure. Some of these word games include intentional grammatical errors (referring to listeners as "*the* you") and overloading conscious attention with imagery too obscure to process: mentions of "the chlorine gargoyle," "the chickenskin swim," or "the Alice pill you snatch from the blind evolutionary drift" are not likely to register with anyone immediately. By the logic of NLP, the attractive ambiguity of such verbal play 'frees' the unconscious as the conscious mind is busy decoding and trying to personalize the more puzzling references. It is interesting to note also that NLP operates on a rather optimistic premise of *"there is no failure...only feedback,"* suggesting that the meaning of any communication is the response generated by it – not the actual communication itself. This is a striking parallel to what William Bennett has been saying all these years about his audiences' reactions 'completing' the band's artwork: "art has the capacity for any reaction," he claims, "and unlike the 'real world', isn't constricted to achieving certain specific responses."[25]

However, the therapeutic, nurturing, "no wrong answer" nature of NLP is not the only usage that Whitehouse explores – the practice of NLP as a manipulative form of hypnosis (and one which

operates under no professional code of ethics) is highlighted in the monologues of dirge-like Whitehouse songs like 'Philosophy'; which utilizes a particularly sadistic NLP 'pattern' aimed at reducing a lover to a state of complete, hopeless dependency. Other tracks like "Dumping The Fucking Rubbish" (appearing on the *Asceticists 2006* CD and reprised on next year's *Racket*), are based on the method of Scientology auditing, firing off a fusillade of highly personal questions at a patient: *"is sex boring to your body? Is sex degrading to your body? Does some body withhold sex from you? Invalidate you sexually?"* etc. Delivered in Philip Best's lucid and disgusted bark, rather than in the languid tones of an apparently sympathetic auditor, these inquiries are revealed as having a purpose beyond merely clearing patients (condescendingly referred to as "pre-clears") of their deeply-ingrained complexes: namely, that of entertaining the questioner at the patient's expense. In what author John Gray refers to as the 'entertainment economy' of the 21st century's affluent nations, the role of auditors and other pseudo-psychiatric professions will come to the fore in order to stave off the dull feelings of personal dissatisfaction and *affluenza*. With the increased demand for professionals to eradicate the anxiety exclusive to this age, there will likely be an increase in more unsavory personalities entering the field: the newer material of Whitehouse offers a striking and frightening view of what can be expected from such emotional wreckers, psychiatric charlatans and self-styled 'gurus': just as Peter Sotos' writings exposed mass media's sham sympathy for the archetypal victim, the contemporary Whitehouse recordings seem to suggest the potential for various therapeutic techniques to reinforce the common master-slave dichotomy. Then again, the ringing intensity of the sound and the merciless interrogative style of the vocals could be the means with which to carry out an unorthodox kind of abreactive therapy – shocking patients into a more desirable existence.

Meanwhile, all of this experimentation with complicated, multi-threaded linguistic information has not diluted Bennett's interest in the transformative nature of simple profanity. Very much a 'renaissance man' of swearing, a lingering, clenched-teeth *'cunt'* or *'fuck'* in Bennett's hands assumes a potency that it hasn't had in years of terminally dumbed-down culture, in which the latter word is used to fill virtually every grammatical function. Quoth Bennett:

"There's a real art to being a good swearer. It's a tightly nuanced balance between timing, the unexpected, intonation, and a special intent that betrays a subtext ranging from mischief, to hard sincerity, to anger, to seduction, or perhaps to irony. And above all, I feel it's important that there's a comforting sense of you being given permission not only to say 'fuck' or 'cunt' back, but also to engage in actions that might otherwise not be appropriate."[26]

It is a curious world that Whitehouse inhabits: one in which an innocuous phrase like "do you see that door over there" becomes an emotionally crippling NLP pattern, while well-placed vulgarities are used to liberate. Yet it is a world that is, more and more, very close to the actual truth of reality.

Bennett's contrarian refusal to conform to accepted tenets of 'extreme' music has, in keeping with his own warnings, alienated many die-hard fans – and yet, his obstinacy has earned him the attention of curators and collaborators from the peripheries of the ever-fluid 'new media' world. This can be argued as an abrupt sea change in aesthetic tastes throughout the modern world, but it can also be argued that this change owes itself in part to Whitehouse' continued existence. It would be difficult to conceive of William Bennett circa 1981 being invited for a sound art-themed lecture at CCA KitaKyushu, a cutting edge Japanese center for art and theory. Nor would the Whitehouse of 20 years ago be receiving honorable mentions in the 'digital musics' category of contests like Austria's coveted Prix Ars Electronica (the CD in question being the 2003 release *Bird Seed*.) Yet even in the latter example, the stereotype of Whitehouse as one-dimensional neo-fascist thugs has persisted somewhat – *Haunted Weather* author and musicologist David Toop, on the Ars Electronica judges' panel for that year, allegedly threatened a walkout if *Bird Seed* was nominated for the top prize. Speaking on this incident (where Whitehouse supporter Peter Rehberg also served as a panel judge for the 'digital musics' prize), Bennett says that

"ARS Electronica's 'honorable mention' story ironically belies some of the outright board

hostility from old-timers like David Toop. Having been thoroughly disenfranchised for so long, I take hostility as a perverse form of vindication, but it's true there's lately been some fantastic support from other quarters – and anyway, it works best not to let one's energy get affected by what people say, good or bad."[27]

New Asceticism

"One of the best things that ever happened to me was getting burgled, it happens to people all the time, it's a miserable fucking experience, you just want to kill the people. They took everything I had, absolutely everything, video equipment, records, the whole collection, stereo, the whole lot. That was the best thing that ever happened to me because suddenly I realised that – and I don't want to sound too spiritual or religious, it's nothing to do with that – I was no longer tied down by my possessions. I thought I can now do whatever I want. The month before, we'd done a concert in Barcelona and had such a great time. Fuck it. I'm going to move to Barcelona. OK, I've got no money, no possessions or anything, but I'm just going to get on the next plane and go to Barcelona. Which is exactly what I did. And it was the best thing that ever happened to me."[28] (William Bennett)

Whitehouse' music has regularly been perceived as minimalistic: a word that hints at conceptual maturity within the art world, but has decidedly more negative connotations in consumer parlance. People conditioned to living in today's information-saturated, hyper-materialistic societies can harbor severe anxiety over seeing some product or service not used in the most economical way possible. So, calling a CD release 'minimalist' often implies that people are not getting what they truly deserve from the music, and that the artists themselves are carelessly squandering a golden opportunity at making a complete statement – with so many billions of people wishing for just one chance to immortalize their ideas and opinions, an act like leaving 1-minute silences between the songs on a vinyl LP (a staple of the earlier Come Organisation Whitehouse records) is seen as some type of artistic dereliction of duty. Along these lines, listeners have complained of paying for full length Whitehouse CDs (at import prices, no less) which contain less than 40 minutes of music, when twice that is possible. It is a grievance similar to criticizing a painter for leaving blank patches of canvas in a painting, or worse yet, relegating musicians to the role of urban planners who must make every nook and cranny of a living environment functional somehow. This shows a woeful misunderstanding of not only Whitehouse' music, but of art in general, which has historically used 'negative space' to provide contrast between compositional elements, or to allow the full absorption of one idea before moving onto the next.

Hungering for an inexhaustible all-you-can-eat buffet of all possible sounds betrays a childish desire to be pandered to, and artists who do this pandering can lessen their relevance dramatically, if not careful. 'Breakcore' producers such as Kid 606 and Venetian Snares, who admire Whitehouse' unflinching intensity and align themselves with Whitehouse associates like Trevor Brown, are capable of dazzling fireworks displays and entertaining bouts of beat-driven fury, but in the end it becomes difficult to ascribe any real meaning to their firehose blasts of verbal and musical information. In the worst scenarios, the music eventually becomes, like a caffeine-based drink which also dehydrates the body, more fatiguing than energizing.

Commercial music since the 1970s has seen an increasing number of electrified virtuosi 'fill' sonic space with as many possible notes per second – digital beat music often just replaces the flurry of notes with a mashed-up flurry of more generalized 'sound events' (distorted rhythms, movie dialogue samples, spasmodically shifting synthesizer patterns.) Track and album titles brim with in-joke references to the equipment used to make the records, as well as with sarcastic references to the pop culture also heavily sampled in order to make the final product. Whether this is a comment, like Throbbing Gristle's more overloaded pieces, on the 'culture of congestion', or just hobbyists dabbling with a potpourri of electronic musical forms, is debatable (although personally I suspect this music is just symptomatic of the 'culture of congestion' rather than a criticism of it – and the producers of this music look like they quite enjoy blasting it from PA systems all over the world.) One thing that is clear, though, is that it is the polar opposite of Whitehouse' approach: one in

which willful denial of expectations, rather than fulfillment of them, leads to greater rewards. With this approach comes a dismissal of the technophilia hard-wired into "extreme electronic" forms like breakcore. As Bennett says:

"I'm only interested in results. It's not about equipment or technology, it's about music, and its success will be measured by how people emotionally respond to it, now and tomorrow. Since we anyway obsessively and self-consciously work outside the established musical traditions and templates, we can easily and effortlessly transcend any raging contemporary music technology debate."[29]

Feeling perhaps that associations with minimalism carry too much baggage with them, Bennett has proposed 'asceticist' as a better qualifier for his sound: in his estimation, this word refers to a conscious, disciplined stripping away of talents that one can otherwise capably utilize, in order to reduce an experience – of listening, performing, etc. – to only its most essential components. The 'minimalist' designation also seems to smell a little bit too much of what Henry Flynt derided as 'serious culture': a Euro-centric, academic compositional style placing too much emphasis on handing down precepts from master to pupil, rather than on nurturing personal, revelatory examination. Bennett's asceticism is more vivid, and pan-cultural in a refreshingly un-patronizing way: the more recent Whitehouse releases *Racket* and *Asceticists 2006* are even loaded with rattling, tactile samples of West African percussive instrumentation – djembes, ksings, doundouns – employed in such a way as to perfectly integrate with the 'lead instruments': in these cases, spiky computerized feedback and queasy time-stretched abstractions. Bennett has also confessed to enjoying more 'primitive' forms of music arising from the world's many non-industrialized, non-computerized enclaves, and the trance states one can attain with maximum dedication funneled into the most rudimentary means. It is this direction in which Whitehouse currently seems to be focusing their energies – while none-too-subtly implying the shortcomings of Western technophilia.

It should be clarified that the religious concept of 'asceticism' – of withdrawing from the worldly to contemplate the divine in solitude – is not one endorsed by the adamantly atheistic Bennett, who believes Christ never existed as a human being, and sees organized Christianity itself as a syncretic mish-mash of borrowings from other faiths, despite its being a monotheistic faith itself. Bennett recommends such books as *The Incredible Shrinking Son of Man* and *The Jesus Puzzle* to bolster his argument, and mischievously invites door-to-door religious proselytizers to drop by his home for tea and de-programming. At the same time, Bennett is not exactly a Diogenes figure, that Greek philosopher so often associated with asceticism – he harbors no illusions that he can improve mankind morally, though there are other similarities with the Cynic philosopher, such as a cosmopolitan sensibility enabled by reduced dependency on material goods. Criticism of humanity's valuing the institution over the individual is another trait shared by Bennett and Diogenes, and Bennett has been especially damning of collectivist ideals which, though they portray themselves as secular, still carry with them the eschatological fervor of religion. From the medieval Brethren of the Free Spirit to the various strains of Marxism, the numerous utopian social movements over the ages have downplayed the issue of depleting natural resources and the danger of assuming man is 'master' of the Earth, while suggesting that new forms of technological progress (such as automation) would make human labor unnecessary, and that there would be a permanent state of play with no checks on human desire – if nothing else, this attitude has resulted in unprecedented environmental devastation, while replicating the 'end time'/'paradise on earth' fantasies of the maligned religions. The denial of the 'savior' complex – whether it be salvation by automation, or the Son of God – is at the epicenter of Bennett's asceticism, as is the personal responsibility that this denial would entail.

Looking back on Whitehouse' whole body of work, it now seems more obvious that the shift into asceticism is not a recent 'awakening' on behalf of Bennett and his collaborators, but a thread which ran through their music all along, and has now been clarified as part of a larger life strategy (although one Bennett admits is mainly his own, not guaranteed to work for everyone.) Reduction

to the non-ornamental essentials of a form is nothing new in the musical field – ask any Tuvan throat singer or Tibetan monk – but rarely has such music been used outside of a religious context, and in the service of brutally personal inquiry. Whitehouse' legacy is the creation of music appealing to *both* ascetics and libertines – who, united in their denial of the collective hive mind, and their adoption of an almost unattainable higher standard, may have more in common than we think.

RE-LAUNCHING THE DREAM WEAPON:
CONSIDERING COIL

Force and Form

"Intention is the key. Intention is what distinguishes the willful act from both the thoughtless and the thoughtful act. When it is one's intention to utilize sonic experience to extend beyond awareness and approach the higher consciousness – intuition and inspiration – it can be achieved."[1] (Z'ev, *Lightning Music*)

Industrial music, among its other innovations, placed emphasis on making music that was completed by some active involvement on the listener's behalf. In the past I've described various post-Industrial music configurations as 'functional music', out of pure journalistic convenience, but now I realize that this was far too vague a term. After all, being entertained, and passing time at one's workplace or during a dull commute without becoming agitated are the 'functions' of pop music, as flat and utilitarian as they may be to the thinkers and dreamers toeing society's margins. Popular music may be grating to people who detest cloying sentimentality, and its built-in obsolescence may offend people who want a more transcendent experience, but saying it doesn't have a 'function' reveals a personal aesthetic bias rather than anything that can be backed up by empirical evidence. So perhaps it's more accurate to divide the musical sphere into two 'active' and 'passive' hemispheres. On one hand there is 'active' music which requires the listener to complete its work through some heightened mental focus, or with a physical activity like shutting off all the lights in the room, re-positioning oneself relative to the speakers that the music is coming from, or maybe manipulating one record by hand as a second record plays by itself. Music which requires no input on the part of the listener, or a negligible amount of mental processing, could be called passive – although even here we have to be careful that the various shades of dance music aren't being dismissed as passive merely because, again, of an aesthetic bias. The concept of passive music, or music for 'leisure listening' only, is a comparatively recent one when we go back to the very roots of the song form: birdsong has always been used as a means of marking territory, or as a device for attracting mates. The success rate of these short musical phrases to make their point was very closely tied to a bird's survival, and the furthering of its species. Numerous ethnomusicologists also theorize that the first primitive human song forms had a function of communicating with neighboring tribes. But even as the variety and amount of passive music has exploded since the dawn of sound recording, the functions of 'active' music have multiplied to the point where its best examples achieve an elegant synchronization of the senses.

+++++++

"The distinction between musician and non-musician – which separates the group from the speech of the sorcerer – undoubtedly represents one of the very first divisions of labor, one of the very first social differentiations in the history of humanity, even predating the social hierarchy. Shaman, doctor, musician. He is one of society's first gazes upon itself, he is one of the first catalyzers of violence and myth."[2] (Jacques Attali)

"...the Bard's curse is supposed to be able to blight crops and bowl over crooked politicians. The Bard is not just another image-monger: the Bard, the shaman-poet, wields power. When the

Bard pays attention, even wild animals come 'round to sniff at the psychic overflow."[3] (Hakim Bey)

The above observations apply to a good swath of the post-Industrial musical underground (many of whom would later divert their shamanistic energies into the more accessible, pulsebeat-driven genres of techno and acid house.) Power electronics, free-form distortion, and relentless death drive may have been sufficient for many post-Industrial performers to clarify their outcast role in society, but for many others with their roots in the Industrial genre, it was not enough – such exercises in unbridled extremity tended to shore up the parochial nature of the performers, and their susceptibility to sheer frustration, more often than not. As per Throbbing Gristle's Peter Christopherson, "it's only a culture with a long history of decadence and decay that has a need for music that strikes that particular chord. In Thailand, for example, people mainly like to have fun, so really only appreciate music that answers or assists in that need."[4] Many of the artists associated with Industrial culture had a decidedly more spiritual bent to their work, and set out to become more like the 'sorcerous' in Attali's above assertion or the 'bards' of Hakim Bey, rather than just downtrodden, disgruntled citizens with a slightly more unsettling way of articulating their grievances. And for what it's worth, many of the same techniques supposedly 'exclusive' to the new breed of violent electronics manipulators had already been employed by individuals worlds away from their (anti)social circles: Afro-futurist composer Sun Ra is an especially prescient example here, having incorporated cyclones of synthesizer violence into his work already in the mid-1960s, and having used sheet metal resonance as a central feature of his 1965 album *Strange Strings*. Even the themes of eschatology, death, and stereotypically 'evil' iconography (see the *Fireside Chat With Lucifer* LP for the latter) were deeply woven into his music, albeit in a more generalized and less 'site-specific' way than in Industrial music. By the 1980s, most other 'experimental' or fringe media contained representatives with a more alchemical or magical bent – especially within performance art and experimental film circles. The palpable tension between global military superpowers, to say nothing of the new plagues sweeping the Earth and the seeming indifference of the well-heeled leisure classes to all of these threats, seemed to increase the number of artists exploring primal or atavistic methods in the face of possible obliteration.

Rubbing Out The Word

"...and, as I point out, the montage method is much closer to the actual facts of perception than representational painting. So, that's it – life *is* a cut-up, every time you walk down the street or even look out the window, your consciousness is cut by random factors. And it was a question of bringing that back into writing."[5] (William S. Burroughs)

While the 'war universe' of William Burroughs may have provided Industrial culture with much of its insurgent tactical apparatus, his luminary status could not have been accomplished without the aid of his long-time friend and associate, Brion Gysin – who in turn influenced the underground's embrace of alchemical process art, while bridging a gap between the European avant garde and the more loosely-defined of cast of characters evolving out of Industrial music. Sound artists as diverse as Throbbing Gristle, the concrete poet Henri Chopin (who published Gysin's poetry in his magazine *Ou*), and Carl Michael von Hausswolff have adapted works or ideas of Gysin's to suit their own needs. At the very least, Gysin deserves credit as the co-author, along with Burroughs, of the now omnipresent 'cut-up' writing techniques – with his declaration of 'poets don't own words', Gysin validated this new enterprise of forming magical narratives out of randomly chosen, re-assembled texts. It was an idea that was dismissed as "plumbing" by Samuel Beckett (when Burroughs relayed to him that he was fusing Beckett's texts with sliced excerpts of the *Herald Tribune*), looked upon with ambivalence by even staunch Burroughs supporters like Gregory Corso, and wasn't entirely without precedent in modern art (see Marcel Duchamp's exhibition of four separate texts placed within a square, or Tristan Tzara's poem composed from paper scraps pulled out of a hat.) Still, it has managed to be the antecedent for a good deal of culture having little to do with the written word. The musical 'sampling virus' of artists such as John Oswald and Christian

Marclay, for one, put the basic cut-up principle to devastating, often hilarious effect by stripping well-known musical quotations of their original context and re-configuring them to serve the artist's own ideological ends. The basic theory of the cut-up has also allowed for simple communications devices (shortwave radio, satellite TV feeds) to be re-interpreted, with a built-in degree of serendipity, as musical instruments when combined with modern studio editing techniques.

Brion Gysin's appeal to the current crop of avant-garde musicians and sound artists lies in his natural, non-trained expressive ability, and also in his ability to distribute creativity across the entire artistic spectrum: to adopt an ecumenical anti-professionalism more suitable for personal questing, in which art and life are one inseparable entity. Many multi-disciplinary artists these days are only called 'musicians' because of their music's immediate physical and emotional impact compared with their other artistic enterprises. This may be because Western philosophy has increasingly lauded the utility of music over other arts, especially in works like Schopenhauer's *The World as Will and Representation* – in which Schopenhauer claims that artistic forms such as poetry engage the phenomenal world indirectly, while music is "the thing in itself". In Schopenhauer's view, music is the direct conduit to the universal idea, since an instrumental musical piece can express a feeling of, say, giddy love – but can't, try as it may, correlate to a *specific* incident of giddy love aroused by a particular person. It may not be a perfectly watertight thesis, but it also can't be denied that music is often placed on a pedestal to the detriment of the other arts. Brion Gysin was certainly well capable of expounding on the transcendental power of music, especially the tornadic musical frenzy he encountered in the Moroccan hill country of Jajouka. Yet his infatuation with it only served to fuel his other creative endeavors – concrete poetry, painting – rather than to divert energy from them. Put in Gysin's own words:

"...ecstatic dancing to the secret brotherhoods [in Morocco] is a form of psychic hygiene. You know your music when you hear it one day. You fall into line and dance when you pay the piper...inevitably something of all this is evident in what I do in the arts I practice."[6]

Brion Gysin was born in Buckinghamshire to Swiss parents in 1916, with his father dying in the battle of the Somme before he was one year of age. Numerous relocations would occur, taking him to New York, Kansas City, Edmonton, and finally back to England where he began publishing poetry at the highly-regarded Downside school (despite his studies there, Gysin taught himself painting and had no formal training in the arts.) His early status as a child without a country perhaps informed the de-centralizing nature of his life work, which would in turn encourage him to become involved with the Surrealist group in the 1930s. After the war, and after garnering a Fulbright fellowship for his studies on the history of slavery, Gysin eventually settled in Tangier and became a restaurateur – spending one of the most fruitful periods of his life in an environment where, as he claims, magical phenomena were a daily occurrence and an accepted fact of life. Unfortunately, this often manifested itself in the form of 'curses' personally directed at him: once a mysterious packet addressed to the "Djinn of smoke" was discovered in his restaurant, The 1,001 Nights. Among other things, the talismanic packet bore an unmistakable silhouette of himself, and an inscription "may Massa Brahim depart from this house, as smoke departs from this chimney." A few days after receiving the cryptic message, Gysin had a falling out with his financial backer, and was effectively through with the restaurant business – a result he saw as testifying to the potency of the curse.

In spite of demonstrable genius, Gysin was by no means perfect. He was beset by a tendency to weave intricate, paranoiac conspiracy theories when the public and the modern art vanguard (including Surrealist figurehead André Breton) showed indifference to his art. A mean misogynist streak may also prevent some students of Gysin from completely identifying with him. Both of the two counter-productive energies crash together when Gysin suggests

"...The reason I'm a flop is that I don't have a really potent built-in widow as a wife, working for my success morning noon and night. Just what Gala did for Dali all those years. While he was producing, she was on the phone setting prices and arranging dinner parties."[7]

RE-LAUNCHING THE DREAM WEAPON

Yet, even with such embittered quotes attributable to him, Gysin's work still provides one of the best templates for new and revelatory sound art – one in which the term 'experimental' art truly means art in which the creators have no advanced knowledge of the results, instead of the bastardized catch-all term meant to describe anything too 'weird' for the tastes of the populace at large. Certain of Gysin's artistic imprints – such as the whirling micro-organisms created by his fluid synthesis of Arabic and Japanese calligraphy (some Japanese-language skills were acquired when he was drafted into the U.S. army), and his gently chiding poetry recital voice – are signature elements obviously coming from years of refinement, keeping his art from ever sinking into the anonymity that most would-be 'experimental' artists inhabit. All the same, he achieved his most striking results by surrendering some part of the creative process to the whims of unknown entities. Commenting on this pure form of experimentalism, Peter Christopherson says:

"I never really know what 'x' is until I get there, so the process of reaching 'x' is always, in a way, the result of happy accidents. The tools nowadays (software in particular) are so complex that chance and randomness are always part of the process. For me the artistic process is ALWAYS a matter of ceding to another entity (not ceding control, exactly, but guidance for sure) – but what it is, or from where that comes, I can't describe."[8]

One of Gysin's most curious contributions to the luminous art underworld was not his poetry or painting, but a stroboscopic light device called the Dreamachine, intended as a 'drug free' hallucinatory aide which could be used indefinitely with no physiological side effects. The Dreamachine was little more than a paper cylinder a few feet high (though other materials such as copper have been used) mounted on top of a turntable spinning at 78rpm, and with geometrically arranged slits cut in the cylinder, through which the light of a single 100-watt bulb would filter and fall upon a viewer's closed eyelids. Unlike other proto-scientific inventions adopted by the counterculture (see Wilhelm Reich's Orgone box in particular), the Dreamachine was built on sound mathematical principles, mapped out by the mathematician Ian Sommerville, which would cause the light to flicker at a rate of 8-13 pulses per second, thus stimulating the optical nerve and simulating alpha rhythms in a viewer's brain. Varying accounts of the dreamachine's efficacy exist, as well as a host of unfounded urban legends (such as the device's contributing role in the shotgun suicide of alt-rocker Kurt Cobain) – but at the very least, it accomplishes the goal of being 'the first artwork to be viewed with your eyes closed'.

Panoramic dream visions or no, the colorful barrage of light that falls upon the viewer's eyelids is an alternatingly relaxing and stimulating thing to behold. With some meditative persistence, a hypnagogic state can occur where viewers begin to fish distinct images out of this ocean of strobing color, producing filmic sequences like those found in dreams, but without dreams' tendency to be totally forgotten upon waking. Gysin's enthusiasm for this device was great: its potential to liberate people from preset patterns of thought and action would have dwarfed anything accomplished by, say, the Situationists, and he once felt that mass-produced dreamachines could replace the television as the central fixture in the modern home. Despite the dreamachine's status as an icon of counter-cultural ingenuity, and a limited number of manufacturers, this would never came to pass, though – for reasons that the reader can probably surmise. Whatever the case, the dreamachine was like a 'kinetic art' attempt at realizing the same goals of the cut-up: bypassing waking consciousness in order to make artwork/life more vibrant, honest and revelatory. Like the shamanistic Tibetan practice of chöd, which attempted to destroy the ego by surrendering the body to the demons lurking in a charnel ground at night, these techniques forewent academic study and encouraged direct engagement with unknown (even hostile) forces as an alternative to conscious thought and reasoning.

Perhaps returning the favor to the younger generation he had helped to inspire, Brion Gysin recommended Throbbing Gristle's largely improvised live record *Heathen Earth* as, outside of his beloved Moroccan trance music, the ideal music for viewing the device. Gysin acolytes The Hafler Trio and Psychic TV would, in turn, record a CD with the intention of being used as dreamachine backing music, while numerous other lesser-known tributes and soundtracks exist.

To say Brion Gysin deserves sole credit for drafting the blueprint of 21st-century counter-cultural expansion would be false, but he has more concretely embodied its principles and methods than most of his 20th century contemporaries. By ejecting the quasi-Luddite fear of technology as a block on spiritual progress, and by merely becoming a 'doer' rather than a recorder of events, Gysin certainly lit a bright and mesmerizing torch to pass on to those working in other artistic media. Only a few were truly ready to have it handed off to them – although one of the willing recipients, Coil, ran with it to places maybe not even imagined by Gysin himself.

Dark Start

The musical constellation Coil was founded in 1982 by the late Geoff Rushton, who would become better known by his *nom de guerre*, John Balance (spelled 'Jhonn Balance' in later years.) A connoisseur of Throbbing Gristle, fanzine publisher (*Stabmental*), and all-around omnivore regarding any kind of esoteric information, Balance eventually took to music as a means of reconciling his celestial aspirations with the mundane realities of his youth: having grown up on RAF base camps in Germany and having been unceremoniously shuttled from one school (and consequently, formative social environment) to another, the then-Geoff Rushton suffered through an isolated youth made more uniquely strange by unexplained hallucinations and visitations – some hellish and some angelic. Claiming to have been partially "raised by mushrooms," the pre-teen Balance experimented intensely with psychedelics before having even sipped an alcoholic beverage, and was likewise inclined at an early age towards such sidereal activities as projecting himself into schoolmates' heads. Well-read and seasoned beyond anyone in his immediate peer group, it seemed unlikely that Geoff Rushton would fade into the background scenery without first delivering some missives from the parallel universe he inhabited – and so it happened when his fanzine writing put him into contact with Peter 'Sleazy' Christopherson. Christopherson, 7 years Balance's senior, describes his own background relative to his partner's:

"I did not have much spiritual awareness before the age of 10, when my parents decided to send me to a Quaker co-educational boarding school – rather than the tougher and more posh school I was previously destined for. I guess they reckoned (correctly) that I needed a gentler 'alternative' approach to my education. At Ackworth all the pupils attended Quaker meetings, during which one sits in silence and anyone (in theory) can stand up and contribute thoughts or ideas to the meeting. Learning the ability to sit quietly with one's thoughts, for an hour or so, is a great and wonderful gift – everything else flows from there."[9]

Although history will likely remember him for his Coil work first and foremost, John Balance contributed to a number of like-minded projects before his flagship project crystallized: Vagina Dentata Organ, Cultural Amnesia, Current 93 and his solo outing Merderwerkers all featured early contributions from him. While still in Geoff Rushton guise, Balance was also able to make good on his Throbbing Gristle fandom by participating in Psychic TV, alongside TG's Peter Christopherson and Genesis P-Orridge. That band's 1983 LP *Dreams Less Sweet* still stands as a high watermark of post-Industrial culture's eclectic abilities: the quintessential 'cult' album, it was recorded in Zucarelli holophonic sound and features such subversive gems as a choirboy recital of Charles Manson's "Always is Always," and words from the final sermon of Jim Jones (prior to the mass suicide of his followers in Guyana) set against a lilting backdrop of '60s pop. The incarnation of Psychic TV during Balance's involvement was a musical collective whose main aim was to examine and parody the power structure and indoctrination methods of such cults, and more 'professional' religious organizations as well (it was pitched by P-Orridge as the musical propaganda wing of his TOPY or 'Temple ov Psychick Youth.') Picking up more or less where Throbbing Gristle left off, early '80s Psychic TV was an iconoclastic hybrid dedicated to the Burroughs rallying cry of 'conflict creates energy.' The music itself was a mixture of the arcane and the futuristic (or 'techgnostic,' to borrow the term from Erik Davis.) It was moored by paganistic/ritual drumming, cut-up tape collages almost identical to those of TG, and a many-hued tapestry of electronic effects. Balance's most visible role within Psychic TV performances was as a performer on 'Chapman Stick' bass: a versatile stringed

instrument whose strings could be either tapped, plucked, or slapped – in Balance's hands it was used to generate a distinctive combination of wolfish growl and keening feedback. Ideologically, the band promoted overt sexuality and ecstatic noise as a means to destroying pre-set systems of social control – going so far as to suggest that exposure to certain types of noise could alter one's own genetic code. Another ritual involved combining three bodily fluids (blood, semen and saliva) and mailing them to TOPY – a wry poke at religious sacraments which was bought hook, line, and sinker by some of PTV's more humor-impaired fans. Although Balance would come to strongly disagree with Psychic TV's emphasis on the collective as creativity's driving force, rather than the individual, the inclination towards the orgasmic would show up again in Coil – sometimes manifesting itself in even more pronounced or more sublime ways than what Psychic TV had suggested.

The departure of Balance and Christopherson from Psychic TV marked the beginnings of Coil proper, as well as a long cooling of relations with Genesis P. Orridge. Both parties would fire shots across one another's bow in the years to come, with P. Orridge even blaming the Christopherson family's influence (Peter Christopherson's father was a former Cambridge professor granted a knighthood) for the infamous early '90s police raids on his home, and his subsequent tabloid status as "the most evil man in Britain." Fortunately for Coil, their decided emphasis was on building and refining their own work rather than on dismantling another's. The project name Coil was originally chosen by Balance for its seemingly inexhaustible multiplicity of meanings – just an association with DNA coils on its own would be loaded with meaning, provided their role in the development of all cellular life. Spiral galaxies are another point of reference, as are coiled serpents of wisdom, hypno-spirals and coiled electrical inductors which provide opposition to changing or varying currents. Choosing a project name with apparent connections to everything was only the first step towards the group's larger project of revealing the hidden order within chaos.

Coil are still one of the most celebrated acts in the post-Industrial scene, and not merely for their connections to its prototype artists. The band could have arguably cultivated the rabid fanbase that it now enjoys, even without its privileged position in the Industrial family tree, thanks to a breathtakingly unpredictable and varied body of musical work. Their *oeuvre* has ranged from hedonistic dance music to multi-layered synesthetic sound art pieces, with numerous stylistic deviations in between. The main reason for this may be that Coil has incorporated a far greater number of cultural (read: not only 'musical') influences into its eclectic mix than most would ever bother with. A single credits page of the booklet accompanying the band's *Black Light District* album serves as a perfect introduction to Coil's theoretical and artistic alliances – the literary anarchism of William Burroughs and Hakim Bey rests alongside the eschatological theories and 'self-transforming machine elves' of Terence McKenna. The gay camp film aesthetics of director Bruce LaBruce are acknowledged in the same space with the sidereal painting of Austin Osman Spare (ironically, an artist who was lambasted as a "Black Brother" by Aleister Crowley.) Other influences not mentioned on this list are no less important to Coil's output, such as the eternal drone of LaMonte Young, Karlheinz Stockhausen's hymns to 'Pluramon,' or Angus MacLise's solar invocations and transposition of Eastern mantra onto electronic instrumentation. From this collective pool of influences and memes came Coil's ability to shape-shift without seeming as if they'd gotten stuck in mid-transformation. Yet Coil is more than the sum of its parts: it is the confrontation between highly personal experience and this canon of underground ideas that makes Coil what it is; and makes for its richest sonic moments. Coil's Occidental origins, for one, are never completely subsumed by their interest in connecting the dots of the globe's occult currents. And if much of the band's work seems to have a 'dark' tinge, it is because, by their own admission, darkness – and not the pallid orange glow of tungsten streetlights – is necessary to see the stars.

Various Panics
Coil's music, at times, seems like it is having difficulty reconciling the lofty sophistication of spiritual ideals with the rapidly decaying world born out of unchecked materialism. They've made no secret of their disgust with the pervasive 'quantity over quality' aspect of modernity, shielding themselves

with mantras such as *"avoid that which is everywhere"*, and counseling the depressed to take a *"deep-rest"* in natural surroundings before relying on mass-produced panaceas. The indomitable, cyclical flux of nature is held up by Coil as being superior to humanity's constant striving towards definite endpoints and landmarks in 'progress', and to this end they have (like Brion Gysin before them) used the Greek nature god Pan as a sort of patron saint. Pop culture aficionados will also be familiar with Brian Jones' album *The Pipes Of Pan At Jajouka* (an encounter between Jones and Gysin in Morocco ended with the latter finding the former to be an arrogant, self-absorbed dilettante.) A biography of Pan in Harris & Platzner's *Classic Mythology* applies strikingly well to the music of Coil:

"Like nature itself, Pan creates both beauty and terror: with the seven-reed *syrinx* (panpipe), he produces enchanting music; he is also the source of unreasoning fear (panic) that can unexpectedly freeze the human heart. With his horns, hairy shanks, cloven hooves and lustful energy, Pan becomes in postclassical times a model for the physical shape of the Christian devil."[10] On the jacket of Coil's *Scatology* LP, there is a short text with the header *'I summon little Pan; not dead'* penned by John Balance, which outlines the beneficial possibilities of Pan's 'unreasoning fear':

"We are great believers in the redeeming powers of Kaos and confusion. Panic is about the deliberate nurturing of states of mind usually regarded as dangerous or insane. Using fear as a key, as a spur, as a catalyst to crystallize and inspire. It is about performing surgery on yourself – psychic surgery – in order to restore the whole being, complete with the aspects that sanitized society attempts to wrench from your existence...a murder in reverse."[11]

This is the preparatory text for an intense piece of guitar feedback, feral singing and head-slamming Linn drum machine rhythms also entitled 'Panic' – the condition known by the ancient Greeks as *panikon deima*. 'Panic' is one of the more immediately recognizable tracks on the original 1984 release of *Scatology*, which was the band's earliest long-playing attempt at reconciling the profane with the divine. As the band discovered to their dismay earlier, with the release of a one-sided record intended "for the accumulation of male sexual energy" (*How To Destroy Angels*), not everyone was entirely sympathetic to their methods of 'psychic surgery'. In fact, the very reference to male sexuality was, laughably enough, condemned as a 'misogynist' statement by some parties – the fact that Coil was a group of homosexual artists must not have been readily apparent. Such misinterpretation – if not outright alarmist fear – of the band's mere acknowledgement of what they were places them in a niche also occupied by contemporary artists and countrymen Gilbert & George, whose own comments on their work neatly mirror the *How To Destroy Angels* 'controversy'. From an interview with the subcultural journal *Rapid Eye*:

RE: One PC criticism of your work is that you don't include women in your work.

GILBERT: We are not politically correct.

GEORGE: Perhaps *too* politically correct. Actually we don't get much criticism from feminists, except the feminazis in America who hate gay men. Modern feminists should agree with us that we are not exploiting women. It became interesting because all over the world people started asking us about women. They never ask [English abstract sculptor] Anthony Caro about women. But we know nothing about women. Most other artists have used women's images for centuries, the art world is run by men.

RE: So, you're not objectifying women in any way...

GEORGE: Also, men are the sex women are the most interested in. The moment you exclude something in art it becomes important to people. We didn't even think about it.[12]

Never ones to capitulate or to let misinformed critics have the final say in anything, though, Coil merely upped the stakes – the packaging of the neo-Surrealist opus *Scatology* was graced by all kinds of blasphemies against the guardians of 'acceptable' sexuality and social mores. There's an excerpt of a pornographic story swiped from the pages of one *Mr. S.M.* magazine, tales of drug-induced religious visions, the obligatory Charles Manson quote, an excerpt from *The Selfish Gene* (Richard Dawkins' pioneering work on natural selection, and the origin of the 'meme' concept), references to "the clap – both the action and the affliction" and a confession by Salvador Dali that

moments of defecation give him the divine inspiration necessary for his 'paranoia-critical' method. All of this intellectually charged, defiantly heretical text is anchored into place by a black sun, an alchemical symbol that clarifies Coil's intentions of transforming shit into gold (also a symbol which bears a strong resemblance to the 8-pointed 'chaos star', another motif heavily used by the band.) From the simultaneously clumsy and grandiose opening instrumental 'Ubu Noir', to the crumbling and apocalyptic denouement 'Cathedral In Flames,' *Scatology* masterfully combines sonic elements both crude and refined, drawing uncomfortable parallels between the ethereal atmospherics of the church and the reverberations of the sewer. Murky production on some tracks meshes with moments of crystal clarity. Heraldic, regal brass parts collide into atonal flare-ups from guitar and John Balance's Chapman Stick. Numerous samples (played on a then state-of-the-art Fairlight CMI music computer) strive to harmonize with the disruptive howls, slurs and choirboy flourishes of Balance's vocals. The execution of this LP would be an unmitigated disaster in the hands of others, but not in the hands of rigorous occultists like Coil, who infuse a ritualistic quality into each individual album cut. The aesthetic inaugurated by Coil on this album would come to define their career-long *modus operandi,* despite their continual re-assessment of technique – in a way, it is a fulfillment of the much-touted Dionysian and Apollonian principles promised by rock music, but scarcely delivered. Coil convert Ian Penman, writing in *Wire* magazine, suggests that Coil's success lies in their refusal to embrace only cosmetic aspects of occultism, hoping that audiences will not call them on their bluff. He writes:

"If Coil were more archly/laxly rock-n-roll, I would doubtless be received in some be-scarfed den, black candles burning, tattoos all on show: all the surface paraphernalia. Such dilettantism probably explains why rock's would be diabolists have come to such grief – why they usually emerge hurt and chastened by the experience. Stubborn ego clings on to contaminate the work, which fails to progress any further than dark-knight affectation."[13]

If the music itself isn't sufficient to drive home the point, there is one final visual reminder of Coil's 'post-industrial alchemist' intentions. An iconic black and white photo on the record's inner sleeve, taken by Lawrence Watson, depicts Peter Christopherson and John Balance in a pastoral English setting, where the sight of cherubic Balance with darkened eyes and a frost-white sheaf of hair contrasts with a heavily-soiled, wild-eyed Christopherson (whose filth-smeared presence is made even more unsettling by his proper business attire.)

Scatology was one of the most coherent explorations of the Burroughs/Gysin aesthetic yet converted into audio form – a fact not lost on Burroughs associate John Giorno, who, in 1985, included the band on his Giorno Poetry Systems LP *A Diamond Hidden in the Mouth of a Corpse.* Yet even as Coil trumpeted the news of their iconoclastic existence to all adventurous enough to listen, death was not far behind – with the AIDS menace taking a personal toll on those close to the band, the post-*Scatology* phase of Coil meditated on death in a way perhaps too intense to be correctly interpreted by an ill-equipped music/'alternative' press. Shortly after their first LP release, Coil issued a crushingly spare, sorrowful cover of Soft Cell's "Tainted Love" (itself a cover version of Gloria Jones' Northern Soul ballad of the same name.) The deathly slow pacing of the song – practically an *a capella* by Balance, save for some tolling bells and orchestral hits – and the harrowing visions of its accompanying video were so extreme at the time, that they were taken to be a sick bit of *schadenfreude* concocted for the band's personal amusement. The threats and denouncements from gay activist groups would, in their refusal to go beyond surface level impressions, ironically equal the hue and cry raised by the conservative agents of morality who once called Throbbing Gristle the 'wreckers of civilisation'. For all the outrage, though, the record would eventually be recognized for what it was – the first real AIDS benefit record released by any artistic entity, underground or mainstream.

With the stark tone thusly set, the next full-length effort by Coil – *Horse Rotorvator* – was a brutal Coil-ification of the classical tone poem, a haunting song cycle produced astonishingly well with only an independent label's budget to work with. The album carried lyrical warnings such as *"you get eaten alive by the perfect lover"* and *"you must realize...that everyone changes, and*

everything dies", staring down inevitable doom in a way that, thankfully, eschewed fashionable Goth teases and aimless, maudlin moping. The inspiration for the album's title and cover imagery came from an IRA assault on a marching parade, a gory and surreal incident which resulted in horse carnage flying at the assembled spectators. The historical significance of this gruesome event was then overlaid by one of Balance's characteristic visions – of the Four Horsemen of the Apocalypse using the jawbones of their horses as a ghastly tilling device. The very lifeblood of the record is death, as well as the events leading up to and following it. From a lush musing on the filmmaker Pasolini's death at the hands of a rent boy, to a cover version of Leonard Cohen's "Who by Fire," *Horse Rotorvator* hardly blinks in the face of its unpleasant, yet all-enveloping subject matter. Its symphonic, cinematic allure is tempered with heavy doses of percussive battering and acidic Industrial squall – exemplified most disturbingly on the short 'bridge' of layered, terrified tape voices contained on "Blood From the Air". Slinky 'crime jazz' (supplied by Jim 'Foetus' Thirlwell) and strange snatches of distended brass only seem to reinforce the orchestral portions of the album, rather than distracting from them – suggesting again that Coil can montage with the best of them. In yet another grand stroke of irony, the LP finds Coil, as a musical entity, in full bloom even as they contemplate their extermination. Having mastered the application of the 'cut up' theory to music, the result was a professional product which, were it a conventional motion picture rather than one of the 'audio only' variety, would have been marketed as an epic tragedy rather than as an intellectual oddity.

Side Effects of Life

By the dawn of the 1990s, with the smiley-faced and pill-besotted rave culture promising a new communal, utopian current (the 'temporary autonomous zone'), there was a massive upsurge in the amount of ecstatic electronic music available on the market – but precious little of it attempted to, as Coil did, highlight the continuity between the giddy 'eternal present' of the culture with future speculation and with previous, more distant moments of illumination: namely, to *"see the future leaking through...see the person who once was you,"* as John Balance sang on the track 'Windowpane'. Techno producers of the late '80s and early '90s were initially refreshing for their willingness to operate in complete anonymity in order to further the cause, but too often were limited in the life experience which makes for truly timeless music. The rave community did indeed pride itself on youthful exuberance: it rejected the inevitable by-products of adult social life such as alcohol consumption, taking a "lest ye become as a child, ye may not enter the kingdom of Heaven" approach that favored pure light and sound over the prizes (marriage, home ownership, job promotions) occasionally found along the way during the phased march into the oblivion of conformity. The movement also seemed to be grasping at a more pure kind of spirituality than what was on offer in the urban (and suburban) sprawls of England and America: a church which served to temporarily pacify the unrest created by poor government and myriad socio-economic inequalities, rather than to offer any lasting, transformative experience. Like the increasing majority of television and print media, its motives were becoming insipid and transparent to even wet-behind-the-ears club kids, who sought to build their own euphoric tribal movement from scratch. The noted psychologist Stanislav Grof sums up the hopes of urban rave culture with an account of his first LSD-assisted self-analysis:

"Even in the most dramatic and convincing depths of the [LSD] experience, I saw the irony and paradox of the situation. The Divine had manifested itself and had taken over my life in a modern laboratory, in the middle of a serious scientific experiment, conducted in a Communist country with a substance produced in the test tube of a 20th-century chemist."[14]

Coil themselves were not totally dismissive of rave culture – Balance congratulated them on, at least, having formed a youth movement which replaced the escapism of hippies with the street-smart "suss" of the punks. This bass-driven Never-Never-Land could clearly have its merits, yet the sum total inexperience of ravers meant that their visceral music was rarely informed by intellectual rigor or by tested methodology. It is difficult to bring judgement down on those who did not have

the economic means to, say, travel abroad or to cultivate specialized skills whose application required years to learn. The worst exponents of the scene, though, got by solely on knowing the right passwords to the clubhouse and waving all the right emblems, while literally removing the 'science' from the colorful science fiction they were weaving. The ideologues of previous counter-cultures (Dr. Timothy Leary, Genesis P. Orridge) made cameo appearances as the 'grand old men' of pharmaceutical questing, but whether ravers took anything from their beat-assisted monologues other than a kind of 'parental endorsement' of their activities, cannot be easily verified. If Coil did not let this culture pass under their radar, it was perhaps because they noticed parallels between the new culture's variety of ecstatic dancing, and the ancient kind romanticized by Brion Gysin in Morocco. John Balance describes his initial positivity towards the rave as follows:

"When [dancing] happens properly, it's a liberation...and I've had a lot of revelations on it, I completely conquered my fear of death. I have a disturbing faith in human nature actually, now... maybe I am deluded (laughs.) Before I thought that the universe was sick, and that people were sick... and I've seen that it doesn't have to be that way."[15]

Yet while the foot soldiers of the rave-olution wielded glow-sticks and put in baby pacifiers to prevent their chattering teeth from grinding into dust (a common side effect of MDMA use), Coil injected their latest effort, Love's Secret Domain, with incantations lifted from William Blake (see the quotes of Blake's The Sick Rose on the album's title track.) The especially subversive sampling and vocalizations on the album did what few bedroom techno producers dared to do: leavening the rolling technoid bliss with admissions of fragility and, in direct contrast to the psychedelic egotism often embraced by 'instant gratification' youth drug cultures, the seeming indifference of the universe to see any individual organism as its center. "Man has given a false importance to death", intones a genteel, sampled voice over tight piston-pumping rhythms and ambient swells, "every animal, plant, or man that dies adds to nature's compost heap". Meanwhile, hitherto unexplored sonic juxtapositions mark the record as another link in Coil's chain of unpredictable releases: 'Teenage Lightning' makes use of vocoder-aided voices over Latin rhythms and flamenco guitar, while one of the few recordings to successfully combine throaty didgeridoo and robotic Roland drum patterns pops up elsewhere. A gorgeous string arrangement even surfaces as an interlude between slabs of electronic mayhem. Impossible to pigeonhole as a 'techno' album, it is really an example of 'Coil' becoming a category of music unto itself.

Despite its purely technical innovations, the record has achieved an over-simplified reputation as being the Coil 'drug album' – the track 'Windowpane' of course references the LSD variant of the same name, while the acronym spelled out by the three words in the album title will be obvious to just about anyone (as will the acronym contained in the "Answers Come In Dreams" remix of the strobe-lit masterpiece "The Snow.") This may seem to come into conflict with the later Coil slogan of 'music to take in place of drugs', yet the band's chemical enhancement during this period was no trifling thing either. John Balance recalls:

"...we started [Love's Secret Domain] in January '87, and then in February '87 we went out to a club, and it took us 6 months to recover from that visit, and we had to start again. Each time we do some recording, we tend to get involved in, uh, mind-altering experiences of one kind or another, and our minds are so altered that when we come to record again, it means something different."[16]

Chemically-guided recording sessions were apparently the norm for the 'LSD' era – Peter Christopherson claims that "we made the studio sacred and then blasphemed it" – although this was to be the apex of Coil's experimentation with chemical intake, as John Balance confesses:

"Personally I found that the path of excess leads to the palace of excess, and to insecurity, neuroses, a profound disillusionment with almost everything, and an insurmountable depression. I have never been one to do things by halves, and I have suffered as a consequence of my youthful adventures with the Left-Hand Paths."[17]

If Balance harbors some regrets for his dissipation into narcotic limbo, he is especially embittered about the side effects of the legally sanctioned pharmaceuticals meant as an alternative:

"I wish I had never gone onto antidepressants. They were a nightmare to come off of and my doctor, along with nearly all the medical industry, seems to want people *on* the fucking things."[18]

Echoing Balance's thoughts on these subjects, Christopherson states:

"I am not a fan of the pharmaceutical industry, and do not recommend un-informed acceptance of advice by it, or by the medical profession in general, especially when it comes to soporifics. I don't think the trend towards popularity (or rejection) of drug use is very culturally or artistically important. People who repetitively use cocaine or Ecstasy for example, are not learning anything or creating anything original, they are just burning themselves up, and causing uncontrolled flows of money that bring about all kinds of damage to economies – and hence uninvolved people – around the world. On the other hand, I do believe the use of some psychedelics can open doors for artists to new perceptions that could impact our destiny."[19]

Christopherson's attitude towards soporifics extends to the musical variety as well, which may mark the distinction between the industry-sanctioned varieties of dance music and Love's Secret Domain: by Christopherson's reckoning, the former was intended to reduce though, while the latter was meant to increase it.

Wounded Galaxies Tap at the Window

By the mid 1990s, it was becoming obvious that, as Tactile's John Everall notices in a personal appreciation of the band, not *that* much was new under the black sun: recent notable innovations, like Scanner's blurring of private and public space with recordings of pirated phone conversations, were eerily similar to the audio voyeurism of Peter Christopherson's street recordings for Throbbing Gristle and Coil. Rising electronic artists of the time, like producer/sci-fi writer/cultural theorist DJ Spooky (a.k.a. Paul D. Miller) were able to perform regional variants on what Coil had done – in Miller's case, melding a distinctly Afro-American futurism and mytho-poetic approach with cross-generational collaboration involving titanic figures like Iannis Xenakis. Positive developments also occurred in the ambient music realm, where projects like Mick Harris' Scorn took the rhythmic structures of hip-hop and dub reggae, and had them sucked into some negative universe, inverting the bland 'chill out' nature of much ambient music into heightened tension and an unnerving sense of premonition. Scorn was, incidentally, one of the chosen few to be graced with a Coil remix of their work, and also one of many such projects to be saddled with the silly "isolationist ambient" designation – a scene shadowed in no small part by Coil, who were proving to be increasingly influential despite a genuinely reclusive character. In fact, Coil were fast becoming the toast of the entire electronic music spectrum, forging bonds with the likes of Industrial dance heartthrob Trent Reznor as well as asymmetrical beat scientists Aphex Twin and Autechre – they were now the perennial act that everyone had heard *of* but never actually heard. Meanwhile, as the 1990s "electronica" boom upgraded to a full-blown glut, more and more musicians took to the wholesale re-think of mass media apparatus, as if Industrial culture had not happened at all: with a new breed of musicians seemingly hellbent on providing a Cliff's Notes version of the lessons already taught by artists like Coil, the only option for them was to once again divorce themselves from the fleeting, the temporal – and, in the case of their ELpH project, from Earthly communication itself.

When Coil titled the double-10" record set by their pseudonymous project ELpH as *Worship The Glitch*, few probably could have predicted that "glitch" would become the watchword for any pre-millenial electronic music using the breakdown of technology as its primary 'instrument'. The existence of technology presupposes the existence of accidents, although, as this singular form of music shows, not all those accidents have to be synonymous with ugly catastrophe. In retrospect, *Worship The Glitch* may have had the misfortune of being released in the same year as Oval's landmark *Diskont 94* album on the Mille Plateaux label – Oval's Markus Popp is, to the present, one of the names most commonly associated with "glitch" as a method and movement: Popp's basic approach was to create woozy and melancholic instrumentals from montaging the music contained on scratched CDs (a habit which he eventually tired of, going on to make purely 'hands off', generative music with his *Oval Process* software.) While it is tempting to draw parallels between

both Oval and Coil for their refusal to be the heroic 'protagonists' of their own music, and to let a certain degree of 'the unknown' filter through, the two do not share a common *raison d'être* – much of Coil's work has been predicated on something like Crowley's motto *"the method of science – the aim of religion,"* while Markus Popp humbly shrugs to *Haunted Weather* author David Toop "I just want to make a contemporary statement."

As Popp was laying out a new theory of user interfaces, Coil was hearing – and feeling – extra-terrestrial presences in their musical equipment, sensing that other entities were 'playing through' them at the time certain functions of their electronic gear seemed not to be working. The exact nature of the equipment and its faults is vague, even clandestine – although Christopherson hints in one interview about being intrigued by the sound of an Eventide harmonizer choking up. All the same, the results are suitably otherworldly, with highly disorienting panning effects and odd changes in the audio's depth of field predominating. Flitting high-frequency sounds zoom in and out with a Doppler effect added, and overall the pieces feel not so much like 'songs' as inter-species attempts at bridging a communicative gulf: they needle away at one's perception in the same way a Morse code transmission might, before abruptly ending. One track entitled 'Opium Hum' is especially beautiful in its peculiarity; the buffering function of some digital studio tool failing as a mournful alien melody taxes the machine's available memory. If *Worship The Glitch* is not regarded as one of the 'canonical' Coil albums, it is definitely one of the most intriguing and unusual. And given the enthusiasm of mentors William Burroughs and Karlheinz Stockhausen (an 'honorary member' of Coil) for reaching into space and eventually ridding mankind of his terrestrial shackles, the ELpH project carries on a grand *kosmische* tradition of sorts.

The last ELpH recording to date is their contribution to Raster/Noton label's award-winning *20 Minutes to 2000* series of CDs, meant to usher in the new millenium – titled *Zwölf* (a polyglot play on words, with the German being *elf* being 'eleven' and *zwölf* being 'twelve'), it is something like a protracted alien birdsong combined with the droning sound of some malevolent supercomputer learning how to hate. In light of the terrifying birth pangs that have so far characterized the 21st century, it is especially eerie to think this may have been composed in part by a celestial being with knowledge of things to come. Or, it could just be Coil having a laugh at the expense of those inclined to make these connections: Coil, after all, did not recognize the Christian calendar as valid and consequently did not view the rollover into the year 2000 as a 'new era' in human history.

Some Cures For Time

"The idea behind the drone state of mind is that, by using my sound environments, you can set up a pattern of harmonically related impulses. The environments are created with harmonically related sine waves that produce periodic composite sound waves. The resulting impulses make a periodic composite waveform that flows through the ear, and is relayed through the neurons and up to the cerebral cortex where, if it's a constant sound, these patterns become continuous [...] If you have this drone state of mind as a point of reference, the mind then should be able to take elaborate flights of the imagination to faraway and very specialized places that it has probably never been to before."[20] (LaMonte Young)

As Coil inched closer towards an arbitrary place-marker in human history that probably had less relevance for them than the coming of, say, the Aeon of Horus or a date on the Mayan calendar, they likewise ignored the trend towards hyper-complexity that ran rough-shod over the ecology. With new cultural fusions sprouting from the sidewalks of Tokyo and New York on an almost weekly basis (to say nothing of cyberspace) an accelerated groping for a collective cultural identity was taking place – but the result was, more often than not, an inconsistent rag-bag eclecticism or a profound shallowness. Style tribes and micro-variations in design and musical expression came and went with depressing regularity. Unprecedented access to satellite broadcasting, the Internet and mobile telephony only seemed to reinforce people's ability to 'say nothing loudly', often overshadowing the valuable role it *did* play in connecting marginalized peoples from around the

globe. Meanwhile, whistle-blowing media theorists like 'dromology' expert Paul Virilio became more in demand to make sense of the reckless velocity at which all this was happening. Coil did not necessarily 'pull the plug' on all things new, shiny and convenient, but they did step far enough outside of the madding crowd so as to not be as dramatically affected by it. One obvious step was to abandon London for the seaside. Another was to strip their music to the bone so radically that it inverted the common ratio of 'content' to 'message': rather than composing pluralistic mash-ups which showcased prodigious editing skill, Coil began to rely on the simplest aural artifacts to open gateways to other dimensions.

Even an approach based on stern minimalism or drone could manifest itself in a number of ways, as Coil antecedent LaMonte Young had already demonstrated with his "theater of eternal music". One product of Coil's drone-based period was the bracing *Constant Shallowness Leads to Evil*, one of the harsher examples of their 'trial by music' phase, Movements with titles like 'Lowest Common Abominator' and 'Freebase Chakra' coalesce into a banishing/purification rite carried out primarily with analog synthesizers and vicious electronic distortion; a cyclical instrumental assault on those citizens of the 'global village' whose misuse of everything from drugs to laptop computers has caused them to devolve rather than to gain any higher realization of themselves: *"color, sound...oblivion"* Balance growls in an indictment of uninformed hyper-stimulation and easy access. In a blatant mockery of the instructional labels carried on bottles of prescription painkillers, the CD also includes a warning not to use while operating heavy machinery or driving.

The compositions on *Constant Shallowness...* would end up being the rough schematic for the music on the first-ever Coil concert tour, which compounded the wrathfulness of that release with 15-minute fusillades of strobe light, huge video projections of wheeling, *yantra*-like symbols, and torrential rains of electronic noise. The band members were outfitted in costumes that gave them the appearance of institutionalized lunatics escaped from some prison spacecraft orbiting the Earth: Balance looked especially unsettling in a reflective designer straitjacket with blood dripping from his shaven temples, an effect that would have impressed even such celebrated madmen as Antonin Artaud. Needless to say, this aura was lessened none when Balance hurled objects at a 'thunder sheet' in the midst of a free-form electronic tsunami, or hurled screams and shouts at the bewildered spectators: it is difficult to tell from hearsay and video evidence alone if this 'concert-as-exorcism' routine was more physically draining for the performers or the audience.

Whereas *Constant Shallowness...* exorcised, the two volumes of *Musick To Play In The Dark* healed using a new 'lunar' technique: dubbed 'moon musick' by the band, the two volumes (released in 1999 and 2000) are among Coil's most critically acclaimed material, weaving together more arcane and state-of-the-art techniques in two discs than most recording artists will attempt in the span of a career. Subject matter for songs ranges from Balance's taking stock of his unwanted obsessions ("Paranoid Inlay"), to alien interventions ("Tiny Golden Books"), and the musical composition follows suit: twittering machines formed from digitized clicks and pops, alien birdcalls, lonesome refrains played on an Optigan 'optical organ', every conceivable tone color of analog synthesizer from sepia-toned to glimmering silver. On the lunar devotional ("Batwings – A Limnal Hymn"), Balance – like Robert Wyatt on *Rock Bottom* – sings in a language of his own invention over a palpable set of descending sine waves. And even as Balance whispers "the key to joy is disobedience" beneath the synthesized tumbling of glass beads that opens the track, there is a remarkable restraint to it all. The release of these albums also gave Balance a personal platform from which to discuss ideas related to the earth's sole natural satellite: he advocated returning to the Mayan calendar and its 13-moon cycle (as well as its inclusion of a single 'nameless' day in the calendar year), and decried all forms of light pollution. The latter was one thing that largely went unnoticed by the Jeremiahs of global warming given the most 'face time' in the media, who focused their energies on recycling plastics and reducing carbon dioxide emissions. Balance, in contrast, was an avid campaigner for reducing the amount of artificial lighting, claiming that it actually made people in populous cities less secure (what car thief would try to steal a vehicle he couldn't even see in the first place?) The function of darkness was, for Balance, analogous to the enforced silence

Christopherson experienced during his schooling at Ackworth – a necessary screen upon which to project one's inner thoughts and to confront them. By this logic, the pseudo-Christian effort to light up the world was tantamount to insanity.

Just as the black sun symbol embodied certain aspects of Coil's *Gesamtkunstwerk* early on, the monad glyph of John Dee – English occultist and advisor to Queen Elizabeth – was the symbol emblazoned on the Coil banner during their final creative phase. Dee was famous for his use of mirrors as 'scrying stones', an activity which would be taken up in the Beat Hotel of 1959 by Brion Gysin and William Burroughs, who hoped to see past incarnations of themselves during brutally prolonged mirror-gazing sessions. The monad symbol, introduced in Dee's work *Monas Hieroglyphica*, does the same for the late-period Coil: used frequently in live projections during the band's concerts, in promotional photography, and appearing also on the artwork of the *Time Machines* release, the monad is a symbol unifying all the raging currents which have run through Coil over the years – if nothing else, two of its component parts are a solar symbol and a lunar crescent. There is also the astrological symbol for Jupiter, indistinguishable from modern 'first aid' and medical crosses, and a wavering line of fire beneath that. Dee himself never fully disclosed the ultimate significance of this hieroglyph, and his writings on it were seen merely as an introduction to a more detailed description that he would give when coming face to face with adepts. So the symbol is also in keeping with Coil's belief that some things are meant to remain secrets until the conditions for their revealing are right – to quote William Burroughs, "just knowing a *fraction* of the secret of the universe would have you climbing up the walls."

The monad hieroglyph takes on a deeper meaning, as with all Coil's symbology, when applied to the sounds on the *Time Machines* release – it is a set of 4 electronic drones, in themselves conforming to the musical definition of a monad (a single note or pitch.) These four tones, which span almost the entire 74 minute duration of a compact disc, have been designed "to facilitate travel through time." To aid this process, the album comes with a set of four image stickers, each one printed with one of the four component parts of the Dee glyph on a brightly colored background. The images, as deceptively simple as the sounds on the album, combine hermetic knowledge with modern pharmacological science. Beneath each one of the brightly colored images, the name of a powerful, if sometimes obscure, hallucinogen is written: DMT, psilocybin, DOET (a.k.a. Hecate) and Telepathine. Printed on the inner sleeve of the album is the slogan *persistence is all*, which would seem at first to be a gentle warning insulating listeners against disappointment – obviously there will be those who expect instant 'mind-blowing' gratification and immediate time-warping effects. Viewed in light of Coil's past influences (*Perdurabo* or 'I will persevere' was another magical motto of Aleister Crowley), it is another attempt to re-introduce such ideals into an era short on patience and long on insubstantial distractions.

The last of Coil's more "conceptual" releases was realized in 2004 – a triple CD and DVD box set entitled ANS. All the enclosed audio works were performed on the monstrous photoelectric synthesizer of the same name, built by scientist Evgeny Murzin, kept at Moscow State University and named in honor of the ecstatic Russian Symbolist composer Aleksandr Nikolai Scriabin (1872-1915.) Scriabin was known, like Coil, for a rich tonal vocabulary and for his immersion in the pantheistic and the esoteric – his connections to Madame Blavatsky's Theosophist circle being one prime example of this. His enthusiasm for the apocalyptic also shone through in his unfinished composition *Mysterium*, a symphonic work performed to be by an orchestra in an Indian temple and basically intended to usher in the end of time. His *Poem of Ecstacy* was another philosophically-informed symphonic work meant to the triumph of the (artistic) will, while his experiences with synaesthesia led to the scoring of works for the *clavier à lumières*, the 'color organ' developed exclusively for the performance of his *Prometheus: The Poem of Fire*. As the keyboard of the *clavier à lumières* was played, colors corresponding to the notation were meant to be projected onto a screen in the concert hall – it was this basic concept that inspired the construction of the ANS unit, and which attracted composers like Edward Artemiev and Alfred Schnittke to have a go at utilizing the machine's uniquely spectral sounds. When handed over to Coil, the results are supple and

singular as could be expected – the set of DVD visuals by Christopherson attempts to add the synesthetic component to a program similar to the one inaugurated on *Time Machines*: a protracted yet effective dive into a pool of slowly moving, concentric electronic ripples, which tame the raging mental flux and allow one to omit needless thoughts. Those who have been spoiled by Coil's excursions into songcraft (circa *Horse Rotorvator*) will tear their hair out in dismay when confronted with *ANS'* enforced minimalism – but they may be missing the point entirely, as well as betraying a lack of knowledge about the numerous mystical traditions that neutralize intensified emotions, immediate impressions and misleading passions by means of such meditative sounds. 'Returning to the purity of the current' was yet another of the suggestive slogans issued by the band, and the synesthetic ambitions of *ANS* and *Time Machines* are nothing if not pure.

+++++++

With just one major career compromise, Coil could have easily slipped into wider acceptance. As it stood, though, they were too firmly rooted in queer culture for the heterosexual Industrial and 'dark ambient' orthodoxy. They were too taken with the mystical and the hermetic for those trying to connect abstract electronic music with dry, obscurantist philosophical concepts. They were too fond of the redemptive qualities of abrasion to sit well with docile New Age adherents. And if a quick browsing of online CD reviews is anything to go by, projects as diverse as 'How To Destroy Angels' and 'Time Machines' tended to infuriate as much as they illuminated. When representatives of the major league media came knocking, it was to kill the band with kindness: one wince-inducing BBC documentary lauds the band for being like "lovely aunties" while giving the impression that the many-faceted band has a library composed of nothing but grimoires and Crowley biographies.

Happily for their die-hard listeners (a skimming of Coil-related Internet message boards indicates that there may be no other kind of Coil listener), no real creative compromise was ever made. The same talents that Peter Christopherson applied towards programming Coil's equipment and overseeing their albums' sleeve design were also funneled into various lucrative day jobs, such as music video direction and the composition of advertising jingles. This allowed Coil to achieve an enviable level of creative autonomy, despite having to simultaneously weather the typical accusations of having one foot planted in the consumer mainstream and one in the underground. As unromantic as these gigs might have been to the more starstruck and idealistic Coil followers, their regular presence finally allowed Coil to sever connections with deadbeat record labels and distributors, and allowed the world to 'come to them', as it were – by the end Coil was selling their material almost exclusively through mail order. Some items in the Coil mail order catalog were also of such an intimate nature that stocking them in retail outlets seemed out of the question: there was the special "trauma edition" of *Musick To Play In The Dark 2* smeared with Balance's blood after a psychotic episode, and "beast boxes" of the Coil live *oeuvre* hand-painted in an ectoplasmic fashion. Perpetuated partially by the mania of the band's own fans, and partly by the band's own desire to 'bless' their final product, raising them from lowly merchandise to functional totems, each new release seemed to have a corresponding *objet d'art* edition. With this in mind, keeping a complete record of the band's discography is a perplexing hobby that one enters into at their own risk.

Coil's success, whatever level it may have ultimately ascended to, was curtailed when John Balance died of injuries sustained from a fall in autumn of 2004. In light of Balance's erratic mental health and relapses into heavy drinking, along with a string of lyrical predictions, it seemed sadly inevitable: Balance sang that *"most accidents occur at home"* (he was home at the time of his death) on one of the final Coil tracks, and *the* final Coil track to be performed live was "Going Up" – a re-working of the "Are You Being Served?" theme which, when associated with Coil, was almost certain to be taken as a musing on death or dissipation into the ether. The original song's quirky

cataloging of material goods, recited while ascending a department store elevator, has, in this context, been re-interpreted as the shedding of material commitments accompanying death, the last in a series of trying purifications. In his final few years, John Balance's vacillating dispositions gave rise to a host of apocryphal tales, vengeful gossip, and the requisite clever winks about how he failed to live up to his stage name – it is difficult to sift the truth out from the well-crafted smear jobs, although one fact, confirmed by those closest to the Coil camp, is the mental toll that the 'live' Coil era took on the often hesitant artist. Not all of Coil's live performances lived up to the grueling standard set by the *Constant Shallowness...* shows, in fact Coil concerts – as their recordings might suggest – served up a full complement of stylistic variations, from sweet nocturnal balladry to demonic noise avalanche. Yet the amount of psychic energy expended by the enigmatic vocalist was greatly out of proportion to what audiences actually perceived – few people, let alone people with the sensitivity and awareness of a John Balance, transition smoothly from lengthy periods of enforced solitude into a public arena as demanding as that of the concert tour business. Balance's terminal discomfort underscored the difference between Coil and those who cleave to music for purely financial and egotistical reasons – the pressures would result in a few Balance-less Coil performances (at high-profile events like Toronto's Mutek festival) and the end of Balance's relationship to Christopherson as a life partner.

Like Brion Gysin, Christopherson has now cut himself off from the drab and paranoiac fundamentalism of West, 'going native' in a culture in which he claims daily life is intertwined with magical happenings. It also provided a necessary reprieve from recent trauma – in a 2006 interview, he states:

"At the time – Spring 2004 – living alone with Geff (who was going though a 'bad patch' – screaming, passing out on the rocks, pissing and shitting the bed etc.) in the cold and draughty North Tower building, with the rain beating in from the sea onto cracked windowpanes with bits of Geff's hair in the glass where he had smashed his head against them, it was a comforting fantasy for me to imagine a different life where I was waited on hand and foot by beautiful brown skinned houseboys, who would do anything I asked of them, and take care of my every need..."[21]

As a resident of Krung Thep/Bangkok, he has had access to, and documented, deeply ingrained aspects of Thai culture rarely seen by Western eyes – one such example is his film of the GinJae festival, in which entranced youths submit to acts of ritual bodily piercing in order to ward off evil spirits. His newer musical work as the Threshold House Boys' Choir (and, more recently, Soi Song with Ivan Pavlov) is the soundtrack to such, fittingly enough, threshold moments. Christopherson now also identifies himself as a Buddhist, because "the basic tenets and precepts seem to make the most sense to me – but also because I cannot help being moved by the passion that even the sleaziest or unlikeliest of street boys has for [Buddhist] spirituality."[22] He continues to be active maintaining Coil's vast back catalog (which may be converted over to BluRay format by the time this sees print), participating in a limited number of engagements with a re-formed Throbbing Gristle, and cultivating a Pan-infused creativity spanning nearly all the available electronic media. If the growing number of 'tech-gnostics' prove to be the 'winners' who write history, then the work of Christopherson, Balance and valued accomplices will be spoken of in the same breath as that of ambitious mages like Kenneth Anger or Harry Smith. That is to say, works which use all methods available to unveil the contradictions of human existence, and to aid personal advancement by acknowledging and overcoming them. Reflecting on his part in this ongoing struggle, Christopherson concludes:

"I certainly feel that the music of Coil was 'informed', and reacting to, as yet unfulfilled & inevitable events... if we were able to lighten our own load, and in doing so, perform a similar service for others then it was worthwhile."[23]

ELECTROVEGETARIANISM:
AN ABRIDGED HISTORY OF MERZBOW, FROM BIOMECHANIC TO BIOPHILIAC

It's an early hour of the morning within the futuristic, jet-black citadel on Osaka's Dotonbori River known as Kirin Plaza. The imposing black fang of a building is often given over to multi-level art exhibitions and live performances, courtesy of the Kirin beverage company's generously deep pockets. The theme for the day, from 11p.m. on to 5a.m., has been 'Op Trance', a lively celebration of optical art's convergence with modern sound art. It seems like a fairly foolproof concept, given the high amount of synesthetic crossover between the two scenes: the deep striations, concentric circles and other serialized patterns favored by 'Op' artists, along with the fearless deployment of intense brightness and contrast, mesh neatly with the working methods of the post-digital sound art milieu. The crisp syncopations and circular, generative sounds being emitted by the host of DJs and laptop-wranglers on hand at Op Trance is a near-perfect compliment to the retina-blasting visual exhibits, among them an entire floor painted in fuschia and lime-green faux camouflage, and multiple sets of strobe-emitting goggles.

In this context, a performance by Merzbow, the Japanese noise scene's ambassador to the world, seems both appropriate and unusual at the same time. It's appropriate in the sense that Masami Akita, Merzbow's guiding force, is a cultural polymath who certainly knows and appreciates

the relevance of Op art in the grand scheme of things. Plus, stunning Op artworks grace the covers of multiple Merzbow CDs: there's the almost mouth-watering procession of undulating black and silver waves on the cover of his *'Pulse Demon'* CD (practically an homage to the work of Op goddess Bridget Riley), and the engraved, foil-stamped pond ripples of the similarly-minded *'Mercurated'*, to cite just a pair of examples. Yet, in spite of all this, it seems somewhat strange that a sound project named in honor of Dada artist Kurt Schwitters' infamous junk monuments would find a kinship with the more structured and geometric parameters of Op art. The similarities are there, though, if one looks beyond the relative rigidity of the working methods: the true unifying factor between Op art and Akita's often formless torrents of sound is not to be found in their respective production techniques, but in the undeniable impact of the results. Just as selected Op pieces warp, 'breathe'/undulate and even cause vertigo under concentrated viewing, submission to Merzbow's noise can bring about aural hallucinations and ephemera that are not included on the recording proper.

Merzbow's concert at the Kirin Plaza certainly delivers the goods as described above, despite him having to follow a succession of crowd-pleasing techno DJs, who are milking the usual 4/4 tempos and wavering, arpeggiated basslines. The clinically calm, poker-faced Akita, with a few gentle brushes of his fingers against the track-pad of his G3 laptop, proceeds to turn the generously loud house P.A. into a set of blaring rocket thrusters. The sweat-soaked audience, already pliant, submissive, and dehydrated after hours of dancing in close quarters, can do nothing but sit back and have their remaining defenses stripped away by the steadily multiplying swells of chthonic sound. A seductive loop of sub-bass frequencies opens the set and then, after a few minutes, in comes the familiar rush of white noise: a bracing sound that brings to mind both the single-minded, relentless determination of mechanical and natural processes, bypassing the clumsy ambiguities of human endeavor. It is like a chorus of jackhammers vying for attention with the roar of a nearby waterfall: a perfect aural summation of the conflict between post-modern man and primordial nature. In the most immersive moments, this sound's effect is that of reaching ecstasy through negation – and by Akita's own admission, the music of Merzbow is inspired by negating all but the most intense motifs of popular music, then systematically piling them one on top of the other. This applies especially to popular music already inclined towards psychedelia or altered states: the rainbow feedback of Jimi Hendrix' guitar without his reassuring melodic structures, or the Dionysian proclivities of Jim Morrison minus the cod poetry and rambling monologues. Touches as unexpected as the 'fuzz organ' of Soft Machine's Mike Ratledge also provide partial inspiration. The side that Merzbow personally takes in the 'man vs. nature' conflict will be disclosed soon enough – but for the moment, as the P.A. speakers throb and shiver under Akita's withering assault, none of this really seems to matter. To attempt any analysis of the sound while still in the thick of it seems totally counterproductive – better to let the cascade of beneficial abrasions just wash over you, and see what comes of it.

Merzbow, one of the most immediately recognizable names in the Japanese underground, takes its name from Swiss Dada artist Kurt Schwitters' monuments of discarded objects known as *Merzbau*. The *Merz* from which these buildings were constructed bears an orthographic similarity to the French *merde* [shit], likening things such as used bus tickets and trampled newspapers to a kind of fecal matter 'excreted' by the urban landscape. Akita's project has existed in some form or another since 1979, although the signature sound described above wasn't arrived at until the mid-'80s, and only by the 1990s was there enough of an international infrastructure to really make Merzbow a household name. The names Masami Akita and Merzbow are, by now, virtually synonymous: the ironically soft-spoken, tranquil man, with his obsidian mane of long, straight hair and wire-frame glasses, has been the only constant member of Merzbow from its inception to the present day. Others have come and gone – most notably Kiyoshi Mizutani and fellow multi-disciplinary artist Reiko Azuma. A host of collaborators have also participated with Akita in that staple of underground communications, the 'split' release – with an album or single side given over to each artist. Akita has been a prolific writer on the arts, music, erotica and esoterica, with articles on emerging subculture appearing in publications like *SM Sniper*, *Studio Voice* and *Fool's Mate* (a

hip alternative monthly throughout the '70s and '80s, but now almost exclusively devoted to the goofy spectacle of 'visual *kei'* – an ultra-androgynous strain of heavy metal-inflected Japanese pop.) His development of the Merzbow aesthetic ran parallel with a series of investigative books that catalog a vast amount of subculture and counterculture. Books such as *Scum Culture, The Anagram of Perversity, Terminal Body Play* and, of course, *Noise War* helpfully explain and 'collect in one place' the most hermetic types of music, sex practice and autonomous creativity to a fairly conservative (but not always close-minded) Japanese audience. For those who are interested, the Tokyo publisher Seikyusha has the majority of these available in lavishly designed hardback editions. Akita's books, in terms of their subject matter, feature a generous amount of overlap with other influential subculture journals of the '80s and '90s – see especially the *RE/Search* and *Rapid Eye* collections. Akita's books function more as an information service, or outright advocacy of imaginative exploration, than as cultural criticism. This is not to belittle his writing efforts, though: the process of distilling such a massive amount of information in the pre-Internet days did require a high level of dedication.

Still, Akita's books are published exclusively in Japanese, and even his growing number of paintings and photographs are not widely exhibited. it is the Merzbow sound which has made the most visceral impact on those willing to receive it, and it is that to which we now turn our attention.

Antimonument

"What still keeps that vitality, even if passive, may be primitive art or the art created after Impressionism. These are things in which either, due to skillful application of the paint, the deception of the material had not quite succeeded, or else, like Pointillist or Fauvist, those pictures in which the materials, although used to reproduce nature, could not be murdered after all. Today, however, they are no longer able to call up deep emotion in us. They already belong to a world of the past. Yet what is interesting in this respect is the novel beauty to be found in works of art and architecture of the past which have changed their appearance due to the damage of time or destruction by disasters in the course of the centuries. This is described as the beauty of decay, but is it not perhaps that beauty which material assumes when it is freed from artificial make-up and reveals its original characteristics? The fact that the ruins receive us warmly and kindly after all, and that they attract us with their cracks and flaking surfaces, could this not really be a sign of the material taking revenge, having recaptured its original life?"[1] (Jiro Yoshizawa, *The Gutai Manifesto*)

While Akita's writing was mainly a straightforward journalistic investigation of controversial material, his sound was steeped in severe abstraction from the outset. The earliest Merzbow releases were made available on his 'Lowest Music And Arts' label, which morphed eventually into the more internationally-minded 'ZSF Produkt' (which featured non-Merzbow contributions from the likes of Controlled Bleeding, Kapotte Muziek, The Haters and domestic stalwarts like KK Null.) While fans of "real music" will likely disagree, these ventures into the netherworld of home cassette production and mail art were some of the most radically uncompromising outlets for independent Japanese music since the URC [Underground Record Club] soundtracked the 1968-1969 student revolution at Tokyo University. Unlike URC, though, both the "Lowest..." and ZSF labels steered clear of any political soapbox, allowing the albums' autonomous distribution, utilitarian artwork and ragingly loud, coarse contents to speak for themselves about what kind of lifestyle the artists might prefer in place of the present system.

Early Merzbow outings were fittingly described as 'assemblages', and had more in common with the elusive, narrative maneuvers of *musique concrète* than with the electro-metallic overdrive of later years. The finished products were not just 'assemblages' in the musical sense, but in the theoretical sense as well, calling on the ideas, attitudes, and code words of virtually any 20th-century anti-establishment art movement fortunate enough to have survived total obscurity. Merzbow of this period was built up from a rich sonic vocabulary of scrapes, clangs, thuds, sandpaper abrasion and muffled explosions, all treated with varying levels of delay, distortion and reverb. Radio broadcasts and disembodied voices from tapes, all coming under the Merzbow

blowtorch in some devious way or another, also added texture and colorful confusion. Imagine if Luigi Russolo and his compatriots were given free rein to use the subway stations of New York City, Tokyo or Berlin as recording venues on a nightly basis – they might have come up with something like this.

Persistent listening to this music will be rewarded by amusing visions of garbage cans being overturned and dragged through the street, motor vehicles running amok, or maybe even a situation like the kind driving J.G. Ballard's novel *High Rise* – affluent apartment complex dwellers throwing social convention to the wind, joyously resorting to primal nature while fighting petty battles for elevators and vandalizing 'enemy' building floors. There isn't any regimentation in sight on these recordings – instead there is a strong feeling that constructive labor has been totally abolished in favor of meaningless play, extreme atavism, and building new communication methods from scratch. Urbanized Japan does, incidentally, put in more man-hours in its offices, factories, and laboratories than any other 1st world country save South Korea and the U.S. – in such an environment, where truly spontaneous acts are looked upon as counter-productive (one Public Security Regulation in Japan even bans stopping on the street for short periods of time without police permission), this kind of sound can be amazingly cathartic. Of course, an argument could be made that this sounds no different than the noisy Japanese public works projects which often last until the wee hours of the morning – but these 'assemblages' are really animated by a different, more individualized spirit. The combination of anarchic improvisation and occasional *detournement*-style documentary exercises (like the sound of rain-slicked streets recorded on the track 'Asagaya in Rain') suggests that Merzbow is re-wiring the psycho-geography of the city to better suit the spiritual needs of the musicians.

Like the quote above from the *Gutai* movement's founder Yoshizawa (who are sometimes unfairly likened to being a 1950s Japanese approximation of Dada) suggests, early tape-era Merzbow music hummed with the sound of raw materials re-asserting themselves; being revived as instruments of chaos. In this sense Merzbow music could be seen as much more optimistic than many in the underground tape-trading communities perceived it to be. Such communities were occasionally overrun by glum and obsessive Whitehouse copyists, atrocity tourists, or dealers in ultra-rightist buffoonery like Terre Blanche, and were not exactly repositories for positive thinking – but it is difficult to see Merzbow's re-appropriation of raw material as anything but a joyous refusal to just let a piece of scrap metal remain a dead byproduct of an impersonal, unsympathetic environment.

Space Metallizer

In relating a capsule history of Merzbow to the Japanese counter-culture magazine *Dice Talk*, Akita confesses that he performed virtually no concerts throughout the '80s, focusing instead on studio works. This was owing not so much to a complete lack of underground performance venues, but because of a reluctance on Akita's part to perform noise in a setting that required heavy doses of rock 'n roll charisma (and, really, would *you* expect dazzling showmanship from someone who regularly includes the caveat 'recorded at bedroom, Tokyo' in his albums' liner notes?) The live concert moratorium was rectified by a 1988 tour of Russia, resulting in one amusing two-date engagement where Merzbow was deemed to be "too loud" and had to return for the 2nd concert using only acoustic instrumentation like balalaika (documentation of this exists, if one can find it, on the *I'm Proud By Rank Of The Workers – Live in Khabarovsk CCCP* LP.) Next came a 1989 tour of Europe, where Akita has returned time and time again in order to offset the Japanese mass media's apparent indifference to his work. During the first of his European tours, Akita confesses to having his back turned away from the audience most of the time, adopting what he calls a "dis-human" posture and placidly tending to an array of tabletop electronic devices. Early supporters, like Frans de Waard of the Dutch Staalplaat and Korm Plastics organizations, still speak fondly of these early diplomatic visits by Akita, but it would take the dawn of the 1990s for Merzbow to truly 'put the pedal to the metal,' as it were, and to craft the distinct sound that, live or on record, would slice

through the defeatist malaise of that era.

If Merzbow's intensified *musique concrète* period brings to mind *High Rise,* then what follows it is – to invoke the name of Ballard's other infamous 1970s novel – pure *Crash.* It is a feverish, orgasmic fascination with mechanized destruction and meltdown; the sound of impact drawn out to the kind of interminable length normally reserved for sacred rites. Like the stylistic variations that went before it, this model of Merzbow uses utilitarian means to erode away at the very bedrock of utility and purposefulness: an amplified electric shaver is just one example of this ethic, as is a comical strap-on device that looks like a cheese grater festooned with spring coils. A pulsing, sweeping EMS synthesizer is also a regular staple of this newer annex to the Merzbau, which swallows space in a way not previously felt by the project's recordings.

Akita was arguably the first artist to experiment with this exact style of music on the Japanese archipelago – Western antecedents include John Duncan (whose shortwave radio experiments on his LP *Riot* helped to encourage the Tokyo noise faction forming around Merzbow), Boyd Rice, The New Blockaders, Z'ev, Maurizio Bianchi and Whitehouse, along with composers like Phill Niblock. In Tokyo's rival commercial city of Osaka, Hanatarash and Hijokaidan also began experimenting with marked destructive tendencies in their music, and with the re-appropriation of urban junk as both a means *and* an end. However, Merzbow in *Crash* mode is not identical to any of the above artists: his noise flow tends to heat a room rather than chill it, as Maurizio Bianchi's desolate noise would. His sound favors ultra-high frequencies and bruising low-end like Whitehouse, yet ejects the hectoring vocal style and the amoral explorations of sociopathy. He massages numerous metal implements as Z'ev would, although with more of an emphasis on electronic amplification and less of an emphasis on shamanistic physical exertion. In short, the mish-mash of noise elements shows that Akita has not lost his talent for scavenging, and therefore his upgrade to a music of pure distortion, engulfing all aural space available, is a natural progression rather than a radical 're-think' or change of plans. Not unlike the characters in Shinya Tsukamoto's 1989 cult film *Tetsuo,* who gradually become grotesque flesh-metal hybrids in the weirdest Kafka-esque manner (and who come to love their horrific plight), it sounds as if Akita's noise-making junk has ceased to be a removable *extension* of the body, and has now grafted itself directly onto the flesh, becoming indistinguishable from organic material. Akita must have had this idea in mind when he dubbed the lo-fi, street-level clique of noise artists developing around him 'expanded noisehands'. Thought processes themselves turn metallic and Merzbow's world becomes a flame-belching, high-velocity surrealist landscape the likes of which Max Ernst and friends would have been proud to help construct. Track/album titles like *Artificial Invagination, Flesh Metal Orgasm, Locomotive Breath* and *Electric Salad* give cues as to the lurching chimeras and monstrosities to be found within this new world.

The temptation to refer to this subconscious scrap yard of razor-edged sounds as 'noise' is overwhelming, and even people with a vested interest in marketing it may never call it anything but that (although some prefer the quirky ethnocentric term *Japanoise* when dealing with Merzbow.) Admittedly, it moves at too quick and too intense a pace for the English language to adequately describe, but it can clearly be seen as structured music by people with the patience to surf the incoming waves of stimuli and to fish certain leitmotifs out of the churning sea of apparent chaos. Listening to Merzbow today, it is easy to forget that once things like Ornette Coleman's free group improvisations, or John Coltrane's final creative phase, were considered the pinnacle of 'noise' because they strayed from 19th-century Western conventions of tonality and rhythm. Even jazz in its more tonal and rhythmic forms was once grating to the ears of the fundamentally-minded: the legendary mentor to Al Qaeda, Sayyid Qutb, visited the post-World War II U.S. and, when defining jazz as "a type of music invented by Blacks to please their primitive tendencies and desire for noise,"[2] hinted at the cultural relativity and almost frustrating elasticity of 'noise' as a concept.

Yet the term 'noise' is likely to dog Merzbow for much longer than it did the free jazz vanguard, if for no other reason because the source materials of the sound are not conventional acoustic instruments, and could be seen as having tenuous connections to 'human' expressiveness.

It seems that, on a whole, the closer one gets to the organically familiar, the lesser the risk of being denounced as noise – and in this hierarchy, the modulation and processing of phenomena like radio interference is much more trying, much more 'noisy' than even the most atonal, off-kilter, and high-volume horn section – the human 'warmth' of the brass trumps that of radio static, no matter how ingenuously it is transformed into musical material. The deft manipulation of electrical processes, for most, has less of an emotional resonance than sounds generated by the interaction of human hands with an acoustic instrument. But the seminal artists of the modern 'noise' genre, the Futurists, were affected enough by machine-generated noise to at least attempt sharing their joy with concert audiences. Sun Ra biographer John F. Szwed, discussing the link between the European avant-garde and the later American upsurge of free jazz, states:

"Noise, they contended, was richer in harmonics than pure sound; and if audiences failed to understand that, they should be trained through concentrated listening to hear the musicality of noise and understand its emotional effect."[3]

Speaking on the subjectivity of noise, Akita has no problem dismissing the old canard that noise is just any form of persistent, unpleasant sound – by this dead simple logic, "most pop music is noise to me," he claims.

Pornoise

Akita has likened his music to being, in concordance with the name of his first micro-label, 'the lowest form of music', just as pornography is generally considered the lowest form of visual art in a technocratic society. This lowness is owed to its purely representational aspect, its supposed inability to engage the spirit, and the fact that even the most artful embellishments within porn will likely be ignored in favor of its functional use as a stand-in for a sexual partner. But before this investigation into this aspect of Akita's work is taken further, the Japanese perception of pornography, and its contrast with Western views on the same, should be clarified somewhat.

Distribution of pornographic literature in Japan (primarily magazines and comics) is far more widespread, extending to the most banal convenience stores – there has not yet been anything in Japan approaching the campaign of Western feminist firebrands (Andrea Dworkin, Catharine MacKinnon et al.) to lobby for these items' removal from such omnipresent shops, on the grounds that they exploit and terrorize women. Distribution of titillating and prurient material extends, in the larger cities, even to the front doorstep of one's home: I can't remember, during my residence in Osaka, many days where my mail slot had *not* been stuffed with 'pink *chirashi*' or soft-porn flyers for innocuously-named sex businesses like 'aesthetic salons' and 'delivery health'.

Although the distribution of pornography is less regulated in Japan, though, the content is more highly scrutinized by the censor's eye (apparently overriding the Japanese Constitution's Article 21, which flatly states that "no censorship shall be maintained"): shots of penetration are not allowed without being covered by a *bokashi* (a digital 'mosaic' or other blurring/obscuring element.) In such a climate, debates solved years ago in the West are just now being resolved in Japan: Takashi Asai, the head of Tokyo's Uplink publishing concern, became the subject of a landmark "obscenity or art?" ruling that favored the latter: he was finally granted legal permission to publish a book of black and white Robert Mapplethorpe photographs, featuring male frontal nudity, as of February 2008. An editorial in *The Economist* magazine attempts to shore up the bizarre incongruity of calling Mapplethorpe's work obscene when traditional art in Japan dealt with this subject matter four centuries ago: specifically the fact that "woodblock prints from the 17th century, called *shunga*, depict penises the size of battering rams."[4]

Amazingly for adult magazines, certain words are even printed in an incomplete, censored form – the word *manko* [vagina] normally has its middle character replaced with a hollow circle, although it will be perfectly evident to any adult reader what the 'mystery' word is. A quick glance at Article 175 of Japan's penal code will shore up the vagaries and multiple possible interpretations of Japanese obscenity law, which seems to be very inconsistently enforced. Fictional pornographic scenarios are also required by the censors' board to have a 'socially redeeming' or even moral

message. The above variables have all combined to make for some of the most bizarre erotic entertainment on record: *anime* cult favorites of the 'erotic horror' genre, like *La Blue Girl* and *Urutsukudoji,* have arisen out of a social climate where sex scenarios have to be outlandish and transgressive enough to compensate for the disappointment engendered by the *bokashi* – enter animated sex with hermaphroditic demons, or even scenes of would-be rape in which the attackers are magically incinerated by their prey before they can climax.

Participation in the production of Japanese porn is also not seen as an instant ticket to social disgrace, nor are porn actresses assumed to be on the receiving end of organized criminal exploitation: sound artist (and Akita associate) John Duncan, in conversation with me, recalled at least one incident where a well-known female race car driver worked on the set of an erotic film of his. This side detour into porn acting was not seen, as it might be elsewhere, as a careless discarding of the status gained by her racing success, or as a desperate means of maintaining the spotlight on herself – it was, by all accounts, something done willingly and enthusiastically, for personal reasons that had little to do with public image. Still, accusations hold that Merzbow is tilling a chauvinistic field by associating his work with the male-oriented porn world. Akita offers up the following defense, invoking Jung and Wilhelm Reich in the process:

"...pornography is the unconsciousness of sex. So, Noise is the unconsciousness of music. It's completely misunderstood if Merzbow is music for men. Merzbow is not male or female. Merzbow is erotic like a car crash can be related to genital intercourse. The sound of Merzbow is like Orgone energy— the color of shiny silver."[5]

It is not the continually cresting and falling tidal wave of mainstream Japanese porn which holds Akita's interest, though – although he has regularly used pornographic images in his mail-art style collages (and had a series of recordings tellingly entitled *Pornoise*), the porn images were just another element in the assessment of mass communications debris: in their crudely xeroxed, discolored form, isolated from the glossy sheen of their parent media, this imagery could hardly be seen as titillating – if that did happen, it was a case of the viewer's visual hierarchy favoring female nudes over the other abstractions gracing Akita's cover collages, rather than the creator's sole intent. The apex of Akita's interest in extreme eroticism was his interest in *kinbaku-bi,* the Japanese art of rope bondage extant as an art form since the Edo Period (1603-1868.) Not always viewed as high art or as a form of sexual stimulus, it was originally a form of punishment by public humiliation, and also a residue of the country's astonishingly bloody *Sengoku* [Warring States] era. Not until the eccentric 19th-century reign of Emperor Meiji would rope bondage become a subject worthy of artistic portraiture, as exemplified by Meiji-period painter Itou Seiu. Nowadays it is a vital visual component of the Japanese arts underground; 'extreme' *manga* artists such as Suehiro Maruo (known in the music subculture for his works gracing the covers of Naked City albums) have used this imagery to stunning effect when combined with a 'social realist' illustrative style. Akita warns, though, that his use of *kinbaku* imagery – connected as it is with deep emotional and historical resonances – is not something intended as a careless 'shock tactic', and more work goes into these particular images than has gone into the use of 'found' pornography. In contrast with the anonymity of those images, Akita has photographed *kinbaku* images by himself and has personal relationships with both the bound models and their binders.

As Akita is fond of reminding interviewers, Kurt Schwitters' maxim of "everything erotic, everywhere erotic" has helped to legitimize both the visual and sonic methods of Merzbow – allowing every object the chance to birth an epiphany, from the hemp rope of the bondage practitioner to the discarded, dog-eared magazine found in the waste receptacle of a Tokyo subway station. And although Akita's project name may owe itself to Kurt Schwitters, there are clearly other thinkers lodged in his personal pantheon – thinkers who paint eroticism and carnality in even more vivid hues. Like his contemporaries in Whitehouse, Akita made no secret of his fondness for French philosopher Georges Bataille: one Merzbow release, *Music For The Dead Man 2,* is actually a soundtrack for Dutch filmmaker Ian Kerkhof's film treatment of the Bataille story *Madame Edwarda.* In some respects, Akita's championing of Bataille's ideals dovetails into his fondness for Kurt

Schwitters – both individuals, in their respective media, seem to believe that transgressive acts can provide a gateway to the sacred. Just as Schwitters elevated scraps of debris and other base materials to high art, Bataille favored the paganistic means of reaching divinity through 'impure' actions. Both Schwitters' and Akita's refusal to become dejected by the scum of their immediate surroundings (in Akita's case, the defoliated sprawl of Tokyo) recalls Bataille's thoughts on the origins of eroticism – namely, that eroticism lies in the "certainty of doing wrong." Some statements by Carl Jung's protégé Aniela Jaffé strengthen the philosophical link between Schwitters' artwork and Bataille's theory of sacred transgression, claiming that

"Schwitters' exaltation of the grossest material to the rank of art, to a 'cathedral' (in which the rubbish would leave no room for a human being) faithfully followed the old alchemical tenet according to which the sought-for precious object is to be found in filth."[6]

Bataille was referring explicitly to blasphemous transgression against Christian religious principles, but in Akita's Japan, the concept of *kirei* (meaning both 'clean' and 'beautiful' simultaneously) has become something of a pop religion in itself, often making considerations like personal grooming and hygiene more important than anything the spiritual realm has to offer – or, in other cases, infusing things like personal grooming and hygiene with a kind of spiritual value. To make audio and visual collage works exclusively with society's refuse, at the height of Japan's mid-'80s 'bubble economy' affluence and opulence (and even in the subsequent 'bubble crash' period), would have been regarded by many *kirei* adherents to be a kind of blasphemy against the public spirit.

The Million Record Man

Pornography thrives through its promises of inexhaustibility – an endless procession of interchangeable bodies willingly participating in an endless number of sexual scenarios; an illusion of constant sexual diversity and infinite virtual sex partners offered in place of committal, monogamous relationships. And if none of these fantasies ever do manifest themselves in reality, the Internet has at least created a situation where these fantasies can be projected *ad infinitum* – with some 12% of the Internet given over to porn (and growing), it can safely be said that more exists than can ever be consumed by the most die-hard, lusty aficionado. Given Masami Akita's fascination with pornography's role in the grand scheme of mass communications, it would seem natural that he mimic pornography's 'unlimited supply' with one of his own.

Akita's breakneck pace of releasing records, with only miniscule stylistic deviations from one to the next, has few other obvious parallels in the mass media world besides the production of pornographic films and magazines – and given that the majority of the design/layout work, recording, mixing etc. is handled solely by Akita, the Merzbow assembly line almost makes the distribution of porn products seem lagging in comparison. The Merzbow discography, next to Sun Ra's, is one of the most extensive in the history of recorded sound, providing a rich variety of choices for casual consumers and continually frustrating the efforts of completists/elitists.

Within this unprecedented discography, release formats run the gamut from the older hand-copied cassettes with photo-copied (again, often pornographic) inserts to conventional mass-produced CDs, with a host of *objet d'art* anomalies in between, like 7" acetates in crudely stitched-together vinyl bags. The liner notes for the Merzbow 'remix' CD *Scumtron* list, for the year 1996 alone, six 7" records, one 10" record, one double 10" record, one LP-only release, and 13 full CDs (two of which are more than one disc's worth of material.) Go back to 1983 on this same list, and the grand total of releases stamped with the Merzbow insignia comes to 69 – but this is really one of the more *conservative* estimates of Merzbow's output, considering that it doesn't take into account the dozens of self-released cassettes, on the 'ZSF Produkt' imprint, that were Merzbow's stock in trade throughout the 1980s. It also omits Merzbow's frequent contributions to various-artist compilations, works that featured Masami Akita in a capacity other than the 'main' performer in Merzbow, and the non-Merzbow cassette releases issued on ZSF Produkt by other respected 'tape underground' artists. Nor does it include two of the most dramatically ambitious releases in the

canon of commercially available music: the overwhelming 50 CD retrospective "Merzbox", or, more amusingly, the Merzbow CD sealed into the CD player of a Mercedes car. The latter item has been, like most things that happen without a clear precedent, hotly debated as to whether it exists or not. Many have written the Merz-mobile off as a quirky urban legend, or as a viral meme intended to expose and ridicule the monomania of noise collectors. Still others are amused just by the possibility that something so pregnant with meaning could exist. The conflicting Merz-mobile legends are best laid to rest by Anders, boss of the Swedish 'Releasing Eskimo' record label, as follows:

"A while ago I had a Mercedes 230 that I didn't drive much. The police told me that I had to move it or they'd tow it away. Well, I didn't want to keep it and I didn't have anywhere to store it so I decided to use it for something else. I rigged the car's CD player with our latest release of Merzbow's "Noise Embryo" CD so that the music started when the car was turned on and it was impossible to turn it off. I put it up for sale as an extremely limited edition of the *Noise Embryo* CD but no one ever bought it, and in the end the car broke down. So we took out the CD and got rid of the car. Now I'm thinking about if it's possible to release a record in a Boeing 747..."[7]

The existence of a 'Merzbow car' would seem to confirm a gnawing suspicion about his gargantuan *oeuvre*, namely that Akita's unmitigated onslaught of releases is a cynical statement on the nature of commerce and the insatiable lust for constant novelty – *the more you have, the more you want* – which is seen most vividly in porn consumption, but certainly applies to any number of consumer goods. One Merzbow review in *Wire* magazine (where Akita remains one of the most heavily-reviewed artists) applauds this approach: "say, is that a 50 cd Merzbow box set in your pocket, or are you just pleased to be erecting a monumental indictment of the music business?"[8] On the other hand, it is an extension of the Schwitters aesthetic to which Akita is partially indebted: like Schwitters' original *Merzbau*, Akita appears determined to view his recorded output as a single continual 'life's work' that will only reach a satisfactory finished state when the artist himself terminates. He has stated repeatedly that "Merzbow is me," hinting at the fact that the furious releasing will probably only conclude with his death.

While it's understandable that mainstream consumers would steer clear of Merzbow's furious sonic scourging, he has not yet earned across-the-board approval within the more limited sphere of the avant-garde, either. Within many of the same organs that sing Merzbow's praises, contradicting voices rise up to bring him back down to earth: in the same issue of *Wire* featuring the above praise about the Merzbox, critic Biba Kopf sneers that "[Merzbow's] discography is way out of proportion to the slim idea it contains," and that "his imagined cultural transgression is like that of salarymen who read SM comics while rubbing themselves against women on crowded Tokyo trains."[9] Interestingly, Kopf seems quite contented to hastily toss out negative Western stereotypes of the Japanese while decrying "the myth of Japanese extremism" within the same column, but that's neither here nor there. Some of Merzbow's most severe critics are, of course, the guardians of 'authenticity', that most sacrosanct of artistic attributes which has already been battered away at by Marcel Duchamp's toilet, Andy Warhol's Brillo boxes, Damien Hirst's formaldehyde-soaked shark and much more besides. The 'authenticity' schoolmarms not only echo complaints like Biba Kopf's (that Merzbow's huge body of work is an exercise in naked self-indulgence), but accuse Akita of plundering the idea bank of the most influential 20th-century art movements without adding any real substance of his own. In the eyes of the harshest Merzbow detractors, he is little more than a glorified "piggyback artist" of the kind who would add his own amateurish, clumsy brushstrokes to a reproduction of a universally recognized masterwork – a charlatan who swipes the artistic lexicon of previous innovators and uses key terms as seductive ciphers, operating in the same way that a flashy corporate logo might work. However, Akita has never professed to be an 'originator' of anything in spite of what his many record labels' press releases may say about him; even in his 1996 book *Noise War* there is but a single mention of his own activities among the discussions of other seminal Industrial and noise artists – some of them less relevant than himself. If Akita fancies himself as anything, it is as a 'safe deposit box' guarding the more relevant facets of 20th-century subculture in a largely unappreciative, conservative, and hostile world, keeping this knowledge on

ice until some cataclysm ushers in a future world that may be able to understand it better.

Among the items re-appropriated by Merzbow are, of course, the project's namesake itself, taken from Kurt Schwitters' concept of ennobling random detritus. The Viennese Aktionists (specifically Otto Mühl) get their customary nod with references to noise performance as 'material action,' and also the curiously titled album *Batzoutai with Material Gadgets*. The Pop art canon is also picked over, with works such as Tom Wesselman's "Great American Nude" being used as album titles, or 'superstars' from Warhol's Silver Factory being used as the 'subject matter' for songs (see "International Velvet", B-side to one of Merzbow's 'Pornoise' series of cassettes.) Would-be Warhol assassin Valerie Solanas even gets sucked into the Merz-vortex, as Akita humorously changes her S.C.U.M. ("Society for Cutting Up Men") into "Scissors for Cutting Up Merzbow". Other references in Akita's name game are slightly more obscure, such as the track title "HGL Made A Race For The Last Brain", a knowing wink directed at exploitation film director Herschell Gordon Lewis. The more celebrated exponents of home turf counter-culture from the '60s onward (see experimental filmmaker Shuji Terayama, or the ruggedly independent Tohoku folk singer Kan Mikami) are conspicuously absent from this roll call, echoing the tendency of post-Industrial sound artists to consistently reach beyond their native shores for flashpoints of inspiration: Zurich Dada and American celluloid sleaze fit Merzbow's research agenda just as comfortably as Tibetan Buddhist ritual would for a European artist.

It is tempting for the anti-Merzbow constituency to write off the 'name dropping' titles as the self-conscious intellectual preening of a fine arts graduate from Tokyo's Tamagawa University, but there may be more practical reasons for the frequent cultural name-checking in his works. Akita could merely take the route of his colleague, the sound artist Francisco López, and not title any of his works at all – but unlike López' ongoing project of 'absolute music,' the cultural references act as signposts which show how hopelessly cluttered and confusing the mass media landscape has become, while at the same time showing how vibrant and varied the counter-culture has remained in spite of it all – providing listeners a rough guide to the triumph of the imagination, as it were.

The jury is still out on the ultimate usefulness of Merzbow's endless record-releasing project, and it is easy enough for some to dismiss claims that his creations are not 'authentic'. As we have seen, pure noise has existed as a form well before the first releases of Merzbow, but this alone hardly disqualifies it from authenticity. The preoccupation with being 'the first' to do something (and therefore more 'authentic' than any future protégés) is a very American one, and this should not always dictate how sincere an artist's intentions are, especially when they hail from halfway around the globe and from an immensely different set of socio-cultural norms. In a nation which is more racially homogenous than most, and in which some 80% of the population lives within the same middle class income bracket, the noise may 'all sound the same,' but the perspectives guiding it are decidedly different than those guiding European and American variants on the same. And even if Akita's noise technique can be traced to a number of predecessors, he is perhaps the first to associate noise with the 'Japanese bondage' meme, and the first widely-accepted Asian emissary of this music, period.

The art world's negative attitude toward Merzbow (that he exploits Western myths about the latent extremism in modern Japan) is more than a little hypocritical when we see what passes for provocative Japanese art in Western galleries and museums. The mid-'90s photo and video works of former fashion model Mariko Mori, for one, are touted as relevant commentary on Japanese female identity (and worse yet, as 'the new Cindy Sherman') rather than as pure exploitation – cultural artifacts indistinguishable from the vast majority of youth-oriented Japanese advertising. That the wealthy niece of an oil tycoon can pass off bland consumerist fantasies (of herself re-designed as a 'female cyborg' or techno-fied Buddhist icon etc.) as works of high irony or serious culture speaks volumes about gallery curators' own blurry projections of Japan: the word 'irony' does not even exist in Japanese dictionaries except as a foreign loan-word, and even then is assumed to be a confrontational device that would likely not be employed by established socialites like Mori. Whatever the case, there are far worse offenders than Merzbow when it comes to pandering to

erroneous Western visions of Japanese life.

Vegetarian though he may be, Akita has a conspicuously omnivorous musical diet, and the giant musical output on his behalf is a distillation of these varied tastes – everything from free jazz to Brazilian psych/space rock group Modulo 1,000 to minimal techno has colored one aspect or another of the Merzbow maelstrom. In fact, a listing of Akita's favorite records on the Essence label's website points at musical influences far removed from the realms of Industrial music and power electronics: King Crimson, Deep Purple and Black Sabbath all emerge as clear favorites. Although Akita has stuck mainly to live performances of his own material, a Merzbow DJ set would have to be one of the more eclectic ones on the face of the planet – his fanaticism for musical archiving and for mildly proselytizing the value of select 'unsung' heroes seems to run parallel with one of his newer efforts: the repair of a brutally scarred Gaia.

There is a sub-category of Merzbow releases that are released in tribute to either favorite musical acts or adored animals, and in both cases there is a genuine desire on Akita's part to become more than just a rank-and-file noise agitator, but to act as a militant ecologist preserving sounds, concepts, and hopefully even whole living organisms. The urgency of this particular mission requires an aesthetic framework that will effectively convey that urgency, and so Akita's magnified bloodstream of noise is just as suited to this mission as it was to parodying or *detourne*-ing the hyper-materialist 'scum of the city'. Merzbow's noise is just elastic and abstract enough that the addition of one extra signifier – let's say, in this case, a sampled bird call – can completely re-wire the noise machine, upgrading it from its role as Orgone generator to that of an alarm warning against the unsustainable abuse of the ecology. This heightened concern for *madame la terre* comes concurrently with a switch to a purely digital recording format (Akita now works mainly with computers and the more noise-friendly applications such as Max/MSP.) Despite the needless protests from the analog cult, the digitized sound is very much a seamless integration with his older material, not the imagined betrayal of Bob Dylan 'going electric.' Like the red-tinted subtitles that scroll across the bottom of a television screen during hourly news reports, warning of changes to the current 'terror alert', Merzbow's 'digital-era' noise is relentless and practically dares one to *not* feel like the genuine threat level has been raised.

Theater of (Anti) Cruelty

The wild sonic vision of Merzbow, as we've seen, is not just an affront to conservative Japanese aesthetics and 'harmony at any cost' social customs – it is also a splash of caustic acid in the face of condescending American and European Japan-o-philes, who delight in reducing modern Japanese life to a set of cutesy consumerist signifiers, or envisioning the buzzing modern Japanese landscape as a harmless video game made flesh. Just as surely as he is no ambassador for the culture of Hello Kitty and other neotonous cartoon characters, Akita is an underground sympathizer of the first level. He voluntarily inhabits a cultural no-man's-land between Eastern and Western traditions, as much out of necessity as out of a real desire to build barricades between his music and any corrupting commercial influence. By dint of his diet alone (Akita is an avowed vegan and 'straight-edger'), he has already excluded himself from the majority of Japanese social life, which invariably revolves around meat-eating and alcohol consumption. There is an even greater pressure in Japan than in the West to eat meat and consume heavy volumes of alcohol, which arises partially out of a post-war phobia of looking destitute – as the logic goes, the only 'sensible' person who would resort to a vegetable diet would be someone without the income to pay for meat dishes (this is assuredly not the case for Akita, who would still be making a healthy income as a landlord even without his recording career as Merzbow.)

The floating abstraction of Merzbow's sound has, until very recently, been open to interpretation, and has shunned the sociopolitical in favor of a more personal quest to (again, partly owing to Schwitters' influence) find an erotic charge in the most mundane materials. It's a quest that seems to have more in common with Andy Warhol's sexually tinted boredom than with anything else in the popular music world – a world that accepts only extreme experiences

(heartbreak, love rapture etc.) as genuine and valid, discounting the gradient of experiences in between. Merzbow's anarchic approach originally made no intellectual demands on listeners other than that they listen in the first place. But now the old, open-ended Merzbow has indeed been supplanted by a newer incarnation with a proper mission: raising awareness of animal rights, and the suicidal reign of anthropocentrism, also called 'speciesism' by *Animal Liberation* author Peter Singer. At least one of Singer's thesis points – that the "greatest good for the greatest number" ideal of utilitarianism should be applied to animals as well as humans – has had some definite influence on post-Industrial music culture, with compilation LPs such as *Devastate to Liberate* promoting the agenda of the Animal Liberation Front, and with several musicians crossing over from endorsement into activism: Tactile member and Coil associate John Everall is one of the more recent cases of a member of this scene being arrested for animal liberation guerilla tactics. Akita has not been as militant (as far as we know), but has been involved in a number of street protests coordinated with the PETA [People for the Ethical Treatment of Animals] campaign against "Kentucky Fried Cruelty," and has stated on occasion how he wishes to use his music as a weapon to counter the noise pollution generated by swarms of Tokyo residents, also hoping that the music's inherent rage and severity would serve as a reminder to humans of their destructive potential. This applies not to the destructive potential of modern warfare, but also to the haughty assumption that nature can replenish itself at a rate equal to the rate of humans' conspicuous consumption.

Straw Dogs author John Gray has referred regularly to mankind as *Homo Rapiens* in his recent works, a designation that Akita would likely agree with. Gray sharply dismisses the possibility that humanity will ever completely subjugate its host body Earth, suggesting that "the biosphere is older and stronger than [humans] will ever be"[10], or, even more damningly, that "either the Earth's self-regulating mechanisms will make the planet less hospitable for humans, or the side effects of their own activities will cut short the current growth in their numbers."[11] Numerous biologists have also noted that human fertility will follow a natural curve instead of continuing to double interminably: actually taking a nosedive once its collective metabolism adjusts to a more resource-poor environment, and following the examples set by other prolific species (including rats, a comparison which agitated misanthropes have made many a time.) This is a happy ending of sorts for biophiliacs, although it side-steps the gruesome realities involved in getting to that endpoint: with humans being an extremely tenacious species, environmental stress will manifest itself in numerous wars over raw materials, extending even to raw materials as fundamental and 'given' as water. Inability to combat new strains of disease, evolving quicker than the antibiotics tailored to fight against them, would be another grim inevitability leading to a population crash. The true tragedy of all this, though, is not that prolific population will lead to terrifying de-population, but that human arrogance will accelerate the inevitability of all this. Fellow vegan sound artist Dave Phillips, who claims to have been on hand at the concert event where Akita experienced his vegan 'epiphany' (an event at the Red Rose in London, alongside the New Blockaders), describes the situation as such:

"Many humans act as if they are elevated, but to think or feel that is just dumb. Humans definitely have qualities that are well worth exploring, but to think we should only consider ourselves, our values and our goals and to put everything else secondary is a way of perceiving and dealing with things that definitely lacks perspective. C'mon, we know we are seriously dangerous, for ourselves and for all around us. We are (or might be) incredible beings, but might is not right. The ways humans perceive things, the value we give to things, are not the only ways that exist to do so, nor that we ultimately exist in. We're all in this together and there's more to 'gain'/learn than what is generally proposed. As well as asking ourselves what we really want, we should also question what really matters and what is involved."[12]

Phillips' insistence that humanity is not elevated above the animal kingdom is not the unfounded, eccentric opinion of someone on the radical fringe of the arts, but a growing consensus among students of animal behavior, in particular animals' communicative mechanisms. The most recent issue of *National Geographic,* as of this writing, catalogs a number of incidences in which

animals have learned communicative behavior supposedly exclusive to humans: an African gray parrot forming neologisms when it doesn't know the English word for an object, border collies that will 'fetch' a photographic representation of an object when the real object cannot be found, and bottlenose dolphins who will exhibit individualized, spontaneous behavior when being given a command to 'create.' Such discoveries lead University of Florida researcher Clive Wynne to conclude that "we're glimpsing intelligence throughout the animal kingdom, which is what we should expect. It's a bush, not a single-trunk tree with a line leading only to us."[13] Other animal researchers, like the primatologist Frans de Waal, have claimed that culture – learned behavior patterns passed from one generation to another by means other than genetic ones – is not an exclusive human property either. De Waal's books *Chimpanzee Politics* and *The Ape and the Sushi Master* are revelations in this regard, and in the former he suggests that the unfocused nature of human perception is to blame for the assumed lack of intelligence in animals, not any actual failure on animals' part. Claiming that "initially we only see what we recognize" when observing animals, In describing the learning process associated with studying chimp behavior, De Waal uses a metaphor of chess:

"Someone who knows nothing about chess and who watches a game between two players will not be aware of the tension on the board. Even if the watcher stays for an hour, he or she will have great difficulty in accurately reproducing the state of play on another board. A grand master, on the other hand, would grasp and memorize the position of every piece in one concentrated glance of a few seconds. This is not a difference of memory, but of perception. Whereas to the uninitiated the positions of the chess pieces are unrelated, the initiated attach great importance to them and see how they threaten and cover each other. It is easy to remember something with a structure than a chaotic jumble."[14]

De Waal goes on to explain how this is the guiding principle behind Gestalt perception, in which the 'larger picture' is greater than the sum of its individual parts. To people like Akita, attempting to observe this 'larger picture' has landed him in Japanese zoos and aquariums, where the suffering and psychological stress of captive animals – in particular, several varieties of seal – has struck him as being too close to its human equivalent for comfort.

So where exactly does Merzbow's biophilia fit into his previous examinations of, among other things, ritual bondage and urban 'scum' culture? It's possible that, having mapped out the limits of human behavior so thoroughly in multiple media, Akita has simply done all he can to provide illustrative examples of the human condition using humanity itself – and, in the best Bataille tradition, has come to the conclusion that man is little better than animal life in its basic impulses and needs. So the logical progression from this point seems to be a shift in subject matter towards the 'source' itself – towards that which humanity has unsuccessfully attempted to estrange itself from. The non-linear nature of Akita's noise has always hinted at the fact that the man/nature rift is less wide than guardians of progress-at-any-cost would like it to be – and his past interest in *kinbaku-ki* hints at this. Akita's documentation of ritual bondage is not an admission that cruelty is the guiding force in nature, but that human social hierarchies, based on wealth and lineage, are inherently flawed in comparison to natural hierarchies based on strength and aptitude. These natural hierarchies have not disappeared from modern human behavior – they have just been absorbed into ritual behaviors like sado-masochistic practice, into private ceremonies which distill the dull, aesthetically blank control and subservience of work-a-day urban life into one compacted threshold experience, in order to 'burn it out' of one's system. Here is a practice which, depending on the personal desires of the participants, voids the privileges of wealth, social standing, and gender as well (remember that many of de Sade's most avid 'libertines' were female.) The man who gives 'masochism' its name, Leopold von Sacher-Masoch, declares that "it is possible to love really only that which stands above us,"[15] hinting at a yearning towards the more natural hierarchy of things. For, try as it may, humanity can't seem to achieve a total dominance of nature – it is the *Homo Rapiens* suggested by John Gray, a parasitic body who can only claim victory by means that would destroy him as well. A mutually assured destruction of both the denuded host and the famished parasite can hardly be called a 'victorious' act.

If nothing else, Akita seems to be, for the first time in a while, preaching to an audience that is not entirely converted to his stance. The audience for noise is less homogenous in its ideological makeup than might seem otherwise, covering both sides of the left-right political divide, and consisting of everything from dyed-in-the-wool nihilists to cautiously optimistic 'peaceniks' with a slightly more pronounced flair for aesthetic aggression than their musical forbears. Perhaps knowing that many members of his audience closer to the 'nihilist' end of the spectrum are more likely to behave in a cynically wasteful, solipsistic manner, Akita has taken a risk in declaring himself to be otherwise: he has re-tooled his presentation and nullified its ability to be appreciated in a completely subjective way. Reviews for recent Merzbow releases, as can be expected, have been decidedly mixed. But again, this is in keeping with Merzbow's (and indeed, most noise artists') desire to confront an audience rather than placate them. It was Georges Bataille, after all, who claimed that he preferred to discuss the Marquis de Sade only with people who were revolted by him.

In Akita's 2005 book *Watashi no Saishoku Seikatsu* [My Cruelty-Free Life], he states that, while vegetarians and vegans are very much ostracized in the modern social landscape, there is a long tradition of vegetarianism and anti-cruelty within Japan – and vegetarianism/anti-cruelty mandated by the highest levels of government, no less. Akita makes a case for Japan's history as being, until recently, a fastidiously vegetarian one: in the concluding chapter of his book, he writes that successive emperors from the 7th century onward (beginning with the emperor Tenmu) went so far as to make official decrees banning meat consumption. One reason for this injunction, originally, was human utility rather than a pure consideration of 'animal rights': otherwise useful animals could not be squandered for purposes of eating. Of the five main animals listed in the ban, horses provided transportation, cattle were used for plowing the fields, dogs served as trusty alarm systems and security guards, and roosters had a knack for telling time. Monkeys served no particular use, but nonetheless resembled humans and were thus off limits. Although this ban was limited to the cultivation period of April through September, hunting and other acts persisted – so in the 5th year of Tenmu's rule, the *houjoue* or 'order to release live animals' was initiated: this decree was largely influenced by Tenmu's Buddhist faith. The ban on slaughter of animals for consumption purposes would be tested during a famine in the year 737, under the emperor Shoumu's rule, although it was not repealed – and a ban on rice wine consumption was tacked on as well. The war-ravaged *Sengoku* period, with its increased need for animals to be mobilized to the various fighting fronts, would bring another blow to humane treatment of animals, as an inevitable side effect of the widespread human slaughter that characterized the age. Then in 1549, Francis Xavier would introduce Christianity to the archipelago, temporarily popularizing the custom of meat-eating, although the custom of meat-eating was one of the reasons cited for the subsequent ban and vicious crackdown on the faith. Over a century later, the cruel treatment of dogs in some regions could net one the death penalty, thanks to the edicts of the "dog shogun" Tokugawa Tsunayoshi (Tsunayoshi also gained some notoriety for feeding dogs fresh fish at taxpayers' expense.)

Western influence would make a resurgence, however, with the appearance of Commodore Perry's black ships during the Tokugawa shogunate, and culminating in the opening of the first Japanese-owned beef vendors in the 1860s. All that remained for a full transition was for Emperor Meiji, upon restoring Japan to Imperial rule, to lift the previous bans in an attempt at promoting a synthesis with the Western powers (although this was not done without some angered protest.) It was one of the many concessions that would earn Meiji foreign accolades like the English Order of the Garter, but would have the Japanese population viewing him as a reckless appeaser. Meat eating would then become especially prominent among the modernizing military, despite the of the advice of noted military doctor Sagen Ishizuka to the contrary. From the dawn of Japan as a legitimate world power, to the post-war American occupation, straight through to the present day, no attempt at a government order on par with Tsunayoshi's actions, or the *houjoue* of Emperor Tenmu, has ever been established.

Akita concludes *Watashi no Saishoiku Seikatsu* with a heartfelt wish for his native country to return to the days in which meat consumption was seen as a barbaric act, and throughout the

book he establishes himself as a gentle and compassionate soul – again, quite a surprise for those expecting a one-dimensional, brutish nihilist cartoon. Akita's tenderness also says something for the malleability of pure noise as a medium – while some continue to use it solely as a metaphor for power and authority, Akita now uses it as either a defensive weapon/a digital deterrent or as the avenging 'voice' of his beloved, yet grievously wounded, flora and fauna. If he can only find a way to foist the unhinged rage of his pro-animal rights music on the pedestrian populace as well, he may yet have a chance to win some new converts to his cause.

+++++++

Despite the chorus of groans arising from reviewers who have to attempt writing of yet another Merzbow release without using the words 'extreme' or 'harsh', the ongoing career of Merzbow has succeeded in a rare coup: broadening his appeal while restraining himself to a tried-and-tested set of techniques. Merzbow has provoked debate at an international level, about all of the themes he has trafficked in – and yet the very existence of this debate, and his status as a polarizing artist, has served to confirm the potency of his creative approach. Within the Merzbow camp there are now refugees from 'old school' Industrial, electro-acoustic researchers, death metal denizens, militant vegans, psychedelic eclectics, fetishists and still more indefinable shades of culture – all united and inspired by the core defining feature of this music. To wit: radical autonomy combined with heightened levels of persistence, and with a refusal to let any ancillary concerns beyond the ideas themselves become the focal point of the work. The 'Merzbox' did not appear overnight, nor distribution deals with virtually every outlet that stocks outré music, nor the opportunity for presenting his art in every conceivable venue from smoky Osaka basements to sterile, hyper-modern galleries and museums. But these things did finally come to pass, and not by squabbling endlessly about the intricacies of musical equipment, by hiding behind the shielding wall of a musical 'scene', by trading in ethno-cultural stereotypes, or by trying to cover up the lack of conceptual rigor with a media-friendly public persona. These are the things that have 'made' Merzbow, and the things which will continue to animate the uncompromising art of this century, no matter how complex its entanglements or how brutal its tragedies.

5.
MASH COMMUNICATION
(AND OTHER SYMPTOMS OF THE SAMPLING VIRUS)

"...The United States is essentially a commonwealth of third-rate men – that distinction is easy here because the general level of culture, of information, of taste and judgment, of ordinary competence, is so low."[1]
–H.L. Mencken

Mencken, that great cranky curmudgeon of American letters, has never been one to speak in favor of any mass movement or popular phenomenon – much of his acerbic essay writing in the 1920s refers to Americans as being unnecessarily optimistic and culture-less "boobs" (christening the bourgeoisie as the "boob-oisie"), simultaneously damning them as self-righteous, prohibitive, humorless Puritans who compound their naiveté with a mania for forming witch-hunting groups like the Ku Klux Klan and Anti-Saloon League. It has to be said, though, that much of his withering criticism, while being firmly grounded in the language and manners of his time, is still fresh in the 'American scene' of the 21st century. The U.S. of today can safely be called a brutally materialist and over-stimulated culture, where more individuals will cast a vote for the next *American Idol* singing star than for the next leader of the free world, where a single professional athlete's 5-year contract could surpass the entire gross domestic product of Zimbabwe or Liberia, and where a young woman died in 2007 attempting to win a Nintendo Wii game system via a radio contest. Said contest, a perversely named affair called "hold your wee for a Wii," required contestants to hold in their urine for an unnatural period of time, eventually causing the victim death by water intoxication.[2] Technological advancement has not exactly made for a nation of intellectually advanced people; and indeed the thrust towards new technologies has – as observed by thinkers as ideologically diverse and adversarial as Aldous Huxley and Allan Bloom – often sent humans hurtling backwards in the rush towards higher civilization. This is maybe not a statement that can be universally applied, but it rings true in the case of media technologies within the United States. America's chosen medium of television has, even in the age of personal satellite dishes, limitless variety in programming, and innovations like TiVO (which allows viewers to make their own TV schedules) extinguish the exploratory, questioning impulse in millions of individuals. In addition, television programming has ruthlessly homogenized dreams and desires, re-branding this process as "bringing people together".

Despite all the ink spent on proposing that television had an "Orientalizing" effect on American youth of the '60s and beyond – providing an irrational 'alternative' to more regimented, linear daily life – it was undoubtedly a minority of young rebels who used television with avowedly mystical intentions. Still, in the height of the rebellious '60s, far more of the agitated middle-class youth were formulating their worldview from co-opted television images of rebellion than those who immersed themselves in Frankfurt School theory or transcendental meditation. Even now, with the more fragmentary culture of the Internet to compete with it, this is something of a holding pattern – the assumption among the rank-and-file coffee shop idealist is that the lines are clearly drawn in the sand: television is 'old media' for the previous generations, while the Internet is for the wild youth with an inexorable pioneer spirit. It is a nice dream, but one which is in combat against decades of hyper-materialism and triviality-as-entertainment, as presented by the 'old media'. As such, even the Internet, as Coil's Peter Christopherson proposes, can only evolve one's personality if they enter into it with that goal in mind:

"If you use the Internet to find information about some really obscure subject, like the use

of mushrooms in rituals in Guatemala or even a subject more obscure than that, it's your choice to have a look for it in the first place. The stuff that you find, even if you find it easily, is still a function of what you sat down to look for in the first place. You know that most of your friends, or the people in the same class at school are not going to be hunting for that same information, they're going to be hunting for Bono's shoe size or something".[3]

Meanwhile, television and other 'one-way' media largely inform every aspect of the youth *Weltanschauung* – especially their idea of what constitutes rebellion. The pre-hippie (1964) warnings of Herbert Marcuse have hung over youth culture for seemingly every decade after the second World War: according to Marcuse, real social transformation and struggle for liberty was impossible in affluent societies where the State was successfully taking care of one's daily needs. As per Marcuse, the creation of 'false needs' was another distracting tactic of central authority. Viacom's property MTV has led this charge since its inception in the 1980s, an identity-making machine which, although providing plenty of sounds and images offensive to the older generation, never operated as an organ for social upheaval as much as it acted as a non-stop advertising engine. Even during the 1990s wave of 'alternative' music led by Nirvana et al., the more activist, subversive opinions and statements of the musicians were reduced to clever asides, making the musicians seem like one-dimensional eccentrics with no real cohesive message or plan: 1990s 'alternative' music was, in many ways, as much of a media distraction and pre-fabrication as The Monkees and other 'made-for-TV hippies' were in the 1960s. More recently, MTV began offering its viewers a more brazen image of conspicuous consumption as the royal road to happiness. The 21st century's cast of MTV music stars have doubled as 'one-man brands' promoting hyper-capitalism – where once these artists existed solely to sell recorded music, they now exist to sell any item which can comfortably accommodate a logo. The existence of these artists illustrates one of the central points made by *AdBusters* magazine publisher Kalle Lasn in his book *Culture Jam*:

"The great power of [trans-national media corporations] lies in their vertical integration. They can produce a film and distribute it through their own TV networks, play the soundtrack on their own radio stations and sell the merchandising spinoffs at their own amusement parks. A property can enter this vertical chain at any point and be spun in either direction. A film becomes a book, a hit single, a TV show, a video game, a ride. Among them, the media giants have the means to produce a never-ending flow of social spectacles, and to nurture them, feed them, massage them and keep them resonating in the public mind. With the exception of a few wild domains still left here and there (public-access TV, pirate radio, zines, some unexplored reaches of cyberspace), the media megacorps have pretty well colonized the whole global landscape and 'developed' it into a theme park – a jolly, terrifyingly homogenized Las Vegas of the mind."[4]

Audio *vérité*

What Lasn mentions above is a bleak picture, but not one which has ushered in the total defeat of independent creativity. A number of different strategies exist for making music which cannot be adopted by giant desire-manufacturing industries. Sound artists like Francisco López, CM von Hausswolff, Sachiko M. and Mika Vainio have so far avoided representation by commercial interests, with sound works of such demanding nature and elemental purity that it would seem absurd to harness them to the quaint, inoffensive 'lower-case culture' of most corporate advertising. The same could be said for their quieter counterparts – Roel Meelkop, Bernhard Günter, Taylor Deupree and others. Anything is possible, but for the moment it seems like their works invite listeners into a world where minimum sonic output will serve a maximum of needs, from study aid to spiritual reflection – it is a concept far from the reach of the 'vertically integrated' corporate world, which uses 'planned obsolescence' to force consumers into buying a stream of cheaply made, short-lived products to complement each other, rather than offering them one well-made and durable multi-use product to begin with. Another method of resistance – one which has seen many precedents throughout the history of collage art – comes courtesy of the defiant groups of so-called "culture jammers" who use the raw materials of corporate advertising culture and mass entertainment

against them: Negativland, The Tape Beatles, John Oswald and a host of others. Whether the end result is irreverent entertainment, scathing commentary or some form of transcendence, their methodology is usually the same – as per the Tape Beatles' Lloyd Dunn:

"It is sort of an empowering act, as far as I'm concerned, to take this stuff that sort of comes out of the pipes like running water... using it as an ingredient in a recipe that we've come up with on our own... and taking what we consider to be meaningful, telling bits, putting them in a new context 'makes them strange' – it estranges the listener from those bits that they're very familiar with, and puts them under a microscope so that they can be examined in a kind of weird mixture of objectivity and subjectivity."[5]

Groups like the Tape Beatles used a large archive of video images as well as audio to re-shape the media landscape, often smashing together the otherwise neutral and inoffensive imagery of big businesses to shore up their banality and shallowness (the Tape Beatles' parent organization 'Public Works Productions' also hints at the corporate ideal of banality as an indicator of progress.) Elsewhere, the '90s phenomenon Electronic Broadcast Network built their multi-media works on the energetic and rhythmic chassis of techno and hip-hop (genres which themselves relied heavily on montage as a method.) The video component of their work was a discolored and retina-frying barrage of multiple screens synced to the time signatures of their music, with the speeches of all-too-familiar political figures and heads of state being contorted into absurd proclamations. One EBN staple was a clip of George Bush Sr. mouthing the chorus to Queen's "We Will Rock You" in the Oval Office, while other prominent newscasters had their nightly monologues seamlessly edited to encourage slavish submission to mind control.

In contrast to the video montage, which has frequently been used to promote State agendas or to consolidate corporate power (e.g. the rapid-fire edits of MTV which often numb the senses enough to make viewers more suggestible), the audio collage has been used far more by insurrectionary elements in society. Forms like the *musique concrète* of Pierre Schaeffer took a bold step by using audio montage of natural and non-notated sounds as early as the 1940s, but explicit socio-political content in sampling would not come about until later. One example of this, from the European continent, is *Preislied* [Song of Praise], the 1972 *Hörspiel* [radio play] of Paul Wühr. *Preislied*, as described by radio historian Gregory Whitehead, was an a-musical collage work which was pieced together from various German citizens' statements of approval for their nation, however:

"...when these positive expressions are isolated from their original context, grouped thematically, and arranged by inflection, the effect is profoundly critical. By separating individual words and sentence fragments from their usual fluid context, by listening to the concern latent in the hesitation and aggressive inflection, by allowing the original voices to recombine according to principles transparent only in the language is raw material, Wühr uncovers a discordant malaise beneath the superficial harmony of everyday praise."[6]

The use of the sample and the sampling collage as critical, interrogative audio weapons really came into its own with Industrial culture: Cabaret Voltaire set the template for many less imaginative industrial dance bands by marrying breakdance electro-funk with ranting preachers, while Throbbing Gristle's tape collages hinted at the omnipresence of coercive, controlling behavior in all areas of modern life. Early Psychic TV built upon this research by collaging *un*controlled, unmediated sound events – recordings of wolf howls and orgasmic climaxes – in an attempt to bypass the superego and obliterate inherited conceptions of 'self.' The Catalan artist Jordi Valls (a.k.a. Vagina Dentata Organ), closely associated with PTV, dealt with much of the same material. From roughly the same era, the anarchist collective Crass had the 'Thatchergate' tapes attributed to them: a collaged conversation between Ronald Reagan and Margaret Thatcher that seemed to present the two leaders as supporting an all-out nuclear war, and which was convincing enough to cause a media panic before it was revealed as a hoax.

On one hand, this focus away from video was just an extension of 1960s youth counterculture's desire to have its 'own' media (underground newspapers, rock 'n roll records,

underground radio) distinct from the one-way, didactic television of their elders. On the other hand, access to television studios was severely limited, and the censorious 'standards and practices' of that day would excise any kind of social commentary from new programs whose initial premise met with interest from network officials. A third reason for the cultural shift towards audio collage was the time-consuming nature of video production and editing, and the of the speed of social and political events relative to this laborious process: by the time a group of artists could compose a masterful work of superimposition like the kind seen in a Kenneth Anger film, current events might have dramatically changed. In short, film was not yet a medium that would lend itself well to broadcasting urgent, time-sensitive messages from the underground.

The content of those messages from the underground has not remained static over the years: while the protests of the 1960s focused their ire on the military-industrial complex, broadcast media has been increasingly exposed as an adjunct to that powerful and resilient body. By the post-Industrial 1980s, numerous angry musical voices had risen up against unregulated, ecologically devastating industry and recklessly expansive, coercive forms of governance – but it would take some time until a music group would make the various permutations of mass communications its primary critical focus. Enter Negativland, the San Francisco-based group of technological whiz kids, media junkies and masterful audio-visual editors. By way of introduction, please indulge me in recollecting some moments from the Chicago stop of the band's *True/False* tour in 2000.

By making a tour stop at Chicago's House of Blues, part of a national chain of mid-sized live venues, Negativland have inadvertently chosen a perfect venue for their trademark form of musical sabotage: everything about the hall, from the faux-rustic atmosphere to the overpriced, deep-fried foods sold at the bar, shrieks 'corporate America', and seems to reinforce the band's thesis statement that everything now packaged and sold as 'culture' in America must pass through a corporate filter first. Jean Baudrillard would have had a field day here, since the venue is loaded with more simulacra per square inch than perhaps any other 'live music' venue in the U.S., save for the dining rooms in children's pizza parlors: those oddly unsettling places where the musical entertainers are a band of robots costumed as anthropomorphic animals. The House of Blues truly is a Disneyland for adults: at the very least, it is a microcosm of the adult American dream that one can participate in de-individualizing work in the financial sector, and yet still regain all that lost 'individuality' through the ritualized consumption of once-autonomous cultural forms like rhythm & blues music. Likewise, the childhood promise of having one's picture taken with Mickey Mouse is replaced with the possibility that real-life "Blues Brother" Dan Akroyd (the local Chicago comedian who partially owns the H.O.B.) may put in a surprise appearance. Perhaps another local venue like the Cabaret Metro, with its venerable track record of representing the city's punk and industrial scenes, would be more accommodating to Negativland's undeniably critical approach, but, here we are – in a venue owned by the world's largest 'live entertainment' business company (Live Nation) which co-opts poor, rural African-American culture while being nestled in some of Chicago's most prime real estate, the Marina City.

The amusing irony of Negativland's appearance here is, in the end, just one part of an extremely amusing 3-hour show, a stimulus festival served up by an indistinct team of white-suited technicians whose racks of gear are camouflaged by pristine white sheets (which, although they have an aesthetic value on their own, are being used as a video projection surface as well.) Their set features such anomalies as a mournful folk song dedicated to a favorite brand of lime soda, advertising detritus layered on top of polished heavy metal loops from ZZ Top, and a kind of audience 'sing-along' using lyrics on an overhead projector. During a lengthy instrumental segment, the band's mysterious master of intercepted communications, 'The Weatherman', appears via TV screen to rant about blighted urban America, while a pulsating bass groove moors his surreal story-telling into place. All told, the show would be a comic masterpiece if not for the effect of having the brain hammered with one out-of-context advertisement or pop music quotation after another: such a congested presentation gives you the unsettling feeling that you have wasted much of your life learning and regurgitating pop culture trivia or performing needless, automatic actions.

After about an hour of the band's noisy 'culture jamming' and chaotic distortion of mainstream media's signature elements, the complex setup of instruments and mixing equipment is temporarily cleared from the stage in order to make room for an unexpected interlude: a Christian puppet ministry supposedly on loan from an organization called 'Faith Fellowship', consisting of three hand puppets protruding from the open doors of a small spot-lit barn house. The side-show is a blatant send-up of the Christian children's skits which led to the fame of the late Tammy Faye Mesner, the former wife of archetypal televangelist Jim Bakker notorious for her garish mask of cosmetics. Jim Bakker-style charisma at least partially informs the character of Negativland mainstay 'Pastor Dick', who, in a winsome voice dripping with middle-American wholesomeness, moderates the proceedings. The three puppets in Dick's charge accurately embody the more grating elements of American Christianity in the era of cable and satellite television networks: there is an unnervingly optimistic 'recovered homosexual' squirrel named Dale Embree, a cynical and vindictive donkey named Chuck Mueller, and a terrified/paranoiac sheep named Nadine Lambert.

Eventually the puppet troupe tears down the 'fourth wall', acknowledging the audience (which they assume is an immoral one.) A sample of their dialogue:

Nadine: (moaning) I don't like it here! I'm afraid!

Dick: Oh, Nadine, now – what are you afraid of?

Nadine: Ohhh...the big crowd of people!

Chuck: Huh! If you want to know the truth, we're not even sure they really ARE people! (audience cheers wildly)

Dick: Now Chuck, our audience can't help what they look like.

Dale: Well, *actually,* Pastor Dick, our audience probably *could* help it. But I believe they've *deliberately* altered their appearance as a 'lifestyle choice'.

Nadine: Now I'm *really* scared...

Nadine then goes on to admit her true fear is that the audience members have not found salvation in Christ – in order to test their faith, Pastor Dick leads the audience in a round of the favorite Bible school tune "If You're Saved And You Know It, Say 'Amen'" – perhaps feeling that this didn't do the trick, though, the troupe joins together in a second barn-stomping number, which lays out their prohibitive and judgmental social agenda in laughably passive-aggressive terms.

The song's main refrain of *"If everyone cleaned up their act, then everything would shine/everyone would be like us, we'd be with our own kind"* betrays the impossible utopian hope of the Evangelical Christian movement, and is punctuated by sermonizing from the puppets about how 'the unemployed should get a job, there's lots of them out there!' and 'I'm sure all homosexuals could make themselves go straight!' Like Laibach's hyper-real 'fascist rallies', this kind of display is both humorous and frightening, and both groups succeed on the strength of their ability to be "more x than x itself": portraying the subject of criticism in such an adulatory, flattering way that it exposes the truly unflattering characteristics of that subject. As we will see, though, this humorous form of 'love bombing' (an exaggerated form of praise meant to win converts to a faith) is just one of the aspects of 'coercion culture' that is reflected in the funhouse mirror of Negativland's art.

Bite Back

Negativland, despite the novelty of many of their actions, are part of a long tradition of wrenching consumer electronics from their intended use as pacification tools. Home entertainment playback devices, like record turntables, were re-envisioned in pieces like John Cage's 1939 composition *Imaginary Landscape No. 1* as tools to be manipulated and not merely 'heard'. Fluxus artists like Milan Knizak showed similar tendencies – see his short *Broken Music Composition* (which pre-dates the CD 'glitch' techniques of Oval by four decades.) Nam Jun Paik, also an artist associated with Fluxus, regularly used television sets as artistic building blocks for his sculptures – one of which is, appropriately enough, an American flag composed of 70 monitors (*Video Flag.*) A strong desire to sever television off from its role as the temple of consumer culture, and to use it as a divining tool,

also shows through in pieces like *I Ching TV*. In his video collage piece *Suite (242)*, a narrator invites the viewer to participate in a ritual which will reconfigure the television as a meditative device: turning the TV screen towards the wall, then tuning the box to a dead channel while cranking the volume of the white noise louder, and dimming the lights in the room – all in a concerted effort to "find out what television has to say to us, from the other side."[7] This was a practice that would be encouraged by members of the Temple ov Psychick Youth and by their musical counterparts Psychic TV, who – echoing Paik's 'monitor sculptures' – would arrange television sets on stage in the shape of their heretical "Psychick cross" logo. The politicized hip-hop act Disposable Heroes of Hiphoprisy did the same in the early '90s, with a Christian cross formed from TVs appearing as a motif in their video for "Television: The Drug Of A Nation," hinting at a different, and more sinister kind of mystical potential for television – one diametrically opposed to the suggestions of Paik and Psychick Youth.

Negativland, however, have mostly eschewed spiritual elements, adopting a more pragmatic view of what their work will ultimately accomplish, and noting the corporate/State media's advanced ability to recuperate any kind of 'alternative' dialogue back into its hegemonic power structure:

"In Negativland, we understand that those who create culture for distribution by the corporate dream machine have no effect on how they operate. Even when work is criticizing the machine that is consuming the work, you will not notice even a hiccup in response. In fact, such work is often welcomed because it proves the machine is the pillar of free expression in a democratic society that it claims to be."[8]

In other words, even the most virulent forms of protest can be re-packaged as entertainment. One 1967 incident on the *Smothers Brothers Comedy Hour* illustrates this scenario perfectly: the 'hippie' act Buffalo Springfield had been booked to perform their protest song "For What It's Worth" on the program, although the numerous cutaways and comedic interruptions during the performance of the song ruined its ability to be taken on face value. As Aniko Bodroghkozy describes it,

"[Buffalo Springfield singer Stephen Stills]' comments about police power weighing down on the rebellious young, and the generational gulf created by the war in Vietnam, were obliterated by the manner in which the lyrics were illustrated. For those already familiar and aligned with Stills' sentiments, the meanings of the song were still available despite the comic intrusions. For audience members who did not know the song and its political implications, the cutaways may have made the material politically meaningless."[9]

Bodroghkozy also suggests that, since the 1960s, there has been a steady increase in anti-establishment, anti-corporatist programming on television: she states, for one, that "businessmen were consistently disparaged and demonized in the aftermath of the 1960s,"[10] citing *Dallas* character J.R. Ewing in this regard. Bodroghkozy also claims that, even in the right-wing triumph of the 1980s, shows which took a politically conservative tack "...ended up being a ratings loser, if the project even got past the development stage."[11] The 1990s and 2000s naturally sealed the deal with the massive popularity of irony-laden, left-leaning cartoon shows like *The Simpsons* on the Fox network, but television was far from being a stimulus for radical new modes of thinking: television transmissions were still, after all, a combination of entertainment and advertising, and the messages contained in ads could easily neutralize whatever morals were contained in the programming proper. Better yet for the advertisers, programs which documented or portrayed some kind of social discontent could agitate viewers into buying more product: personal crises could help to sell beer, soporific drugs, and various identity-enhancing items in an attempt to alleviate the discomfort caused by footage of genocidal slaughter in Africa or child abuse in middle America.

Meanwhile, the 'serious' 24-hour news networks of the 21st century present cultural upheaval in a kind of "infotainment" format, so framed with slick graphics and high-tech effects, that the events themselves appear to have been fictionalized or dramatized. The utterly trivial (like a celebrity's 'coming out' or secretly filmed drunken escapades) can be projected as something of

world-shattering importance, and matters of world-shattering importance can be downgraded to passing irritations. To this end, the 'sound bite' (which will hereafter refer to short clips of audio as well as video with an audio component) is still one of the most deadly arrows in the corporatist media quiver, with an efficacy that can, in the space of a few seconds, destroy or discredit political campaigns, cultural movements, and academic careers that have taken years to build. So, unsurprisingly, the sound bite is also the main weapon in Negativland's acute counter-strike on media exploitation – the group's best pieces are built from dozens at a time. Just as the corporate media has co-opted 'alternative' ideals and diluted them into fashion statements and purely cosmetic concerns, the dominant icons of mainstream media have been by re-designed by Negativland as something else entirely. By isolating select moments from countless audio and video recordings, and pairing them with 'leaked' recordings of badly behaving celebrities or intercepted private communications, all kinds of things become possible: a well-loved radio announcer is unmasked as a cynical and vulgar egomaniac, leaders of obscure religious cults alternately lend their endorsement to MTV stars and damn them to the eternal pit of hell, *Sound of Music* star Julie Andrews joyously sings that "girls with blue whiskers, tied up with noodles" are one of her "favorite things."

Triumph of the 'Stupid'

The puppet show farce described above is not Negativland's first foray into criticizing the media as an evangelizing tool – perhaps its first major success in turning this media against itself was the track "Christianity is Stupid" off of their 1987 *Escape from Noise* LP. This would soon become the fuse for a deviously executed media hoax that would raise the bar for all future attempts at 'culture jamming', exposing the gullibility and manufactured hysteria hard-wired into mass media, especially the 'infotainment' of nightly news broadcasts.

The original song samples liberally from a 1971 Christian propaganda film entitled *If Footmen Tire You, What Will Horses Do?,* which illustrates a nightmare scenario of American takeover by Communist forces that will happen if the country does not experience a full-scale Christian "revival". Of course, a land invasion of the U.S. was hardly feasible during the Cold War period, but that is beside the point. The exasperated narrator of ...*Footmen,* a reedy-voiced Southern Baptist preacher named Estus Pirkle, becomes fodder for Negativland in a most unequivocal way when his doom-and-gloom pronouncements are snatched from the original context of the film, and set against a backdrop of thudding industrialized rock. In the film, Pirkle narrates a scenario in which beleaguered Christians are forced by their Soviet captors to sit around a campfire "from 5 o'clock in the morning...to 10 o'clock at night" endlessly chanting "Christianity is stupid... Communism is good... *give up!*' Negativland removes this selected quote from its surrounding narrative framework, reducing Pirkle's message to the exact opposite of what it wished to convey: in song form, its defeatist message is more like the kind of 'Tokyo Rose' broadcast used to deflate American troops' morale in wartime. Of course, on one level it is a poke at the terrified bunker mentality that is adopted by the evangelical Christian movement even when it is, in reality, quite powerful. More importantly, though, it is also a comment on the power of the "blurb" or "sound bite" to severely alter a speaker's original intentions, harmonizing them with whatever pre-scripted template that the mainstream media is presently using. And if the original manipulation of the Pirkle footage was not illustrative enough of this tendency, it was taken even further in Negativland's live concerts of the time: hearing Pirkle's alarmist message re-edited to say "Christianity is Communism!" takes the content to even loftier plateaus of subversion.

For Negativland, the mass media 'soundbite' or sample is perhaps their most compelling instrument, despite the band's competency with traditional keyboards, guitars and vocals. The Estus Pirkle quote is just one in a staggering catalog of alternately chilling and laugh-out-loud appropriations collaged together with surgical skill – a skill that, given the effort and timing involved in selecting individual samples from an ocean of recorded and broadcast sound, can capably be called virtuosity. The band also has a special talent for unearthing the clandestine: much

of the sampled material in Negativland's *oeuvre* was clearly *not* intended by its originators to be in the public domain. Try, for starters, a pirated recording of the legendary American 'top 40' radio DJ Casey Kasem, as he unleashes a breathtaking torrent of profanity on one of his aides in the studio sound booth: upon receiving a request to dedicate a song on air to the deceased dog of a listener, an audibly enraged Kasem rants about the impossibility of segueing into this dedication from a "fucking up-tempo number". The Kasem rant has been left intact, largely unedited, because in this case it 'speaks for itself' – Kasem tells us all we need to know about the hot-tempered control freak which occasionally lurks behind his public façade of wholesome likeability. But this may be the exception in Negativland's sampling campaign: for every Kasem rant there is something like the piece "O.J. and his Personal Trainer Kill Ron And Nicole." This is built on samples from an O.J. Simpson exercise videotape, in which the ex-football star and widely suspected wife murderer good-naturedly chats with his personal fitness trainer about his blood circulation: "...getting the blood flowing," as it were. This is set against a backdrop of screams and other violent sound effects. It is the kind of stuff that easily provokes lawsuits over defamation of character, and Negativland did take a definite risk with this kind of presentation – but first more about their work itself before the consequences of that work come to the fore.

The true *coup de grâce* of Negativland's "Christianity is Stupid" came not with its inclusion on the *Escape From Noise* LP, but with the subsequent usage of the song in a carefully staged, tragicomic media event. In the beginning, this was not a simple one-off prank, but a means of releasing the band from some unwanted obligations: *Escape From Noise* had, somewhat unexpectedly, gained the band an attentive following in the alternative music world. Even an independent record label like SST, to which Negativland was signed at the time, would have wanted to convert this popularity into a concert tour – an option which, according to Negativland's Mark Hosler, was an impossibility for the band:

"The real reason that we had to cancel the tour was that we weren't going to make money; we couldn't afford to take time off from our jobs and lose money. One member of the group suggested that we think of a more interesting reason why we can't tour, and so we put out a bogus press release saying that we were being investigated by federal authorities, because of a possible connection between the song 'Christianity is Stupid' and a quadruple ax murder in Rochester, Minnesota. A few fanzines came out that reported it, and then a magazine in California called *BAM* wrote about it, and it just started to snowball. Then KPIX, which is a CBS News affiliate here in the San Francisco Bay Area, picked up on the *BAM* article, came to our studio and interviewed us. After that ran on TV, the *San Francisco Chronicle* saw the KPIX news broadcast and then *they* wanted to write about it, and at a certain point we decided that it was turning into something where we were going to be guilty of this gratuitous exploitation. There was no way to ever get around that, but it was turning into that more and more, so we then decided that the best thing to do was to make a record out of it that explained what had really happened: how we had lied."[12]

Although the influence of "Christianity is Stupid" on the aforementioned murder was a concoction of the band, the murder itself was a real incident plucked from the headlines of the day: a 16-year old Rochester teenager named David Brom had indeed murdered every member of his immediate family, allegedly over religious disagreements (which, as the hoax went, were amplified to the breaking point when "Christianity..." sent Brom over the edge.) The 'religious argument' angle of the hoax was included as a nod to the media's then current, pseudo-scientific obsession with backwards messages and subliminals included on popular music recordings. One such element in the 1980s news cycle was the allegation that, upon hearing the message *"do it"* subliminally encoded in a song off Judas Priest's *Stained Class* album, Nevada teenager Ray Belknap killed himself with a 12-gauge shotgun. In the ensuing trial over subliminal content, the issue of Belknap's troubled relations with his family, and his general mental instability, were predictably downplayed by the prosecution (although Judas Priest's defense attorneys certainly made them an issue, as can be seen in the documentary film *Dream Deceivers*.) Although Judas Priest was on trial and the family of Belknap was not, the family did have to acknowledge some factors that would put their son 'at risk'

of committing suicide upon hearing such an apparently neutral message as *"do it".* According to *Skeptical Enquirer* writer Timothy E. Moore, both Belknap and his friend Ray Vance, who seriously disfigured himself in an attempt to commit suicide alongside his friend

"...felt socially alienated; they were emotionally distressed, often depressed, and impulsive. Vance once broke another student's jaw in a fight at school. Both had a history of drug abuse, petty crime, school failure, and unemployment. Family backgrounds were violent and punitive. Belknap had attempted suicide before and had expressed suicidal intentions. Just prior to the shootings, Belknap gave out some of his Christmas presents early and indicated a desire for his sister to name her baby after him if anything happened to him. Most of these factors were mentioned by the judge in his final ruling. They were included 'reluctantly' to show that the deceased were at high suicide risk (see Litman and Farberow 1994.)"[13]

Furthermore, Moore (who was a witness at the trial) writes that the effectiveness of subliminal messages has never been proven in any rigorous study:

"There is not now, nor has there ever been, any reliable empirical evidence that subliminal stimulation can produce anything other than fairly brief and relatively inconsequential reactions. Further, there is no evidence whatsoever that subliminal directives can compel compliance, and no such evidence was presented at the trial. Perhaps with the help of the defendants' experts, the judge came to realize that subliminal directives do not have the influence attributed to them by the plaintiffs. A more thorough grasp of the issue might have yielded a summary judgment, thereby precluding a long and expensive trial".[14]

Finally, it should be mentioned that the placement of such a hidden message by a professional music group would be a reckless career move. As Judas Priest vocalist Rob Halford intimated, what band, with serious aspirations towards making money in the entertainment business, would want to risk depleting its fanbase by ordering them all to kill themselves?

Although the Judas Priest trial would not take place until 1990, it was precisely this climate of poorly researched, sensationalistic reportage that spawned the 'David Brom' element of Negativland's scam. Negativland's Don Joyce suggests that the "Christianity..." hoax was so successful in its critique of media that it was revelatory even to the band. The group had always been reasonably suspicious about the actual degree of truth contained in mass communications, but had even their own expectations shattered by reporters' willingness to accept Negativland's bogus press release as a legitimate news source:

"We found out that journalists *routinely* do not check sources, they simply re-print, cannibalize and copy what's been written elsewhere in the news, which *they* believe when *they* read it. And it's so routine it's frightening."[15]

Meanwhile, "Christianity is Stupid" made a 21st-century comeback of sorts, in a media climate once again obsessed with the violent fringes of religiosity: to coincide with the release of Mel Gibson's gore-soaked film *The Passion of the Christ* ("the most violent film I have ever seen" according to film critic Roger Ebert)[16], Negativland used "Christianity..." as the soundtrack for a video collage composed almost entirely of films – *Passion* and others – depicting Christ's flogging and crucifixion. In doing so, the band was in clear violation of the Digital Millenium Copyright Act (DMCA): the film used to edit *Mashin' of the Christ...*, since it was obtained around the same time as the movie's actual theatrical release, would have been an illegal decrypted copy, and the DMCA states that it would be illegal to use this material even in the making of collage art. Nevertheless, the *Mashin...* video is still in heavy circulation on the Internet as of this writing, and it was even uploaded to peer-to-peer file sharing networks by some mischievous subversives who convinced downloaders that it was a full version of Mel Gibson's original *Passion* film.

The Copyright Fence

Unfortunately for them, Negativland will not be remembered only as the band that pulled off the grand *Helter Stupid* performance almost without a hitch, but as the band which engaged in a

financially and emotionally draining legal battle with Island Records – at the time the record label of the platinum-selling Dublin rock heroes U2. The saga began with the 'leaked' Casey Kasem radio rehearsal mentioned above, in which the disc jockey goes into a fit of pique when being forced to read out the names of the U2 band members on air – *"these guys are from England, and who gives a shit!"* is Kasem's famous explosion (made extra humorous by the fact that, moments before in the same recording, Kasem had correctly identified the band as being from Dublin, Ireland.) Despite some foolish public relations moves made on behalf of SST Records, to whom Negativland was signed at the time (SST released a t-shirt featuring a "KILL BONO" design), the record was more concerned with the ambiguity and limitations of broadcast language than it was with launching a direct attack on U2's star status. In fact, the record featured a number of other samples which obscured the record's exact message: more samples of anti-rock 'n roll evangelists railing against the power of "the beat", more random irate callers to radio shows, more enlightening voices cutting through the insanity to lecture on the history of vulgarity in broadcast media. Nevertheless, this was not enough for Island's lawyers, who served Negativland with a lawsuit before even issuing a 'cease and desist' order.

Initially, the objection from Island Records came as a result of the U2 ep's cover art being a "deceptive" use of their property: a viewer's visual hierarchy might cause them to think it was indeed a new U2 album, since the word 'Negativland' appeared on the cover in much smaller print than 'U2', which was also placed above 'Negativland'. The cover art for the offending record featured the letter U and the number 2 in a bold typeface which spanned the album cover, but also featured a graphic of a Lockheed U2 spy plane (a visual pun whose meaning was initially lost on Island's legal watchdogs.) As Negativland and their sympathizers have noted, it was ironic that the name of a well-known Lockheed product was being appropriated, even "trademarked," by a world-renowned rock band – this with no protest from the plane's manufacturers. The ep *did* feature liberal sampling of U2's smash hit "I Still Haven't Found What I'm Looking For," with one version of the song replacing Bono's lyrics of romantic longing with a laughably awkward and obsessive stream-of-consciousness monologue from the nasally-voiced 'Weatherman' (also the band's specialist for intercepted communications.) This would be discovered by the Island team soon enough, but in the meantime, there was the controversial cover. About this, Don Joyce says:

"We would have changed the cover if they'd asked us to, but they never did. They never even asked about that. They just had this sledgehammer approach which is based on being so big and so rich that no one can fight them."[17]

Negativland's near-destruction at the hands of Island's legal team turned them into unwitting spokespeople for the concept of fair use and copyright law. The band has been especially acute in its condemnation of entertainment conglomerates, like Disney, who rise to prominence in very much the same way that Negativland did: by tossing aside the myth of 'originality' and creating new works that may be indistinguishable from previous works, at least in certain aspects.

Don Joyce features in a short film entitled *Mickey & Me*, which details the case of a video store owner being served with a $110 million lawsuit by the Disney corporation, merely for the act of making theatrical trailers for Disney films available on his store's website – an act which was, in essence, *promoting* Disney product. Disney's strong-arm legal attempts to have complete control over their properties (Mickey Mouse, Donald Duck etc.) are shown as being hypocritical in light of Disney's own numerous appropriations: *Snow White*, though falsely assumed by some to be a Disney original, was simply an animated re-hash of an earlier silent film, which was itself inspired by a Grimm Brothers fairy tale. *Steamboat Willie*, the legendary 1928 Mickey Mouse cartoon which was the first cartoon to feature a musical soundtrack and sound effects, was revealed as a structural parody of Buster Keaton's short film *Steamboat Bill Jr.* Professor Lawrence Lessig of Stanford Law School, also featuring in *Mickey & Me*, summarizes the inconsistency and power consolidation of such multi-media megacorps in a manner worth being quoted here:

"Was *Steamboat Willie* theft of Buster Keaton's *Steamboat Bill*? I think the answer's got to be 'no, it wasn't'. Yet, the freedom to make *Steamboat Willie*, which was the core behind Mickey

Mouse, would be denied today if anyone tried to take a Disney character and make an equivalent takeoff, and produce a new line of creativity on the basis of that. Now that's to show, you know, one argument in this is the argument about hypocrisy. What justification is there for this radical expansion in the ability of the past to control the future, when so much of the greatest part of the past was made in a context where creators before *it* were not able to control it?"[18]

On the topic of legal troubles, the trials of Canadian 'plunderphonics' godfather John Oswald should not go unnoted either. Like the 'U2' ep, John Oswald's 1989 Plunderphonic CD, an independent release, caught the attention of the record label lobby group CRIA [Canadian Recording Industry Association] through a cover which mimicked the design of Michael Jackson's *Bad* – the head and leather jacket of Jackson, from the original *Bad* LP, were placed onto the body of a naked white woman. According to Oswald, some 6,000 copies of the original album leaked (and one of these may fetch you a 4-figure dollar sum, if you own one)[19], but all the rest were unceremoniously crushed, along with the master recordings. In no way, though, did Oswald ever attempt to convince listeners that the music on the 'banned' Plunderphonic CD was his own creation from start to finish: he has even gone so far as to list all the sources he has sampled on his releases, using the credits in the same way that the writer of a research paper would use bibliographical notes. For his song titles, Oswald also delights in soldering together the names of appropriated musicians in order to form *portmanteau* such as "R.E.M.T.V. Hammercamp" and "Marianne Faith No Morissey" (see his release *Plexure* on the Avant label for a full listing of these Frankenstein monsters.) Another game involves using the names of the original artists and making them into anagrams for the listener to decipher: Michael Jackson becomes "Alien Chasm Jock," James Brown becomes "Jem Snowbar," and Bing Crosby becomes "Gibbons Cry." Oswald's mischievous practice also has its visual equivalent in sound artist Christian Marclay's *Body Mix* series of collages, which take unmodified original LP album covers and overlay them at key points so as to create aberrant pop-rock monstrosities from conjoined body parts.

John Oswald's work, while it has met with the same controversy as Negativland's, and also uses dense masses of manipulated samples as its raw material, largely ignores the topical content that animates Negativland discs. Although one of the seminal pieces of this genre – Oswald's 1975 piece *Power* – combines the bludgeoning rock of Led Zeppelin with an equally intense revivalist preacher, his later Plunderphonic works have passed on the chance to criticize crass TV entertainment, consumerism, and prudish forms of religiosity. Unlike Negativland, Oswald composed his most talked-about pieces by himself with a digital audio editor, and did not make the occasional forays into mimicking 'real' pop song format with conventional instrumentation (although Oswald is a capable sax improviser on the side.) The concept of *ostranenie* ['making strange'] figures heavily within the music, which, despite a preponderance of humorous content, can also delve into the realm of the haunting and beautiful (this is especially evident on later discs released under Oswald's birth name rather than the Plunderphonic moniker.) While it's hard to repress instinctual laughter upon hearing Oswald loop James Brown's grunts and elated shrieks to inhuman lengths, there are moments of bliss, as well, like when Michael Jackson's "Bad" is given some kind of Gaussian blurring treatment, reducing the Quincy Jones dance-funk concoction to a narcotic haze of stuttering voices and brittle rhythms. It is an obvious bit of computer processing magic, but is no less captivating because of it. Once again, Christian Marclay pops up as a point of reference: in this case for his feted art object *Record Without A Cover*. A thick haze of disorientation hangs over this crafty audio montage of samples from $1 bargain bin records, and not just because the record – as suggested by its title – was meant to become dirtied and rapidly degraded upon purchase, gradually absorbing new audio ephemera (pops, crackles etc.) into the original mix. Like Oswald, Marclay tantalizes the listener with the sound of vaguely familiar "made strange" – the record's obscured and fouled sound snippets capably disrupt the mental filing processes of popular music junkies, especially those who are too concerned with "who-did-what-when" musical trivia to enjoy audio artefacts at a sensory level – as odd as it may seem, *Record Without a Cover* is (for this author anyway) a genuinely pleasant listening experience on its own merits.

The broad usage of the quasi-legal audio sample, as both an aesthetic device and as a lucid form of socio-political commentary, now figures into the work of an expanding number of artists: the anarchic, often contrarian "irritainment" of Negativland and Messrs. Marclay and Oswald was more recently yanked into the new millennium by Stock, Hausen & Walkman (a blatant pun on the Stock, Aitken & Waterman pop music assembly line – Andrew Sharpley and Matt Wand are the 'civilian' names of the band's twin sample-wranglers.) Stock, Hausen & Walkman's release of a record entitled *Buy Me/Sue Me* would seem like a subtle hint that the ongoing drama swirling around copyright law was beginning to supercede musical content (in this record's case, the 'musical content' was limited to 42 locked grooves, each one containing a different voicing of the word "me" repeated *ad infinitum*.) More detrimental than the legal tug-of-war over sampling, though, may be what happens when these adversarial forces of hyper-commerce *embrace* it as a means of creative conduct, replacing the acumen of more critical artists with the desultory "throw something against the wall and see if it sticks" quality which is its hallmark.

Good Jammer, Bad Jammer?

"The process of replication functions even in cases in which the intent is critical, or the identification is made with a non-conformist model; anti-conformism creates a norm for replication, and in repetition music is no longer anything more than a detour on the road to ideological normalization."[20] (Jacques Attali)

"These ad people thought it would be really cool to hire Negativland. They wanted to give us their ads to cut up and do things with, and mock them and manipulate and do our Negativland 'thing' to. Since they were offering us a lot of money – $25,000 or so – both Don and myself immediately thought, 'Wow, we'd like that money, that sounds great. Is this an opportunity we could do something with?' Because over the years when weird things have happened to us, like when we've gotten in trouble, we've looked at these things as opportunities, not problems. In this case, my brain was doing the same thing: 'Can we somehow subvert these guys and do something interesting with this, and turn the tables on them?' And what I then realized was, 'Wait a minute, they called us because they want me to be thinking exactly what I'm thinking right now! That's what they want the ad to be.' So then I realized that we'd been had, we were fucked. There wasn't any way you could out-think them."[21] (Mark Hosler)

As suggested by Hosler above, the artistic technique that was once a gesture of defiance from the corporate feudalists' downtrodden serfs has been absorbed back into their machinery. The aesthetic of irreverent re-appropriation and "guerrilla remixing" has successfully wormed its way into a mainstream Western culture which now embraces irony and self-reference as 'hip', 'cool' marketing tools. In the U.K. and U.S., the coveted youth demographic of 18-35 years' age has, since the 1990s, favored consumer products which re-package familiar iconography in a manner more in keeping with the younger generation's post-modern questioning of cultural absolutes, and in keeping with their occasional dives into pure cynicism. Film comedies, especially those coming out of Hollywood, aim to court this market with 'spoof' movies featuring little more than a visual mash-up of characters and situations from dozens of other recently released films. During the writing of this chapter, the directors Jason Friedberg and Aaron Seltzer, famous for this gratuitous brand of entertainment, have parlayed another one of these films into an $18 million box office opening. Considering the legal troubles which have dogged Negativland, John Oswald and numerous other artists for their parodic use of popular songs, it seems puzzling that movies like the one in question (*Meet the Spartans*), whose very lifeblood and narrative substance is formed by chaining together exaggerated reenactments of moments from other popular films, are given the 'green light' to exist. It is a popular enough formula with the 'booboisie' so derided by Mencken, but it has also sustained a firestorm of criticism. Of a previous Friedberg and Seltzer production, *Onion* critic Nathan Rabin encapsulates the confusion surrounding these 'spoof' films' existence: "Is it enough to simply place a familiar pop-culture phenomenon into an unfamiliar context? Can contemporary comedy be

reduced to the simple equation 'pop-culture reference + slapstick violence or scatology = hilarity?'"[22] So far, the answer seems to be a resounding 'yes' in a culturally cannibalistic America.

The popularity of the re-appropriation aesthetic is also evident in the youth fashion and design industries, where the turn of the millennium has been marked by a deep suspicion of imagery that appears sincerely happy or unashamedly positive – the assumption is that most, if not all, prosperity in 1st-world cultures must be either superficial or ill-gotten. So, these images, when employed, should therefore be worn in a 'critical' manner or should be combined with other paraphernalia that diffuses their meaning. For example, a cute, pastel-colored t-shirt from a popular cartoon franchise like Hello Kitty or My Little Pony combined with the more violent and monochromatic imagery of punk rock bondage gear. The skull and crossbones, once the heraldry of outlaw motorcycle gangs, has also been "cute-ified" by being knitted into brightly colored socks, scarves, mittens and other clothing items. This mixing and matching of cultural signifiers from all over the map extends to the realm of the spiritual, and crosses class divisions as well: crucifix pendants being worn by people with no allegiance to Christianity, Celtic knots combined with Taoist icons, or cheaply made, mesh-backed truckers' caps worn with expensive designer jeans. Other unmistakable signifiers of class, like cans of the cheap, poor-quality 'working class beer' Pabst Blue Ribbon, are thrown into the mix as fashion *accoutrements*. The above styles, popularized by leisure culture magazines like *Vice*, show what can happen when re-appropriation is abused: in this case, mockery of the working poor by the well-funded, youthful elite of districts like Williamsburg in Brooklyn, or Chicago's Wicker Park neighborhood.

For the purposes of this chapter, let's assume that 'abusing' this aesthetic means using it in ways contrary to what the aforementioned artists have done. Advertisement-laden magazines like *Vice* tend to visually 'sample' the culture of the underclass or of the outsider, pulling it into the glossy world of high fashion – such actions reinforce the dominant culture's oppressive program of stereotyping rather than subverting it. Sampling – be it the 'text sampling' of a Burroughs/Gysin cut-up, the visual icon sampling of a Heartfield anti-fascist collage, or a Negativland sound work – is meant to challenge the status quo or dominant order and to pinpoint its weaknesses, not to strengthen that order's monopoly on expression and guiding discourse. In the case of *Vice* readers, the willful adoption of lifestyle habits associated with poverty is called 'irony' – but is really a smokescreen for reactionary attitudes; a thinly-veiled support of the status quo.

The backlash has already begun, though. If nothing else, the limitations of the post-modern youth culture blender to create meaningful discourse is at the center of an increasing number of angry editorials and bitter satires – Chris Morris' and Charlie Brooker's 2005 comedy mini-series *Nathan Barley* is a prime example of the latter. Brooker is inspired in no small part by the success of pseudo-anonymous South London graffiti artist Banksy, whose work Brooker calls "imbecilic daubings" and "vague, pseudo-subversive preaching".[23] The show's titular anti-hero is a parentally-funded, would-be subversive (in his own words, a "self-facilitating media node") who runs a calculatedly offensive website called 'Trashbat'. Barley enjoys broadcasting and consuming meaningless acts of cruelty online, is enslaved to social climbing and material acquisition, and seems basically incapable of taking anything seriously: when Barley's roommate Claire, a video journalist, attempts to show him her documentary film footage of a of a 'junkie choir,' Barley immediately assumes that the film is meant to ridicule the sincerity of the choir members.

Some of Barley's antics are almost indistinguishable from Banksy's: a flyer for a Trashbat dance party features disturbing images of detainees at the Guantánamo Bay prison, mimicking a stunt in which Banksy snuck a dummy in Guantánamo prisoner garb into Disneyland. In one episode, the 'splash page' of Barley's Trashbat site features an image of a police officer slitting his wrists, which is a carbon copy of Banksy stencil design. When not directly referencing Banksy, Barley still finds other ways to shock for its own sake: he wallows in self-promotional pseudo-profundities such as *"Trashbat is... two people leaping from the Twin Towers... and they're fucking on the way down!"*[24] In addition to taking aim at Banksy, the program fixes its sights on *Vice* magazine as well: the fictional magazine *Sugar Ape* in *Nathan Barley* lampoons the real-life tendency of *Vice* to

"remix" atrocity and to deal with social issues by trivializing them. One episode prominently features a *Sugar Ape* special issue entitled 'The Vice Issue', whose centerpiece is a fashion shoot featuring female models pretending to be underage and placed in sexually compromising positions. The use of sampling and re-appropriation has become, in the hands of fictional fauxhemians like Barley and his real life equivalents, a valuable tool in declaring that 'nothing is sacred', even though such a proclamation ignores the existence of belief systems beyond the boundaries of the 1st world: and even *within* the 1st world this is far from a blanket truth. If anything, the tendency of privileged "media nodes" to marginalize and misrepresent has encouraged more violent retaliatory actions from those who wish to re-sanctify their environment.

Banksy himself is not nearly as grating as the Brooker/Morris TV caricature, although he hints at the efforts of overground culture to absorb his work by claiming that "Nike have offered me mad money for doing stuff,"[25] and has been commissioned to design an album cover for Brit-pop sensations Blur, while courting the attention of mega-stars like Brad Pitt. His art, as portrayed in catalogs like *Existencilism,* shows an art with a definite disrespect for authority: columns of riot police with smiley face logos inserted beneath their visors, rats wielding detonator devices and other wrecking equipment, London Tower guards relieving themselves on city walls in plain sight. Banksy also traffics in absurdist moves such as stenciling his name onto animals. It shares many of the same goals with copyright-flaunting forms of underground electronic music (Banksy outlines his contempt for the advertising industry in the preface to his catalog *Wall and Peace*), and presents a form of publicly viewable art which requires no admission price. However, Banksy becomes questionable when making statements that smack of absolutism: see his axiomatic saying "there are no exceptions to the rule that everyone thinks they're an exception to the rules," or his not infrequent claims that "all cops are x" or "all artists are x." It is this kind of heavy-handedness and inflexibility that leads eventually to new dissent-smashing political systems, as one *Guardian Unlimited* reader points out:

"Banksy's political attitude is actually deeply conservative, because it assumes most of us are zombies who need to be 'shocked and awed' into a new consciousness through 'radical' juxtapositions of symbols. The parallels between the proponents of 'subvertising' and 'culture jamming' and the American neoconservatives are telling. We just see the shadows on the wall; only they can see the truth."[26]

Banksy is also allied with hip-hop producer and 'mash-up' artist Dangermouse, with whom he initiated a project criticizing the debutante heiress Paris Hilton: copies of her debut CD were purchased from record stores throughout the U.K., then replaced in store bins after the original artwork had been defaced, and song titles had been altered to comment on Hilton's 'celebrity for the sake of celebrity'. Dangermouse also gained some fame (and a 'cease and desist' order from EMI) through his release of *The Grey Album,* which mixed together the vocals from hip-hop artist Jay Z's *The Black Album* with the Beatles' *White Album*. While it is an occasionally humorous exercise (and one which even inspired a sequel mixing together both the 'black albums' of Jay Z and Metallica), it is questionable what kind of artistic statement it hopes to make. It is perfectly fine as entertainment, but attempting to read a deeper meaning into it will not always yield profound revelations. Many graffiti artists mobilize with no other agenda than just alleviating the stifling boredom and visual monotony of the city, or enjoying the element of danger that comes from defying the surveillance state. Likewise, many mash-up producers merely want to have a laugh and invite others in on the fun. If nothing else, it places a technique which was once the exclusive domain of the avant-garde into the hands of an even younger and less professional group of creators than ever before, who have newer ways of skirting the edicts of the corporate music industry: even artists in the hip-hop and post-Industrial genres had to deal with record pressing plants and printers where their work could be refused, or where it might be scrutinized by RIAA officials. Not so with the 'mash-up' generation: with Internet distribution and home CD-r duplication as a possible method, they can reach thousands of listeners before the full weight of copyright law comes down upon them – if their activities are noticed by the law at all. Like Banksy's

stencils, though, the musical mash-up is a very hit-or-miss affair, not always achieving the consistency and idiosyncratic value of Negativland's attack. Mark Hosler admits to enjoying music of the genre, though:

"There are thousands of 13-year-olds all over England who are taking their PCs and iMacs and they're just dragging little sound files one on top of another to make new songs. It's very punk rock. It's great. You don't have to know how to play anything at all. Also what's interesting is that it seems to have no political, cultural critique in it whatsoever; it's just about making some funny thing you can dance to. A couple years ago on the 'True/False' Tour, I used a ZZ Top song played at the same time as Julie Andrews singing the theme from *The Sound of Music*, and made it work, and it was really funny. It's a very satisfying thing to pull off."[27]

It can be argued that some mash-ups do much more to entrench the cult of personality surrounding entertainers than they do to expose them as pre-fabricated 'one-man brands': a theory proved in part by the popularity of Dangermouse (now one half of the platinum-selling hip hop act Gnarls Barkley) as a 'legitimate' producer now recording 'real' tracks sanctioned by the record industry. Other mash-up technicians, like Kid 606, are unashamed about their creations' use as a celebration of (or even a 'love letter' to) the original mega-star, and as a "what if..." fantasy of an aesthetic fusion that would probably be outside the musical range and contractual obligations of that wished-for star. Kid 606 is known for his love of sonic grit and self-destructing, clattering synthetic beats, as well as a love of harsh and confrontational musical genres such as Industrial and grindcore – even with such a pedigree, his use of vocal tracks from eccentric R+B artist Missy Elliot in a mash-up is a wish for an alternate universe in which both artists reside on the same artistic and commercial plateau, rather than an attempt to demean Elliot's work. This kind of thing can be viewed objectively, though, and sometimes only the artists' personal statements about the final intent of their work – if any statements are published at all – can truly answer the question of whether the mash-up is an attack upon, or an embrace of, popular culture. For every confrontational commando unit like V/VM, there is a sympathetic figure like Jason Forrest who "does not share V/VM's contemptuous approach to pop culture"[28] and claims that

"I think my music is really sincere... there's no 'isn't this funny' kind of gesture involved. If there's a rock riff, it's a rock riff that I really love. The Go-Gos song I use is just a fucking great Go-Gos song."[29]

On a side note, Forrest, who records as Donna Summer, has not yet been called upon to stop using the name of the 'real' disco diva Summer on his records. It either suggests that Forrest has been keeping too low of a profile to be discovered by the guardians of intellectual property, or it marks an interesting sea change in the attitude of the record industry that so mercilessly descended on Negativland for their *U2* record. With the substantial decrease in record company profits rising from illegal music file-sharing networks, perhaps the powers that be have turned their attention elsewhere for now, perceiving free downloading and distribution of their product as much more of a threat than people like Forrest (who is, after all, paying homage to their product and visibly promoting it.)

Some groups manage to both succeed *and* fail at presenting the mash-up as social commentary: the Evolution Control Committee's mash-up of Public Enemy's intense and militant rant "By The Time I Get To Arizona," twinned with the peppy, inoffensive muzak of the Tijuana Brass, manages to highlight the enraged political message of the Public Enemy track even more than the original version, although their 'breakcore' reworking of Spandau Ballet's lachrymose, icy ballad "True" really offers no new comment on the original – as with Kid 606' Missy Elliot appropriations, it would be hard to call it genuinely disrespectful; and not all listeners will come away from hearing it with the impression that the band is, through their frenetic and noisy reworking, attempting to comment on the mental damages sustained from overexposure to this 'one hit wonder'. V/VM, in the case of their 2000 *Sick Love* CD, merely takes love songs from the past 3 decades and, rather than taking samples of each or layering them on top of other musical materials, plays them straight through from beginning to end while digitally pitch-shifting, de-tuning, and distorting the

otherwise un-edited original tracks. V/VM describes the often eerie and vertigo-inducing results as "metamusic – a commentary on music." V/VM also changes the titles of the originals to include puns on meat and animal butchery – a regular practice of the band's which has seen Falco's "Rock Me Amadeus" retitled as "Rock Me Ham-adeus," and has also seen them use the alias Notorious P.I.G. in certain circumstances. The approach can be inconsistent, alternating wildly between good humor and genuine irritant.

Smashed Holograms and Endless Grains

Although the sample bombardment of the new mash-up generation is effective in generating diverse reactions, there remain those who are critical of this approach and its overwhelming/fatiguing quality. In the era of quasi-legal music downloading, it is only a matter of time before the pioneering efforts of such artists will be surpassed by even more mind-boggling paeans to hyper-complexity, to say nothing of the sheer amount of music being consumed. Still, the net amount of sound consumed by an individual does not always translate into a solid understanding of that sound's potentiality and implicit meaning. Techno-cultural professor and sonic activist Bob Ostertag, who has built a large portion of his career on sampling (and who has released a few CDs on Negativland's Seeland label), suggests an alternate method:

"I think the way I approach sampling technology is... how do I say it... for a lot of folks, the way they approach it is to sample everything and then put it in a blender. I've never been interested in that – for me it's always been a question of really thinking very carefully about what I wanted to sample, and finding one thing – not finding a hundred or a thousand things, but finding *one thing* that was meaningful to me, and not using sampling to decontextualize that or to rip it out of its native environment and make it into something else, but to do the opposite. To use the sampling to 'blow it up', to allow people to get inside of it or confront it in a way that they hadn't confronted it before. My piece *Sooner Or Later* would be a good example of that. For that I made a whole hour of music out of just this little sample of this boy burying his father. All those samples were taken from works that I had real connections to in real life – I spent several years in El Salvador during the war there, and made the recording of *Sooner or Later* out of that. To me that's the antithesis of the way that sampling has mostly been used...you go out and sample a million things, the whole world and then you blend that world into one mix. I wanted to do the exact opposite – taking one thing and blowing it up so that it became a whole world in itself."[30]

This technique, although highly divergent from the sample barrage of Negativland or John Oswald's plunderphonics, offers an equally valid statement, and an equally essential counterweight to mass media's inexhaustible supply of contradictory, transitory messages and images. Ostertag's work *Sooner or Later* is one of, as can be assumed from the description above, uncomfortable intimacy. In a media culture that has been conditioned to see the burial scenario described by Ostertag side-to-side on television with, say, reportage on a college basketball game and updates on the stock market, it is truly mind-altering to be suddenly immersed in an emotionally intense experience at such a microscopic level. The same effect is accomplished in Ostertag's piece *Burns Like Fire*, which zeroes in on explosive split-second fragments of voices of street ambience during gay riots in San Francisco, looping the selected sound samples or freezing them in place. Some would argue that these edits ruin the 'you-are-there' documentary effect that would be accomplished by an unedited street recording, since they place the recorder in the role of an intrusive narrator, somewhat like a roving TV news anchor. But in this case, the edits do not work in an intrusive way – rather, they have a complimentary or contrapuntal effect to the unaltered snatches of sound. In their own manner, they act like a highly abstract Greek chorus: with their rippling and echoing effects they summarize all that has gone before, albeit in a non-verbal manner.

The intimacy conjured by being enveloped in a single, isolated sound has also been used to further more hermetic or mystical ends: Jordi Valls' Vagina Dentata Organ recordings, each one mercilessly focused on a single sound sensation (of human orgasm, wolf growling, or revving motorcycles) utilizes the tactic of the sound 'becoming the world of the listener' as a kind of

religious indoctrination. Organized religions tend towards a heavy degree of repetition in their rituals, especially in the sonic representation of key concepts, in order to make a distinction between the disordered chaos of the natural world and the Apollonian clarity of the faith. This concept seems to lie at the heart of Valls' recordings (released on a label named World Satanic Network System), which are unrepentantly ascetic and repetitive, elevating the isolated sound to a function as a totem; a 'power focusing' tool. Valls' Psychic TV collaborator Genesis P. Orridge also sees the advent of electronic music sampling in grandiose mystical terms:

"It can be said, for me at least, that the transformational implications inherent in sampling, looping, cutting-up and/or thereafter re-assembling both found data materials and infinite combinations of site specific sounds, is as probably equivalent to, and as socially significant and profound as, the popularization and mass proselytisation of LSD and the splitting of the atom. All three involve thee cutting-up of the essential 'matter' of science, religion and language; the basic, potential inhibiting, cornerstones of what has been coined – our contemporary 'dominator' culture."[31]

When referring to sampling's ability to contain worlds within a small 'bite' of information, P. Orridge uses the analogy of the 'smashed hologram': when the projection surface of a holographic image is smashed, the same image will be replicated as a perfect whole on each individual 'splinter' of the original surface. Expanding on this idea, P. Orridge states that

"It has always been my personal contention that if we take, for example, a SPLINTER of JOHN LENNON, that that same splinter will in a very real manner, contain within it everything that John Lennon ever experienced; everything that John Lennon ever said, composed, wrote, drew, expressed; everyone that ever knew John Lennon and the sum total of all and any of those interactions; everyone who ever heard, read, thought of, saw, reacted to John Lennon or anything remotely connected with John Lennon; the specific time zone, calendar date that it theoretically resided in; and every past, present and/or future combination of any or all of the above".[32]

San Francisco multi-media artist Ken Sitz, while not approaching the poeticism of P. Orridge's 'smashed hologram' analogy, also likens sampling to being a device which breaks up long periods of stagnation and forces cultural evolution. According to Sitz, sampling does not bring about sudden, revelatory disruptions in patterns of behavior, but works incrementally to erode away at these patterns:

"The way culture evolves is just like how DNA evolves or mutates – regardless how quickly it changes, it's based on material that existed before. An accumulation process of small incremental changes can produce sudden 'discontinuities' like the collapse of the Eastern Bloc or the Berlin Wall coming down."[33]

Echoes of Sitz' suggestions can be heard in a 2004 CD by Leif Elggren, *The Cobblestone is the Weapon of the Proletariat,* in which samples of a single stone, being thrown once in a Stockholm street, become all the raw material needed for 10 album tracks' worth of supple electronic humming, sputtering and sawtooth noises. Elggren's method here has more in common with magic than with the hard sciences mentioned above: it is an alchemically altered sample used as a 'wishing machine' to bring about cultural change and empowerment. It may be a bit of a stretch to presume that a carefully chosen sound bite, in the right context, can become a faultless virtual copy of a person, place, or event. What can be done, though, is for the sample to re-intensify experiences and mental associations that have been dulled and rendered as one-dimensional, bringing these sensations as close as possible to the realm of the tactile.

Certain electronic composition techniques also give the isolated sample an opportunity to bloom into a total sonic atmosphere, to become a sound world of its own. The technique of granular synthesis is one prominent example of this, and it should not go unnoticed that granular synthesis was first proposed by the Hungarian inventor of holography, Dennis Gabor (although Gabor's discovery has taken a back seat to the subsequent re-discovery of the technique by Iannis Xenakis in the 1970s.) Granular synthesis uses the 'grain' as its basic sound unit (this can be any electronic tone or sample typically of a 5-50 millisecond duration), layering these miniscule particles on top

of each other while shifting playback speed and phase. *Microsound* author and *Computer Music Journal* editor Curtis Roads (generally credited as the first composer to develop a granular synthesis engine) has demonstrated the ability to form mesmerizing 'clouds' of sound from layering individual grains, which are controlled by the musician in a half random/half deterministic fashion: in other words, the frequency of a grain's waveform can be randomized, but only within an upper and lower limit set by the musician or composer.

Granular synthesis really needs to be heard to be fully grasped, but in any case it is an indication of where sampling culture may be headed next: when a simple cough or sneeze can be stretched into a seamless oceanic drone, or morphed into a cluster of distinct pointillist sounds before returning to its original form it is – at the very least – another vivid demonstration of how we can use the materials of the mundane in order to transcend it. Roland Barthes once wrote an essay entitled *The Grain of the Voice*, in which he proposed that the whole body of a performer can be contained in that performer's voice – with granular synthesis and other novel forms of sample transformation, we now have an opportunity to put this theory to the test; to see if one's sampled voice, or any highly personal sound information, can still retain its original identity while going under the surgical knife of granulation effects.

+++++++

"He declared he wanted to kill art ('for myself'), but his persistent attempts to destroy frames of reference altered our thinking, established new units of thought, 'a new thought for that object.'"[34] (Jasper Johns, on Marcel Duchamp)

Otomo Yoshihide, the Tokyo-based improviser who, in his former group Ground Zero, gave Japan some of its more vibrant and hectic sample collage work, has coined the term "sampling virus" and referred to his home as a "6-mat virus factory" (Japanese apartments are measured in the number of *tatami* mats covering the floor, with 6 being an average size.) His 1993 CD on Australia's Extreme label, *The Night Before the death of the Sampling Virus*, also uses this metaphor for the sampling technique, recalling William Burroughs' proclamation in *The Job* that "the word" was a viral phenomenon. For Burroughs, linguistic communication was mainly a parasitic force: language was a form of communication that handed cultural presets down from a few authoritative voices to an exponentially increasing number of parroting ventriloquist dummies. The source could, however, be attacked through the deliberate re-arrangement of messages, since "the word" invaded at an unconscious level, and becoming conscious of it – or making the word 'concrete' – was the key to regaining control over one's own evolutionary process. It is especially telling that, some 3 decades after Burroughs first used the term "word virus," "viral advertising" has become an ubiquitous watchword of global marketing. In the case of sound sampling, there is still a viral effect, but with a major difference: the "virus" is now being spread by countless groups and individuals who seek to break pre-ordained patterns of behavior, opening up new territories where the reciprocal exchange of information and ideas are capable of supplanting top-down forms of dominance and control. With such a prevalence in the electronic music of the day, the "sampling virus" may continue to evolve, always staying one step ahead of the vaccine.

6.
BEYOND THE VALLEY OF THE *FALSCH*:
MEGO (AND FRIENDS) REVITALIZE 'COMPUTER MUSIC'

A Viennese Tragedy

21st-century Vienna is a smoothly functioning capital of a couple million residents, almost 30% of the total Austrian population. Here, a U-Bahn train can whisk you across the Danube (with no more than a 5-minute wait between trains), shuttling you from the Gothic/Romanesque opulence of St. Stephen's cathedral to the ultra-modern austerity of the city's diplomatic hub, 'UN city'. The city's past as an imperial epicenter of musical significance hardly needs to be recounted here – the titanic, archetypal figures of Beethoven, Mozart and Schubert are still never far from any informed discussion of Viennese cultural history, even if they hardly figure into the current discussion. What may be more relevant is the occasional flash of concentrated eccentricity which arises in opposition to the city's conservatism: sitting side by side with more traditional homes, you can find the undulating, children's storybook architectural novelties of Friedrich Hundertwasser, built around a unique biomorphic design and his maxim of "the straight line is Godless." During the reign of the embattled, ultra-rightist Austrian Freedom Party chairman Jörg Haider, the eye-popping façade of the Viennese *Hundertwasserhaus* could also be seen with draped in banners bearing anti-Haider slogans. Sadly for Vienna, some of its more well-known cultural exports are also its most patently ridiculous – the late Johann 'Falco' Hölcel, for example, whose unnerving bilingual synth-funk was once aptly described as "...obnoxiously patronizing attempts at African-American lingo, accents and music, sung in a constipated gurgle as appealing as hearing someone vomit outside your window."[1] Whether the international success of Falco in the 1980s was due to the novelty of seeing stereotypically frigid Austrians rap and strike scripted 'bad boy' poses, or whether people genuinely enjoyed him on an unironic level, is debatable.

Luckily, though, any small amount of scraping beneath the surface of commercially viable Viennese culture will reveal things much more gripping, albeit reserved for the brave (and even Falco was once a bassist in Drahdiwaberl, media theorist Stefan Weber's humorous and controversy-courting socio-political rock spectacle.) If you should find yourself walking through the city's world-renowned Museum Quarter, ignore for a moment the generous selection of elegant 18th-century architecture and the enticements to see Gustav Klimt's glittering Art Nouveau pieces, and make a straight line for the charcoal-colored futurist facade of the Museum Moderner Kunst (MOMUK), which houses a permanent collection of artifacts from the Viennese Aktionists in its basement. The illuminating archive of Aktionist films, photographs, texts and art objects mythologizes a group of

artists which often used the body as just another form of 'material' in their works; a group of artists who realized that the only way to nullify harmful excesses was to engage them head on. This engagement process involved such superlative acts as self-mutilation by razor blade, lying blindfolded and passive beneath a cascade of animal blood, and the exposure of hidden or silenced bodily processes – all of this had a very sacrificial aspect to it, as Aktionist Hermann Nitsch was careful to point out, with the artists sacrificing both their flesh, sanity, and societal reputations, so that the spectator could achieve some degree of individuation without submitting to the same level of trauma (although numerous 'participatory' aktions did integrate audiences into the ritual as well.) As for the aforementioned social reputations, arrests and police interference played no small part in the Aktionist story, especially after the infamous *Kunst und Revolution* event of June 1968 – after which Günter Brus earned the maximum allowable penalty for acts of public indecency (a combination of the Austrian national anthem, male nudity and urination being the most grievous offense in question.)

Originally a loose constellation of writers, poets, performers and painters, the Aktionist movement was eventually whittled down to four main personalities in the public eye: Hermann Nitsch, Günter Brus, Rudolf Schwarzkogler, and Otto Mühl. Nothing has really come along since to supplant their reputation as the most transgressive artists on the European continent, although the number of 'honorable mentions' has been significant. Unlike the Surrealists and other movements which continually strove to meet the criteria of a megalomaniac 'leader' (Andre Breton in this case), the Aktionists were a very de-centralized group, united in aesthetic and method but completing a good deal of work while independent from each other. A thorough exploration of the body's malleability was used to completely different ends by each: Nitsch used orgiastic encounters with flesh, blood, and cathartic noise for religious/transcendental purposes, while Mühl argued the case for perverts as society's whistle-blowers – they who "reveal society's vulnerable points." Elsewhere, the elusive, esoteric Schwarzkogler used the overwhelming and synesthetic nature of his work to achieve an Apollonian clarity and to annihilate base urges. On a side note, the Aktionist-affiliated philosopher Oswald Wiener (who lectured at *Kunst und Revolution,* among others) has, in recent years, written expansively on the subject of artificial intelligence.

Although browsing the surviving artifacts from the Aktionist era is no substitute for being in the midst of their aktions as they happened, it doesn't take long to grasp the single-minded passion that characterized this movement. Just as the newer form of 'extreme computer music' has roots in Industrial music, so too does Industrial music have an acknowledged debt to Aktionism, made clear by some of Genesis P. Orridge's typically verbose musings on the subject:

"How can an artist, a person of such sensitivity that the mere option of creativity is intrinsically sacred, re-immerse themselves into such an ultimately Utopian way of life as 'art' whilst living in the very centre, the oh-so-recent source of Adolf Hitler's demonia? The sheer enormity and incomprehensibility of atrocity, of bestiality, of unrelenting horror and the actuality of annihilation of reality originating as it did in a not so long passed and certainly not forgotten bourgeois Vienna is beyond belief. When you are born from the womb of aberration, how do you express and contextualise the crisis of an urge to create with honour? How do you absolve, debate, transcend, and include this history hidden in the same normality around you in the 50's that which seemed normal in the 30's? How do you free your SELF from the vile legacy of your community's past? [...] The answer, I would contend, based upon the courageous revelations of these writings, rants, rages and meditations, could only be through what we witness here in Viennese Aktionism, no matter from which aesthetic point of viewing, or with however much dilutionary hindsight we chose to enter and access the unspeakable catharsised out of these souls and into, onto, even through the body."[2]

The 'demonia' experienced by the Aktionists was, for them, crystallized in the most direct experiences possible: Otto Mühl experienced it as a teenaged soldier fighting on the western front with the Wehrmacht – particularly in the incomparable 'Battle of the Bulge' under Gerd von Rundstedt's command, in which 135 of his comrades were reportedly numbered among the 85,000

German dead. Hermann Nitsch, being Mühl's junior by 13 years, was far too young for frontline combat, but he recalls the bombing of Vienna in his early childhood as a formative experience. While not entirely enraptured by the reality of war, Nitsch echoes the sentiments of the Italian Futurists in the sense that "war can assume an aesthetic appearance" and that "the compulsion to live life intensely, albeit in a world of suffering, is also undeniable."[3]

Hinting that the work of the Aktionists is far from over (and mildly criticizing select unnamed members of the movement for their 'addiction to method'), Genesis concludes his above appraisal with a warning:

"The wordless scream of fervent rage against a national (and international) system of authority, mediated as an institutionalised obscenity of violence and oppression, seems unnervingly appropriate and relevant once more."[4]

With this conclusion, though, comes the inevitable question – how to scream with more 'fervent rage' than the Aktionists? Obviously P. Orridge himself tried with similar explorations in COUM Transmissions, Throbbing Gristle and eventually with Psychic TV's 'modern primitive' program of piercing, body modification, ecstatic dancing etc. – but at some point the model of Viennese Aktionism could go no further without crossing over into a form of perverse entertainment for the benighted masses. This was already evident when Günter Brus, upon returning to 'normal' painting and de-emphasizing his, was vilified as a 'sellout' by audiences just beginning to warm up to him.

Overall, sound and music was less of a contribution to the Aktionist oeuvre than it was for previous manifestations of the European avant-garde. For the set pieces of Otto Mühl and Hermann Nitsch, though, sound did occasionally become an integral part of their overwhelming synesthetic presentations – beginning in 1966, Nitsch had a ten-piece 'scream choir' on hand to accompany the religious ecstasy and spiritual purging of his choreographed bloodbaths, as well as a noise orchestra whose only scored instructions for performance were what level of intensity at which to play (there were three noise 'phases' in all.) Scores for Nitsch' aktions also include instructions to play 'beat music' (whose music, exactly, is not made clear in the scores) at speaker shredding volume. In 1964 Otto Mühl held a whimsical 'balloon concert' and later, in 1972, recorded the *Ein Schreckliche Gedanke* [A Terrible Idea] LP, the penultimate statement of Mühl 's 'cesspool aesthetics' as a strategy against conformity. The ...*Gedanke* LP is largely composed of Mühl lovingly languishing over German-language vulgarities and gleefully erupting into shock tantrums. On a side note, a record of James Brown's greatest hits was a puzzling partial soundtrack (not including the screams and laughing fits of the participants) to a spastic 'total aktion' of Mühl 's entitled *Führt Direkte Kunst in den Wahnsinn* [Does Direct Art Lead to Madness?].

Having already been the epicenter of one of the most demanding forms of 'body art' in the 20th century, it would make sense that the next major artistic upheaval to come out of Vienna would be a non-corporeal one – and, in this case, one localized almost completely within computers. One that seemed to have no physical form at all: incubated within hard drives, raised by software applications and sent out to the world through loudspeakers. And even though Viennese Aktionism of the late '60s still remains a watershed movement, thorough examinations of the body would eventually move far beyond the Austrian borders, becoming *de rigeur* throughout the '60s and 1970s. Players like Chris Burden, Marina Abramovic and Vito Acconci continued to raise questions about what constituted a transformative or abreactive act, and what was just sheer terror or torture (for themselves as well as their public.) Several decades before meditations on institutional torture entered the mass consciousness via revelations about government agencies' brutal interrogative techniques in prosecuting the 'war on terror', the '70s crop of body performers, like Burden, were dragging themselves through glass or forcing themselves to sit on an upright chair atop a sculpture pedestal until falling off from exhaustion. Even typically pleasurable acts like masturbating were, in pieces like Acconci's *Seedbed*, brought into the realm of confrontation and criminal threat – in the 1971 piece *Seedbed*, Acconci committed said act underneath a gallery-wide ramp, fantasizing out loud about gallery patrons as they walked on top of him. Although there may still be some room for provoking the atypical reactions that can be provoked when, like in Acconci's piece, the private body

becomes a social body, it seems difficult to build on the work of these artists – and the Aktionists – without eventually contorting the creative process into an insincere game of "one-upmanship".

Like the above artists, the new computer music in question would never show things purely in a positive light. Although there was the sepia-toned serenity of select pieces by artists like Christian Fennesz (and numerous others who swore by Brian Eno's brand of Zen ambience), there were also outlandish synthetic symphonies of choking, sputtering and shrieking: abrasive, yet richly textured and meticulously mixed noises which conjured nothing so much as modern history being written by accidents; the unreliability of mechanical processes being the rule rather than the exception. Like Jean Tinguely's 'meta-mechanic' sculptures, which destroyed themselves after mimicking the utopian production line aesthetic of industrial cultures, a new kind of art was emerging that suggested the sound of the digital world collapsing upon itself.

Computer Welt

Before discussing the merits of this new constellation of computer musicians, it would be useful to reflect on the development of 'traditional' computer music, in order to ascertain key differences between then and now.

The German-speaking music world's relation to the world of personal computing has been a long and storied one; fueled in no small part by foreign pre-conceptions of Teutonic peoples as cold, calculating, technologically precise automatons. Well before the advent of personal computers, the machines were relegated to the subject matter of pop song fantasies, such as teenybopper queen France Gall's "Der Computer Nummer Drei," an upbeat daydream about a computer which is programmed to seek for her 'the perfect boy'. Kraftwerk, of course, took the above pre-conceptions and ran with them to previously unimagined heights of popular acceptance. The band applied a slick, reductionist technique to both their music and their stylized, uniform appearance, replacing girl-meets-boy romance with a romance of electronics and circuitry, even going so far as appearing like gender-neutral robots, inhabiting a hitherto ignored pop-cultural space in between rock 'n roll's preening masculinity and bubblegum pop's sighing femininity. This was done in addition to romanticizing, in songs like "Autobahn" and "Trans-Europe Express", public institutions more associated with the European continent than with the Anglo-American sphere of affairs – and the ironic result of this was the enthusiastic absorption of the Kraftwerk aesthetic by that same Anglo-American culture industry: namely, English synth-pop and American hip-hop. However, by the time Kraftwerk had recorded their paean to the information age, *Computer Welt*, there was still not anything resembling a personal computer in the group's sound studio – their most acclaimed music was composed on analog, voltage-controlled synthesizers, and even their most convincingly 'computerized' sounds, like their deadpan vocoder incantations, were achieved using analog systems. Credit should be given the band, though, for sparking an argument about the human role in live performance of electronic sound: long before the first musician appeared on stage with only a laptop, the band had performed concerts using automated dummies bearing the band members' likenesses.

The *Neue Deutsche Welle*, a German-speaking punk and new wave movement active during the late '70s and early '80s, also embraced computers while criticizing certain aspects of the rising inorganic culture, and – in the case of the group Der Plan – pointed out attributes of Germans' collective behavior that were more computer-like than computers themselves. This tendency can be seen in their single *Da Vorne Steht 'ne Ampel*, which ridiculed Germans' obsessive need to follow rules regarding traffic lights and crosswalks, even if there was no traffic in sight. NDW hits such as Abwärts' "Computerstaat" were jittering and spiky blasts of paranoia emanating from fears of an Orwellian surveillance state, of which the computer would be a prime enabler (the song leavens the techno-phobia with almost comically paranoiac images of KGB agents lurking in the woods and Leonid Brezhnev hanging out by the nearest swimming pool.)

In most cases, though, a widespread interest in musician interface with computers would have to wait until the 1990s, whether in Germany, Austria or elsewhere. One of the main reasons

for this was the now unimaginable amount of latency (noticeable lag between any kind of user input and any audible result) present in computers. This was to say nothing of the flaws that computers exhibited even before fingers took to the keypad: heaviness and 'clunky' awkwardness, impersonal command-line interfaces instead of the more customizable graphic user interfaces, and an unattractive design that did not lend itself well to an individualistic class of beings like musicians (although this may be a purely subjective judgment – it is possible that many still prefer the beige and chocolate hues of a mid-80s Apple IIe to the clean, android silver of a 21st century PowerBook or MacBook.)

Out of all the above, though, the latency problem was perhaps the most pressing issue – one could still perform music on an ugly computer, or one in which commands were carried out by typing lines of code rather than manipulating pictorial representations of instrument controls. Max V. Mathews, one of the founding fathers of the computer as a performance instrument (his 'Music I' program on the IBM 704 computer is credited with the first computerized micro-performance in 1957), touched on this issue when explaining the dilemma of using electronic instruments prior to the current digital age:

"Until recently, general-purpose music programs all had one major restriction – they could not be utilized for performance because computers were not fast enough to synthesize interesting music in real-time, that is to say it took more than one second to synthesize a second of sound. Special purpose computers called digital synthesizers overcame this limitation. But real-time synthesizers brought with them a new major problem – rapid obsolescence. The commercial lifetime of a new synthesizer is only a few years, and therefore music written by such machines cannot be expected to be playable in a decade."[5]

Matthews' predictions have so far turned out to be true, as evidenced by at least one software performance application – Miller Puckette's MAX/MSP – which has been utilized by sonic voyagers from Autechre to Merzbow. MAX/MSP and other applications like it – PureData, C Sound, SuperCollider – were practically unlimited in terms of what sounds they could synthesize, yet unlike keyboard synthesizers, they contained no preset instruments, relying on a musician's proficiency with coding skill in order to come up with the necessary algorithms. It is often touted that these programs annihilate the need to "pay your way" into musicianship, because of this emphasis on ingenuity and intellectual dedication over gear accumulation. So, in a way, such software encouraged a continuation of the do-it-yourself ethic built up over the previous few decades of revolt against the music business, and with a massive increase in audio fidelity and timbral or tonal variety. Instruments which exhibited this astonishing variation in tone/timbre could be built up by musicians from scratch, with no equipment needed other than a single PC. The only real limitation, other than the processing speed and hard drive storage capacity of one's computer, was the amount of effort that the individual musician wanted to put into designing a patch. This may have still been too much of a "left brain" activity for those whose education was purely in the arts and humanities – but on the other hand, it was a validation for those innovative music producers who, nevertheless, didn't have the dexterity or innate sense of rhythm to master 'real' instruments – it must have been gratifying to, with a patronizing smirk, finally counter the nagging, dubious presumption "*anyone can play guitar*" with another one – "*anyone can program a MAX patch.*" Opponents of live computer music performance could, of course, fire back that this is a lazy capitulation to the 'law of least action,' e.g. if there is a choice between an escalator and a staircase, people will take the escalator every time. But is there really anything *wrong* with 'taking the escalator', provided that it doesn't deny people the choice of 'taking the stairs' if they so desire? This fear of being supplanted is somewhat irrational when applied to music ('physical' rock bands are swelling in number now, thanks to computer-based home recording environments like ProTools), and worse yet, it puts us in a position where the amount of physical exertion involved in a creative enterprise is the focal point of the art – bringing it into the realm of sport – and *not* the end results.

Yet the prevalence of new computer music software has, according to Bob Ostertag in his 2001 paper *Why Computer Music Sucks,* also stirred the guardians of serious Computer Music (the

capitals are Ostertag's own) to silence the more 'populist' musicians and exploratory amateurs, claiming exclusive rights to the methodology of computer-based sound. Ostertag comments acidly on this elitism, saying that the Computer Music of academia is mainly just the digital-era offspring of their previous plaything, serialist composition. According to Ostertag:

"...it is a phenomenon seen time and time again in academia: the more an area of knowledge becomes diffused in the public, the louder become the claims of those within the tower to exclusive expertise in the field, and the narrower become the criteria become for determining who the "experts" actually are."[6]

It is one thing to hear so-called Computer Music being denounced by the 'man on the street', or by someone with clearly Luddite tendencies, but it is another thing entirely to hear incisive critiques from people like Ostertag, who have worked extensively with computers and are well aware of their technical specifications. Ostertag is especially well versed in the MAX/MSP language, having rigged up joysticks and computer drawing tablets as the real-time controllers of his patch designs. Speaking about his experience as a judge for the Prix Ars Electronica's coveted Digital Music prize in 1996, Ostertag admits that

"...after listening to the 287 pieces submitted to Ars Electronica, I would venture to say that the pieces created with today's cutting edge technology (spectral re-synthesis, sophisticated phase vocoding schemes, and so on) have an even greater uniformity of sound among them than the pieces done on MIDI modules available in any music store serving the popular music market. This fact was highlighted during the jury session when it was discovered that a piece whose timbral novelty was noted by the jury as being exceptional was discovered to have been created largely with old Buchla analogue gear."[7]

While suggesting that ancient electronic relics are still capable of producing striking music, Ostertag also suggests that the results coming out of more high-end digital equipment hardly justify the hours of coding and computer maintenance involved in making a simple etude (which may be no different from a thousand others of its kind.) Still, there are those who will insist that concessions to this kind of formalism are a necessary precursor to artistic greatness (or acceptance by one's peers, at the very least.) Psycho-acoustic musician John Duncan, who shares some kinship with the more radical new breed of computer musicians thanks to releases on the U.K. record label Touch, suggests the opposite – that refusal of these formalist rites of passage provides the true creative spark:

"From what I know of history, this has always been so: academics reinforce tradition and frustrate change. The exceptions to this – frustrated outsiders creating change – are exciting. That's where the real inspiration is, the energy that drives the creative process."[8]

From the comments of Ostertag and Duncan, we can surmise that, in this century, resistance is steadily mounting against the type of Computer Music that will only be enjoyed within a 'closed circuit.' In other words, enjoyed by a select clique of individuals who can accurately note what sounds and timbres are being created by what algorithm within a larger piece, but cannot enjoy it as a stand-alone piece of music.

Sadly, being exiled by the academy does not always mean that an artist will be greeted with open arms by the public at large, either: there still exist market forces to deal with, imposing their own constraints on creativity and allowing only token expressions of true threshold experience. Rejection by both academic culture and leisure culture can be a deathblow to many aspiring artists, but then again, financial reward was never one of the points on the agenda of *Direkte Kunst*, nor was acceptance by an intellectual elite.

Rise of the Twisted Hard Disk

One of the more impressive and consistent organizations behind the of has been Austria's Mego label (now re-branded as Editions Mego, with much of the former label's catalog available to be purchased online.) Other splinter groups doubtless arose around the same time (thanks to the

technological advancements listed above), and therefore giving Mego pride of place here may raise the hackles of some – but if they did not merely kickstart this scene, their collective aesthetic sensibility, more than the sum of its parts, has been instrumental in drawing attention towards the peculiar methods and maneuvers of a larger constellation of electronic artists.

he Mego label was originally an offshoot of the Austrian techno label Mainframe, the brainchild of Ramon Bauer and Andreas Peiper. The Mainframe label, while not reaching the same dizzy heights of un-compromise that defined Mego, did deviate from the standard techno/rave template in some colorful ways. The label's flagship act Ilsa Gold, for one, was known for fish-out-of-water experiments like combining distortion-fueled 'hardcore' techno elements with the sampled (and decidedly unfashionable) sounds of German-language folk relics like Karel Gott, or perhaps with the plaintive wailing of some 'alternative' coffeehouse rock leftover from the early 1990s. The pounding aggressiveness of Ilsa Gold's more anthemic numbers, combined with a sampling method that placed exuberant irreverence at center stage, would also be a harbinger of things to come.

The nucleus of the Mego label, as it is known today, would eventually be formed when Peter 'Pita' Rehberg joined forces with Bauer and Peiper upon the dissolution of Mainframe. Rehberg, the most visibly active of the original trio today, keeps the archive of older Mego releases in print under the newer Editions Mego label (which, in spite of the name change, does not differ significantly in content or approach from its predecessor.) Rehberg transferred from London to Vienna in the late '80s, a musical omnivore previously busying himself with numerous rock-oriented groups, DJing, and fanzine writing – also taking time out from the scene for an extended visit to Minneapolis at the dawn of the 1990s (he now operates most frequently in Vienna, London and Paris.) Having previously subsisted on an eclectic musical diet of post-punk, industrial noise and the dub offerings from the On-U Sound label, Rehberg was somewhat skeptical of the new 'electronic dance music revolution' spreading through warehouse raves and a deluge of white-label vinyl releases – to him this was just another development in electronic music, rather than the clean wiping of the slate that, in their usual hysteric tones, culture observers were making it out to be.

Still, the 'electronic dance music revolution' provided some of the necessary cover for Mego to engage in its more intense and unmoored sonic experiments: with a thriving local techno scene to draw upon (proximity to hubs like Munich also helped in this respect), and the credibility that came from playing an intimate role in that scene's growth, some deviation from the norm was permitted them. Simultaneously, the nascent Mego label had support from the more hazily defined post-Industrial and noise subculture in Vienna; local alliances with organizations like the Syntactic label (known for hopelessly limited 7" single releases of the genre's leaders) gave the Mego team a rare opportunity to 'play both sides of the field', as it were – local connections even helped to secure gigs at unlikely venues like the hip youth hangout Chelsea (whose website boasts of it being "simply the best of indie, pop, and beats") , where Rehberg recalls blowing out the house speakers in a live collaboration with noise stalwart Zbigniew Karkowski. The up-front, blasting energy of such performances was, to say the least, unexpected in environments where electronic music had previously taken on a "support role," a function much like that of mood lighting. Electronic dance music, in all its endless variations, had previously added color and exotic flourishes to the ongoing Continental European social drama, plugging the awkward silences that occurred in between flirting with strangers or scoring drugs. Now, here was an electronic music which manifested itself in unbelievably loud sheets of sound as techno did, yet forced passive bystanders *not* to divert their attention elsewhere (unless they just chose to flee from the performance venue altogther.) Reviewer Mark Harwood, reviewing Rehberg & Bauer's performances at the "What Is Music?" festival in Australia, accurately describes both poles of audience reaction when suddenly being sucked into this whirling vortex of disorientation:

"Pita thrilled the Melbourne crowd (one male witness reported to have shed tears, while other folk moved about in what can loosely be described as 'dancing') and diced the Sydney audience, shredding one of his tracks by cutting out every few seconds. At a safe distance, you could see numerous people exit, fingers firmly in ears."[9]

Andrew McKenzie of The Hafler Trio – who is not directly allied with Mego, but whose work maps a similar psychic terrain – also summarizes the performer-audience disconnect that could come about when listeners are forced to decode an incoming rush of mutated sound signals, often in the form of genuinely painful frequencies or tonalities, without any form of 'visual aid' to assist them:

"Focusing on output requires attention, practice, and a degree of consciousness. None of these come for free, and none of these can be assumed to be existing qualities of an audience. The best that can be done is to attempt to attract those qualities by means of developing them in oneself. What follows from that is feedback on the state of things as they are, not as we might like them to be."[10]

If the effect of this sound was jarring within a venue that normally played music, then hearing it broadcast from more unorthodox locations took things to a whole other level of bewilderment. One such unorthodox location was the *Riesenrad* [Ferris wheel] at the Prater amusement park in Vienna, which movie buffs will recognize as the site of a famous Orson Welles monologue in *The Third Man*. Originally built to commemorate the golden jubilee of Franz Josef I in 1897, it was one of the first Ferris wheels ever built, and became a universally recognized landmark of Vienna. So, what better place to stage the defiantly outré sound of the local Mego-affiliated computer music group Farmers Manual than in one of the city's most beloved tourist attractions! In the summer of 1997, Farmers Manual prepared a novel live set that would last the duration of one ferris wheel ride (about 15 minutes), conflating sentimentality and nationalistic pride with 'the shock of the new' and with the decidedly more alien – such high-concept performances (albeit 'high-concept' infused with playful mischievousness) may not have approached the spectacular overkill of Karlheinz Stockhausen's composition for a quartet of helicopters, but they did exhibit the elasticity of this new music: its lack of lyrical dictation, its tendency to not be pinned into place by an incessant backbeat, and its use of portable electronic devices for both recording and playback meant that it could be performed in all variety of public places while generating the same polarized reactions of curiosity and hostility. In a nod to the clandestine punk rock concerts staged on riverboats during the period when certain Central European countries were Soviet satellites, Farmers Manual and several others have taken this approach to the waters on the 'Mego Love Boat.' The tongue-in-cheek whimsy of such actions extended even to the formation of a Mego go-kart racing team; with Mego catalog number 052 being assigned to a 2-stroke racing vehicle.

Farmers' Manual in particular have been fanatical about documenting the live aspect of this music – one web archive features gigabytes worth of live material from them and allied Mego acts, while their *RLA* DVD catalogs every surviving live recording made of the group from 1995-2002. It is a brutally effective comment on just how much the music subculture has changed since the days of, say, The Grateful Dead: where once fans devoted years of their lives to tracking down and swapping bootlegged, "no-two-are-alike" cassettes of live performances by their psychedelic torch-bearers, now fans of such a 'computer music jam band' could have their every single performance delivered for a comparatively meager investment: only the cost of a commercial DVD, or the time it would require to download all the shows from the Net (at http://rla.web.fm, for the curious.)

All innovations in live performance aside, Mego is a label mostly judged on the merit of its recorded output. Mego's initial foray into the world of conceptual music, and away from techno as we now know it, was the *Fridge Trax* collaborative effort between Peter Rehberg and General Magic, an alias for the Bauer/Peiper creative duo. The latter duo is also responsible for the mind-bending 1997 computerized song cycle *Rechenkönig*, a surprisingly cohesive collection of shimmering audio debris. This particular album epitomizes the 'Mego style's' emphasis on the primacy of the abstract sound assemblage rather than linear narrative, yet with the same good-natured irreverence that informed the earlier Mainframe releases (note the familiar patter of Barney the purple dinosaur on the album's opening track.) In a description that reminds us Farmers Manual's mischievous appropriation of the *Riesenrad,* reviewer Alois Bitterdorf states that

"...much of this sounds like the amusement park rides were left to run, and run around, on

their own a little too long, and in the meantime some of them have gotten into the medicine cabinet again, oh no, heavens!"[11]

In many ways *Rechenkönig* is a culmination of the work begun earlier on *Fridge Trax,* itself an intriguing study in the sampling and manipulation of household appliances' hidden sound world. The album ranks with Frieder Butzmann's *Waschsalon Berlin* (a recording of the unique, churning rhythmic activity of Berlin laundromats) as a slickly listenable attempt at humanizing the inert and voiceless. At once an alluring piece of and a possible joke directed at those who complain of electronic music's "frigidity", *Fridge Trax* capably threw down the gauntlet, which would be picked up in turn by the lush, unsettlingly natural computer compositions of guitarist and laptop manipulator Christian Fennesz, and by a whole supporting cast of other wild brains, whose work will be reviewed here soon enough.

Meanwhile, the problem of presenting this music live was partially solved as the 'bar modern' Rhiz opened for business beneath the overhead train tracks of the city's U6 U-Bahn line. Specializing in presentation of 'new media,' and immune to noise complaints by virtue of being situated along a major traffic thoroughfare, Rhiz became the default venue for much of the Mego label's live presentation. The rumble of the overhead trains and chatter of passerby (who are free to peer in at the live proceedings, thanks to floor-to-ceiling glass windows on either side of the venue) occasionally intrude upon the more contemplative moments of live performances, but all in all the venue has done a fine job of allowing this music to be itself. However, support from other quarters – namely, the Austrian arts funding organizations – has been somewhat more tepid, As Peter Rehberg recalls:

"I'm one of the few Austrian/Viennese labels that doesn't get any support or funding from the funding bodies here, whatever they call themselves... which, on one hand, is a bit of a bummer because it's all got to be financed by myself, but on the other hand it gives you the independence to act on your own – you don't have to be obliged to be nice to anyone [laughs]. And I kind of like that kind of independence. It would be nice to get funding, but they obviously don't recognize my label as a worthy cause. It's a bit of a joke because every other scratchy label here gets funded, but I don't care, because I actually sell records – so I can get the money back."[12]

Acquiescing a little, though, Rehberg also admits that he is

"...not anti-funding, as places like the Rhiz couldn't exist with out. Although I do get annoyed with labels getting money for a release, and the they package it in the cheapest way possible..... ah, don't get me started.."

Endless Summer, Get Out: A Tale of Two Sound Cards

It is tempting, in retrospect, to see Mego's progress as eventually coalescing around the prolific efforts of Peter Rehberg and Christian Fennesz. Consequently, it is also tempting for some to pit these two against each other in an adversarial struggle between aesthetic polarities: one reviewer, in a scathing review of Pita's 2004 release *Get Off,* even likens the two to being the "Lennon and McCartney of electronica", implying a stylistic divergence between Rehberg's caustic, unfeeling experimentalism and Fennesz' pretensions to melodic pop and pastoral simplicity. This "rivalry" exists more in the minds of such reviewers than it does in reality, though, as can be surmised by the number of live collaborations between the two, and by other shared traits: neither claim exclusive allegiance to the Mego label, and both are capable, when necessary, of making occasional breaks from their 'signature' style.

Although Christian Fennesz' contributions to this music are well deserving of their landmark status (his *Endless Summer* tops both the sales charts and critics' lists for the Mego label), it is Peter Rehberg's work which has most caught this author's attention. Fennesz' most noted works, with their blissful and asynchronous clouds of sound, are rife with references to idealistic worlds come and gone (see the sunny, utopian Beach Boys quotations of the aforementioned album), and as such it is difficult to divorce them from being either a critique of, or tribute to, past music. Stripped of the nostalgic aspect, or really of any human quality whatsoever, Rehberg's solo work as Pita has no

easily identifiable cultural precedent with which to connect it, and thus makes sentimentality nearly impossible – yet, in spite of this, some Pita works are striking in the emotional depths that they can plumb while being completely inhuman (Pita compositions in particular are mostly based on patches and virtual instrumentation within the computer, with a minimum of sampled sounds.) The 1999 release *Get Out* is one of the first and best examples of this approach: an unforgivingly stark and jolting montage of sonic atmospheres which, crossing the threshold into near-total unfamiliarity, serves as a perfect fugue for the death of the previous millennium. Without even track titles to base it in the world of consensus reality, it is a demanding listening experience for all but those who would intentionally seek it out, and one so highly subjective that even this author's assessment of it should not be understood as definitive.

Perhaps the lynchpin moment of *Get Out* (and consequentially, one of the more canonical moments of new computer music) proceeds as follows: a ghostly inaudible murmur of filtered melody on the 2nd untitled track, seductive by way of its elusiveness and obscured by steely pinpricks of clipped, high-register sound, becomes resurrected on the 3rd track as a backwards orchestral loop of uncertain origin (maybe a Viennese composition?.) The listener is lured into a false sense of calm content, perhaps expecting that this will play out as a balmy piece of oceanic ambience. This is clearly not the case, as the orchestration is abruptly pounced upon by an exceptionally harsh digital decimation. For those who survive this unexpected ambush, the rewards are great, as the distortion causes all kinds of harmonics and auditory hallucinations to emerge from the simple looped phrase – which, at this point, is so laden with overdrive effects that you can no longer tell easily if the original sound source *is* being looped, or if slight modifications are being made to the sound source as it goes along. The track's technique of 'constant crescendo' seems borrowed from earlier forms of techno dance music, but, transposed to different instrumentation, could just as easily be a blast of white light from Swans, one of Rehberg's many influences in the post-industrial landscape of the '80s. A mish-mash of genre leaders like Merzbow and Terry Riley would be another way to describe this, although this scathing 11-minute opus is clearly more than the sum of its influences.

The remainder of the album plays out as a less epic, but still absorbing, set of viscera-tickling noise episodes and alluring disturbances, the kinds of things that are referred to as a 'mindfuck' in music fanzine parlance: maybe a lowbrow summation of a very complex compositional style, but an apt one nonetheless. After wandering through a sonic terrain so twisting and non-linear that it would put a smile on the face of even a hippie mystic like Friedrich Hundertwasser, we come at last to another lengthy track looping a single gliding bass tone alongside the restless rhythmic sputtering of a Geiger counter (a comparison which has been made perhaps too many times now when attempting to describe Mego-variety music, but, again, an apt one.) The artlessness of this send-off is exquisite, and reminds us of how far society has 'progressed' since Industrial music first began to make its critique of mass media's indoctrination methods. It conjures images of blank sedation under brand-name soporifics, or of row upon row of modern, uniform office cubicles cooled by the pallid glow of computer screens, only the alternation in the rate of the screens' flickering offering any hope of differentiation from one cubicle to the next. The promise heralded by Throbbing Gristle's 1980 track 'IBM' – that of the computer's 'voice' dictating coded orders to spellbound and pliant humans – has been fulfilled here in a most unequivocal way.

And while this new form of computer music could have satisfactorily ended with the disembodied pastiche that was *Get Out,* it was really just getting started, and was growing too much like a rhizome to accurately chart its progress in linear terms of "who did what when": to see Peter Rehberg, Farmers Manual's occasional spokesman Matthias Gmachl, or any other individual affiliate of Mego and its companion labels as an ideological "center" or key "signifier" would be erroneous. An international 'scene' was nevertheless born, which culture scribes – with their penchant for easily-digested, monosyllabic tags like 'punk' and 'grunge' – were quick to pounce on and designate as "glitch". Musical taxonomy still refers to this music as such, perhaps giving too much credit to the generative computer music of Oval as the 'scene leader' within this milieu, and also assuming that

accidental composition is the *only* means utilized in making this music. More important than the actual 'glitching' process was the music's philosophical vagueness, and its refusal as a 'movement' to uniformly romanticize or condemn virtual culture, a refreshing departure in an age of insubstantial or dangerous proclamations and territorial claims.

Digital Chiseling

The Lettrist movement of poetry, initiated in Paris shortly after the second World War by Romanian expatriate Isidore Isou and Gabriel Pomerand, proposed that every art form goes through a tidal ebb and flow of technique known as the *amplique* [amplic] phase and the *ciselante* [chiseling] phase. In the amplic phase, the form is refined and made more ornamental until, at last, the day finally comes when nothing more can be done to enhance that form – it is filled to bursting with ornamental flourishes, with grandeur and opulence, and it adequately encapsulates the spirit of its particular era. Once this saturation point is reached, the 'chiseling' point begins, in which a summary is made of all the form's most distinctive characteristics, and afterwards the entire structure is 'chiseled' away at and destroyed. Those who most vigorously take part in the 'chiseling' also have the distinction of laying the foundations for the next amplic period. In his Lettrist manifesto of 1947 (*"Introduction a une Nouvelle Poesie et a une Nouvelle Musique"*), Isidore Isou comically insisted, despite little public renown, that he was one of the key 'chiselers' of his day, and that he was already respected as part of a grand tradition – see chapter titles like "From Charles Baudelaire to Isidore Isou" for an idea of Isou's exaggerated self-appraisal. While seeing oneself as a legend in one's own time is more than a little preposterous, Isou and his compatriots did indeed contribute to a post-war trend of 'breaking down the word,' which would see multi-disciplinary icons like Brion Gysin carry the torch directly to the current generation of artists. In Isou's estimation, letters were the atomic particles of poetry – since the Dadaists and Futurists had already obliterated 'the word' through their experiments, all that remained was for the sounds and symbols associated with letters to be examined.

It is tempting to see the computer music of the Mego label *et. al.* as an aggressive chiseling phase of electronic music, simultaneously abrading away at the venerated technical accomplishments of previous styles while offering clues about how to proceed with the next artistic undertaking. At the very least, it consolidates the gains made by the more visceral forms of electronic sound coming at the waning of the last millennium: it often outdoes the Industrial music of Throbbing Gristle or Whitehouse for sheer intensity and (ironically, given the state-of-the-art technology being used) can connect with the listener on an animal level. At the other end of the pole, the sound can be reduced to tiny pixels or flakes floating about the listener's headspace – inviting you to hear the world in a grain of sand. The act of 'tearing down', though, is not something that can hold the attention of the general listening public for long, and eventually needs to be supplemented by something other than the urge to clear away dead cultural waste. While a handful of 'chiselers' have a definite plan in mind for how to improve on the cultural landscape once they have reached a new 'zero point,' many are assuredly along only for the ride, and are caught up in the admittedly intoxicating thrill of destroying P.A. systems and fucking with the mass consciousness. Kenneth Goldsmith, in his editorial *"It Was a Bug, Dave: The Dawn of Glitchwerks,"* warns against the deceitful instant gratification that can come from the simple act of plugging in and tearing down:

"...as is generally the case with new technologies, most artists are simply exploring what sounds the computer is capable of when it's programmed to go apeshit. As a result, there've been scads of discs released recently that make for worthless listening experiences; most seem to be little more than musicians flexing their muscles, trying to establish the parameters of a vocabulary. In hindsight, it took an awful lot of aimless experimentation before the vision of a Stockhausen or a Pierre Henry emerged to give shape to the then-new forms of electronic music or music concrete."[13]

Goldsmith is correct in suggesting that this kind of thing does take time to refine – the "less is more" maxim of architect Mies Van Der Rohe is something too often ignored by novices in any

field, who are so delighted with the new functions a new device or technology has to offer, that they use them indiscriminately and to the detriment of other equally useful tools.

Composer Kim Cascone, known for innovations his with programming tools such as C Sound, also proposes that the 'failure as evolutionary mechanism' ethic of the newer computer music is nothing new, although he does add one crucial distinction between then and now:

"Much work had previously been done in this area, such as the optical soundtrack work of Laszlo Moholy-Nagy and Oskar Fischinger, as well as the vinyl record manipulations of John Cage and Christian Marclay, to name a few. What is new is that ideas now travel at the speed of light, and can spawn entire musical genres in a relatively short period of time."[14]

Further downplaying the need to play by any one set of rules, Cascone continues:

"The technical requirements for being a musician in the information age may be more rigorous than ever before, but – compared to the depth of university computer music studies – it is still rather light. Most of the tools being used today have a layer of abstraction that enables artists to explore without demanding excessive technical knowledge...more often than not, with little care or regard for the technical details of DSP [digital signal processing] theory, and more as an aesthetic wandering through the sounds that these modern tools can create."[15]

Inviting suggestions like Cascone's have encouraged a slew of young experimenters to begin wielding chiseling tools of their own – and the elder statesmen of this new intensity haven't completely discouraged them from doing so. Lettrism itself made direct appeals to the youth of the day, especially the so-called 'externs' who felt that the social system of the time presented them with no clear function or political voice. In the same respect, computer music innovators have had encouraging things to say, such as this from Zbigniew Karkowski:

"...I think that today all the art and music schools are absolutely obsolete, they are not necessary. There is no need for people to go to art school anymore. You can find access to all the necessary tools you need on the Internet. If you want to use digital technology, you can download the applications you need and learn how to use them in a rather short time [...] Young creative people don't go to schools, they buy a computer, a small, portable home studio, they travel, make some records and become millionaires after six months [laughs]!"[16]

Peter Rehberg, at least, has made good on Karkowski's advice: although not a university graduate, he still claims he has been into music "since I was about 12" and was one of the many beneficiaries of gradually more affordable electronic music equipment in the 1980s (evidence of this is available on the Spanish Alku label's *82-84 Early Works*.) One of the successes of digital music constellations like Mego is their simultaneous appeal to a younger, more anxious (and, as per Karkowski's quote, non-academic) audience of digital age 'externs', as well as the more established and studied avant-garde. Take for example Mego ally and Tokyo improviser Otomo Yoshihide, who likened the Austrian label's 'computers on auto-destruct' abrasion of to an amalgam of electro-acoustic music and punk rock. While the total noise wash of a Mego disc like Kevin Drumm's *Sheer Hellish Miasma* might appeal to the 'externs', the Fluxus-tinged 'wounded cd' experiments of Yasunao Tone (who shares a Mego disc in collaboration with Florian Hecker) might be suitable for the conceptual avant-gardists – Kenneth Goldsmith, for one, is an admitted fan of Tone's aesthetic. Being an artist with a penchant for the mischievous gesture (Goldsmith has published, among other things, books cataloging every movement of his body over a 24-hour period) he has a kindred spirit in Tone, a sound artist who composes by 'bandaging' the playable surface of CDs in transparent sticky tape. Since the music is not bound to a corresponding visual culture, though, as earlier music-based subcultures have been, the audiences for the above artists could change with relative ease, and with a minimum of squabbling as to who 'represents' or even 'deserves' the culture more. And so, an interesting paradox arises from all this: a music that has so much of the human element vacuumed out of it, it ends up appealing to a broader section of humanity than many other genres you could name – genres which cater specifically to the needs of a single age group or social caste.

The varied audience for Mego likely would not have happened, though, without a cast of music producers who themselves came from divergent backgrounds and creative perspectives. For

every street-level Peter Rehberg, there is a mathematically-minded *wunderkind* like Florian Hecker, trained in the stochastic technique of modernist mastermind Iannis Xenakis, with CD liner notes that will make the technical layman's head explode with their references to pulsars, particle synthesis and 'spatio-temporal confusion'. Hecker is also noticeable for using the PulsarGenerator software of Albert de Campo and Curtis Roads, editor and associate editor of the *Computer Music Journal* from 1978-2000, and author of the fairly left-brain oriented audio manual *Microsound* (we can only guess what kind of arguments Curtis Roads and Bob Ostertag might have.)

Both Hecker and Rehberg, regardless of their training and methodology, often come to the same conclusions with their sound: they are equally capable of wringing intense shrapnel storms and more delicate, sparkling sound artifacts out of their computers. It is also telling that both have a habit of using the word 'acid' in the titles of their pieces (see 'Acid Udon' from Pita's *Get Down*, or 'Stocha Acid Vlook' from Hecker's bracing *Sun Pandaemonium*) – although it is not clear if this is a mutual nod to the disorienting, dissolving properties of LSD (and the similar effects delivered by the music), or some other devious in joke cooked up between the two. Dig deeper into the Mego back catalog, and you can find episodes of teeth-shaking, elemental noise from Russell Haswell alongside the bittersweet digital daydreams of Tujiko Noriko. Still more faces of the label emerge in the multi-media synergy of the Farmers Manual trio, the alternately cruel and hilarious stage dramas of Fuckhead, and Merzbow, who puts in at least one solo appearance on the label. The inclusion of Merzbow invites an interesting parallel between Masami Akita's reassessment of urban detritus and the other Mego artists' willful embrace of the computer error. Finally, no overview of Mego is complete without considering the visual design and layouts of house artist Tina Frank, whose special oversized CD folders helped the label's releases to stand out amidst the standard CD jewel cases on store shelves – often forcing retailers to place Mego music in a privileged position before having even heard it. Frank's designs are also notable for their playful use of patchwork assemblages and toxic colors, certainly a deviation from the geometric puzzles and sterile schematics which graced the covers of the first generation of 'computer music' LPs.

The colorful cast of characters that made up the Mego roster is not a unique product of the various personalities descending on the pleasant-yet-conservative Austrian landscape, or the social invention of a single charismatic personality to whom others gravitate. More than anything, it is a product of all these people being in the right place at the right time: a time in which the compact-yet-powerful music setups used by the musicians make it impossible for one dominant personality to emerge as a tyrannical tastemaker. Without such a person reigning over the proceedings, the risks involved in collaborative experimenting are much less, and small networks of like-minded individuals can ricochet their ideas off of each other with little fear of losing their place in some musical hierarchy. As outlined by perennial digital culture optimist (and original investor in the techno-utopian *Wired* magazine) Nicholas Negroponte:

"Like a force of nature, the digital age cannot be denied or stopped. It has four very powerful qualities that will result in its ultimate triumph: de-centralizing, globalizing, harmonizing, and empowering."[17]

By Negroponte's sunny reckoning, the conditions should now be ripe for dozens of other organizations to be formed along the same lines as Mego – and at least a couple of these are worth mentioning.

Electric Friends

This open-minded ethos of "available to anyone who understands it" is not, by any means, an exclusive Mego property: several other record labels and organizations have such an overlap with the artists represented by the Mego label, that it's counter-productive to engage in arguments over who deserves sole credit for starting this trend towards weirder, wetter computer music. The OR label, for example, which was organized around Russell Haswell and erstwhile Touch boss Mike Harding in London, features releases by Karkowski, Hecker, and Farmers Manual (whose *Explorers_We* sits alongside Pita's *Get Out* as a *pièce de résistance* of the genre) alongside the more

free-form, noisy, and non-computerized entries from Daniel Menche and Incapacitants.

Like Mego releases, OR releases distinguished themselves from the outset by dint of their unique packaging. OR CDs came packed in jewel cases without corresponding booklets, the printed graphics on the CD surface substituting for 'covers' in a skeletal form of graphic presentation that was rife with interpretations, any of which could be correct: were the CDs released in this manner as an ecological consideration (saving paper), an economical necessity (printing costs would be severely reduced), or as a revolt against commodity fetishists who demanded that all their consumer products come in pointlessly ornate packages? Whatever the case, it was a simple move in which the CDs' exceptionality was multiplied through the subtraction of a very 'standard' component. Other OR compilations, designed by Haswell, would feature the inverse of this design: a clear CD jewel case with an austere graphic-less booklet (text and UPC code only), but with the CD laid bare by a missing tray card. The audio of select OR CDs was likewise 'subtractive' in its method: the *Datastream* release by Edwin van der Heide and Zbigniew Karkowski simply converted digital data from the Microsoft Word program into audio signals, with no real attempt to 'play' or edit the results. This subtractive aesthetic was taken to one logical endpoint when GESCOM (a portmanteau of 'Gestalt Communications' featuring members of Autechre, Russell Haswell, and other anonymous players) released the first non-Sony album in the *world* to be commercially available on Mini Disc. The only problem? A very small segment of music consumers outside of Japan had the equipment to play it on, although the Mini Disc format had existed since 1992. It was one kind of move to pare down graphics and audio content to the bone, it was another entirely to deliberately cut the art off from its audience – although there is some humor involved in the way this release confused and inverted typical patterns of consumption: fans would be forced to buy a new piece of equipment to play a single album, instead of stocking up on albums to feed the hungry home stereo equipment which they already owned.

The Falsch label was another unique outpost for all the above-mentioned digital quirks and disruptions: this time Florian Hecker and Oswald Berthold were the sound curators, with "hyper-music on purpose" being their slogan. Running from 2000-2005, Falsch offered music in a much more minimally packaged format than even OR: that is to say, no physical objects at all. Falsch was basically an outlet for 'releasing' downloadable sound files of the above-mentioned artists, along with mavericks like Voice Crack and CoH. Compilations eventually appeared in CD form, but only after a good deal of had been relayed across the fiber-optic pathways of the Internet.

Spain's Alku features a familiar cast of characters: Messrs. Hecker, Rehberg and Tone all feature in their catalog, along with a scathingly loud combo called EVOL, consisting of Anna Ramos and Roc Jiménez de Cisneros. What the label also features in spades is a deviant sense of humor, commenting on the fragility and frustration of our relationship with technology in a series of prank-infused conceptual releases. One Alku CD-R release, *El Formato is The Challenge* (a wry poke at a McLuhan-ism which still haunts us), features only a couple tracks in 'conventional' music formats, while the rest of the release is given over to computer files with file extensions in varying degrees of usability and obscurity. Most amusing of the contributions on this disc may be V/VM's track, *Scanner, Wire Magazine August 1999*. This is a play on words using both the name of the British sound artist Scanner, and the method used to make the track – according to one net review, "V/VM have scanned music-mag *The Wire*'s front cover image of Scanner to see if the music sounds as pretentious as Mr. Scanner does."[18] Another Alku release, *Imbecil*, contains no music at all, but a series of ridiculous computer programs which range from the amusing to the simply useless. It is a kind of micro-rebellion in itself against the idolization of computers' "smooth functionality" – via *Imbecil* you can make a 'kernel panic' (a sudden unexpected shutdown exclusive to Macintosh computers) happen on your expensive machine at any time you like; and if that isn't enough of a tip of the hat to Tinguely's 'auto-destructing' art, you also have an option to have a special Microsoft Word script write a suicide note for you. Yet another *Imbecil* side project, a curious Macintosh UNIX script called 'foofoofoo', is not useless at all, and is actually quite convenient for those wanting to make 'automatic' compositions which can later be edited. Foofoofoo will raid a

user's hard drive for sound files, taking miniscule clips from each one and reassembling them into one unpredictable juggernaut of a non-linear digital composition (the more soundfiles one has, the more epic the effect, obviously.)

Meanwhile, the titles of essays by Alku flagship act EVOL reveal a more serious and ponderous approach that mines chaos theory, fractals, and questions the real use of computers as randomizing machines – in one revealing short essay from a computer art exhibition, e +, the Alku team answers the question "can a computer come up with a random number?" as such:

"Technically, NO. Practically, there are hundreds of computer programs and computer-driven algorithms out there that – at least – claim to do it. But when it comes to the philosophical part of it, things get trickier: if a computer is a deterministic machine (that is, all it does is completely determined by its current state), it certainly cannot do something "by chance". You can do it, your friends can do it, but not a computer."[19]

It's an interesting conclusion for those who compose 'computer music' while quoting from John Cage on indeterminacy. The Alku team also shows us, as so many other 'glitch' musicians indirectly suggest, that computers are still somewhat imperfect even in areas (such as mathematics) where we deem them to be superior to humans. In fact, we are still far from being overtaken by artificial intelligence, for those who take comfort in this fact. Consider the 'Turing Test': in this famous test, a human judge monitors a conversation between a human and machine, with both attempting to have a typically 'human' conversation (marked such 'exclusively' human traits as irony and a sense of humor.) If the judge cannot tell human from machine over the course of the conversation, the machine is said to have 'passed' the test. No computer system has done this as of this writing, and many are often prone to hilarious 'communication breakdowns'. It is also an interesting fact for those who think music of the kind represented on Mego, Fals.ch, Alku etc. is a form of brazen computer idolatry: the work of the 'glitch' squad shows us that we often give computers more power as omniscient devices than they really deserve. Maybe Otomo Yoshihide was not that far off in calling this music a kind of computerized 'punk', since it, too, is a musical form celebrating the fact that the power structure – and the technology that enables it – cannot function perfectly all the time; occasionally things just happen to 'slip through the cracks'.

Even as this has been said, though, one of the Alku label's more recent releases, (*Less-Lethal Vol. 1)* abruptly dispenses with the humor and compiles tracks meant to be used as 'sonic weapons', giving a musical voice to the dark suspicions swirling around the clandestine activity of the military-industrial complex. Hannah Arendt's famous proclamation of the "banality of evil" does not apply to the mean, bracing tracks on this CD, since the artists seem bent on exposing the primordial violence and the intoxicated, omnicidal urges of the global military machine. As the mass media discusses brainwashing and torture (re-branded for the squeamish as "enhanced interrogation technique") in a manner as detached and methodical as the pain dealers who carry out the orders to do such things, it is up to artists to once again provide a more convincing 'running commentary'. Lasse Marhaug and Zbigniew Karkowski contribute some of their noisiest, direct work here, while Dave Phillips' steadily rising and multiplying spoken mantra of *"there is no right or wrong"* need only be played under the influence of the right spirit-numbing pharmaceuticals in order to turn the listener into an impressionable zombie/berserker hybrid. It is a release which leaves an uncomfortable aftertaste, warning us that, even as we gloat over how technology empowers us as citizens (and gives us nearly all of the exciting new music described in this chapter), a vast network of military, security, and 'intelligence community' officials earn their pay by making that same technology act as a digital straitjacket.

Many more such record labels and autonomous organizations exist and continue to develop – some, like Antifrost, capture the attractively vague technological atmosphere of the entities listed above. Others, like the Erstwhile label in New York, borrow from the rosters of these organizations and give them an opportunity to explore avenues (usually quieter and more intimate ones) not explored on the works recorded for their 'parent' labels. As with any genre of music or any artistic approach, further waves of artists will arrive and dilute the potency of the seminal releases with a

harvest of sound-alike material, and many who have built their careers on unrelenting intensity and will suddenly lose their nerve or 'burn out'. But for the moment, this music appears it could have a surprising longevity. Each artist in this style works within a set of confining parameters, but has a flexibility within those parameters that is not available to more conventional forms of music. The general lack of concern with giving the 'scene' a human 'face', and with collectively nominating a single figure or spokesperson who epitomizes that 'scene', have allowed for much more dedicated investment in the audio content.

Embracing The Alien

"For years one of my main activities was making music with computers. I remember when the first music software for personal computers became available in the 1980s. The music created with this technology played with an electronically precise meter (the time between beats), making it sound radically different from the rhythm of music made by humans. Most musicians working with computers at the time had the same response I did: 'Well, this is sort of cool, but it sounds so *machine-like*, no one will ever listen to it. To be really interesting, this technology is going to have to evolve to sound more human.' And software engineers busied themselves trying to make computer music sound human. But before they could solve the problem, a new generation of kids had come up who *preferred* the machine-like quality of computer music. Music with an electronically-precise, not-humanly-possible meter has now flooded the world."[20] (Bob Ostertag)

In the essay from which the above excerpt is taken – Bob Ostertag's "*Are Two Dimensions Enough? The Networked Screen and the Human Imagination*" – the author puts forth the argument that supposedly 'second best' virtual experiences, like playing a game of video football rather than watching it live, are actually more appealing to many people than the "real life" equivalent, owing to a greater degree of control placed in the user's hands (as the argument goes, why would one want to watch a TV football broadcast cut through with advertisements and other diversions, when they can command a virtual copy of their favorite team and have some direct effect on steering the game's results?) Internet pornography is also an obvious and prevalent example of this, what with its possible use as a 'testing ground' for certain fantasies, and its low risk factor when compared with interpersonal contact and intimacy: Ostertag proposes that "pornography was previously something that one looked at while fantasizing about being with another person...pornography has moved from being the substitute to being the ideal."[21]

Back to the world of music production, it is interesting to consider how much the developers of computer-based instrumentation once fretted over its inability to reproduce the unique timbres of naturally occurring sounds. Kim Ryrie, who co-founded the company responsible for the groundbreaking Fairlight CMI [Computer Music Instrument], eventually decided to try building a microprocessor-based synthesizer after some disappointments in the 1970s. "My frustration set in because of my ability to produce more natural sounds,"[22] Ryrie sighs. Elsewhere, the promotional material for the E-mu Emulator sampler, released in 1981, asked "how would you like to play a turkey?" proudly mentioning the ability to accurately reproduce a plethora of other natural sounds (dogs, violins, etc.)[23] Nowadays, the presets on digital synthesizers and the sample banks included with music software tend to do the opposite of what Ryrie and the E-mu staff hoped to accomplish: to make synthetic sounds distinctly at odds with the realm of the natural, sounds which intrigue through their distance from reality and not their closeness to it. Moreover, in a culture where sampling technology can now easily imitate organic sounds, the real hallmark of sophistication has become sounds that are 'neither here nor there' – sounds whose sources cannot be easily discerned as a sampling of 'real life' or as a computer-created chimera. The curiosity surrounding these novel sounds bypasses the realm of the sentimental and directly stimulates the imagination of the listener.

The generation gap indubitably plays some role in computer music of the day: the older generation seeks a reinforcement of tradition and a vindication of their past culture-shaping victories, and most young people are invigorated by a 'cool noise' whose brightness and novelty can

be attributed to *their* era and none other, while convincing them that their generation is helping to dismantle the orthodoxy of previous generations. But this argument is somewhat flawed when we consider that the generation of Peter Rehberg, Ramon Bauer, Zbigniew Karkowski, Russell Haswell et. Al. is in, or nearing, its 40s already (to say nothing of the septuagenarian Yasunao Tone.) Although there are a slew of younger counterparts to these musicians, their creations are, so far, not much more radical than the works of their seniors. The middle-aged segment of the new digital music milieu came of age just in time to see the failures of the hippie counter-culture, with its reliance on absolutist exhortations like "never trust anyone over 30!!!" Nor were these musicians ever an ideal representation of the *zeitgeist* of their own generation, functioning mostly as intellectual outsiders wary of commerce and hyper-competition in all its manifestations, especially in the arts. The present speed and omnipresence of electronic communications once again plays a role in bringing together and extracting the common motives from the myriad of differences between the post-1960s generation, Generation 'X', and Generation 'Y'.

If listening to alien sounds is a demanding experience for the traditionally minded music consumer, continually eluding attempts to connect them with familiar events and memories, then *talking about* these sounds is even more of a challenge. The idiosyncratic project names and track names of these computer musicians have more in common with F.T. Marinetti's Futurist poetry (or, again, with the atomized creations of the Lettrists) than they do with any kind of conversational exchange. Impossible-to-pronounce project names like GCTTCATT are like onomatapeia for the incomprehensible speed of computer processes, or at least bring to mind the explosive neologisms used in comic books to give readers an idea of the sound accompanying a sudden action. Likewise, Florian Hecker's habit of using those very processes as track titles borders on the infuriating: tracks/albums like 'Femtoje Helical', 'Ciz-Glemp 2' or *[OT] Xackpy Breakpoint* are so unlike the phonemes normally heard in human languages, that one can only compare them to instructions fed into a machine – or, stranger still, as the undecipherable, time-distorted communications which take place in one's dreams. Even the Futurists, in their mania for smashing traditions, still had conventional titles for their sound and poetry works. However, Russian Futurist poet Alexei Kruchenyk may have been a century ahead of his time when he formulated *zaum* poetry in 1911 – built from the phonemes *za* (beyond) and *um* (mind), Mel Gordon describes this phenomenon as follows, offering some clues as to the possibilities of strange new digital-age neologisms:

"According to Kruchenykh, the Futurist poet has at his disposal this other form of vocalization, one rich with private associations and new sound ideas: *zaum*. The secret of primordial creation, that is, the trans-rational language, could lead the artist far beyond the restraints of socially sanctioned patterns and the vise of national vocabularies."[24]

Like the strange neologisms used to frame the music, the computer music under examination does not try to seduce by invoking the familiar. Heavy distortion, degradation, and convolution (a technique in which the 'acoustic signature' of one sound is mapped onto another sound, resulting in strange new hybrids), among other forms of digital signal processing, all work in concert to create music which is enticingly *unlike* one's immediate surroundings. As words like 'degradation' might imply, the axiom 'cleanliness is next to godliness' has no meaning here: clean, hi-fidelity sound samples are often ignored in favor of exploring the digital murk. The music appearing on Mego-style recordings often features sounds that could be likened to the jagged-edged 'raster' versions of graphics, rather than smooth vector images that maintain their resolution no matter how large they are expanded (a point not lost on the German label named Raster/Noton.) There is a high preponderance of low-resolution, "bit decimated" sound, and in one instance – the Rehberg & Bauer CD *Faßt* – the final mix of the album was inexplicably reduced to an inferior 8-bit resolution instead of the 16-bit resolution common for commercial CDs.

The creation of deliberately junky sound artifacts using state-of-the-art equipment and complex coding is a novel move indeed: and this, once again, confirms Otomo Yoshihide's claim that Mego music is a computer-based upgrade of at least some punk rock ideals. Out-of-control punk musicians destroyed their own equipment as the apotheosis of their stylized "I don't care" nihilism,

hinting that such gear was ultimately mass-produced and expendable, without the spiritual value conferred on it by the previous generation of 'dinosaur' musicians (of course, there was also the underlying hint that the musicians themselves were seen as expendable in the urban landscape.) Computer musicians, using their laptops for a number of functions beyond music production and performance, were not so quick to smash their equipment (I have still not seen such a gesture at even the most violent concerts of laptop-generated noise), but they could still resort to smashing the bits themselves, taking streams of 'clean' audio and trashing it with ingenuous software plug-ins. This, then, fulfills the dual purpose of criticizing the utopian elements of digital culture in a unique, non-verbal way, and also of providing the niche audience with something enjoyably alien. Whether it is a biting critique, or just a 'cool noise', depends only on the listener's personal inclinations towards technology.

+++++++

It remains uncertain whether the music generated in the wake of the 21st century computer music mini-boom will ever reach a mainstream audience. Certainly music styles that were once thought too sonically extreme or socially confrontational for public consumption – punk, thrash metal, hip hop – are now fused to the grid of commercial culture. One thing *is* certain, though, and that is that the critics of computer-based performance and composition will have even more contentious developments to face with music interfaces becoming even more compact and farther removed from the realms of technical skill exhibition: patches for open-source programs like Pure Data are already being ported to tiny devices like the iPod, making real-time performances possible from within the most squalid of personal spaces and making composition something which can be done on commutes by train (a practice which Christian Fennesz has already admitted to.) More radical, far-flung developments, like the implementation of wireless electricity, would even overcome the battery power constraints faced by these portable devices, if the studies of researches like MIT's Marin Soljacic bear fruit. More importantly, time that would otherwise be spent transitioning from one activity to another could be spent on at least some rudimentary form of creative work. For better or worse, the shrinkage of electronic musical interfaces may also lead to more unprecedented occurrences: another step in the direction of an eventual 'first-level cyborg' symbiosis between flesh and synthetic material – music generated by a direct brain-computer interface, or by means of special sub-dermal implants hooked up to amplification.

Before any of this wild speculation comes to pass, though, there is still the issue mentioned above – whether this music will be accepted by the general public as a stimulating distillation of the increasingly complex human experience, or whether it will be rejected as just more willful obscurantism and aesthetic nihilism from increasingly disliked 'contemporary artists'. If we chart the progress of previous forms of extreme electronic music, though, the most likely result is that elements of it will be assimilated by and used as the ornamentation for more standard musical fare – maybe a "glitchy" introduction to add exoticism, or a looped sample of static electricity buried underneath a lovelorn, pining vocal. And, of course, thanks to the voracious nature of advertising and marketing culture, and its propensity to censor itself less than the music business proper, there are always plentiful opportunities to sneak these materials in through a back door. After all, it was not too long ago that one Austrian bank perfectly exemplified the possibility for almost anything to be re-assimilated into the daily functions of commerce. Their reward to new bank account holders upon signing up? Bank books and ATM cards adorned with aesthetic representations of spilt blood, courtesy of Viennese Aktionist Hermann Nitsch.

7.
TO KICK A KING:
THE KINGDOMS OF ELGALAND/ VARGALAND

"A while ago, I bought your new football 'Kick A King'. Now I want to complain. I want my money back! In the advertising, you say that it looks like the Swedish famous king, Carolus XII. But that's not true. It looks like Margaret Thatcher's ass! So I want my compensation. I don't want to kick an ass... I want to kick a *king*."
(Leif Elggren, from 'A Hole In The Palisade')

It would be hard to say, with any degree of certainty, that the 21st century push towards a 'global village' has been met with global approval. The existence of continental super-states like the EU (and similar proposed experiments, like the 'North American Union'/'Security and Prosperity Partnership') may have eroded away at the concept of national sovereignty and geographical borders, but they have done little to erase long-standing cultural differences and widely varying attitudes regarding the notion of "progress." The belief that everyone is expected to achieve modernity at a similar pace, at the expense of deep-seated indigenous or tribal beliefs, has already seen catastrophic acts of violent retaliation (or 'blowback,' to use the jargon forwarded by the CIA.) The prime example of this theory is the destruction of the World Trade Center buildings on September 11, 2001 – ostensibly ordered by a fanatical Wahabi Muslim who detested the American bases on sacred lands in Saudi Arabia. 7 years after that initial shock to the system, other examples of resistance to U.S.-style democratic "makeovers" pop up at a rate too fast for this book (which is, after all, supposed to be a survey of modern electronic music, something we will return to after this brief interlude) to accurately record. The enemy of the Western Utopian dream is now just the inverse of what it was during the Cold War: instead of a superpower state, like the Soviet Union, which was too strong for its own good, the focus of fear now lands squarely on 'failed states' like Afghanistan and Iraq, where chaos, factional violence and a "nothing to lose" mindset reign – and where, as an endless string of panicked TV commentators remind us, a weapon of mass destruction can fall into 'the wrong hands' at any time.

The failure of globalization, though, is not limited to its propensity for meddling in the affairs of sovereign nations in the hopes that they will adopt Western-style democracy and global capitalism. Thinkers who are inclined towards musings on eschatology, like Paul Virilio, see it as, at

the very least, a bizarre inverted world where acting at a distance seems more natural than taking action locally: "globalization is turning the world inside out like a glove...from now on, the near is foreign, and the exotic close at hand."[1]

This is not Virilio's only gripe with globalization: he also worries that "*globalization provides the 'state of emergency'*, that foreclosure which transforms, or will soon transform, every state into a *police state*, every army into a *police force* and every city into a *ghetto*... [italics from the original text]."[2] Indeed, the weakening of individual rights and individualistic values engendered by globalization has also become a serious issue. Western governments, especially that of the U.S., have become gradually more centralized, gathering unprecedented amounts of executive power into the hands of a small core of individuals – ironically adopting the strategy of the once-hated Soviet Union in the process.

With this has come a whole host of draconian laws designed to stifle dissent: provisions like the Military Commissions Act of 2006, the USA PATRIOT Act, and the (get ready for it) Violent Radicalization and Homegrown Terrorism Prevention Act effectively destroy the values that the U.S. embraced when it existed as a Constitutional Republic, rather than an imperial stronghold of transnational corporations and war profiteers. Some of said values include the legal right of *habeas corpus,* and other civil liberties long since entrenched in the American legal system – this is disheartening enough without also considering the extremely vague wording that makes up such documents as the "Violent Radicalization..." bill. It is such vague, freely interpretable definitions of "terrorist" and "enemy combatant" which allow for virtually anyone to be classified as a State enemy to be dealt with by military force and incommunicado detention. Of course, as Randolph Bourne warned, "war is the health of the State" – and a state of perpetual war against anti-globalist militants has clearly strengthened and centralized all the State's functions while giving it an excuse to quash expressions of individuality – to say nothing of *bona fide* resistance – within the homeland. The percentage of citizens who still see these pogroms as a necessary evil is astonishing, and many have plainly come to the conclusion that it is 'for their own good', exposing an irrational belief that it is possible to have both tight security and total freedom. Yet, according to Håkan Nilsson, a spokesperson for the enigmatic KREV [Kingdoms of Elgaland and Vargaland]:

"The state, of course, will never admit that any of its actions are carried out to preserve its power and/or the existing order. It will always pretend that everything is done with the utmost care for the benefit of the citizens. The fact that this is not the case is amply demonstrated by several examples of state actions. In the late 19th century, Baron Haussman created the boulevard system we now find emblematic for the city of Paris. The question is, as is well known, was this an action of a philanthropic government, which tried to open up a closed city, bringing daylight into a maze-like infrastructure? Or was it rather something that allowed the same government to easily transport troops from one area to another? Given the history of the Paris community, and given the fact that city planners from ancient history to the present have been in military service, the most common and obvious conclusion is the latter one."[3]

The example of Haussman is a pertinent example in this discussion, since it is a case of, as Nilsson points out, making the city of Paris more appealing to tourists and apparently more 'free', but in reality "this was the first application of the idea of opening a space as a means to fortify it".[4] The same tactic has arguably occurred with cyberspace: the creation of a superficial autonomy which causes citizens to 'let down their guard' and act a little too freely while under observation. However, the primary target of the "Violent Radicalization..." bill was the Internet, which is still the most de-centralized medium of mass communication, whether routinely monitored or not. There is no 'headquarters' for the Internet, it is a network composed of countless micro-networks, none of which are expected to report back to a single higher authority. Seen as such, the true surprise is that central governments had not begun talk of censoring/ regulating the Internet *sooner* – given its ability to provide convincing counterpoints to 'official versions' of reportage on the state of the nation – 'official versions' which are usually brought to you by major news networks with the sponsorship of major defense contractors.

Since long before the dawn of mass media or the Internet, though, we have been conditioned to accept at least some form of centralized power – if not the ugly and paranoid kind outlined above – as the best way of doing things. We even look to nature as proof of this, although some of the situations we use to 'prove' the existence of centralized power are completely false, as Nicholas Negroponte points out:

"We commonly assume, for example, that the frontmost bird in a V-shaped flock is the one in charge, and the others are playing follow-the-leader. Not so. The orderly formation is the result of a highly responsive collection of processors behaving individually and following simple harmonious rules without a conductor."[5]

Negroponte also goes on to point out how certain actions, like a concert audience clapping in complete unison, can be accomplished in seconds without having to seek the permission of a central authority. The model of central control, he says, is actually highly unstable, and that

"...[decentralization] is viewed more and more as a viable way to manage organizations and governments. A highly intercommunicating decentralized structure shows far more resilience and likelihood of survival. It is certainly more sustainable and likely to evolve over time."[6]

People toiling away at artistic trades seem to acknowledge this fact better than people working in trades which are thought to be more "socially useful". Past attempts at centralizing music production, for example, have been awkward at best and disastrous at worst: to wit, the French National Institute of Music created in 1793. This august body forced a central ideological assessment of every aspect of music production, from the instruments used (imported German woodwinds were declared *verboten* by the Institute) to the rate at which music was produced – monthly quotas were instituted for production of revolutionary hymns, marches, etc., which undoubtedly led to a staggering amount of middling, sound-alike music. This may just be a more rigid version of how established commercial entities (e.g. major record labels) operate at present, the main difference being that major record labels would never admit to putting limits on their contracted artists' creativity. Whether control is in the hands of a state government or corporation (and admittedly the two entities are gradually merging into a single functional body), the result is the same: artists are reduced to a role of recycling the dominant ideology in their works, cutting them off from a vast amount of spiritual expression. Luckily for major record labels, the goals of most of their recording artists neatly coincide with their own: the artists want to attain huge profits and visibility, eventually securing a place in the national elite (see the knighthoods conferred upon Paul McCartney and Beatles producer George Martin), and their corporate bosses hope to do the same.

With the situation as such, it was perhaps inevitable that some of the more innovative artists in the field of sound would choose to declare their independence – not solely through the means of independent record labels, or concerts and other events held in autonomous spaces, but through creating an entire 'state' of their own. Leif Elggren and Carl Michael von Hausswolff, the two individuals at the heart of the KREV undertaking, have been in collaboration since 1979-1980. By von Hausswolff's admission, they had been working with concepts such as hierarchy and symbology from that point up until the formation of KREV in the 1990s. Von Hausswolff claims that KREV was the logical conclusion to a lengthy flirtation with these ideas, saying "we realized that it would be interesting to move these concepts into a practical function – we decided to use the concept of the State."[7] The twin kings have a long history of de-centralized artwork building up to this conclusive act – and at least some of this is worthy of summarizing before going into detail about their invisible empire itself.

Claiming the Thrones

The official motto of Linköping, Sweden is *"Där idéer blir verklighet* [where ideas become reality]" – whether they had people like Carl Michael von Hausswolff in mind when offering up this simple prayer to ingenuity, it is hard to tell. Von Hausswolff was born in Linköping (he now lives in Stockholm, after a long stint in the 2nd city of Göteborg) and he has certainly taken the concept

of "ideas becoming reality" to an appreciable level. Especially when raw sound is concerned, he has taken this evanescent material and concretized it in a dramatic way. The *curriculum vitae* on his personal website proudly proclaims his music's "polyfrequential ability", which has the power to alternately lull audiences to sleep and to provide a "'feeling that the flesh came off the bones,' due to the vibrations of the low frequencies used."[8] The von Hausswolff *oeuvre* can involve a number of things from unprocessed field recordings to, at its most static, single electronic tones which melt away a listener's defenses. Asked about the whys and wherefores of this sound, he replies:

"I think it's my lack of concentration and focus that makes me want to go deeper into a specific sound. A stripped and persisting sound forces me into it – there's no escape! The reason why I started to work with recorded material was that from a certain point of view there were not many references and I could go about doing what I wanted to do without being interrupted by negative criticism. I was too lazy to learn an instrument and just wanted to go on doing something new... so I created my own world and continued from there. Now, of course, I see references everywhere because I have moved into a certain kind of community of composers and artists – but at that time (1979/1980) we were not many around."[9]

Carl Michael von Hausswolff is practically synonymous with the advancement of sonic art in Sweden, working both as the bonding cement for a 'scene' and as an artist in his own right. Among other accomplishments, he has curated the 2nd Göteborg Biennale (2003), launched an event entitled *Against All Evens* and curated the *Freq Out* event, which consisted of prominent sound artists being invited to an electronic tone composition within a specified limited segment of the audible frequency spectrum. He has also had a hand in the formation of the Radium 226.05 and Anckarström record labels. The former was recognized as the leading support network for sound art in Sweden, while the discography of the latter especially documents a sort of movement in Sweden based around highly concentrated sound art with a bare minimum of ornamental flourishes or crossover with transitory popular culture. While on the board of the Swedish art organization Fylkingen (which was formed in 1933 and has remained active ever since), von Hausswolff was also instrumental in the reformation of the Fylkingen Records label, which archives the past and present electronic music compositions from a country which boasts more pioneers in this field than any of the other Scandinavian nations. On this subject, von Hausswolff states that

"Fylkingen and Moderna Museet [The Modern Museum]played a large role in the history of Swedish experimental music and performance art, and artists like Sten Hanson, Bengt af Klintberg,Öyvind Fahlström and Lars-Gunnar Bodin have not only been creating a large portion of works – they have also promoted younger artists in order to build up a strong tradition. The Swedish artists have also been well connected to the outside world of electronic music, sound poetry and performance, and this has created a flux of art coming into the country and going out. In Finland, the electronic music scene has always been to connected to an underground type of movement...and in Denmark and Norway this scene has basically been dead. Only recently have a bunch of great musicians, composers and artists been emerging in these countries. A good example is the case of Else Marie Pade from Denmark. She composed her first electronic music pieces in the mid 1950s – a pioneer!! – but no one in Denmark (and in the rest of the world) knew anything about her music until 2001, when two CDs where released by her...a perfect case of total ignorance from the musicologists, critics and cultural spheres."[10]

Although the respective destinies of CM von Hausswolff and the Fylkingen organization are not totally inseparable from each other, Fylkingen does deserve some further acknowledgement for nurturing the creative climate which would culminate in artists like von Hausswolff and Elggren, and the Kingdoms of Elgaland and Vargaland by extension. The history of Fylkingen, in particular, parallels the history of the avant-garde and of the non-conformist urge in Swedish art. Early LPs released by the organization focus on indeterminacy in electronic music and 'text-sound compositions' by Sten Hanson and others, with an impressive variety in the results. Arguably there would be no forum in Sweden for electro-acoustic music without Fylkingen, much less documentation of the more radical activities which took place in Sweden in the 1960s. That intense

anti-authoritarian spirit was embodied in adventurous souls like Åke Hodell, the former fighter pilot whose disillusionment with military regimentation led to concrete poetry works like the *Verbal Hjärntvätt* [Verbal Brainwashing] LP. The maddening verbal repetition on the LP tracks, such as 'General Bussig,' begins to hint at how easily mental resistance can be abraded away at in situations of military indoctrination. More interestingly for students of electronic music's development, though, is another military-inspired piece from 1967 entitled *Strukturer III* [Structures III]. For Sweden, this was a kind of breakthrough in 'noise as music,' or at the very least a vindication of the Italian Futurist program. At a time when academic (mainly serialist) electronic music and tape music was just starting to court wider attention, Hodell dared to use the medium in a decidedly less ponderous and comforting way. According to Torsten Ekborn's notes for the Fylkingen reissue of *Verbal Hjärntvätt*:

"I assume that the audience, reading the title in the programme, envisioned a calm electronic glass pearl display of serially trimmed sinus tones. When the piece started, a hellish noise came from the loudspeakers, strategically placed in a ring around the audience. [...] *Strukturer III* turned out to be a sound collage with authentically and chronologically demonstrated the acoustic happenings of both world wars. Perhaps the most frightening part of the piece was that no one ever heard any human voices, neither commands nor moans from the wounded. It was the death machines themselves which got to perform, the infernal concert presented by humanity when it tries to murder itself."[11]

The piece in question, if nothing else, was a harbinger of the current era, wherein people readily consume such soundscapes as entertainment in movie theaters rigged with Dolby surround systems blasting at 120 decibels. However, Hodell's piece would still be quite a challenge to these same movie-goers if it were only the raw sound presented without an accompanying heroic narrative. The military phase of Hodell (which Ekborn cautions us was not "radically pacifistic," given Hodell's position as one of just a few fighter pilots preparing to defend Sweden against invasion by the Nazis), was just one phase in a diverse, but cohesive, program of avant-garde innovation. Hodell's next phase would concentrate on sound pieces which were a striking mélange of narrated/ spoken text, dramatized text, purely electronic atmospheres, taped sound events and even interludes of 'traditional' music. These "text-sound compositions," as they came to be called, were a distinctive art form building on the 1960s' intercontinental explosion of sonic art re-assessing and atomizing "The Word" (as personified by Brion Gysin, John Giorno, William Burroughs, Francois Dufrene, Henri Chopin, and others.) Within these sound experiments are the germ for later creative work by von Hausswolff and Elggren, as well as an incitement for Hodell's contemporaries, like Lars-Gunnar Bodin, to see what they could do with the "text-sound composition" template. Sadly, the 'total ignorance' that von Hausswolff applies above to Else Marie Pade also seems to have extended to Hodell, Bodin and others, as documentation on their activities outside of Sweden was quite limited.

Like Hodell's compositions, Carl Michael von Hausswolff's sound art, whether 'comfortable' or not, suggests the human organism's inextricable bond to forces of decomposition and decay just as it documents mankind's attempts at becoming greater than itself through architectural triumphs. As to the former, he has released a pair of mini CDs on the Viennese Laton label dealing with rats and maggots, even coming packaged with such dubious prizes as packets of rat poison and real insect larvae from Thailand. Another title, *Leech,* on Carsten Nicolai's Raster/ Noton label, references such cyclical processes by naming itself, and the composition process involved in recording the CD, after a creature which feeds off of decomposing bodies and open wounds (Von Hausswolff's digital "leeching" here involves sucking sonic elements from original sound pieces, the remixed versions bringing to mind cleaned-out buildings or hollowed shells.) His abiding interest in the interplay between emptiness and richness, decay and vitality is occasionally carried out in visual experiments as well, such as his ongoing series of *"Red"* art actions. For each of these events, Von Hausswolff explores a city at night looking for select locations to be illuminated with blaring red floodlights, photographed in this reddened state, and then returned to normal. This act has been carried out in locations from Liverpool (where the Mersey river was reddened) to Santa Fe (where an abandoned

cemetery was given the same treatment, titled *Red Night*.) Photo documentation of these 'reddenings' reveals how easily a human habitat can have purposefulness either stripped from it or re-invested in it: in some cases, the red flood lighting feeds life into the sleeping structures, in others it casts a pall of death or fear onto landscapes that would otherwise be quaint little idylls. This process reveals how the malleability of human nature can be applied to virtually anything that mankind builds, that our extensions and 'second skins' may shelter us from the elements, but not from our susceptibility to drastically change on a moment's notice.

Contrasted with the surgical intellect that marks much of von Hausswolff's work, KREV's co-ruler Leif Elggren (another son of Linköping, born there in 1950) can seem positively impish, a comic foil in a sense. This is not to say that the multi-disciplinary Elggren lacks a capacity for serious and severe introspective work, playing on universal fears of mortality – his semi-autobiographical book *Genealogy* is partially dedicated to the concept of "death as a lifelong friendship", while his striking line drawings of faceless and polymorphous humanoid figures permeate one with an uncomfortable sense of fragility (for examples of such, see the John Duncan retrospective catalog on Errant Bodies Press, or the cover of the Anla Courtis/ Lasse Marhaug release *North and South Neutrino,* on Antifrost Records.) The two kings also share past artistic undertakings which, although done independently of each other, almost mirror each other in their intent. The Von Hausswolff LP *Operations of Spirit Communication* used electronic devices such as sonar and oscilloscope to of ghostly presences hiding within the electric grid, while Elggren has also had a long-standing fascination for communicating with the dead using almost alchemical methods. He narrates a compilation CD entitled *The Ghost Orchid* which serves as a primer for the research of EVP [electronic voice phenomena] researcher Konstantin Raudive and his successors – EVP study being the hunt for possible spirit voices or inter-dimensional voices contacting the Earth-bound through unexpected "breakthroughs" onto radio signals. One of Elggren's most idiosyncratic sound installation pieces, *Talking To a Dead Queen,* was inspired by a recurring vision of Napoleon's, in which the great conqueror saw vibrating copper staves hovering in midair, and heard them assuming the voices of influential figures from his past giving him – much like Joan of Arc – strategic tips on when and where to strike his enemy. Elggren inserted a copper wire or 'antenna' into five scale replicas of the coffin of Sweden's Queen Christina (who took the oath as king rather than queen, to satisfy her father's wishes), and also placed a television within each coffin, all of them playing footage of Greta Garbo playing the Queen in Rouben Mamoulian's 1934 film *Queen Christina.* Using copper materials as a kind of 'medium' in both the spiritual *and* technical sense of the word, Elggren amplified them with contact microphones and recorded the resultant electronic feedback for a CD release.

Besides the fascination with spirit world and ether, both artists have experimented with techniques of lengthy isolation and/or deprivation: their shared high tolerance for 'stripped-down' sound seems to come from a mastery over the chaotic vicissitudes and manifold needs of their minds and bodies, steadily burned out of them through voluntary ordeals. Von Hausswolff once inhabited a gallery for a week with only three chickens as his constant companions (they were named after the sounds of their clucking: 'Pboc', 'Pbac', and 'Bpuc') while Elggren spent ten days in an even more self-obliterating fashion: for his 1981 piece *10 Days: An Expedition,* Elggren fasted and deprived himself of both sleep and communication for a 10-day duration, allowing people to view him through small holes in the wall of the exhibition space. A diary was kept of this event (which has not been read by Elggren since the original performance.) Such willful excursions into absolute pain and near-insanity would, in many principalities, earn you a long period of time under lock and key and constant observation.

Leif Elggren is one of those rare souls capable of meshing rigorous avant-garde inclinations with a joyously anarchic sense of humor. Elggren has to his credit a growing archive of works which, on one hand, have very clearly defined artistic aims and exhibit a keen knowledge of the 20th century avant-garde tradition. Many of these same works, however, are infused with the knowingly mischievous humor of schoolchildren outwitting their dull, stentorian teachers. One such example

of this method, already something of a classic among aficionados of concrete poetry and outsider art, is the book *Experiment With Dreams* that Elggren co-authored with regular collaborator Thomas Liljenberg (Liljenberg has more recently joined Elggren for an absurd CD purporting to contain the final unpublished poems of the hard-living Charles Bukowski.) Among the most roaringly funny items in this tome, whose purpose is to shine light on "the frighteningly unjust distribution of human opportunities that continues to occur on earth"[12], is a series of letters written from fictional aliases to a host of inaccessible celebrities, world leaders and captains of industry. The aliases themselves are all worth a hearty chuckle or two: see 'Pinnochio Fish' and 'Stromboli Oil Ltd.', for starters. More humorous still is the sincere and optimistic tone of the missives as they try to convince these cultural elites to (among other things) buy the sperm of famous people from them, provide Camille Paglia's nose for kissing, or elevate German ex-chancellor Helmut Kohl to the position of Pope. There are also, of course, multiple entreaties to *"send money on [sic] Swedish postal number 15 99 80-2"*, directed at everyone from John Lee Hooker to Santa Claus. The pair's dispatch to French pop chanteuse, animal rights activist, and controversial "hate speech" provocateur Brigitte Bardot, dated May 15 1995, is worth reprinting in full, simply to illustrate the delirious extremes to which this particular project goes:

"Dear Miss Bardot!

We are planning to start a fish factory in Lofoten, Norway.

Our plans is [sic] codfishing, but we are not interested in the fish, but what's in the stomach of the codfish. So we will have a lot of fish refuse that we now will offer you. We know that you are a great friend of animals, and perhaps this could serve as catfood?

Looking forward to your answer.

Sincerely,

–Leif Elggren/ Thomas Liljenberg"[13]

What seems to be, at first, a series of prank letters being sent into the wilderness with little hope of reply from the actual addressees, blossoms into a much more potent piece of cultural criticism on closer examination. Like children's letters to God, the letters in *Experiment With Dreams* ooze charming naïvete, and the reader can be be more or less certain that no replies to these requests are forthcoming. In reality, though, many replies to the letters did arrive (Elggren says that these were "personal and indignant"[14]), although the two dreamers chose not to publish the replies in the book: "merely to give our dreams 'full access' in the play of values that characterise human activities."[15]

Few artists, in any discipline, seem capable of critiquing power relationships as concisely as Elggren, and in a way that does not reek of sanctimonious posturing: his works have surveyed the power relationships of royalty to commoners, of governments to civilians, and of humans to other living organisms. Even power struggle on a microscopic level has been considered by Elggren, in his CD-length sound study of viral behavior, *Virulent Images/ Virulent Sound*. For the liner notes of this particular project, Elggren tries to build a case for the possibility of viruses becoming contagious through *visual* means (photographs, etc.) In a brief but startling statement of caution, Elggren makes cunning use of the fear-implanting techniques that have kept so many otherwise marginal political figures in power. Elggren urges us to contemplate the following nightmare scenario:

"Imagine: a poster campaign of photographs of the Ebola virus, massively enlarged, posted on the walls of the world's cities during the night, fully feasible with today's world-spanning subversive networks. One look at these posters on the way to work in the morning and an Ebola epidemic would ensue..."[16]

Whether Elggren sincerely loses sleep over this possibility or not is difficult to say, although the fact remains that he hasn't followed up on this thread in more recent public exhibits and recordings – perhaps suggesting that this was a one-off hoax meant to parody the prevailing power structure's method of keeping its citizens constantly vigilant; continually pre-occupied by fear of an unseen yet omnipotent bogeyman (and thus less capable of noticing the erosion of other daily living standards.) Elggren's alarming text could be seen as merely transposing the current discussion of

terrorism onto the realm of microbiology. The *Daily News* of New York at least thought the same of Elggren's warning, publishing it on the 1st anniversary of the Sept. 11 terror attacks. Two other newspapers – a Slovenian paper and an Austrian one, respectively – refused publication of the same piece. As if removing the mask of the paranoia-stoking authority figure to reveal the artist beneath, Elggren concludes this text with a claim that "being excluded from the vision of Paradise has always created an opposite reaction and nourished grand dreams of the highest form of revenge".[17] At *this* point we can more or less tell that Elggren is speaking 'as himself' rather than as a trouble-stirring *agent provocateur*, since most governing bodies would never admit to something like economic unfairness being the wellspring of societal discontent (and, indeed, vicious eruptions of terrorism.) It is much easier for them to hand down a Manichean myth that pure good and pure evil simply spring fully-formed from the womb, without any socio-economic factors at all contributing to the spread of 'evil' acts. In a single cogent observation, Elggren hints at the truth of the matter: that grandeur and opulence, being held within tantalizing reach of the economically and spiritually impoverished, will often lead to equally grandiose and opulent acts of destruction, or at the very least, violent fantasies of the same.

Death, Be Not Proud… KREV Banishes Mortality

This is but one passing example of how Elggren engages the myriad of power relationships in the present world, and throughout history. Elggren's frequently hilarious, occasionally devastating critique of authority highlights nature's parsimonious distribution of happiness to the unfortunate masses born without silver spoons in their mouths. This in itself would be enough subject matter to adequately pad an artistic career from start to finish, but Elggren widens his attack to deal with even more insurmountable problems: namely, the tyranny of mortality itself. Indeed, an irregular newsletter published by Elggren is titled *The New Immortality* (taking its name from a similarly titled 1939 book by John William Dunne), and its very limited printable space is sometimes saturated with observations on the fragile nature of the human organism, especially the internal bodily functions not immediately visible to the naked eye (one issue of *New Immortality* also offers a surprisingly cogent argument on why we should fill toilets with Coca-Cola instead of potable water.)

One full-page spread in the 2nd issue reprints a 1689 autopsy report of the Queen Christina, which, in the broader context of Elggren's work, can be read as a suggestion that class struggles are ultimately irrelevant in the face of mortality's tyranny. No discussion of mortality can proceed, though, without some thought given to the irreversible forward thrust of time, and it is Elggren's consideration of time's limitations that has made for some of his most unique sound work. Take, for example, his CD-length audio collaborations with Thomas Liljenberg, entitled *9.11 – Desperation Is The Mother Of Laughter* and *Zzz*. The audio information on these discs is little more than an hour's worth of laughing and snoring, respectively. In both scenarios, the action is forced or simulated rather than spontaneously generated in real situations of deep sleep or giddiness. The *'ha, ha, has'* running the length of "Desperation…" sound stilted and alien, carrying with them too much of a repetitive rhythm and too much of a 'flat affect' to really be generated as a response to something funny. Sound art archivist and poet Kenneth Goldsmith, in a twin review of *Desperation…* and *Zzz*, makes a fairly accurate portrayal of these records' contents when he writes:

"Elggren and Liljenberg are not *really* sleeping and laughing – they are only pretending to. As such, its fiction is more akin to hysterical Artaud-inspired theatre than to documentary. Both discs start off straight enough: At the beginning of *Zzz*… it simply sounds like two people sleeping, a snore here, a cough there. But as the disc progresses, the snoring gets more theatrical and obnoxious until, about half way through, it turns into a snoring opera, with the two protagonists taking turns belting out twisted arias of snorts, yawns and honks. Same goes for *9.11 (desperation is the mother of laughter)*: The first few minutes are just two guys sitting around laughing. 30 minutes into it, it's obvious that the exercise is verging on the absurd and the laughter becomes forced and sinister. By the end of an hour, it's positively painful to think that two men have been laughing as hard as they could for such an extended period of time."[18]

Goldsmith, who has actually given *"Zzz"* airplay on his weekly WFMU radio show, also notes the similarity between these recordings and the endurance trying, epic-length films of Andy Warhol (see *Sleep, Empire* etc.) It's an apt comparison, one which Goldsmith builds on in a manifesto of sorts called 'Being Boring':

"Nothing happened in the early Warhol films: a static image of the Empire State Building for eight hours, a man sleeping for six. It is nearly impossible to watch them straight through. Warhol often claimed that his films were better thought about than seen. He also said that the films were catalysts for other types of actions: conversation that took place in the theatre during the screening, the audience walking in and out, and thoughts that happened in the heads of the moviegoers. Warhol conceived of his films as a staging for a performance, in which the audience were the Superstars, not the actors or objects on the screen."[19]

So could it be, then, that through such apparently monotonous and tortuous exercises, Elggren and Liljenberg are actually trying to empower their listeners, to 'level the playing field' by giving them an authority equal to or even surpassing that of the artist? With such aims in mind, the Kingdoms of Elgaland and Vargaland were formed.

Both the Swedish duo of Elggren/von Hausswolff and Andy Warhol have made a continual project of offering 'divinity' to 'mortals' (read: those without celebrity status.) However, while Warhol was content to do this through the aforementioned films, through silk-screen portraits of ordinary people (patterned after his original silkscreens of bona fide screen immortals Liz Taylor and Marilyn Monroe), and through other visual means, Elggren and von Hausswolff upped the ante by conferring actual governmental authority upon themselves – authority which they would, in turn, make freely available for anyone else who wanted it. While such a regal self-appointment seems like a comical novelty, Leif Elggren reminds us that

"All power is self-appointed, it is only a matter of who stipulated the rules. If you are a highly-ranked person in the present society, you can manipulate the rules for your own good and create the social structure around you. For instance, Napoleon Bonaparte crowned himself. Adolf Hitler manipulated himself to the highest position via threats and violence. George W. Bush bought himself this position. Christ was the most powerful as all because he was intelligent (or smart) enough both to claim or refer to a power that was beyond our worldly life, an almighty spiritual power that was the ONLY basic power in this universe that appointed him to his position and gave him his task."[20]

The Kingdoms of Elgaland and Vargaland are now over 15 years into their existence. Elgaland is a portmanteau of 'Elggren' and 'Land', while 'Vargaland' is likely a similar play on words with von Hausswolff's name ('varg' being a Scandinavian word for 'wolf'.) Formed in 1992, Elggren describes KREV as

"a youthful union and nation that spreads over the whole of our planet, bordering all existing nations...a wholly unique position in which, for the first time in the history of the world, we have a real opportunity of developing a worldwide, boundless society, in which we every individual as King or Queen over their own lives."[21]

While KREV was in the germination stages, Elggren also attempted to form a political party, Partiet [simply "the party"] with musical collaborator Thomas Liljenberg – Partiet took part in the official Swedish election campaign. One major plank in their party platform was that the world itself should be renamed "Me", an act which presaged the consummate power which KREV would accord to each and every individual being. Partiet, though a novel form of political theater for Sweden, was not quite as attractive and radical as the joint project with von Hausswolff, which soon came to take precedence and to absorb many of the ideas of the Partiet constitution.

The official Constitution of KREV, ratified in October 14 of 1992, makes audacious claims on authority, nullifying the privileges accorded to those born into prestigious bloodlines, or those who use wealth as their sole signifier of worldly status. Although the authority of the King is listed in the Constitution's third article as "dictatorial and unrestricted", and again in the fourth article as "superior to all religions, past and future," this authority is actually that of the citizen, since they

may enter into KREV at any position they choose. This is made more clear by scanning further into the Constitution; the eighth article makes it clear that "every citizen owns unrestricted power over his/ her/ its own life in harmony with his/ her/ its personal model and idea". This melding of unprecedented authority is made clearer by a 'hierarchical diagram' included in the Constitution, which shows no clear hierarchy at all, but an intertwining of royalty and commonality via an 8-pointed star-symbol (at other points on the star there are a 'monad' symbol, a 'recycling' symbol suggesting infinity, and arrows marking both ascent and descent.) Furthermore, the adoption of the title 'King' by Elggren and von Hausswolff (and consequently, by all their subjects) seems to be a purely semantic gesture: a 'king' is simply the highest, most well-known and most romanticized form of earthly authority that some can conceive of, especially in the Northern Europe of the two KREV protagonists. The usage of the 'king' title, in their case, does not betray an actual desire to borrow all the nomenclature and symbology of royalty. Take for example Elggren's 'crown', as proudly displayed on the cover of the book *Flown Over By An Old King,* which is merely a battered old engine filter for a car. If anything, the fallibility of royalty has long been a recurring theme in the works of Elggren and von Hausswolff: Elggren has used King Carolus XII (1682-1718) as the principal figure to illustrate this point, noting how Carolus' overly ambitious militarism caused his humiliation at the hands of Peter The Great, stripping Sweden immediately of its status as a 'world power'. On the subject, Elggren says:

"The King and his 30,000 soldiers were defeated outside Poltava in Russia, and the great Swedish dream of total power over the world was destroyed. Carolus XII died in Norway in 1718, shot in the head by God knows who. Sweden was totally devastated and bankrupt because of all the war projects out in Europe. [...] The Swedish people were totally exhausted and on their knees with misery and poverty. They hated the war, and the assassination of the King at last stopped the endless fighting. The country needed to be rebuilt."[22]

An interest in regicide also lends itself to the name of the Anckarström record label, formed in 1991 and named after Jacob Johan Anckarström, the assassin of King Gustav III of Sweden. The label, which includes Elggren, Phauss, John Duncan, Zbigniew Karkowski and Dror Feiler, is notable for bringing the notorious assassin's name into public usage for the first time since a 100-year ban on uttering the name "Anckarström" was lifted. Even the official motto of KREV – "for every king, there is a ball" – warns of the mortal limits on the reign of those who would put forth a public image of immortality and divine descent. While this phrase may sound perfectly innocuous to non-residents of Sweden, the underlying message becomes more clear when we learn that Gustav III was killed by Anckarström at a masquerade ball at Stockholm's Royal Opera.

KREV and NSK: A Comparison

The Kingdoms of Elgaland-Vargaland are not the only virtual state founded by culturally critical artists. The concept of the Utopian island – or, at the very least, an isolated and fortified space where one can concentrate on creative work rather than contributing to the external world's historical narratives – has surfaced a few other times within recent history. Among this largely unwritten history of artists' colonies, squats and the like, the example of Fela Kuti's Kalakuta Republic (established in 1970s Nigeria) is a particularly audacious one. Although the Kalakuta Republic was little more than a multi-purpose compound squatted by hundreds of young, loyal Fela devotees, where the infamous Afro-beat maestro engaged in polygamy with dozens of wives, enjoyed a steady flow of marijuana smoke, and often held court wearing little more than a pair of bikini briefs, it was a crucial respite for those who sought it out – a parallel universe where intoxicated musical frenzy drowned out the brassy, insubstantial rhetoric of Nigeria's failed "militicians" (a local expression for military men becoming civilian rulers) and where tribal divisions were diffused in the midst of all-night sessions. Of course, this challenge to authority did not go unheeded, and the almost inevitable military raids on Kalakuta would deal a blow to Kuti's faith in the power of indigenous *juju* magic to resist evil. As a cruel post-script to the Kalakuta siege, Kuti's mother was even thrown from a second-floor window of the compound, resulting in injuries that would hasten her death.

With such terror tactics at the disposal of the world's more dysfunctional and paranoid governments, the example of Kalakuta shows how difficult it is to create any truly secessionist state without violent interference. As such, the creation of a simultaneously unified and fragmented entity like KREV – a virtual or imaginary state – points to one way in which people can use a kind of mass projection like this as a critical stop-gap on the way to more concrete forms of resistance. Leif Elggren is noted for his aforementioned alchemical audio experiments, "proto-science" at the best: but just as alchemy has ended up being the spark for actual, verifiable advances in chemistry, perhaps this "proto-territory" can lay the theoretical groundwork for an actually existing State which is recognized as "real" by more people than just its voluntary citizens. It is easy or some to dismiss the proclamations of von Hausswolff and Elggren as charlatanism, as calculated in-jokes and reckless eccentricity: but, as it was once written about the hopelessly Utopian Charles Fourier and his contemporaries, "it is true that they were all dreamers... but, as Anatole France said, without dreamers, mankind would still be living in caves."[23]

Just narrowly beating KREV to be the first in the race for an artist-founded 'virtual State', the Slovenian arts collective Neue Slowenische Kunst [New Slovenian Art] established its NSK State as a territory in 1990, after over a decade of playing with the imagery and aesthetics of state control (there is no rivalry or enmity between NSK and KREV, in fact NSK is listed as a 'diplomatic relation' of Elgaland-Vargaland.) The NSK was a multi-media collective sub-divided into groups or 'departments' specializing in certain artistic disciplines: the industrialized music group Laibach provided the bombastic soundtrack, IRWIN functioned as a painting and design group, while the Department of Pure and Applied Philosophy under Peter Mlakar (heralded by the NSK website as the "De Sade of Slovenian literature")[24] managed the NSK's theoretical apparatus. For those who were curious about exactly who did what within NSK, the group published an infuriatingly obtuse organizational diagram, in which "immanent, consistent spirit" informed all stages of the NSK undertaking, with things getting far more vague from there on in.

Like KREV, the NSK State issues passports to its citizens – enticingly advertised by the NSK as having "...a unique nature and a subversive value" while setting up 'embassies' or 'consulates' in any geographical territory where the art of NSK is being exhibited. In the case of both virtual territories, these makeshift embassies are most often situated in humble, private spaces like apartments and personal kitchens: the graffiti-encrusted walls of the Nanba Bears music club in Osaka represent one such KREV consulate visited by the author. Initially, such spaces make the 'embassy' project seem like a mischievous nose-thumbing at the assumed grandeur of official diplomatic bases, or at the strict limits set on what is permissible as a 'cultural space'. However, as NSK archivist Alexei Monroe writes:

"...they are also a serious reference to present and past realities. The [NSK] Moscow project directly refers back to the 'Apt-Art' tradition of staging art events in private residences to avoid official censorship in the former USSR."[25]

The Apt-Art concept, the early 1980s brainchild of artist Nikita Alexeyev, was indeed a radical (and, for the political climate of the time, necessary) solution to the question of how to get one's art recognized in an environment where cultural production relied exclusively on State approval – it was a 'temporary autonomous zone' long before the term came to be associated with rave parties and other subcultural social gatherings within the Western democracies-in-decline. Alexeyev's effort involved the total sacrifice of private space to the artistic endeavor: all available wall and ceiling space was given over to the hanging of artworks, and whatever floor space remained might often be occupied by underground acoustic music combos. It is also said that Alexeyev had no space for a bed, and had to sleep in an inflatable boat in the middle of his living room. The risk of being discovered by State officials was still omnipresent, as well: indeed, Alexeyev eventually had his apartment trashed by KGB agents in 1983. Nevertheless, various Apt-Art cells sprung up in the Soviet Union, with varying degrees of success, until Mikhail Gorbachev introduced the *glasnost* period and its focus on the transparency of information.

NSK was – although not without its own serious experiences with State monitoring and

censorship – lucky enough to survive up until the present day. During the Soviet era of the '80s, the NSK operated in a Yugoslavia which was considerably 'freer' than the numerous other republics absorbed by the USSR: Yugoslavia had open borders to the West, and the political concept of "self-management" (inaugurated by Tito and Edvard Kardelj) attempted to distance itself from the Stalinist model followed by other Eastern states. However, "self-management", despite its attractive resonance along the lines of concepts such as "independence" and "autonomy", unsuccessfully tried to create the illusion that the State was taking a completely 'hands-off' approach to Yugoslavian cultural development.

Yet, in spite of that, NSK refused to merely pander to Western paranoia about a monolithic Eastern empire (and, later on, about the Balkan states descending into a morass of brutal ethnic and religious war.) One of the defining features of NSK was its ability to make equally damning critiques of both Western hegemonic tendencies and the more distinctly 'Eastern' modes of totalitarianism, not presupposing that either had a monopoly on the mechanisms of censorship and repression. The unflinching ambiguity of NSK's works made it all the easier to shift the weight of their criticism to one side or the other, as happened when Western hegemonic power and 'market censorship' became more of an issue after the Soviet collapse in the 1990s. This is especially evident in the Laibach records of the time, such as 'Wirtschaft ist Tot' [The Economy is Dead] and the subversive disco of their *NATO* album. Ironically, for a large-scale art project which sought to ultimately carve out its own identity independent of geographic boundaries, NSK and Laibach ended up becoming synonymous with Eastern European culture. Having done this, NSK reversed a situation which Alexei Monroe mentions: "...like the 'Third World', 'Eastern Europe' is still largely seen not as a source of cultural product but as a passive market for it."[26]

There are a few other key differences between the two virtual states. For one, the social, economic and political circumstances during their respective formations: the Balkan region, which was traumatized by the time of KREV's formation in 1992, was hardly comparable to an affluent Sweden which had been either at peace or officially neutral since 1814 (a state of simultaneous tranquility and *ennui* which is encapsulated in Elggren's biting spoken word piece "The North Is Protected".) Official KREV passports go beyond even the NSK concept of the "State in Time": the first page of the author's Elgaland/Vargaland passport proudly and curtly proclaims that "the bearer of this passport is immortal" and that the passport is "valid in every time and space – past, present, and future, existing or non existing." In an age of increasingly ridiculous and unfulfilled political promises, this one seems to trump them all: and in doing so, it handily parodies the charismatic politician's claims to almost godlike power: the ability to completely transform human nature within a 4-year election cycle or '5 year plan'. By conferring such infinite access to its passport-bearers, the founders of KREV perhaps hope that no one will ever again be, in Elggren's words, "excluded from the vision of Paradise." In an interesting twist on the government legislation of mortality itself, the granting of immortality by KREV now contradicts official state policy in the People's Republic of China, where (in an effort to snub the efforts of the Tibetan Dalai Lama) monks were banned from reincarnating in 2007.

A Democracy of Sounds

The NSK State has the popular band Laibach as its musical ambassadors, and a Department of Pure and Applied Philosophy to produce a formidable amount of theoretical text outlining the State's evolution and goals. By comparison, KREV has merely a couple texts on its official website, and while its list of citizens is impressive in the breadth of its cultural contributions outside of KREV, few of those contributions have been explicitly 'dedicated' to furthering the idea of KREV. Or have they? It could be argued that 'living by example' is a potent form of ambassadorship in its own right. Some, like KREV's "minister of lamination" 'Gen' Ken Montgomery, have contributed their talents to the cause by naming KREV ministries after them (Montgomery's special talent is the use of a laminating machine as a surprisingly versatile music composition tool.) Others have lent a hand in composing one of the increasing number of KREV national anthems, released in a series of 7" singles by the Ash

International label. There now exists a version performed by an Afro-beat ensemble, a klezmer group, a mariachi band, one by organist Marcus Davidson and of course the requisite versions by Elggren and von Hausswolff. Unlike NSK, though, there is no regular KREV musical propaganda department, even though one can be the 'minister' of any personal interest at all that they might have, from Roquefort cheese to snorkeling (for those who are interested, the ministries of digital food, toxins, cartography and ambiguity are already taken.) This is interesting, since a disproportionate amount of KREV citizens are shared with the Scandinavian sound art scene, or with the more exacting modes of noise and electronic music. The Swedish composer Dror Feiler is part of the aforementioned Scandinavian scene, and not an official KREV citizen, but some of his thoughts do clarify the correlations between anarchic music and a boundless state. Just as KREV's citizens seek to make territorial boundaries obsolete, musicians of Feiler's 'new avant-garde' are

"...crossing the borders of categories, exposing and even creating unexpected relations , like composers do in their computer, sampler and synthesizer-based music, and DJs do in the mix. Such is the praxis of the NEW AVANT-GARDE: a democracy of sounds breaking through predictable hierarchies of instruments [...] and of narrative structures (the familiar dominance of plot and character in art.)"[27]

Feiler warns us also that we "become deaf when and musically unconscious when we hear nothing but perfect melodies and perfect chords in popular music, [and] perfect structure, instrumentation and electro-acoustic sounds in the 'new music' scene [...] this is the potential fascism in music."[28] Feiler's anti-fascist angle is something to take into consideration, given the recent criticisms of electronic noise as a "fascistic" tool to obliterate contrary voices with an insurmountable display of deafening and physiology-altering power. The argument over the political implications of supremely loud and physical music is far from over, but the very existence of this argument, and the diversity in opposing viewpoints, seem to confirm its freedom from fascism's anti-individualist and centralizing tendencies. The 'fuzzy' nature of this variety of avant-electronic music, rife as it is with distortion, time-stretching and digital convolution techniques, lends itself nicely to the 'fuzzy logic' of systems far removed from fascism's inflexible polarities.

Taking Feiler's statements on music as a cue, the similarities between radical music and a radical anti-State like KREV, then, have to do with the 'borderlines' in their respective situations. Elggren says of KREV that "our physical territory is not very big...just the border areas around the planet, a bunch of very thin lines."[29] The focus on using the interstitial points as the basis for creation, rather than the established and clearly demarcated 'territory', seems to be what Feiler is proposing as the way forward for music, as well.

Music remains just one form of expressive ability, though, and many of the KREV citizenry, beginning with its kings, do not limit themselves to this mode – often they have the designation 'music' placed on their diverse activities simply by virtue of having them documented on an audio recording. In the final reckoning, KREV is more art than politics, a project that does not merely mock mankind's collective yearning for some divinely conferred nationhood or collective power, but a project which embodies art's purpose as the 'ultimate discipline': "working in a totally open field with all the unimaginable and imaginable parameters of life."[30]

A Government in Exile?

The Kingdoms of Elgaland and Vargaland are happily gaining ground: the most recent acquisition of the Kingdoms to date has been the annexation of the Bodensee, the body of water situated between Germany, Switzerland and Austria. This was met with much fanfare, including the opening of the famed Cabaret Voltaire in Zurich as a KREV embassy. At the same time, however, KREV's application for membership in the United Nations, sent out in 1994, has gone unanswered. None of the 'real' countries of the world have officially recognized KREV either (even though Portland-based artist and KREV citizen Daniel Menche, in declaring himself the King of Italy, may try to use his clout in that area.) Elggren states that the citizens of KREV are living in a 'diaspora' as a result of such

situations, placing them in the unprecedented situation of having citizenship in all of the world's states and in none of them.

However, writing off the actions of KREV's citizens as useless may be premature. Leif Elggren is fond of, when describing this project and many others, invoking the image of a street-corner lunatic with a paper crown who declares himself King. He also reminds us, though, that merely appropriating symbols of power can convince others of its possession by a certain individual or group. In this sense, the Kingdoms of Elgaland and Vargaland are hardly a 'joke' – one needs look no further than the claim of Jesus Christ to be the Son of God, and the lasting effects that this has had throughout history. A legal basis for the existence of KREV may not in place now, but such legal recognitions of nationhood have normally come about as a result of their lands' seizure through mass murder or other such means. Hakim Bey once wrote that "all 'states' are impossible, all orders illusory, except those of desire,"[31] also claiming that there is "no *being*, only *becoming* – hence the only viable government is that of love, or 'attraction.'"[32] By these criteria, the Kingdoms of Elgaland and Vargaland – built purely on a foundation of wishes and dreams rather than on warfare and economics – have more of a claim to legitimacy than most.

8.
FRANCISCO LÓPEZ:
THE BIG BLUR THEORY

As we progress further into the dense forest of uncertainty that is the 21st century, something becomes painfully clear about our relationship to recorded sound: the overwhelming majority of it is inextricably linked to an image of some kind. The art of the record album cover has, by now, been immortalized and anthologized in countless coffee table books and museum exhibitions, while the physical appearance and photogenic quality of the musician has become every bit as important of a marketing point as their instrumental virtuosity. Consumption of recorded sound as a lifestyle accessory, or as a metaphor for some fixed set of experiences, has lessened its value by lessening sound's essential ambiguity – suggesting, for example, that the sound of a distorted guitar must always be a 'soundmark' of youthful rebellion, or that the sound of a harp must be a prelude to ascension into a stereotypical image of heaven, complete with gossamer angels frolicking on clouds. Sound artist Brandon Labelle, discussing the challenges of perception involved in making site-specific sound, suggests an asynchronous relationship between the time it takes to comprehend audio information *vis-à-vis* visual information:

"I find that vision and sound differ radically in terms of duration: to enter a space and listen to sound is much different than entering to look at something. Often, sound just takes a great deal longer to comprehend and appreciate. Vision in a way is much more stable – well, maybe in the way I am using it – so, it somehow rivets attention; like a photo album, a viewer flips through during which time sound may enter the 'picture', as a kind of backdrop that suddenly comes forward on a corporeal level. Maybe that is presuming that sound 'interferes' with vision, straddles it, undoes it, etc. In this regard, often the visual operates almost as a 'musical' instrument from which the acoustical originates – that is to say, we look toward the instrument to understand the sound."[1] As

an artist who specializes in sound installation pieces, LaBelle likely knows, all too well, the frustration that can come from trying to communicate a sonic idea in a space whose visitors consider themselves 'viewers' first and foremost, and who can come to view sound as an intrusive or parasitic influence on their complete digestion of visual data. However, the mediation of sound has existed long before the intervention of, or intersection with, the visual artifact – prior to this, it was language that intervened and imposed itself onto sounds and made them either complementary to, or subservient to, vocal and narrative elements. If sounds were left alone, they might not be able to tell a *specific* story, but this would not mean that they didn't have some form of narrative quality to them, once organized in an evocative enough way. Humanity has had a long history of distrusting or fearing unmediated sound, giving it a support role in Bardic lore, theatrical productions, films, and other forms which enlarge and celebrate the human experience – but whether sound has been allowed to be in the 'driver's seat' of such productions is open to debate. This should not be taken as a dismissal of all sound experiments that involved stimulation of the other senses: there is a strong tradition of music, especially in the electronic field, of working with synesthetic experience (to be touched upon later in this text) and with the way that pre-set behaviors and beliefs can be dramatically altered when a synchronicity of sound with sight, smell, taste or touch opens up hitherto unnoticed pathways.

Maybe the real problem, then, is not the 'visualization' of sound, but the attempt to present sound in an anthropomorphic way, or in a way that supports a grand teleological view of human history (i.e. that all we do as a species has some ultimate 'meaning,' that every miniscule word and gesture must signify something infinitely greater than itself.) I would argue that the most intense and successful synesthetic experiences have been inspired when a sight, smell, etc. collided with a sound that was *not* being overlaid by unequivocally 'human' elements. It would be truly disappointing if 'pure' sound were phased out in order to make way for a world in which all the sound we heard was nothing but *symbolism*. This could apply to any artistic discipline as well: Marcel Duchamp once spoke out against the preponderance of "retinal" painting, suggesting that mastery of formal composition was not always enough to stimulate the imagination.

Resisting a teleological appropriation of sound – and indeed any artistically arranged form of sensory information – can be difficult. It's not particularly easy to argue that the great musical works of the past, dealing with such teleological principles and themes as Promethean spirit within humanity, have not had the ability to provoke and inspire. Even those whose method was destructive leaned towards a possible Utopian or apocalyptic premise for their work, as theorist Raymond Williams suggests the Italian Futurists did: "The Futurist call to destroy 'tradition' overlaps with socialist calls to destroy the whole existing order."[2] Williams attenuates this statement somewhat, though, also admitting to some ambiguity in the terminology of F.T. Marinetti's Futurist Manifesto: Marinetti's pronouncement that "we will sing of great crowds excited by work, pleasure and riot...the polyphonous, multicoloured tides of revolution"[3] was one that, per Williams, "carried with it all the ambiguities between revolution and carnival."[4] At any rate, this kind of thinking is extremely resilient and is hardly confined to the creative classes, having been bounced back and forth between both sides of the Left/Right political divide and having been adopted by evolutionary theorists and Church clergymen alike. Meanwhile, the blazing speed in technological development and the acceleration of human conflict seems to confirm the belief that "something is coming" on the horizon, although what that "something" is will likely remain hotly debated for the foreseeable future. If the various socio-political inclinations are united in any way whatsoever, they are united by a stark fear of insignificance, by an increasingly urgent need to expose secrets and to endlessly catalog minutiae into lists ordered by relevance.

La Bahia Inútil

In the middle of his book-length essay *Impossible Exchange,* philosopher Jean Baudrillard takes a brief detour to offer us an intriguing image of a curiously-named geographical area in the South

American land mass:

"When you travel from Punta Arenas to Rio Grande in the south of Patagonia, for a hundred kilometers you skirt La Bahia Inútil – Useless Bay – where the sky is low, purple, and immense, and the sheep have an air of night owls about them. It is all so vast and empty, so definitively empty, that it does not even merit a name; as though God had by some oversight cast this superfluous landscape down here – a landscape all the stranger for being part of an entire landmass, Patagonia, where all is useless and senseless."[5]

As Baudrillard's observations might suggest, purposelessness does not always have to equal bleakness or a terrifying void: if anything, his rich description of this 'superfluous landscape' inspires further investigation. Meanwhile, the world of recorded sound may have its own Bahia Inútil in the works of the bio-acoustic researcher and composer Francisco López (formerly based in Madrid, with recent residencies in Montreal and Amsterdam.) López is certainly no stranger to the sweeping 'useless' steppes of Patagonia, and he has made a number of eyebrow-raising statements like "I have no interest in changing the world... actually, so little that I have interest in *not* changing it", "I work hard really hard to create useless things – and I'm proud of it", and finally "purposelessness... that's what we really need". It would seem, on the basis of these statements, that he is the anti-teleological artist *par excellence*. López seems fairly uninterested in what will eventually come of human endeavor, to the point of being more Taoist in his actions than anything. At the very least, López could be seen as a sonic disciple of Romanian philosopher E.M. Cioran (an admitted influence on the composer), who believed "we are not failures until we believe life has a meaning." Sound, for López, may still have valuable functions relating to the spirit, such as 'creating soul' (a proposal courtesy of Greek composer Jani Christou.) However, he rejects attempts to make sound a shaper of the human historical narrative, like Jacques Attali did when suggesting that sound has a 'heraldic' or prophetic function:

"To tell you the truth, this sounds like bullshit to me...I see no ability in music for 'prediction'. If anything, with regards to historical time, most music seems to have an ability to mark the present and, even more clearly, the past. Think of any example, from Elvis Presley to Inuit music."[6]

Restlessly criss-crossing the globe with just a selection of portable recording equipment, López' sound experiments bring to mind the characters in the Tarkovsky film *Stalker* (another admitted favorite of the composer): treading through the fluid and vast "Zone" where emerald foliage melts into rusted-out machinery and abandoned weapons, and where a curious, palpable irrationality is always in full bloom. López is easily one of the most prolific agents of the art of field recording: an art which concerns itself with the seemingly neutral activities of documenting and cataloging the sonic phenomena of the biosphere, and its man-made extensions, without attempting to act as an arbiter – a 'narrator' – of any of these processes. It should be clarified that field recording is not merely, as the name would suggest, something which must take place in a pasture, savannah or other environment left relatively unmolested by humanity: the practice, as it stands now, extends to the most electrified, concretized, and developed sectors of the hyper-modern metropolis as well, thanks in part to the efforts of artists like López himself. The hum of generators, the strangely lulling drone of dissipated highway activity, and bubbling polyglot marketplace voices are all authentic field recordings on par with the ones more likely to be utilized as the backdrop to a *National Geographic* TV special.

While some of the more acclaimed works of field recording still deal exclusively with of the 'secret life' of the animal kingdom (Chris Watson's 1998 Touch release *Outside The Circle of Fire,* for example, features astonishing recordings of African 'big cats' napping under trees), this other face of automated and electronic society can produce a documentary effect similar to raw nature recordings. Just as birds recorded in the wild sing different song phrases than when in captivity, humans and their activities sound different than when they are dragged into a recording studio or an environment where they are aware of being focused upon: a desire to create an unvarnished 'sonic image' – the *image sonore* of *musique concrète* luminary Pierre Schaeffer – that presents things 'as they really are' permeates the culture of field recording; and if this goal is not attained,

then at least the adventure involved in traveling to and immersing oneself in certain locations can be personally edifying for the recorder. It is perhaps the latter action that is more important to Francisco López, since he remains skeptical about the ability of field recordings to truly substitute for any given environment. He has likened this process of perfect audio reproduction to "building a zoo", something which offers, at best, a limited synopsis of a total natural environment. Expanding on this idea, he states that

"I was specifically referring to the idea of field recordings making you 'feel transported to the place', so common in New-Agey interpretations of environmental recordings. Sitting comfortably in our favourite armchair – without the heat, the cold, the thirst, the flies, etc. – might indeed be an engaging experience, but certainly of a very different nature than that of 'being there'".[7]

The process of field recording, despite such 'New Age' methods of marketing it, does not end with furtive attempts at zoo-building and taxonomy. Many sound artists have also applied the basic techniques of field recording to uncovering another kind of 'secret life': that of stationary objects, occasionally massive in scale, that are not normally perceived as static monoliths not making any kind of 'sound' whatsoever: suspension bridges, for example, or the mic'ing of the World Trade Center's 91st floor by Stephen Vitiello (Vitiello was a resident artist of the WTC complex two years prior to its destruction.) In Vitiello's case, the simple use of home-built contact microphones, applied to various pressure points of the structure, revealed a deep and ghostly rumble which is difficult now to see as anything but an ominous harbinger of the towers' ultimate role in the great game of global power struggle (this piece's inclusion in group exhibitions, like a war-themed show at Vienna's MOMUK in 2003, did little to minimize the historical overlay onto an otherwise open-ended sound piece.) Had the events of September 11 not occurred, this would have been just another in a series of Vitiello's similar experiments with contact microphones acting as stethoscopes, gauging the breath and pulse of the seemingly inanimate: Vitiello has attempted the same sort of experiments with more mundane materials: his *Contact Microphones on Steel Plate* utilizes a rusted sheet of metal somewhere in the tiny desert principality of Marfa, Texas.

Though these combined field recording techniques usually seek to re-integrate listeners into a world that is not tyrannized by retinal information, some amount of metaphorical comparison with visual culture is inevitable: there is Schaeffer's *image sonore* as noted above, and many allusions within the sound recording culture to theater, or a "cinema of the ear". The French acousmatic artist Lionel Marchetti is particularly enthusiastic about this expression; in one essay he invites prospective recorders to go on a "sonic shooting", also likening the acoustic space around a recorder to "...the poet's page, the painter's canvas, the calligrapher's roll...television, or the computer."[8] Yet, even while employing these visual metaphors, Marchetti hints at the dynamic potential of sound recording – in his reckoning, a kind of catalyst for the evolution of hearing itself:

"The purpose of painting is its ability to give us fixed visual images, framed – while at the same time very far from shifting reality – yet which can lead us to another version. Is it not the purpose of the recorded sound – we could say 'fixed sound' – to give us sonic images devoid of visual associations, which would thus powerfully stimulate another kind of hearing than that of one's interior imagination?"[9]

On this point, at least – 'sonic images devoid of visual associations' – Francisco López would likely agree. The possibility of attaining 'another kind of hearing' that overrides the tumultuous noise of one's own inner dialogue seems like a monumental challenge, but then again, few have made the adequate preparations necessary to confront this challenge on the level that López has.

Invoking the Absolute

Whatever you do, don't call Francisco López "minimalist". While you could be forgiven for applying this overused designator to the man's packaging aesthetic (López usually releases CDs in plain jewel cases with no booklets, and with unassuming titles like "Untitled #159"), it hardly applies to the

man's actual recorded output: with only a minimum of filtering, EQ adjustment and studio finesse, López records and presents sonic scenarios either too overwhelming or intimate in their character to be confused with cerebral, academic minimalism. From narcosis induced by the unaccompanied sound of a vinyl record's crackle, to buried memories unearthed by different shades of rain forest ambience, this sound's capacity to evoke or invoke sets it apart from the minimalist music typically performed in concert halls – in the end, lack of notation and an increased emphasis on extended duration of 'pieces' are the only aspects in common between the two forms.

Distance from minimalism also applies to the composer's breadth of lived experience. To remind his listeners from time to time of the sense of adventure that has been distilled into his voluminous body of recordings, López will tease the imagination with an unabashedly romantic tale: perhaps a scuba dive off the Cuban coast followed by a puff on a 'Montecristo A' cigar, or lying on the floor of the Costa Rican rain forest in total darkness with leafcutter ants as his gracious hosts. For most, this would be a vacation story to be recycled as a piece of pining nostalgia over and over again, during brief cigarette breaks outside of the office workspace. For Francisco López, it's merely what he did on that particular day – a footnote in an expansive diary of sensations and interactions that have accompanied a definitely above-average amount of global travel.

López is a cutting critic of formalist minimalism, instead entranced by what he calls 'blank phenomelogical substance' – not even the titanic influence of a composer like John Cage is given a free pass by López, who attacks the 'proceduralism' of his work – López is particularly incensed by Cage's statement that "a sound is a sound" although only *certain* sounds are 'music'. If Cage himself comes under critical scrutiny, then his followers – 'Cageans' – are held in even lower esteem by López. He writes:

"I believe that the Cage 'revolution', instead of 'freeing music from taste and traditions', re-restricted it again to the fences of the same old Western paradigm of formalism and proceduralism. It's no use to fight the traditions just running away from them within their land, and staying in a hideout offered by them and, therefore, [an] illusory as such hideout. This is puerile and futile. Let's cope with the traditions face to face instead of exaggerating what we want to change from them in a convulsory movement of negation. I don't think it's possible for music to be freed from taste and memory (and Cageans themselves are a proof of this) but, what is more important and relevant, I don't think it should; even in the more extreme position of anti-traditionalism."[10]

As a reaction against all the aforementioned schools of thought, López suggests 'absolute music' as a more fitting signifier for his work. López cautions, though, against possible misperceptions of the term 'absolutist', a term often used in the West to criticize some obstinate individual mired in their own way of doing things, regardless of its efficacy. López is himself a champion of flux and continual metamorphosis, steadfastly denying that 'absolute' is a synonym for some kind of creative or conceptual metastasis:

"It has nothing to do with 'inflexibility' or non-change. The term 'absolute music' was created, during Romanticism, by poets defending the idea of music being the most sublime of all arts by its detachment from text and specific meaning. This was a reaction to previous epochs of intense dependence of music from text in opera, and heartily defended the notion of music attaining its full, real, essential potential and strength when devoid of descriptive or narrative elements alien to the music itself. This is a remarkable oddity in the universal history of music, and I personally find this idea completely akin to my natural perception of the essence of music and sound."[11]

López also explains that, according to Carl Dahlhaus, 'absolute music' is a phenomenon "...whose contemplation alone allows one to escape the bounds of mortality in moments of self-forgetting."

López has earned his notoriety in the sound art world not just for offering a constant flow of new releases, but also for an adamant refusal to let textual references, visuals, and any non-sonic element sully the purity of the aural experience. To this end, López blindfolds his audience members (complimentary blindfolds have also been included with select CD releases of his), performs from a

mixing desk in the center of the audience rather than on a proper sound stage, and veers away from any conversation relating to the 'tools of the trade': anything which will serve as a distraction from the listener being able to accurately form a sonic universe as unique to them as possible. Without a doubt, this tendency may startle or alienate concert audiences used to paying money for spectacular visual extras like laser light shows, film projections and the pyrotechnic eruptions cued to coincide with the more triumphal portions of the musical program, but no amount of complaint has yet convinced López to change course. It follows that he is also highly disinterested in linking his compositional output with personal experiences or epiphanies – a naïve attempt on my part to make the composer disclose some of this information was met with characteristic intensity:

"I can't recall a single instance in my life in which 'understanding' the reason of any creative actions... has changed anything essential in my work. I find that kind of analysis completely useless and uninteresting."[12]

Confucius once said that "when a finger points at the moon, the idiot looks at the finger," an axiom which might be applied towards the present-day obsession with "gear" and other ephemera of the modern sound stage. Francisco López is perhaps one of the most outspoken opponents of this stage – seeing it as a needless intermediary between an artist's vision and the audience's perception of the music. He proposes that "music should be liberated from theater" and also reminds us that "Pythagoras had such a great idea... all the concert halls should have a curtain to hide the orchestra; for the dignity of music."[13i] The term 'acousmatic' does derive, after all, from the *akusmatikoi*, the group of Pythagoras' acolytes who would only listen to their teacher speaking from behind a veil. In modern acousmatic music, the veil of Pythagoras has been replaced by loudspeakers or sound amplification equipment, which project audio information but offer no hints as to the source material comprising the original recordings.

In sharp contrast to some of his other electronic music peers, López does not see the new trend towards reduced on-stage skill exhibition (e.g., 'performing' by blankly staring at a computer) as anything sincerely radical or contrarian. In fact, he believes that on-stage presence, in and of itself, causes even the most radical new music to share common goals with pop music's development of a personality cult – whether dazzling virtuosity is exhibited on that stage or not. It's a sensitive issue, especially considering that most of the artists surveyed in this book, including some of López' own past collaborators, still rely on a conventional stage set-up for live exhibitions of their sound (although the exact reasons for doing this vary from one performer to the next, as do the degrees of willingness to appear in such an environment.) In response to *Sound Projector* interviewer Gregory Gangemi's suggestion that appearing onstage with a laptop still reduces the performer to a kind of 'idol', López responds:

"...well, it's an idol anyway, no matter what you do: if you're dancing like the Spice Girls or you have a laptop on stage you're an idol for a different kind of people. Or you're an artist or a star or whatever. It's like....what is the reason for someone with a laptop to be on stage? Originally, the reason for musicians to be on stage was for people to be able to hear the music and see them of course. But now I think those reasons are not operating anymore. Or a DJ on stage, for example... a DJ on stage, I don't see the point of that. It's sort of following the traditional rock 'n roll show aesthetic, translating that directly into something that could have more potential."[14]

The presence of onstage DJs has always stoked a debate about the degree to which audiences really desire total freedom: for each faction that wishes merely to dance uninhibitedly, there is another that enjoys being led around by the nose and following a clear set of cues that cement their role as a participant in a loosely-scripted, popular drama. It seems the 'idol' factor will remain with us as long as there exist those who enjoy the security of a hierarchical "performer vs.observer" or "'shaman' vs. initiate" relationship.

However, the idolization of the artist is not, according to López, the sole problem arising from the staging of live electronic music – there also exists a kind of technophilia among audience members, or a desire to know the precise technical specifics of the sound being produced: what hand movements and knob twists correspond to what noises, what plug-in or clever coding

technique is causing 'x' effect. Owing to the relative newness of electronic music tools compared with the traditional string, woodwind, percussion and brass instruments, the desire to decode the relationship between the artist's movements and particular musical functions becomes a game that, although it gives audiences something other to do besides lapsing back into conversation, can interfere with the actual direct experience of the sound output. As per López:

"If somebody is looking at me during the live show, they will be looking at what I am doing with the equipment, trying to figure out how I am doing that, what is happening...I'm concerned with this because it's a problem, and I don't want people to look at that. I want people to focus on what's going on in the space."[15]

López' objections should certainly raise a host of questions for the aspiring sound *artiste*. Yet it seems unlikely that musicians, armed with either the most bare-bones sound equipment or the most complex and unwieldy setups, will be able to tear themselves from the performance stage. The need for validation by an audience is something that only the bravest souls seem able to truly distance themselves from – and most would likely treasure the increased social contact that comes from having befriended audience members on the strength of a successful concert. Even the most confrontational noise artists seem to enjoy a bit of 'networking'; a good round of chatting or a post-show meal shared with enthusiastic audience members as the evening winds down after the performance. Human social nature almost invariably trumps the will to let art stand on its own merits, in a way that does not have to be 'authenticated' by any kind of critique or peer review. For López, though, who confesses to being a 'loner' and seems quite content as a solitary cell, the social element attached to even the most experimental of music is yet another corrupting influence:

"I'm one of those who believe more in the idea of creators having – for good or bad – their personal path, rather than one that is molded and defined in response to the degree of acceptance. The latter is a very dangerous path, and I naturally don't have any inclination to that."[16]

One release of López' – a cassette anomaly entitled *Paris Hiss* – perhaps sums up, better than any of the above writing, his attitude towards the role of personal identity in the final presentation of his work. This release, on the Banned Production label, comes with two sticker labels affixed to either side of a cassette, bearing the artist's name and the album title. Since these labels cover the two tape reels in the center of the cassette, it cannot be played without first destroying or rupturing the sticker labels – an act which, like López' cover-less CDs, discards the importance of the creator's persona in favor of actual content.

The Morality of Sound? Schaeffer vs. Schafer

Francisco López, in spite of his background in biology and his strong emphasis on bio-acoustics, has criticized the traditional 'acoustic ecology' blueprint as laid out by composer R. Murray Schafer (author of the seminal *The Tuning in The World*) in the 1960s and beyond. Although López is no anthropocentric man by any stretch of the imagination, he is a vociferous opponent of Schafer's own Luddite opposition to man-made technology. Schafer recoils in horror at the artifice of urban environments, derisively calling them 'sonic sewers', and calling for anti-noise legislation in booklets such as *The Book of Noise*. Schafer has, in the past, composed sound pieces based on Vancouver traffic noise, although his forte has been elaborate performance pieces set in the wilderness, featuring an eclectic mingling of Asian, Egyptian and North American spiritual themes. Schafer's attitude towards the noise of mechanical processes, and their irrevocable destructiveness, is swept aside by López with little effort – López states that noise is just as much a component of nature as it is of the urban environment; that the rain forest is as saturated with audio information as vital intersections in major cities. If we have to decide this argument merely on the basis of comparative experience with world travel, then the peripatetic López emerges as the clear winner. Speaking at a lecture in Kita-Kyushu, Japan, López says this on his disconnect with Schafer:

"I have no intention of telling anyone how the world should be, especially like Hildegard Westerkamp and Murray Schafer. Where I deeply disagree with these people is that they feel that they have to tell the rest of the world how the world should be. The main concern of the World

Forum for Acoustic Ecology, which is based on the ideas of Schafer, is to tell people that the world today is very noisy. And indeed it is, but isn't that the way it should be? Is nature better when it's quieter? Are machines evil because they make a lot of noise? Is that noise boring because it's always the same?"[17]

The innate 'evil' of machines, computers etc. is, as López' comments hint at, a concept very much based in Western, Romanticist ideas of naturalism, with nature being a benevolent, protective matriarch, her silence being tantamount to tranquility of the spirit. However, an incident described in architect Jack Kerr's book *Dogs and Demons* (an intense, alarmist work chronicling the deterioration of traditional Japanese values) illustrates that some residents of urbanized areas in Japan can actually find natural noise to be an intolerable *intrusion* – one anecdote in Kerr's book recalls how, on the 'suggestion board' of a Japanese town's ward office, someone has writ large (and in total sincerity) KILL ALL THE FROGS in frustration at the sleep loss engendered by the amphibians' nightly performances. At the same time, the Japanese Construction Ministry can mobilize cement mixers and other heavy equipment to residential areas in the dead of night, with little public protest (although I *personally* didn't enjoy having a New Blockaders concert being re-enacted on the sidewalk outside my apartment, at 3 a.m. on a 'work night'.) So, for one, Schafer's view of 'destructive' machinery is not something that is universally agreed upon. Many urban residents are either calmed or invigorated by the sureness of mechanical repetition, a welcome bit of certainty within an urban landscape otherwise choked with sticky social dilemmas. Schafer's objection also seems to be on purely aesthetic grounds: rather than attacking the long-term effects of constant mechanical noise on human sanity, and the migration or mating habits of native animal species, he assails this noise-making apparatus from a mystical point of view. This begs the question: why is the swarming mass of trumpet calls and monks' voices in Tibetan liturgical music capable of lifting one to spiritual heights (even someone with no knowledge of Tibetan language or religious custom), while meditation upon the dense, hypnotic sound qualities of a video arcade or factory isn't? Furthermore, what should be done about naturally occuring sound phenomena, massed insectoid noises for example, indistinguishable in rhythmic or timbral quality from a mechanical or synthesized equivalent? Such synchronicities crop up in unexpected places: many who have ingested psilocybin mushrooms, for example, have reported an industrial-strength grinding and buzzing noise after ingesting the organic matter, and while walking in environments far removed from any kind of industrialization.

López personally refuses to characterize any form of sound as 'evil', but then again, doesn't view it in any moral light whatsoever:

"I think creative work with sound should be allowed to have all possible levels of intensity for those who might want to go through them. In a way, this is nothing more than a reflection of what we find in reality, where things have very wide dynamics, in terms of loudness, frequency content, time/pace, etc. If by 'noise' we understand harsh, loud sounds (I'm not so sure this is the best way of defining it), a lot of people are already convinced of their interest in this. And, to be sure, I never had the intention of convincing anyone about any of this."[18i]

López' reluctance to map a personal agenda onto nature separates him not only from the World Forum for Acoustic Ecology, but from much of the stigma surrounding 'ecology' in general: the term *ökologie* itself was first put into use by Ernst Haeckel in the 1860s, the Social Darwinist ideologue who used ecological concern as a front for providing a pseudo-scientific basis for the biological superiority of Teutonic peoples. The historian Daniel Gasman proposes that "racially inspired Social Darwinism in Germany... was almost completely indebted to Haeckel for its creation"[19] and that "his ideas served to unite into a full-bodied ideology the trends of racism, imperialism, romanticism, anti-Semitism and nationalism."[20] This ideology was the *carte blanche* that the Nazi regime needed to legitimize its quest for *Lebensraum:* since virtually all other peoples outside of the Aryan race had an inferior understanding of nature, it followed that their subjugation and eventual liquidation would be the salvation of all biological life on the planet.

While the pluralistic Schafer would undoubtedly bristle at being compared with such people,

the belief in humans as liberators and saviors of nature is shared by both him and by the 'ecofascist' radicals who follow in Haeckel's footsteps. The urge to 'save' a supposedly inferior or helpless life form often turns into a brutish form of domestication or colonization, and for many this tendency to 'save' conceals a host of ulterior motives, or at least betrays a deep sense of remorse over past actions. It is here where López' distinctly 'hands off' approach to acoustic ecology separates him from such tendencies – he refuses to set himself up as a 'chosen' emissary of mankind to the natural world, saying things such as "the more I like an object, the more I want it to be possessed by someone else...someone with the courage and skills I lack for keeping material things alive and healthy."[21]

The Wild Hunt for Beautiful Confusion

Undoubtedly, lengthy and sustained exposure to high-decibel output on either pole of the frequency range is going to have a damaging physical effect. While opponents of noise will certainly point to this as a key factor in the need for it to be regulated, this is not the only point of concern: there is also the psychological transformation that intense noise engenders; the possibility that it will turn otherwise meek souls into uncivilized, raging Berserkers. Those who fancy themselves as the defenders of a biosphere under attack from torrents of mechanized or electrified noise are put in a precarious position when also making this latter claim; because they must also admit the possibility of noise as an archaic, paganizing force – not the sole domain of Futurists and urban developers. One Austrian esoterica enthusiast, writing under the pseudonym of Adam Kadmon, reminds modern readers of the atavistic use of noise in Teutonic rituals like the *Oskorei* or "wild hunt", which provided the antidote to monotheistic belief systems' divorce from the terror of nature:

"Noise played an essential role in the wild hunt, as it did in many pagan celebrations...magical noise as an archaic technique of ecstacy was a characteristic of many non-Christian cultic activities. Bonifatius, later canonized after cutting down the 'Thor Oak Tree' (for which he was killed by pagans for this outrage), cursed the noisy processions of the Germans in winter. The German language uses the term *Heidenlärm*, heathen noise. Deadly silence and murmuring apparently seemed to be the trademark of the Christian liturgy..."[22]

Kadmon, drawing on a variety of sources, characterizes the *Oskorei* as a hellish and chaotic rite in which the goal of increased noise levels – the noise being generated by human cries, percussion, crashing of cymbals and so on – was to "awaken nature, which slept in the frozen earth"[23], not to distance technocratic mankind from its influence. Kadmon then proposes that this tendency has been, in the late 20th century, reinvested into the bloodthirsty werewolf subculture of extremist heavy metal: the cartoonishly-attired denizens of the Scandinavian Black Metal cult, in particular, bore some similarities to the *Oskorei* riders by masking their true personalities in grim face paint and demonic pseudonyms. The endless trance-like whirling of Black Metal instrumentation (queasy tremolo guitar riffing and strobing "blastbeats" played on multiple bass drums) causes Kadmon to ask "is Black Metal, with its hard, austere sound, the *Oskorei* of the Iron Age?"[24]

This brings us back to the relationship between noise and evil. This relationship is not wholly discouraged by countless musicians and noise-makers with definite pretensions to evil, who prefer their music as loud and distorted as possible in order to create a stimulus on par with that of cataclysmic events such as war or natural disaster. Black Metal, with its incessant, morbid miasma of guitar fuzz, and its cold, rasped and shrieked vocals, is widely noticed as one of the more evil manifestations of modern music. Queasy tritone intervals – one of the most dissonant intervals in the Western harmonic concept – are deliberately employed thanks to their accursed status as the *diabolus in musica* during the Middle Ages. Songs are intentionally under-produced or perversely stripped of mid-range sounds to make a kind of audio metaphor for lack of compromise (moderation and temperance being values which these Nietzschean ax-slingers find particularly

FRANCISCO LÓPEZ 139

abhorrent.) Black Metal musicians compliment their sonics with a hostile image, girding themselves with such misanthropic talismans as ammunition belts, homemade arm gauntlets bristling with nails, and invariably black clothing. Of course, a thorny mythology surrounding the scene – loaded with incidences of church burning, murder, racist agitation and ritualistic self-abuse (the bands Abruptum and Senthil have both claimed to torture themselves in order to produce more authentic recorded shrieks) irrevocably completes the 'evil' package.

But without the harsh visual components, the severe blasphemies re-printed on the albums' lyric sheets, and the band members' own attempts to promote themselves as Vlad the Impaler reincarnate, could even Black Metal avoid being pegged as an ugly form of 'sonic sewage'? By Schafer's logic, no – since any attempt at liberating the sounds from their composers would be a deceitful task, a capitulation to 'schizophonia'.

But, just as Brion Gysin claims that 'poets don't own words', López contends that musicians and composers do not own *sounds*, and therefore the entire concept of a 'connection', and consequent 'separation', between sound and source is false. Firing another shot across Schafer's bow, López states:

"Since sound is a vibration of air and then of our inner ear structures, it belongs to these as much as to the 'source'. To criticize sound recordings in [schizophonic] terms is simply not to understand the meaning of the Schaefferian concept of sound object as an independent and self-sufficient entity. The schizophonia of Schafer and the *objet sonore* of Schaeffer are antagonistic conceptions of the same fact."[25]

Maybe it is no coincidence, then, that one of López' own better-known pieces, *Untitled #104*, released on Montreal's Alien8 label, is a 40-minute hailstorm of extreme Metal samples, and that (despite the vague familiarity of one or two 'grooves' arising from the maelstrom) it sounds uncannily similar to his recordings of natural phenomena. The vertiginous assault of drum sounds on the piece hearken back to López' distant past as a drummer for various punk bands. More to the point, though, one reviewer accurately summarizes the piece's ability to warp perception through a kind of stimulus flooding, noting "once you make it through the first 5 minutes, all that's left is a whistling rumble that mostly reminds of the sound of gas pipes."[26] This is an especially challenging piece for López to pull off, since the sounds are so hopelessly wrapped up in the willfully contrarian and harsh world of heavy metal – or, maybe more accurately, it is a challenge to the listener to hear this bombardment and to imagine the sound in a non-'metal' context, free from corresponding mental imagery of black leather, spilt beer and thrashing manes of hair. In recent years, plenty of musicians not aligned with the "metal" subculture have attempted such sound pieces, which tantalize the listener with something vaguely familiar, yet systematically delete key points of reference (especially the histrionic vocals), leaving them rudderless on a sea of indifferent noise and – when confronted with such a 'pure' form of the music – wondering how they came to embrace this music in the first place. *Untitled #104* can be counted among the better of these experiments, with a few others – Kevin Drumm's *Sheer Hellish Miasma*, selected works by Merzbow – offering the same sort of enlightenment through the total exhaustion of a particular musical concept.

This feeling of intense dislocation is, to borrow from López' own lexicon of terms, a form of *belle confusion* – a voluptuous beauty that comes precisely from having no immediate connection or relation to anything at all; having a vast sonic space all to one's own. This can be accomplished just as easily with the battering power of *Untitled #104* as it can with pieces so quiet and elusive that the ears would 'squint', if they could, to ferret out the carefully obscured, dust mite-sized details. It should be noted that a skill for mining the depths of quietude has endeared López to other such representatives of this style (Bernhard Günter, Marc Behrens, et al.) just as his ability to transform sound from ethereal presence to physical force has placed him in a league with psycho-acoustic heavyweights Zbigniew Karkowski and John Duncan. It should not be assumed, though, that López' explorations of quiet have some more 'intellectual' basis than his into the visceral, flaring loudness of his recorded boiler rooms and war machines. He is careful to warn against "...a common misinterpretation of silence and quiet sonic events as having some kind of hidden

"conceptual" content"[27i], stating that

"It is my belief that this has to do with the limited conception of narrow dynamics in most music standards. This applies to many sound creative frameworks such as the volume dynamics, the frequency range, the timbral palette and the pace of unfolding for sonic events. When music is a commodity for background 'ambience', for dance, for radio broadcast, for big live shows with crowds, and so on, the constraints (mostly unnoticed) keep holding a strong grip on us. When music is a world in itself, the territories are vast and thrilling. We can go from – 60dB to 0 dB and feel all what is happening, we can endure deserts and oceans of 10 minutes of silence, we can flow in mountain and abyss crescendos of 40 minutes, we can walk on thin shreds of thin air or be smashed by dense waterfalls and things like that, which I do in my pieces. There's nothing conceptual about this, but rather an immense spiritual universe of open possibilities, or at least this is what I forcefully try to create."[28]

López also argues that silences and perception-testing murmurs within his work should not be seen as some kind of aberration when the visual equivalent of such (i.e. smears of paint on a canvas) has been accepted as a legitimate compositional technique. This hostile response to low-volume information has always dogged the unwitting emissaries of so-called "extreme electronic music": see also the uncomfortable reactions engendered by the inter-song silences on early recordings by Whitehouse, for example, and – by contrast – the almost universal acceptance of 'negative space' as a device in visual artwork.

The interest in capturing the full range of dynamics runs parallel with López' frequent invocations of the power of spirit (although this should not be confused with religious questing, he has in fact called religion an unnecessary "side effect" of spirit.) López seems intent on creating something as amorphous and prone to subjective definition as that which we refer to as 'soul', and it is hard not to draw parallels between his love of blurred boundaries/indistinct horizon lines and the spiritual goals of disciplines like Zen Buddhism ("what seems to be evolution for others is dissolution for me...a big *blur*...it's so beautiful.") What López strives for in his sonic transmissions could just as easily be the *satori* of Zen monks, that moment when all perceptible phenomena fuse into one; the ecstacy in Rimbaud's *L'éternité* when he witnesses the sea mingling with the sun. Like such experiences, whose intensity can hardly be translated into mere words (thanks to the final dissolution that they cause between 'knower' and 'known'), the attainment of the 'big blur' is similarly an experience that defies the most advanced vocabularies: and Francisco López likes it this way. It is his beloved E.M. Cioran, after all, who referred to words as "silent daggers," also claiming "we die in proportion to the words we fling around us." In López' appraisal, conversion of sound to language is no more likely to succeed than conversion of sound to visual information – and no more necessary.

When all is said and done, López' approach challenges more than just the usual musical conventions, but questions the very nature of our human relations themselves (both our relations to one another, and to the biosphere we inhabit.) Whatever worth this approach may have for others, his unapologetically solitary method of exploration has seemingly worked for him personally: revealing the sonic component of a universe that, while not becoming any more purposeful, becomes ever more detailed and lush, and also exponentially more confusing with each would-be 'breakthrough' discovery, playfully evading our most carefully laid snares and our attempts at dominance through rationality and pragmatism. López' ongoing, intuitive journey into total dissipation would be a painfully lonely one for most musicians, plenty of whom are fascinated with the process of metanoia, or an attempt to forge a novel worldview. Meanwhile, the Big Blur just seems to beckon more seductively with each failed attempt at novelty.

9.
VOX STIMULI:
JOHN DUNCAN'S UNRESTRAINED EXPLORATIONS

It is a perfect late spring day in 2006, alive and humming with warmth and light. I am hemmed in on all sides by old growth trees – these are in turn populated by innumerable small birds who dart in and out of sight, their individual song phrases weaving together into a seamless ebb and flow of whistles and chirps. If we were to go by stereotypical conceptions of "extreme" artists, this would be an unusual day on which to be calling John Duncan long distance, notorious as he is for his steely psychic discipline and artistic interactions with the traumatic – he has been called an "anti-everything conceptualist... a cruel American"[1] by the editor of a popular alternative music magazine, and has been described by the American artist Mike Kelley as a man whose life "struck me as a living hell... his artwork... was completely caught up in self-loathing."[2] However, John Duncan in conversation is almost complimentary to the surrounding idyll of springtime tranquility, hardly a dark and poisonous cloud creeping in on the idyllic scene. He speaks in a calm and metered tone that belies his decades of frontline experience – "mellowed out" would be an inappropriate term, although there is a certain sense of him being at peace with himself; content with the cumulative results of his past research. He also speaks with a noticeable absence of any kind of verbal filler, diving without hesitation into lucid explanations of his work. As with so many other people populating the netherworld of so-called "extreme" music and sound art (a term inherited rather than forwarded by these artists themselves), raw sensationalism and "don't try this at home" cautionary nagging are all too often the elements that guide discussions on his work: artists like Duncan have also provided certain critics with an irresistible 'straw man' to set up in opposition to their alleged humanism and control of the moral high ground. But, if we equate 'morality' with a sense of selfless sacrifice, as many do, John Duncan easily trumps the critics in this debate – at various points Duncan has sacrificed his physical safety, his nationality, and even his literal manhood onto the altar of creative research.

When Japanese music critic Takuya Sakaguchi refers to John Duncan as "never a conceptual [artist], but a stimulation artist,"[3] he strikes at the core of what makes this man's idiosyncratic body of work merit further discussion. John Duncan's sound works and installations largely eschew the theoretical and the metaphorical, and are especially untainted by any hint of the ironic – "lower-case culture" could not be farther removed from his repertoire of intense actions, which demand spontaneous and revealing reactions on the behalf of participants (as well as provoking a separate set of long-term, residual effects.) What, then, are some of these actions? Concerts of shortwave radio noise performed in total darkness (or with thousands of watts of white light shining on the audience.) An event in which a voluntary audience entered naked and stranded into a darkened section of an Amsterdam cellar, with no clue as to when they would be eventually released. Direct confrontation of friends in their homes by the handgun-wielding artist, himself wearing a mask and later "unmasking" himself by calling up these friends and asking them their personal reactions to the confrontation.

Sensory information, in its polar extremes of saturation and deprivation, is at the heart of nearly all these actions: for every sense-flooding noise concert of Duncan's, there is an action which is literally imperceptible: pieces like *The Secret Film*, enacted in 1978, embody this latter ideal perfectly. *The Secret Film* is a Super 8 film existing only in the memories of a scant few individuals, whose identities themselves are secret, and who agreed at a secret meeting to have the contents of the film burned, before the clandestine filming location itself caught fire and was destroyed. Even

without any form of physical evidence, let alone much commentary by the artist on the piece's motivations, *The Secret Film* has the potential to encourage an endless variety of discussions about the nature of the creative act itself – what could an artist's end goals be in a piece that will, at best, only be remembered through an increasingly unreliable proliferation of rumor and conjecture? Is it an indictment of the cult of personality projected onto 'genius artists'? Is it a commentary on the way in which myths and legends still dog us in the age of mass media? Is it a gesture of unalloyed nihilism? Finally, can we consider something to be 'art' which exists only in the imagination, whose only acknowledgement as a previously existing cultural artifact is some brief posthumous documentation by its creator? We can either allow ourselves to be liberated or enslaved by the truth that there is no clear answer, but what we come away with is ultimately something of our own formulation – not handed down from any higher authority. So, both the techniques of saturation and deprivation are utilized in actions like the above to re-familiarize participants with pure concepts of self – and there is always a distinct possibility that the use of this information will go beyond any of the intended consequences.

Duncan's role as a "stimulation artist" demands that he assess all kinds of sensory information – not sight or sound only – and with the possible exception of taste, he has indeed surveyed the entire territory of human sensory perception and reported back with discoveries ranging from the unbearable to the sublime. In my aforementioned conversation with the multi-disciplinary artist, he assures me that "the sort of fixed divisions between forms of creative expression, that I was taught as a kid, are breaking down really fast," adding "...and that's how it should be."[4] Duncan is, of course, partially responsible for this breakdown that he mentions: if any artist can be acknowledged for applying the now clichéd concept of "pushing boundaries" to his work, John Duncan is it. Currently based in Bologna, the American expatriate (born in Kansas in 1953) has made a career of pushing against – and occasionally dissolving – the complex arrangement of barriers we construct around our social selves. Duncan has gone through several distinct creative phases in Los Angeles, Tokyo, Amsterdam and Italy, each phase bringing a new set of social relations into the picture to test the incorruptibility of Duncan's aesthetic – so far the purity of his approach has remained intact, although the challenges have been numerous.

Free Music, Black Rooms, Blind Dates: The L.A. Years

Had circumstances been different, this meager biographical sketch of Duncan might have veered closer to that of Kim Jones, an artist from whom he claims a flash of inspiration. Jones, a combat veteran of the Vietnam war, came to notoriety for his *Rat Piece*: while dressed in his full combat regalia, he set a live rat on fire in the performance space, explaining that this was one way in which deployed G.I.s dealt with the interludes of crushing boredom that linked together episodes of superlative fear and violence. Duncan himself escaped deployment to Vietnam through applying for Conscientious Objector status, but just barely: his application was, with some help from his school instructors, approved in 1971 by the draft board in Wichita, Kansas – a body which was not normally inclined to do so. Having dodged this particular bullet, Duncan relocated to Los Angeles and began his university-level artistic studies.

Originally trained as a painter, Duncan chose CalArts as the site for these studies, where he recalls becoming disillusioned with "the school's emphasis on career building at the expense of research"[5] and an insistence on the school's administration that he "...crank out more and more big paintings, as I became obsessed with looking more deeply into the relationship between the maker and the viewer."[6] This obsession led Duncan to study the work of playwright Jerzy Grotowsky, particularly his notion of a 'poor theater': that is to say, a theater in which the relationship between actor and audience was the guiding element of the presentation, rather than the spectacular visual elements which strove to raise theater to the level of media (TV and film) which were imparting a wholly different message. In a notable parallel to the aesthetic which Duncan would later develop, Grotowsky employed all-black stage sets and insisted that "by gradually eliminating whatever

proved superfluous, we found that theatre can exist without make-up, without autonomic costume and scenography, without a separate performance area (stage), without lighting and sound effects, etc."[7] However, unlike television or film, it could not exist "without the spectator relationship of perceptual, direct, communion."[8]

Duncan's involvement in the arts did not, from the outset, involve sound – in a career which involved such startling levels of intimacy, though, it was inevitable that sound would become an integral component, given its need to emanate from a source existing 'here and now,' and its relationship to the listener always having something to do with present actuality. Eventually, the musically-untrained artist would gravitate towards sound together with a circle of individuals – the Los Angeles Free Music Society – who cheerfully declared themselves "the lowest form of music," a claim which would also be trumpeted across the Pacific by Masami Akita of Merzbow. The activities of the LAFMS ranged from Le Forte Four's comical breakdowns, electronically-enhanced sound poems and good-natured synthesizer abuse to Airway's overloaded, aggressive take on free improv (LAFMS founders Rick Potts, Joe Potts, Tom Potts and Chip Chapman participated in both groups, incidentally.) Duncan also formed the cassette label AQM [All Questions Music], whose first releases included recordings of his Reichian breathing exercises and an ambient recording taken inside a car being driven on a mountain road. The group CV Massage would also come into being in Los Angeles, its membership including Duncan as a drummer alongside Michael LeDonne-Bhennet, Dennis Duck, Paul McCarthy, Fredrik Nilsen and Tom Recchion – the group's sole live performance involved a 'solo' turn by Duncan performing on a jackhammer, which was sent careening dangerously throughout the performance space. The jubilant anarchy of the LAFMS was, by all accounts, a unique chapter in the city's musical history, although Duncan would come to embrace wholly different concepts of music.

By Duncan's own admission, the formative experience of being raised in a strict Calvinist household – where rigidity of character and denial of emotional expression were the rule – informed at least some of this work, which boldly explores the emotional responses to human contact and the materiality of phenomena like sound, something which has been thought to have a solely 'ethereal' existence. Duncan magnifies the fundamental aspects of human communication to a point which can become, for the unprepared, genuinely terrifying – but unlike many of the current crop of derivative 'shock' artists, he has made a habit of not trying to reproduce terror for its own sake, instead suggesting that projection and simulation of threshold situations are learning experiences for artist and audience alike. Duncan's one-time means of employment was one such set of experiences, which he describes as

"...the closest I've been to a war situation, in South Central Los Angeles. I was driving a city bus. All the other drivers who were driving that line or driving in that general area at the same time, which was midnight to six in the morning, had weapons of some kind. They carried guns, they carried knives, they carried meter-long chains that they could use as a whip. I didn't carry anything at all. They were always getting into trouble. The most extreme example was a driver on a line that was parallel to mine. He got cut in half by barbed wire. Someone came on the bus and sort of came up behind him, looped the barbed wire around him and used it like a saw. People were threatening me all the time, every 15-20 minutes, all night, every night, all through the year."[9]

Although Duncan never attempted to assail his audience in the same exact manner that his bus fares did to him, the general aura of confrontation and risk has pervaded much of his work. Experience with such a constant, elevated level of threat can be a crucible for those who survive it; Duncan himself relates how a strategy of 'absorption,' rather than retaliation, made this survival possible:

"I learned that if I ever carried something, I would attract someone who was more desperate than I was, and wanted me to test him. By not having anything, by not carrying a weapon, I managed... I carried psychology. I would listen to people, show them respect, and be ready to move out of the way as best I could if they lunged at me. It turned out that in just about every case, that was what they really needed most. This was the most effective tool for dealing with these

situations."[10]

Not all the experiences on Duncan's bus route proved so easy to overcome – one such harrowing experiences is alluded to on the 1981 *Creed* 7" release, one of Duncan's earliest recordings to be pressed to vinyl. An unsettling piece on the record's B-side, ironically entitled "Happy Homes", features Duncan in conversation with the L.A.-area radio therapist Toni Grant. Duncan discusses an incident when he witnessed two adult bus fares dragging a 6-month old baby in a pillowcase behind them, and recalls the initial shock that led him to call the police. If this is not disconcerting enough, there is a follow-up incident:

"I saw something similar to that about 3 weeks ago, and... did absolutely nothing about it. This time, the child was about 9 [years old], and her mother was blind, and...the child had open sores covering her arms and legs, every part of the body I could see that was exposed. This time I didn't call the police, I just drove, and didn't do anything about it. That is why I'm calling. I just feel completely numb, and that has me very worried."[11]

Immediately, the vulnerability and uncertainty expressed by Duncan on this recording sets itself apart from the would-be confrontational megalomania evinced on other "Industrial" recordings of the same period. Unlike artists whose work saw its potency diluted by a sort of historical and geographical distancing from personal experience – lyrical fixations on the Third Reich, for example – Duncan denies us the possibility of escaping into the myth that cruelty is the exclusive property of some possessed dictator in a faraway land. The "Happy Homes" dialogue reveals that such taboos as wanton abuse against the powerless are, unfortunately, universal – not confined to mythical conflicts that reach definite historical conclusions. During his Los Angeles period, Duncan would return to this theme at least once more, with an almost clandestine installation –*The Black Room* (alternately titled *If Only We Could Tell You*) – set in a fleabag hotel. *The Black Room* conjured up the claustrophobia engendered by societal powerlessness: within the jet-black painted space, an electric sander was placed out of sight behind a closet door, which it violently rattled, at once simulating a child's convulsive fear of violence and the violent act itself. Across from this was a single typed page bearing countless repetitions of *"we hate you little boy"* and *"DIE DIE DIE"* complemented by such hallmarks of verbal abuse as *"We taught you everything you know...we always knew you'd be ungrateful"* and *"Look at all the horror...every bit of it is your fault."* It seems that creative acts of such stark potency are not done just as optional exercises in understanding the vicissitudes of human nature, but as compulsory means of abreactive therapy.

Duncan's willingness to amplify the painful events localized within his own body and mind has earned him a reputation, somewhat unfairly, as a "masochist." But such a term would insist that Duncan receives an erotic charge from his voluntary endurance tests, and this is not always the case, even though he admits that "both ecstasy and suffering are two major components in my life."[12] If anything, his more frightening works are informed by an educational imperative more than they are guided by the pleasure principle: Duncan repeatedly stresses in interviews that he wishes for performances to be a transformative experience for both performer and audience, not merely a matter of generating catharsis through shock: "the whole idea of doing all this work is to set up a situation where at least *I* learned something. Hopefully the other participant learned something too, but I set these things up so that others can learn something from them."[13]

With these things in mind, it's necessary to touch on one of Duncan's most critically dissected works, *Blind Date.* Although the media's lust for sensationalism guarantees that *Blind Date* is often discussed to the detriment of understanding Duncan's numerous other works, its story does need to be recounted here for the unfamiliar. Duncan's period of American performance came to a dramatic close with this 1980 performance piece, and he states that the reactions to it "made it impossible for me to show art in public in the United States... that was one of several reasons why I left the United States in the first place."[14] Contemporaneous reactions to *Blind Date* were limited to a couple of obscure magazine reviews, although the work has since taken on a near-mythical importance (which has not always gone hand-in-hand with an understanding of the piece's motivation and implications.) Even requests to *initiate* the action in the first place resulted in

physical violence (Duncan's being ejected from L.A.-area sex shops), since the centerpiece of the performance was to be sex performed on a cadaver. Duncan was eventually able to bribe a mortician's assistant in Tijuana to provide the cadaver, into which Duncan would spend his "last potent seed" before returning to the Los Angeles Center for Birth Control and having a vasectomy performed as the piece's *coup de grace*. Audio was recorded of the act, and some visual evidence of Duncan's vasectomy – as shot by Paul McCarthy – survives as well.

Duncan's caveat to a 1997 clarification of the piece's intentions – *"think of me as you will"* – acknowledges and accepts the, at best, mixed reaction to this work. In discussion with Takashi Asai, the editor of Tokyo's culture magazine *Dice Talk* and head of the Uplink publishing company, Duncan reiterates how *Blind Date* was a cleansing act of simultaneous destruction and rebirth, meant as the logical conclusion to an experience which was already having a deleterious effect on the artist:

ASAI: In your commentary you wrote that *'I want to inflict punishment on myself'*, but are you masochistic?

DUNCAN: No, I'm not masochistic. In order to discuss this action, it's necessary to discuss the fact that, at this time (1980), I lost a great love of mine. Even though I loved her immensely, in the end it was impossible to make her happy. For this reason I wanted to inflict punishment on myself.

ASAI: So punishing yourself was the intention of the work?

DUNCAN: In America at the time, the masculinity of white male society was completely defended through penis worship. However, I became aware of the superficiality of this kind of thinking, and my thought was totally altered by this experience with the loss of a loved one. Another factor like this: I've been living in Japan for several years. Japan was a completely unknown country – living in a country with an inflexible societal structure, where I did not know how to speak my mind or communicate through reading or writing, I became all too aware of the narrowness of my thinking and way of seeing things, and thought that I must create irreversible works in order to achieve a more universal viewpoint.[15]

So, in the end, *Blind Date* was meant to be only one in an ongoing series of radically re-configuring actions, rather than a stand-alone act of willful violence perpetrated on the self (or on the passive, deceased 'partner' in this case.) The problematic part of the whole presentation remains not Duncan's voluntary vasectomy, but the use of an unwilling participant prior to that: this is especially curious since the hue and cry over *Blind Date* came not from a religiously-inclined conservative base, but from a largely secular art world. Such people would not normally subscribe to concepts of an immortal soul, something that would be a prerequisite of a situation in which a still-existing ethereal intelligence is aware of its former mortal shell being violated. So, even in isolated incidents where the work was violently rejected, Duncan can still be said to have succeeded in teaching people about themselves – in this case, that a private belief in post-mortem consciousness lay buried beneath the publicly presented personae of certain secular, existential individuals. While critical rejection of *Blind Date* was damning in and of itself, just as bad is the misinterpretation by those who *accept* the work because of a misperceived 'ghoulish' and inhumane quality: assorted misanthropes hoping to tie the work in with the world of 'snuff' films and sadistic strains of pornography, all the while conveniently ignoring any explanation by Duncan himself and relying largely on 2nd-hand accounts. Laboring under the delusion that any artwork offending the sheepish majority must be good, many failed to grasp that 'offending' with stark death imagery was never the *raison d'être* of *Blind Date*.

This is not to say, however, that Duncan shows no interest in human mortality and its widely varying complement of effects on those still living. Speaking on a fellow sound installation artist, Duncan shows that he is not the only one in his field to have used real human remains as a catalyst for some kind of psycho-spiritual transformation, and that others have even used such materials as aesthetic devices:

"Right now, one of my favorite artists is someone who I don't know if she was really trained as an artist – her name is Teresa Margolles. She comes from Mexico City, and... her art is based on

her experiences working as a forensics technician at the Mexico City medical examiner's office. What she does is she prepares human bodies for autopsies – she performs autopsies as well, and her art is all about that – the human body and the spirit of the deceased. For example, making situations where you walk into a big room and it's filled with soap bubbles. And as you're moving through the room, these soap bubbles are sort of alighting on you and exploding. And then you find out that the fat used to make this soap is actually human fat. There was another [exhibit] where we met, actually – she had sound coming from these 4 speakers in this little white cube that she built. There was one open entrance, and the one thing you saw there besides the speakers was this framed A4 page, that you had to walk through this little cubicle to read. And when you got there and read it, you realized that the sound was of an autopsy being performed. Then you looked down and realized that you were walking through this white powder, which was human bone. And when you walked out, you noticed that there were these paths/footprints of white powder going away – the powder from these human bones was being traced all throughout this entire hall."[16]

Duncan explains that, on occasion, Margolles has used unmistakable remnants of the dead – for example, the tattooed skin of a boy killed in a Mexico City gang fight. However, more recently she has "...gotten much more abstract – you see something and don't realize that it has some connection to human corporeal existence. You see a cement bench and it doesn't occur to you to think like that."[17] Continuing along these lines, Duncan says that

"I see this, to an extent, as risky territory, because she risks getting into an area that's so abstract, it really doesn't make a difference if the elements she's using come from the same source. After a while, it might not make a difference. If she loses that, it would be a big loss – she'd have to come up with something quite powerful to make up for it, and I can't imagine what it might be."[18]

The impossibility of placing a work like *Blind Date* into any convenient subdivision of the performing arts has led to comparisons with artists like Paul McCarthy and Chris Burden, with these two artists at least sharing the same geographical confines as Duncan. Comparisons between the work of Duncan and the New York-based artist Vito Acconci, who has also worked heavily with sound in his installations – most often the unprocessed sound of his distinctive gravelly voice – occasionally arise as well, and in some instances, similar territory is being explored. In their 'performance' phases in the 1970s, both conducted experiments attempting to discover what it must be like to be of an opposite gender, and both allowed audiences opportunities to possess, harass, or abuse the artist: one piece of Acconci's involved a standing long jump contest in which any participant defeating him could win a date with one of two female acquaintances, while Duncan's *For Women Only* involved showing collaged pornographic films with a banal sound component of television snippets to an exclusively female audience, who were invited after the screening to abuse him sexually. However, the choice of performance arena is one of the greatest differences between the two, and one which has perhaps vindicated Acconci while leading to heated arguments over whether or not Duncan is simply a petty criminal or provocateur. With the exception of his famous 1969 *Follow* piece (in which Acconci stalked total strangers through the city until they entered an enclosed space, and then mailed notes about his targets to other members of the arts community) most of Acconci's more confrontational performance work took place within the confines of a gallery atmosphere.

By comparison, Duncan repeatedly carried out actions on the streets of Los Angeles, and in public spaces that were unlikely to attract only people with a knowledge of performance and body art – his 1976 *Bus Ride* saw him, on two separate occasions, pouring fish extract into the ventilation system of a city bus with locked windows, attempting to see if the resulting odor's olfactory similarity to sexual excretions would effect passengers. In both cases, riotous and astonishing acts of violence resulted from the bus fares. Elsewhere, Duncan's 1978 piece *Every Woman* saw him returning to a street that he had surveyed the previous night "as himself", returning the next night dressed as a woman in order to experience the fear of possible assault.

Then there was *Scare*, a piece tangentially linked by art critics to Chris Burden's works, thanks

to common iconography (in this case, a fired handgun is shared between *Scare* and Burden's *Shoot* – although it should be noted that the gunman firing on Burden in the latter piece did not intend for the bullet to find its mark.) Duncan's comrade Carl Michael von Hausswolff has deftly noted that it should be considered a 'sound piece', since the firing of blanks from a pistol at point blank range provided an unequivocally sonic dimension to the piece. In fact, Von Hausswolff's observation could be applied to a good deal of performance art (especially that of the stereotypically confrontational kind.) It is somewhat disappointing to consider reviews where the sound component in these pieces is barely mentioned, although there are exhaustive descriptions of the visible destruction wrought over the course of certain performances. *Blind Date* itself was staged as a 'sound' piece in which audio of Duncan's infamous coital act was played before a Los Angeles gallery audience. Lest it seem like the hostility towards Duncan following this event is exaggerated, it is important to give him the final word on this:

"Several of my closest friends tried to arrange for me to be extradited to Mexico and arrested on necrophilia charges. When that effort proved to be legally formidable, they decided to threaten anyone publishing or showing my work with boycotts, which effectively banned my work in the US for several years. With other friends, it created a sense of separation, a wall that in some cases still remains. I felt, and was, abandoned by every one of the people I felt closest to. Some claimed that the cadaver had been raped, that the fact that the body was apparently Mexican meant that my action was racist, the fact that the body was female meant that the action was sexist, etc., etc., to the point of surreal comedy. This was an important lesson. It taught me that each of us has a psychic limit. When something puts sudden stress on that limit and has no apparent context we can use to 'frame' it, we instinctively resist. Because our resistance isn't based on reason, any attempt we make to try to explain our resistance logically, or morally, will sound absurd, just as these claims of rape, racism or sexism were and are absurd. At the same time, it's as real as anything else, so it's just as absurd to criticize anyone with such a limit as being personally or socially 'weak'."[19]

Underground, Rooftop and Ether: Ascending in Tokyo

All of this interaction with the particularly vast, American strains of fear, violence and sexual anxiety was soon to come to a close, once an invite to Japan initiated a number of shifts in the locus of the artist's activity. As suggested in the previous dialogue with Asai, Duncan's relocation to Japan was fraught with revelatory experiences and, as is often the case, numerous misunderstandings as well. A man by the name of Takuya Sakaguchi was the initial contact for Duncan in Japan, a biologist studying, as Duncan recalls, "higher nervous energy, which is how the Japanese title translates ...the connections between the locus sirius neuron and the visual cortex."[20] This research was carried out with the eventual goal of increasing human memory through the growth of brain cells. Sakaguchi's day job, with its emphasis on fostering some form of biological growth, conveniently merged into his interest in self-produced sound art. After first hearing Duncan on the 1979 *Organic* LP released through AQM, Sakaguchi began a letter-writing campaign that would provide the germ for Duncan's eventual arrival in Japan in 1982, once the fallout from *Blind Date* had made further Stateside developments too difficult.

The expatriate artist's local influence would expand significantly throughout the 1980s – this is evidenced by a number of collaborative concerts or record releasing efforts with groups like Hijokaidan, Toshiji Mikawa (also of Incapacitants), Chie Mukai and O'Nancy in French. All of these individuals were, and still are, firmly planted in the underground, but – if high online auction prices of their original recordings are anything to go by – are now venerated as the brave, lonely souls whose diligence made broader developments in visceral expression possible. Like Sakaguchi, most of these individuals were tied to day jobs apparently dreary in comparison with their anarchic, colorful musical output. Toshiji Mikawa remains, as of this writing, a section chief in a Tokyo bank, while other members of Hijokaidan were described by Duncan as

"...a housewife, a secretary and an office worker... Hijokaidan is known for their performances, where one of the women who does vocals will also do actions like pissing on stage,

or shitting on stage, and the rest of the members will sort of move around on the stage after this... *in* this... and play homemade electronics, and in the process destroy these homemade electronics. And, as I said before, when I introduce Hijokaidan, people who are not familiar with their gigs when they first see them are rather skeptical that these people are office workers that they're looking at on the stage. But then when they start playing, they shut up, and listen, and, well... change their minds, I hope."[21]

During the 1980s, not many Japanese artists would equal Hijokaidan's propensity for showmanship, which simultaneously showered audiences in humor and terror. Duncan would respond in kind with performances of his own, though – performance pieces like *Move Forward* (1984) featured about 20 minutes of massive, tangible sound output in the darkened, concrete-walled 'Plan B' space in Tokyo, accompanied with film collage – of war atrocities, S+M ritual etc. – being projected onto a paper screen which covered basically the entire visual space of the forward-facing audience, since the projection screen stretched from ceiling to floor and from the left wall to the right. In an unmistakably climactic moment, this screen would be set ablaze by Duncan at the end of the film portion, its fire-consumed remnants sprayed into the audience with a fire extinguisher. Like the earlier *Secret Film,* here was another piece that ended in fiery destruction, continuing Duncan's interest in the elemental – the final destruction of the projection surface, after being used for such an overload of provocative imagery, could on one hand suggest a return to a *tabula rasa* in sorts, an 'unlearning' or transcending of aggressive impulses. Then again, blasting the audience with the remnants of the projection surface could be seen as another none-too-subtle hint that some residue of these primal destructive urges would always be with them, flying back into their faces when least expected.

Actions like the above, which featured a level of un-compromise at least on par with the actions Duncan carried out in the U.S., need to be put in some sort of geographical and historical framework. If they do not seem particularly jarring to jaded veterans of 21st century information overload and post-'9/11' nihilism, we must remember that the mid-1980s were an unparalleled period of economic prosperity for Japan. The era of the *endama* – powerful yen, or yen appreciation – was about to begin, and according to one retrospective article on Japan's '80s prosperity,

"Japan's per capita income hit $17,500 a year – second highest in the world. Land values soared. A square foot of Tokyo real estate sold for the equivalent of $2,000; a simple wood frame home for 1.5 million dollars. Japan's Economic Planning Agency calculated that the market value of the nation itself, a California-sized archipelago, was four times greater than that of the U.S."[22]

Just like the rise of Beat poetry in 1950s America, oppositional aesthetics in such a culture of easy convenience and economic dominance (Japan was also the world's #1 creditor nation at the time) would have seemed ridiculous to the rank-and-file 'salaryman' or 'OL [office lady]'. This is to say nothing of their elders, who, even if they found this culture rampantly materialistic, found it vastly preferable to a state of total war. Defenders of Japan's mainstream culture could even argue that its market power was what allowed these contrarian activities in the first place: since everything else was so readily provided for her citizens, the existence of some fringe elements displaying a kind of *Nippon Aktionismus* 'proved' the robust health, flexibility and all-inclusive nature of the dominant culture. This is true, if only to a certain extent: a good deal of young Japanese from the time lived rent-free with family members (and a sizable number still do today.) With such disposable income on hand, consumption of cultural materials became a choice way to spend this surplus cash: copious amounts of books, magazines, and comics were needed for daily train rides, while large numbers of LPs and cassettes were necessary to enhance cramped home life and to keep current with one's peer group, who more often than not kept meticulous and status-defining checklists of "must have" media. The ability to consume more media in a smaller amount of time would often turn into curiosity about more 'exotic' flavors of culture, and so the door was open to things like Hijokaidan, Merzbow, and John Duncan – if one's tracking instincts were sharp enough.

But increased spending power and unprecedented diversity in consumer choices was only

one side of the story, and at any rate, simple *availability* of radical culture and media did not equal broad-based *acceptance* of its content. At best, the ongoing saga of groups like Hijokaidan was carried out in tiny capsule reviews at the rear pages of magazines like *Fool's Mate* and *Rock Magazine,* who would cover the *noizu-kei* [noise movement] phenomenon less in the 1990s and 2000s than in the 1980s, even as concert performance and releasing activity in that corner of the underground multiplied exponentially. At any rate, having a safe existence as a contributor to a massively affluent society was not enough to satisfy all people all the time: this often brought with it intense levels of fatigue (as evidenced from the large numbers of napping businessmen on home-bound subway trains), and unsustainable levels of hyper-competition. There was also an alienation from the forces of nature, an appreciation of which was so vital to earlier manifestations of Japanese culture. Meanwhile, Japan's status of relative cultural isolation and insularity made the various escape routes into other cultures – such as learning second languages – more difficult than usual, and certainly too time-consuming to attempt while already spending one's days at the office and nights at the *karaoke* bar in moments of compulsory camaraderie. While it was actually cheaper in the 1980s to spend one's slim allotment of vacation time abroad in Australia than within Japan proper, long-term involvements in other nations were not as common, which often made the appearance in Japan of a figure like John Zorn or John Duncan a welcome 'fly in the ointment' catalyst for new cultural developments.

One notable feature common to most of Japan's 'outsider culture' denizens was their visual similarity to members of the Japanese mainstream: plenty of neat, short haircuts, and indistinct, conservative fashions were to be found among the genuine radicals and perverts. This was in part a necessity, something that allowed people to slip into their underground mode without having to explain themselves to suspicious co-workers. This was also just another rejection of the prevailing materialism, which had spawned countless visually oriented culture tribes: rigidly defined cliques of brightly plumed yet harmless youth whose status as living street-corner sculpture *was* their main cultural contribution. Such cliques would insist that professional musicians must be marked by special coordinated outfits, handed down by the editors of the premiere Tokyo style guides. But groups like Hijokaidan were the ambassadors of a new anti-professionalism, not "musicians" as the general populace in Japan would have understood the word – as such, there was no set uniform for makers of underground *Gesamtkunstwerk,* performance art or other impossible-to-categorize forms of unmediated expressiveness.

Pockets of resistance – or at least pockets of people who acknowledged and attempted to examine their own 'outsider' status – sprung up not only in the culture of free noise and Industrial music, but also in the 'alternative' comics scene rotating around weekly magazines like *Garo* and the willfully crude (but not inarticulate) comic artist/essayist Takeshi Nemoto. Direct collaboration between the two scenes seems to have been rare, but both persistently attempted to confront base instincts with the intent of reaching higher eloquence and awareness beyond the glossy but insubstantial artifice of consumer lifestyles. Nemoto's description of his comics as "propagating like the graffiti you find on a toilet stall" was interesting, especially considering men's toilet stalls were the precise 'exhibition space' of Duncan's 1985 collection of A1-size collage posters. Like the alternately discomforting and arousing materials used for *Move Forward,* Duncan's collages of war imagery and exaggerated pornography were not what anyone had expected to see greeting them in an immaculately well-tended Japanese public restroom, where grooming rituals and maintenance of professional appearance were carried out just as much as the less noble acts of urination and defecation. The posters were placed in Tokyo's epicenters of fashion (Shibuya), finance (Hibiya), government (Kokkaigijidomae), and entertainment (Shinjuku) – with this strategic placement, Duncan's simple act hinted that, if the present technological and materialistic utopia was not *built* on primal lusts and aggressive impulses, these things were certainly not absent from it.

Actions like the above were not as common as Duncan's musical performances, which were done both solo and in collaboration. Takuya Sakaguchi claims that "the number of shows that John did during that short stay in Japan were not small",[23] and whatever this exact number may have

been, doing just a monthly concert would have been an ambitious undertaking without the proper connections: 'pay to play' policies in Japanese clubs have traditionally priced regular performance schedules outside the range of all but the most dedicated musicians, often forcing the usage of alternate spaces like record shops and cafes.

A 'no bullshit', 'get down to business' attitude was not confined to the Japanese underground musicians' unadorned physical appearance during live performances, but it was also manifested in their choice of sound creation devices, themselves a world away from the dazzling new array of electronic instruments being churned out in Yamaha and Roland workshops. Incapacitants and Hijokaidan had their short-lived, homemade "black box" electronics, while O'Nancy in French created and controlled feedback from amplified oil barrels. For Duncan, shortwave radio was the instrument of choice: a highly portable tool which resisted an user's manipulative movements as much as it accepted them, and which was capable of an extensive dynamic range of sound for those who were willing to hear the musical qualities and rhythmic structures arising from a panoply of hums, crackles, static blasts, and plaintive coded signals. Although he had already been using shortwave during his with the Los Angeles Free Music Society, its use really 'came into its own' (in my humble opinion) during the Japan years.

The shortwave radio was an interesting choice merely for its historical resonance: in the same way that the tiny cell structure of underground music rendered the support of giant media conglomerates unnecessary in order to participate in the shaping of culture, Guglielmo Marconi's brainchild made it unnecessary to have the princely sums of money necessary for longwave transmitters and giant antennae, also opening the communicative floodgates much like the Internet would, some 70 years in advance. The difficulty of censoring shortwave broadcasts and monitoring listeners' access to these broadcasts also gives it some distinct advantages over the latter medium. Duncan claims that, during his stay in Japan, he was staying awake until almost sunrise drinking coffee and making shortwave compositions, fascinated by the fact that

"...it's always different, shortwave is never the same twice when you turn it on from night to night, you don't hear the same things ever. And I'm not talking about the regular stations, I'm talking about the events between the stations – that was where shortwave really got interesting – it was always unique, always different, and the human voice is [also] like that."[24]

Even though Duncan adopted shortwave for such aleatory qualities, it has uncannily adapted itself to his personality and his own artistic intentions: the results that he achieves with the shortwave radio cannot be easily compared to, say, the work of AMM's Keith Rowe with the same device. Rowe's subtle and almost cautious approach to this tool parallels the aesthetic he developed with tabletop guitar, while Duncan uses the instrument in a way that, like much of his other work, rewards concentrated, high-volume listening of the recorded results. Rowe also became a recognized 'virtuoso' of shortwave by his ability to maximize the serendipitous power of the instrument (suddenly finding broadcast voices which seemed to comment on AMM's improvisations as they were happening.) Duncan was, as he has stated above, more concerned with the interstices: in his hands the shortwave radio was not so much a medium for transmitting human communications as it was for transmitting the sound of atmospheric disturbances and galactic forces greater than what normally fell into our immediate field of comprehension. The sound artist/composer Michael Prime, who performs using a 'bioactivity translator' (a device which amplifies the fluctuating voltage potentials or bioelectric signals inherent in all natural life) has written simply, but eloquently, on the larger implications of harnessing shortwave transmissions as an expressive tool:

"Shortwave signals interpenetrate our bodies at all times, and provide a vast musical resource. The signals may originate from cosmic sources, such as the sun, pulsars, and quasars, or from human sources. However, they are all modified and inter-modulated by the earth's own nervous system, the magnetic particles that surround the planet like layers of onion. These layers expand and contract under the influence of weather systems [...] to produce complex patterns of manipulation."[25]

More fascinating than any of this, though, is the way in which these forces have combined to produce signature sonic elements whose source is largely taken for granted. Prime continues:

"Many of the characteristic effects of electronic music (such as ring modulation, filtering, phase-shifting and electronic drone textures) were first heard in the interaction of radio broadcasts with the earth's magnetic layers. Perhaps Gaia was the first composer of electronic music."[26]

Such sentiments have inspired a whole micro-movement within the music detailed in this book, populated by artists like Swiss 'cracked electronics' duo Voice Crack and the exacting Bay Area sound artist Scott Arford, whose hyper-real compositions tend to straddle the 'concrete' and 'abstract' divide. It also has to be admitted that, as far as instruments go, the shortwave is an incredibly versatile producer of sound textures for the price – like most sound generators that are incapable of producing melodic music, it relies on variation in other audible phenomena: the thickness in the distortion of its signal, the velocity of its crackling and chirping noises, and the randomness in the attenuation of otherwise constant electrical hum. The shortwave functions both as a tool for personal enlightenment and amusement, as well as being a metaphor for the challenges we face in making meaningful communication, beset on all sides by countless forms of natural and human interference: at least this is the feeling one gets when listening to Duncan's shortwave-based pieces like *Riot* and *Trinity*, dense and occasionally opaque manifestations of elemental sound.

Radio would become a productive tool in Duncan's hands in more ways than one, though, as he also set out to make pirate broadcasts of events that would likely never make it onto commercial Japanese radio (and, to this day, still haven't.) His pirate radio program *Radio Code* was the kind of thing which, given its superior ability to investigate and document street-level reality when compared to the mass media, calls into question the concept of "amateurism". Although *Radio Code* was broadcast using no more than a Walkman, a transmitter with a 7km range, and a stereo microphone with earphones taped to it (this allowed for music to be played from the Walkman while "talking over" it as a typical radio DJ might), the sheer eclecticism of the sonic art it presented was well beyond the scope of other media outlets in the area. A radical fusion of preciously unheard music, social commentary and fairly innocent playfulness was employed: highlights included on-location broadcasts of O'Nancy in French and Chie Mukai's band Che Shizu, an audio portrait of an attempted suicide (recorded live from her home after hospitalization), and an episode of the show given over to some enthusiastic high-schoolers. The title of a Hafler Trio cassette culled from a broadcast on *Radio Code* – *Hotondo Kiki Torenai* [something you haven't heard before] – accurately summed up the refreshing nature of the technically simple yet journalistically sophisticated approach.

Infiltrating the world of radio, holding deafening live sound performances, serving as a core member in an expanding circle of dissatisfied urban primitives: these accomplishments could have been enough on their own, but Duncan did not limit himself even to these things, branching out into film and television production as well. His *John See* series of erotic/pornographic films may be some of the only films from the era (1986-1987) to involve a non-Japanese director at the helm. Duncan became involved in this medium with the assistance of Nobuyuki Nakagawa, a protégé of the avant-garde filmmaker Shuji Terayama. Needless to say, the results were an unorthodox based on collaged images (similar to the kind previously used in *Move Forward)* rather than the linear, clumsy attempts at 'acting' and 'narrative' that most porn films attempted. The *John See* soundtracks, likewise, were a world removed from the silly synthesizer percolations and ersatz funk typically scored for mild pornographic fare. Looped orgasmic noises, treated with electronics, gave the impression of being adrift and weightless in some limbo of carnal desire (see the piece *Breath Choir Mix*), while other soundtrack segments heightened erotic tension through ambient rumble and vaguely familiar, low-pitched rustlings and murmurings (*Inka, Aida Yuki Passion.*) Duncan's experiences within this corner of Japanese society featured human interactions significantly different than the ones portrayed in modern-day cautionary fables: rather than descending into a slimy netherworld of the type scripted into Hollywood docu-dramas, populated by Yakuza bosses, drug-addicted runaways and emotionally stunted nymphomaniacs, Duncan's colleagues on the

filming set were reportedly very pleasant, and diversified in their reasons for working in adult films [for the sake of not repeating myself, readers should refer to the 'Pornoise' section of the chapter on Merzbow for further details on these encounters.]

Meanwhile, Duncan's pirate TVC 1 station – broadcast on the frequency of the state-operated NHK after their 'signing off' time – was a small victory for guerrilla media in an environment which increasingly accorded advertising as much importance as regular 'entertainment' programming. TVC 1 also functioned as a sort of companion piece to *Radio Code*. Fans of the media hijacking made so popular by the 'cyberpunk' genre (not least because Tokyo was the staging ground for the seminal writing in that genre) would find Duncan's actions positively romantic: a lone insurrectionary broadcasting from Tokyo rooftops with equipment that could fit securely into a single briefcase (antenna, transmitter and all), melting into the night and the nearest subway train before his location could be targeted by the authorities. Yet, for all this cool anti-hero romanticism, TVC 1 was less concerned with any kind of "fucking up the system" as it was with merely filling the gaps in what people were able to perceive through a broadcast medium: to wit, the station never interfered with any official NHK programming, and as such could project itself as an alluring alternative rather than as a chaotic interruption for its own sake. The intent was to be an 'additive' rather than subtractive form of communication – and among the additions made to Japanese culture were things which likely had never been seen in the whole of Asia: footage of Aktionist artist Rudolf Schwarzkogler, for one. Shaky production values merely contributed to the images' sense of otherness, as did the broadcasting of material whose originators had probably intended for it to remain private: play with a videocamera by a couple enjoying themselves after sex, or an 'accidental' set of artful visuals filmed by an electrical engineer in a small apartment.

Dutch Courage

The next major port of call for Duncan was Amsterdam, a place buzzing with possibility for artistic cross-pollination, and also a place far removed from the workaholic confines of Tokyo, whose full spectrum audio-visual overload nonetheless concealed a deep-seated social conservatism. The Amsterdam of the mid '80s-mid '90s was home to the adventurous Staalplaat/Staaltape record label, and a plethora of pirate radio stations, squats, and other unpredictable flare-ups of cultural autonomy. According to Staalplaat member Erik Hobijn, such activities spun off of the more hectic atmosphere in the dawn of the 1980s, when the squatters' movement regularly engaged police forces in street combat. Hobijn also reports that

"The squatters did some pretty heavy actions. They broke into security places, stole computer files and published them, broke into police files and published them – they had their own magazines to expose all kinds of hot news [...] The squatters are generally horrible – very dogmatic. But in another way it was unbelievable, we had two years of riots just for *fun*, starting around the day the new Queen appeared."[27]

The smoke from these skirmishes had more or less cleared by the time of Duncan's arrival, but the heady underground violence of the early 1980s had helped to lay the foundations for one of Europe's most consistently rewarding creative environments. Claiming to end up in Amsterdam "'by chance, as far as that concept goes," Duncan soon found himself part of another unique constellation of sound artists: one which has not been replicated to this day, and seems unlikely to do so anytime in the near future. Since Duncan's departure from the U.S. owed itself to friction between himself and the arts community there, his exit from Japan tempts one to imagine scenarios of a daring escape from arresting authorities or shady underworld elements with a definite ax to grind. The real sequence of events surrounding his next major move, though, is less theatrical than this: with his Japanese wife of the time transferring to Amsterdam to work for the European branch of a Tokyo-based company, Duncan had the chance to follow along, did so, and that is that.

Relocation to the Netherlands was perhaps not as much of a dive into stark unfamiliarity as the Japan relocation, and it had the effect of solidifying a number of relations that had already begun in Japan, while steadily forging new connections. Z'ev, a.k.a Stefan Weisser, the mystically-

inclined metal percussionist and text-sound artist (who, like Duncan, also attended CalArts), was possibly the first link in the expatriate sound art community living in Amsterdam. If true, this would be another in Z'ev's penchant for "firsts": his *Shake, Rattle and Roll* was the first full-length music video to be commercially released on VHS format, and he was also among the first within the Industrial sub-culture to infuse tribal or 'primitive' motifs into his presentation, emblazoning intricate sigil designs onto his drum heads and swinging sheets of metal about him in a cyclonic, often hazardous dance. Like Duncan, Z'ev settled in the Dutch capital partially due to romantic involvements, in his case with University of Amsterdam professor Dorothea Franck. The sudden accident-related death of a roommate in Z'ev's previous New York loft residence also contributed to his eventual relocation.

Credit should be given to the enigmatic and tireless activity of artist Willem de Ridder, as well: the self-proclaimed "master story-teller" of the Netherlands. De Ridder was named the Fluxus chairman for Northern Europe by Georges Maciunas, and hosted a prodigious number of collaborative organizations whose whimsical titles keep one guessing as to the precise functions they carried out: the "Association for Scientific Research in New Methods of Creation", the "Mood Engineering Society", the "Society for Party Organizing", and the "Witch Identification Project", for starters. The Amsterdam club Paradiso, a vital hub for the continental European tours of independent musicians, was formed in part with de Ridder's assistance, while he labored away on several magazine and broadcast projects concurrently. De Ridder's influence on the Northern European underground of non-specialist artists has at least earned him a place on Carl Michael von Hausswolff's *The Wonderful World of Male Intuition* album, whose track listing reads like an abbreviated who's-who of feted, maverick explorers of the scientific and spiritual: de Ridder's name is listed among perception-benders like Albert Hoffman, Alvin Lucier, John C. Lilly, and Gregory Bateson.

Certain of de Ridder's activities overlapped with Duncan's desire to draw out the latent forms of pure expression within individuals not normally perceived as 'artists': de Ridder's radio show *Radiola Salon* guaranteed air time to virtually anyone who sent in a tape of themselves, not a far cry from Duncan's *Radio Code* experiments. Personal affiliations overlapped to some degree, as well – de Ridder's affair with 'post-porn modernist' and highly sexualized performance artist Annie Sprinkle, and their concurrent desire to transmute their sexual desires into transmittable energy, brought Sprinkle into the orbit of the Hafler Trio's Andrew McKenzie, who himself was involved with Duncan on and off throughout his tenure in Amsterdam (McKenzie also shared a residence with de Ridder at one point.) A frank dialogue between McKenzie and de Ridder exists on tape under the title *This Glass is a Bicycle*, and some of de Ridder's personal thoughts on the nature of human suffering are worth re-printing here for the purpose of contrasting them with Duncan's own:

"There's not one single item in the universe which is out to destroy us. It doesn't exist. We can *think* it like that, and it starts to seem like that, but it's only an illusion. So all our suffering is only because we're volunteers there – it's really what we love to do [...] We don't know anything else. In fact we're so used to it, it feels so much like home, that a lot of people get very *angry* when you tell them they don't have to suffer. [They say] 'oh YEAH? Well I'm gonna suffer! It's my RIGHT to suffer!' You know what I mean? [...] And, great, if you want to do it, you should do it. But all of this feels very uncomfortable, because you're actively resisting the laws of nature."[28]

It would seem that, with positive-minded statements such as these, the ebullient de Ridder would be the perfect foil to Duncan, an artist who, if he has not directly welcomed suffering into his life, has not attempted to diminish its value as a kind of evolutionary mechanism. Whatever their differences may be on this issue, the two artists seem to be in agreement about the usefulness of spontaneity, or of ceding control to variables not given pre-set values by the artist. Continuing from his statements above, de Ridder notes the following:

"You see, our training in struggle, and absorbing discomfort on the path to success, encourages us to really plan in advance. We think we have to plan everything. But... we don't know. We really don't know what's going to happen, all the possibilities, we only make stupid decisions [...]

So *don't.* You limit yourself tremendously by planning. If you can trust that the universe is a support system, and that all the details are perfectly organized for you better than you could ever organize them yourself, then you [will] lead a fantastic life. [...] All you have to know is *what you want.*"[29]

With spritely, good-natured characters like de Ridder presiding over the counter-cultural development of Amsterdam, artistic work done there was bound to have a different flavor to it than that the works accomplished in the blighted war zones of Los Angeles or the insomniac sprawl of Tokyo. Or was it? Amsterdam may have offered a stereotypically 'laid-back' atmosphere in comparison to Duncan's other places of residence, but one side effect of this was ample time for reflection and the conclusion of unfinished business, and for refining earlier ideas within the confines of more professional environments (including recording sessions at Sweelink Academy Electronic Music Studio and the STEIM [Studio for Electro-Instrumental Music] Laboratories, home of the LiSA real-time audio manipulation and sampling software.) Notably, *Radio Code* broadcasts continued on a weekly basis, occasionally offering exclusive recordings of the Japanese underground to Dutch audiences. In Amsterdam Duncan also composed the pieces *River in Flames* and *Klaar,* which in a way are his signature recorded pieces: most of the sonic elements associated with Duncan are painstakingly interwoven into these lengthy, exhaustive audio exegeses: a melting down of previous materials which have run their course, ready to be forged yet again into something new. Von Hausswolff describes *River in Flames* in more vivid terms, as "a cleansing piece where nothing was hidden, nothing was obscure, and nothing was veiled. A naked John Duncan puking his past away like an overdosed Lacan on peyote."[30] It is a *pièce de résistance* of its form, no matter how we choose to describe it: nerve-tingling computerized warning signals, unbearably intimate Janovian primal screaming and time-reversed moaning, indistinct grey ambience heard through solid walls, ecstatic electrical discharge, and the resurgence of Duncan's shortwave radio...all of these combine to make the penultimate portrait of a world which seems indifferent to our elaborately constructed fictions and histories: the giant coronal mass ejections from the sun, humbling our best attempts to communicate with each other across the radio spectrum, being just one example.

Another key recording during this period was *The Crackling,* done in collaboration with Max Springer and using the linear particle accelerator at Stanford University as the original sound source. Although this particle accelerator's size now pales in comparison to the mammoth (17 miles in circumference) Large Hadron Collider beneath the French-Swiss border, it is still claimed to be the world's longest straight-line object: an amusing side note when considering the very 'non-linear' way in which Duncan's art usually proceeds. Also interesting is the fundamental concept behind these gargantuan atom smashers: making larger and more complex structures in order to seek out the infinitesimally small, the particles which would reveal the very secret of the universe's functioning. The purpose of these vast constructions – probing of dark matter and seeking the universe's early origins – is neatly analogous to Duncan's research with the human organism, seeing as it unashamedly seeks out the sources of our inter-personal friction and neuroses, and our own internal *'terra incognita'* or psychological and emotional 'dark matter'.

Any hope that Duncan's work, while being based in Amsterdam, would be attenuated in a haze of legalized marijuana smoke and general *laissez faire* ideals was further dashed by installation pieces like *Stress Chamber,* first enacted in 1993 at the "Absolute Threshold Machine Festival" in Amsterdam (the first major Dutch exhibit of 'machine art'). Consisting of a metal shipping container large enough to accommodate humans inside, and with running motors mounted on three of the four container walls, participants in *Stress Chamber* were told to enter the darkened container completely naked, encountering intense vibrations of a palpable character. Duncan's catalog description of this piece informs us that each motor, equipped with an eccentric flywheel, would cause vibrations at the container's resonant frequency – these fluctuations in vibration created the illusion of the sound being a moving object, another 'body' as it were – no longer just a ghostly presence whose place in the hierarchy of human senses was not as elevated or authentic as the sense of touch.

By this point in Duncan's career, 'touch' is becoming the operative word for nearly all his

exhibited and recorded works: and not merely because of his affiliations with a record label of that same name. Sakaguchi's description of Duncan as a 'stimulation artist' begins to really ring true during this time, as both the touching caused by surface/skin contact and the figurative meaning of 'being touched' – having one's emotions stirred and beliefs interrogated – become recognizable as the sutures holding together this complex body of work. Of special interest is the fact that pieces like *Stress Chamber,* involving a solitary individual subjected to the elements, can arouse as diverse a set of physiological and emotional reactions as pieces involving a direct interface between two humans. The latter category would be best exemplified by *Maze,* another Amsterdam-based piece in which participants voluntarily went nude into a basement room, unaware of when they would be released (some flash photos of this exist as documentation, later projected with a shortwave soundtrack accompanying them.) When all of Duncan's pieces to this point are surveyed and interpreted as a single ongoing project, several categories of 'touched' individuals emerged: the 'touched from a distance' voyeur (as in the *John See* series of films), the direct participant in a corporeal ritual or ordeal, and the artist himself (who is, after all, hoping to learn from these events, whether a satisfactory audience response is generated or not.) What all these myriad forms of contact achieve is to question whether one 'touch' is truly more 'real' than the other; obviously one could respond to physical touch with blank indifference and yet be wildly stimulated by erotic simulacra, and vice versa. To his credit, Duncan does not interject himself into the audience's assessment process by saying things must be otherwise, or that certain reactions are contrary to his work's 'intent.'

Love In All Forms: Scrutto di San Leonardo, and Beyond

"Around 1987 or so, I was very interested in the musical area dealing with noise (more or less 'composed', or at least somehow regulated) and what's commonly intended as 'post-industrial'. It was right then that I met John Duncan's music for the first time, instantly remaining fascinated by that sound. It was clearly evident that his pieces communicated to my whole being through something much different than sheer 'noise'. John's sonic propagations – even the harshest ones – must be placed in the context of that big vibe upon which life itself is based. There's an underlying harmony at work, an awareness of phenomena that no word can explain, but upon which we can rely for the betterment of our persona. About ten years later, I was writing for an Italian new music quarterly so I contacted Mike Harding at Touch to see if Duncan was available for an interview. I thought of him as someone who didn't want to know about stupid things like explaining his art. Imagine my surprise when, fast-forward less than a week, I received a very nice letter from John, who agreed, with an Italian address! The man whose work I admired so much, who I believed to be hidden in some remote arsehole of the world, lived instead near Udine, Italy. When in the interview I asked him why, the reply was 'Love. In all forms'. That should say everything about the man. Needless to say, he's one of the nicest, humblest persons that I ever met." (Massimo Ricci, *Touching Extremes*)[31]

At least one form of love, shared between Duncan and the Italian multi-media artist Giuliana Stefani, prompted yet another relocation, from Amsterdam to the village of Scrutto di San Leonardo along the Italian/Slovenian border. This is not too far (at least by this author's hopelessly American interpretation of geographic distance) from where the flamboyant warrior poet Gabriele D'annunzio once stormed the city Fiume (now Rijeka, in Croatia) and declared it an autonomous state. The pair of Stefani and Duncan shared a studio in the small hamlet for nearly a decade, a period over which collaborative efforts between the duo, and with a score of other sound artists, would cement Duncan's reputation as an innovator in this medium. CD releases appeared in which Duncan shared lead billing with Elliot Sharp, Asmus Tietchens, Francisco López, Edvard Graham Lewis (of Wire) – his aesthetic increasingly lent itself to collaborations with those who were not afraid to use drones, noise, barely perceptible sonic nuances and unorthodox recorded sound sources to activate all possible regions of the human sensorium. Although not directly connected with John Duncan, the ecologically oriented Michael Prime again provides some insight into the efforts of this small but

potent circle of sound researchers:

"In my music, I try to bring together sounds from a variety of environmental sources into a performance space – particularly sounds which would ordinarily not be audible. I also use live electronic processing to give these sounds new characters, and to enable them to interact in new ways. For instance, traffic sound may be filtered so that it resembles the sound of surf, while actual sea sounds may be transformed to conjure up images of an interstellar dust storm. Electronic processing allows microscopic and macroscopic sounds to interact on an equal basis."[32]

Prime's emphasis on microscopic and macroscopic – bypassing the more mundane aspects of our consensus reality – is something which animated much of the music being composed by Duncan and his colleagues during the late 1990s and the dawning of the 21st century. Pieces like *The Crackling*, by virtue of their subject matter and source material, had already managed to tackle life at both the micro and macro level. Meanwhile, affiliates like Mike Harding's Ash International record label, an offshoot of the slightly more "accessible" Touch, gradually became repositories of audio exploration into phenomena of the kind described by Prime. In the Ash International catalog, CD-length examinations of EVP [electronic voice phenomena, or the occurrence of unknown voices, attributed alternately to spirits or alien intelligence, breaking through radio signals] nestle alongside LPs of hypnotizing tones inspired by Anton Mesmer's experiments in animal magnetism, intended to induce hypnagogic states. Duncan's releases on other labels, such as the piece *Change* released on the *Mind of a Missile* compilation on Heel Stone, succeed on their ability to amplify the sounds of an inanimate object – a missile's guidance system, in this case – which nonetheless was not a 'neutral' object when it came to evaluating its usefulness. Ambiguity of technology and malleability of perception came to the fore in pieces like this, where the electronic tones produced were ironically quite gentle and languid – even something to be meditated upon – when considering the sounds originated from a device of such deadly power.

It is interesting to note that, despite working with such inhuman elements in his sound compositions, Duncan did not fully abandon the corporeal as raw material – far from it, in fact. His 1998 piece *Distraction*, in which strips of acetate were smeared with the artist's blood and set between glass sheets, shows this to be the case, in the most literal sense (the 1998 piece *Specchietto per le Allodole* also involved Duncan's blood smeared over a rotating cylinder, as seen with a small hole in a gallery wall.) His interactive installation works, meanwhile, required the audience themselves to submit to a higher-than-usual degree of bodily intimacy and voluntary vulnerability within a public space. Duncan's *Voice Contact* piece, enacted in several locations in Stockholm, Tokyo, and Canada from 1998-2000, was one such example of intense corporeality: this was accomplished by requiring viewers of the piece to strip completely naked and then enter a darkened hotel suite, where a heavy audible drone causes further disorientation and a quiet, beckoning voice is heard offering instructions to move forward (note the echoes of the earlier *Maze* piece.) More recently (in March of 2008) the theme of finding one's way in total darkness was utilized for *The Gauntlet*, in which visitors to the exhibition space were not required to be naked, but were supposed to navigate their way through the space using small penlights – the uncertainty and fragility of this journey into darkness is occasionally amplified by blaring anti-theft alarms triggered by infrared sensors, once again forcing an unmediated and honest reaction along the lines of *Scare*.

The same can be said for his *Keening Towers*, an installation set up outside the Gothenburg Art Museum in 2003. Utilizing the recordings of Duncan conducting a children's choir in Italy, which were then projected from 24-meter tall, galvanized steel towers lording over the museum's entrance (making the piece a sort of 'gauntlet' to be run by museum patrons), the eerie piece is difficult to sever from the realm of emotional resonance; from nearly universal conceptions of purity and the sanctity of childhood. It should be noted that the recording of *Keening Towers* was one instance of Duncan taking on the new role of conductor – another from this period would be his concert appearance conducting the noise-friendly Zeitkratzer orchestra, an event for which the artist was veiled in darkness with the exception of his spotlit conductor's hands.

Duncan states that *Keening Towers* was done with the purpose of giving his personal 'ghosts'

a voice, and indeed this points to a larger attraction to vocal phenomena as a whole. As Duncan says:

"All of the traditional instruments either have their basis in the human voice – either imitating the human voice or accompanying the human voice. The human voice is so complex, it can be manipulated by even the most sophisticated instruments that we have available to us right now – state of the art, whatever – and at the same time, it's still possible to recognize the source as a human voice. That is fascinating – I really find that fascinating, and that's why I'm working with the human voice so much now."[33]

The human voice gains this fascinating uniqueness from its ability to produce nonlinear effects, owing to the construction of vocal folds from a three-part material, whose properties cannot be duplicated by the vibrating strings on manmade instruments. While these same instruments would normally have an advantage, by virtue of having larger resonators compared with the human voice, the voice compensates by using an idiosyncratic energy feedback process: the vocal tract stores energy during one part of the vibration cycle, and feeds it back to its source at a more opportune time. The vocal tract can assume a variety of shapes as well, "mimicking" both a trumpet (minus its valves and coiling tube) and something like an inverted megaphone. Aside from this, the power and versatility to be found in something small or invisible synchronizes perfectly with the themes infused in the rest of Duncan's *oeuvre*.

Incidentally, much of that *oeuvre* has not even been mentioned yet in these pages – it is simply too deep and broad to be contained in a single chapter of a genre-surveying book, requiring its own dedicated volume. I can only console the reader by saying that the un-discussed work has a satisfying amount of conceptual overlap with that already discussed here, even if its final form, and the circumstances surrounding its creation, are decidedly different.

Postlude

Whether we find John Duncan's cultural contributions enervating or invigorating, it is difficult to deny that they encapsulate the best aspects of modern autonomous artwork: they cut 'middlemen' and all other varieties of 'middle ground' out of the picture entirely, they steer clear of pedantry (the camouflaging of half-formed ideas with ornamentation) they champion immersion in the flux of the creative process rather than striving for a specific pre-determined result, and they value mutual exchanges of energy between artist and audience (yet do not always require an audience for the art to proceed in the first place.) The constant motif of purging the unnecessary, and reducing oneself to a compressed core of essential ideas and energy, is another key to both Duncan's process and end product.

The great paradox of an artist like John Duncan is this: the more he reveals himself, going well beyond the accepted boundaries of "confessional" artwork in the process, the more mysterious or enigmatic he seems to appear to the uninitiated. But this is not any fault of the artist himself: if he appears to be a suspect figure, it is a result of the prevailing warped perception of our common era, in which flagrant honesty courts suspicion, and ironic distancing is the preferred mode of "communication" for millions. There is no easy cure for a modern culture so heavily steeped in easy distraction, mixed signals and self-deception. But in lieu of a doctor to prescribe such panacea, personal encounters with "stimulation art" of John Duncan's kind will do just fine.

10.
UNCOMMON SENSE(S):
SYNESTHESIA AND ELECTRONIC MUSIC

"...that any affinity at all is possible between a musical composition and a visual representation rests, as we have said, upon the fact that both are simply different expressions of the same inner nature of the world. "[1]
-Arthur Schopenhauer

Convergence Mania

As any techno-cultural pundit will enthusiastically tell you, the 21st century is the century of "convergence", in which communications technology is increasingly unveiling its own equivalents of the Swiss Army knife: pocket-sized, hand-held, wireless devices which function simultaneously as movie and music players, mobile phones, gaming engines, internet connectivity devices, still image and video cameras, musical instruments, calculators...who knows what other functions will be piled on top of these before this text sees the light of day. With so many functions now capable of being handled by so little equipment and energy expenditure, visions of the future both Utopian and dystopian have flown off the shelves at a hitherto unprecedented rate. Prophesies abound that this synthesis of communicative modes and cross-pollination of technological functionality is a stepping stone towards realizing some kind of fully-integrated *Übermensch*; eventually our ability to communicate with and comprehend each other will accelerate to the point where humans morph into sophisticated telepaths. More grandiose yet, there will be some ultimate "awakening" along the lines of what Erik Davis describes in his dizzying techno-mythological primer *TechGnosis*:

"With matter and mind narrowing to a single point of what technology gurus call 'convergence', we will find ourselves sliding down a cosmic wormhole that [Pierre] Teilhard [de Chardin] dubbed the 'Omega Point'. At that node of ultimate synthesis, the internal spark of consciousness that evolution has slowly baked into a roaring fire will finally consume the universe itself."[2]

In other words, the present convergence of technologies – communicative or otherwise – will be just one further step towards the exponentially more awe-inspiring cataclysm that Davis mentions above. On face value this vision is hardly Utopian, sharing more in common with the grim eschatology of Norse myths like Ragnarok, in which the earth is consumed by fire and the stars are extinguished from the sky. Still others, like the unabashedly hallucinogen-fueled author Daniel Pinchbeck (whose book *2012: The Return of Quetzlcoatl* makes Davis' writings look simply genteel in comparison), welcome such a fate, as it can only bring about a Golden Age following a Kali Yuga Dark Age of Ignorance, or a reversal of the Tao, or some other such species-wide epiphany. Technological 'convergence' or 'singularity' has become the plaything of starry-eyed eschatologists, whose hope for such may be somewhat more stylish in alternative circles than more well-known eschatological fantasies like the Second Coming of Christ – although the yearning for salvation still remains. I will stop myself here, since my criticisms of Pinchbeck and his New Age ilk warrant a separate volume almost unto themselves.

While technological synthesis is being put forward as the harbinger of unbelievable revelations to come, other forms of actually-existing synthesis have been somewhat ignored: fascinating fusions much closer to home than the apocalyptic mergers and comic book catastrophes suggested by overwhelmed "tech-Gnostics" and Silicon Valley shamans. Much has been said and printed about the ongoing fusion of cultures, of gender, of technological functionality, and plenty

more besides – but what about taking this obsession with convergence to a neural and perceptual level, and investigating the fusion of the senses themselves?

The Frequency Painters: Galton's Offspring

Among the many famous and outrageous proclamations by the artist Marcel Duchamp, one deserves special attention within the narrative of this book: his encouragement for other prospective artists to "make a painting of frequency." At the time, such a suggestion must have seemed like just another eccentric aphorism meant to further confound the guardians of the art establishment. In the present age, though, making a "painting of frequency" has never been easier: if we use the acoustical definition of frequency – the number of cycles per second (cps), now more commonly noted as hertz – it would be simple to do this in a very literal sense. One would merely have to choose a frequency and paint a waveform, with the appropriate number of peaks and troughs, along a timeline: peaks and troughs massed more closely together for a higher frequency, and placed further apart for a lower one. However, painting a frequency, in the traditional sense of the word, has not been necessary since the advent of the oscilloscope: an electrical device that basically, on its display screen, makes a "painting" of a frequency every time it is operated. Its value as a tool which can provide visuals, however minimal, in a 1:1 ratio with a corresponding sound, is not lost on the group Pan Sonic. The Finnish duo have used oscilloscope readings in sound installations and concerts to further enhance the physical presence and precision of their rolling, faultlessly rhythmic sub-bass tides. Coming full circle, it was Duchamp himself who ended up following his own advice, during one of his many chess matches (Duchamp actually preferred chess to art, calling it "much purer than art in its social position".) In a now-legendary chess match with the composer John Cage, the chessboard was miked and attached to an oscilloscope which would 'interpret' the sounds of the chess pieces gently thumping on the field of play.

Synesthesia is the common term used for fusing of the senses, in which one type of sensory information leads to involuntary responses from another sensory pathway. Within modern culture, this still seems to be a bizarre and novel thing, since we are acclimated to compartmentalization and ordering of the senses. Our prioritizing one as more useful or more authentic than the other may have the split between secularism and religiosity as one possible cause. Take, for example, the skeptics' rallying cry of "I'll believe it when I *see* it", and contrast this with the number of religious revelations in which sound confirmed – or implanted – a belief. The prophet Muhammad hears, rather than sees, the archangel Gabriel, who dictates to him the 96th *sura* of the Quran. Mystics such as Teresa of Ávila also claimed to be a conduit for supernatural speech that was heard more directly and clearly than anything within the hearer's immediate spatial confines. When keeping score of all the mystics, prophets and ascetics, there are few exceptions to this rule, although Hildegard von Bingen's encounters with the divine voice are spoken of in synesthetic terms: the 'words' she hears resonate in a way alien to human linguistic patterns, instead she has to explain them with such visual metaphors as "trembling flame" or "a cloud stirred by the clean air." Even Socrates, adored by modern rationalists, claimed to be divinely inspired just by hearing the voice of his *daimonion* – a claim that would not help to defend him against accusations of introducing new gods to the Athens of the day. I will not try to make a case here for these auditory hallucinations being 'divine downloads' or psychologically-based phenomena, but it is interesting to note how many divine interventions were "mono-sensory" ones; either heard or seen but not both.

Synesthesia, although it has been under research by the scientific community since the late 19th century (Francis Galton is widely recognized as having lit this particular flame in the 1880s), is still brushed aside by many as an unreliable pseudo-science, as the whimsy of 'loose cannon' mystics who have the most tangential connections to the larger social universe. Only over the last quarter-century or so has it gained any real ground in a peer-based research community (papers looked over for material to supplement this chapter almost all dated from the present decade.)

If criticisms against researchers of synesthesia are harsh, then harsher still are the shots fired in the direction of actual people claiming to be synesthetes. Many are assumed to be just attention-

hungry, poetic eccentrics with an above-average skill for wordplay, or outcasts desperately trying to put a sexy gloss on their alienation by convincing the world at large that they possess a mutant sensory awareness. Still others are portrayed as the casualties of hallucinogen overkill, having fried their brains on dissociative drugs, now caught in a state where their senses have been permanently cross-wired. The latter group of people are still some of the most maligned in pop culture: the stereotype of the "way-out hippie" who can barely maintain an ambulatory state while *"hearing colors, man"* has proven to be comic gold in a ruthlessly pragmatic era which has divorced itself from the of the psychedelic daydreams of yore. Of course, drug users cannot be true synesthetes unless they are in the quite impossible state of permanent 'tripping' – the ability to 'hear colors', 'taste clouds' and all other variety of sensory fusions is limited to the period when the user is in an altered state of consciousness; it is rarely a residual effect of drug use. Not all drug users experience synesthetic effects while 'tripping', either, thanks to a wide variety of variables in brain chemistry. At any rate, the belief still persists that the various means of communicating the synesthetic experience, especially verbally, are no more than metaphor. Sorting out *voluntary* metaphorical expressions from *involuntary* experiences with synesthesia can be a difficult undertaking indeed.

Statistically, the vast majority of synesthetes appear to be women, with multiple studies placing the occurrence of synesthesia at a ratio of 6 females for every 1 male. This is particularly interesting in light of the synesthetes acknowledged by recent pop culture – Richard D. James of Aphex Twin, for example – who are skewed more in the direction of maleness. The synesthete's urge to creatively express their perceptive anomalies may also come from the predominance of synesthetes who are dominantly 'right-brained' (this in turn leads to a disproportionate amount of left-handed synesthetes.) It's also interesting to note the hereditary nature of synesthesia, something which affected the family of author and acknowledged synesthete Vladimir Nabokov. This hereditary aspect of the condition has been used as a defense by one of synesthesia's leading legitimizers, Dr. Vilayanur S. Ramachandran. Responding to the common argument that many so-called 'synesthetes' are just adults who associate numbers and colors due to certain memory-enhancing games played during their childhood development, he dismisses the skeptics' claim that

"...synesthetes 'played with numerical magnets' when they were children. Five was red, six was blue, seven was purple, and it just stuck in their minds. This never made much sense to me. If there's a relationship between playing with magnets and childhood memories and synesthesia, why don't we all have synesthesia? Why does synesthesia only run in certain families?"[3]

Ramachandran is referring here to what is reported as the most common form of synesthesia: 'grapheme-color' synesthesia, a form which, when authentic cases of it are discovered, tends to be a congenital form of the condition passed down along the x-chromosome. In grapheme-color synesthesia, written or audible numbers, letters or other snatches of text are associated with a color which does not change from one instance to the next. A verifiable synesthete, although he or she might see a number written in black ink in front of them, may still ascribe a different color to that number in their mind's eye: without the black ink number 7 placed in front of them, they will invariably "see" that 7 as "yellow." One prominent example of this grapheme-color coordination is, according to researcher Patrick Martin, "the almost universal agreement, amongst those who bear this ability, that 'O' has a brown texture and 'I' has a whitish hue."[4] There is a definite neural basis for this phenomenon, since the part of the brain's temporal lobe dealing with number recognition – the fusiform gyrus – is situated right next to the part normally associated with processing color information.

Having said all this, the type of synesthesia most often employed or simulated by electronic multi-media artists of the day – synthesis of sight and sound – is adventitious as opposed to inherited, raising the amount of skepticism that musicians may be true synesthetes rather than just creators of convincing yet scientifically ungrounded experiments in sensory flux. Obviously, in English a 'tone' can refer both to a grade of visible light and of sound, and in German the word for 'timbre' – *klangfarbe* – translates directly to 'sound color.' With the total number of practicing artists far outpacing the number of acknowledged synesthetes, the amount of art meant to *evoke*

synesthetic experience is naturally far more common than art driven by the experience itself. Still, musicians as diversified in approach as jazz bandleader Duke Ellington and György Ligeti have confessed to some form of synesthetic experience. The latter stated that, for him,

"major chords are red or pink, minor chords are somewhere between green and brown. I do not have perfect pitch, so when I say that C minor has a rusty red-brown colour and D minor is brown this does not come from the pitch but from the letters C and D."[5]

Ellington's synesthetic confessions are more eyebrow-raising, however, considering the new variables he injects into the experience: the 'colors' of sounds can change depending on the *person* they are associated with, and the image of these sounds is broadened to include not just color, but texture:

""I hear a note by one of the fellows in the band and it's one color. I hear the same note played by someone else and it's a different color. When I hear sustained musical tones, I see just about the same colors that you do, but I see them in textures. If Harry Carney is playing, D is dark blue burlap. If Johnny Hodges is playing, G becomes light blue satin."[6]

The Russian composer Aleksandr Scriabin, aligned with Helena Blavatsky's Theosophical Society and taking occasional cues from Nietzschean thought, was never proven to be a synesthete, but did develop one of the earliest 'synesthesia simulators' in his 'light organ', a feat for which he usually gets top billing among artists both genuinely synesthetic and 'pseudo-synesthetic' (Olivier Messiaen and are Wassily Kandinsky also get honorable mentions in listings of such artists.) As can be guessed by the frequent references in his work to divinity, ecstacy and all things Promethean, Scriabin was on a sacred quest to renew the world through art, and one way to do this was to merge audible and visual information. Blavatsky insisted, for one, that five "sacred colors" needed to be arranged in a specific way in order to properly conduct magical rituals. Scriabin's theory of color was also influenced by Isaac Newton, who assigned a different color to each interval in the musical circle of 5ths. Scriabin then streamlined this theory by associating spiritual qualities to the tone-colors: blue and violet lent themselves better to spiritual flight, while reddish tones were more earthy or associated with the material realm. By this logic, one might instinctively expect a higher frequency to correspond to the a higher end of the spectrum of visual light, when mapped onto a keyboard. This is not the case with Scriabin's system, where F-sharp is the "blue" note while the lower D-flat is violet. Many contemporaries were understandably skeptical of these associations, although Scriabin did have an ally in 'colored sound' convert Rimsky-Korsakov. It was he who attempted to convince the wary Sergei Rachmaninoff about his theory, using one scene in Rachmaninoff's opera *The Miserly Knight* as an illustrative example that Rachmaninoff was unconsciously promoting a synesthetic compositional method. The scene involved the opening of some gold-filled treasure chests and was scored in D-major, the key that Scriabin associated with yellow or 'gold.'

As much as epiphanies like this one gave Scriabin reason to boast, posthumous discoveries point to the fact that he built up his theory of color gradually, rather than having known these correspondences from early childhood development, as a *bona fide* synesthete would. In the Scriabin museum, there exist notebooks containing several different hand-written versions of his correspondences between musical and visual tones – even without exact dates ascribed to them, it becomes obvious that the composer was gradually refining a system rather than always being possessed of a unique color-sound translation ability.

In The Simulation Arcade: DIMI, UPIC and Beyond

Modern musicians and composers seem to have, for the most part, gotten beyond the 'Scriabin syndrome' – the belief that one's highly subjective theory of light and sound has universal resonance. As per Peter Christopherson of Coil / Threshold House Boys' Choir:

"The generation of patterns of light triggered by sound is a tricky business. Mechanically one is quite limited to interference patterns etc. Automatic devices such as the I-tunes Visualizer do an amazing job given the limitations of the technology, but still tend to produce 'moving wallpaper'

that lacks some element of humanity [...] Generally I know that the mind is able to assume or feel connections between all kinds of images and sounds, in all sorts of ways that are far more complex than the simple generation of pattern (interesting though that is), and it is these connections that I find more interesting at this point. For example the way the music of THBC effects one's perception of the images on the dvd [accompanying their *Form Grows Rampant* CD]."[7]

Others from the post-Industrial milieu, like text-sound performer and percussionist Z'ev, seem similarly unconcerned with making a 'perfect' 1:1 correspondence between sound and any other sense, acknowledging that there will be a multitude of sensory reactions to any given sound stimuli, and that a universal reaction will be very difficult to attain. Yet some still believe they can instill aspects of the synesthetic experience in an audience by means of sonic overload, or by the removal of sensory elements which would normally be present in a concert environment. The habit of performing in the dark – a practice increasingly common among electronic musicians, from Francisco López to Andrew Liles – is one way to bring this about. Z'ev suggests that, in a situation where there is paradoxically much more sonic information than visual information, some kind of synesthesia can arise through entoptic phenomena (light being *visualized* without light actually penetrating the eye):

„After about 1985 [...] I started to perform primarily in the dark , and in that context the music triggers a synesthetic experience. That is, it triggers the naturally occurring phosphene activity, like what will happen if you close your eyes right now... you will be seeing some sort of *something* there. When you are in the a place that is so dark that when you open your eyes there is no light, the phosphene activity is enhanced and begins to respond to the sound stimuli which is occurring as I play. People have a variety of experiences, ranging from abstract imagery to geometric imagery to cartoony type things to visuals which are as very representational, as if it were a dream."[8]

One manifestation of the phosphene activity that Z'ev mentions is the habit of 'seeing stars': amorphous blotches of deep color appearing before the eyes when there has been some form of bodily impact – a blow to the head – or occasionally from an explosive bout of sneezing. Given the sheer volume and bodily impact that can be generated by Z'ev's chthonic play with metallic percussion, this sort of thing is far from impossible.

As maligned as the stereotypical "way-out hippie" of the 1960s may be, with his catalog of unrealized dreams, the sensual creatures of this era at least provided the atmosphere in which some prototype sense-fusing machines could be built. The Finnish composer Erkki Kurenniemi is one such character, who, surprisingly, considering the work he has accomplished, did not graduate from university, claiming that he "...found the theoretical physics of the time faulty and wrong."[9] Elaborating on this, he states that "perhaps my rebellion also involved the question whether the world is definite or indefinite, continuous or discrete. I made a somewhat loud exit in the early 1970s."[10]

Kurenniemi tapped into the '60s' spiritually-inclined and sensual 'flower child' *zeitgeist* with a variety of novel electronic devices, one of the most whimsical being the DIMI-S or "sexophon", an instrument to be played by 2-4 players, whose tactile interactions with each other's bodies would cause wild sonic fluctuations (with practice, functions like tempo and pitch can be tamed by careful users, but unbridled randomness may also be part of the fun.) A recent DVD overview of Kurenniemi's work features footage of the composer teamed up with CM von Hausswolff and countrymen Pan Sonic, in a rare moment of physical humor, mischievously tagging each other on the forehead and clasping each other's hands as the machine converts their movements into sound. It's amusing to observe the DIMI-S' electronic warbles uncannily corresponding to the musicians' bodily interchanges: evasive little musical phrases with metallic timbres zip in and out of one's perception like a ball being kicked through midair. Although these movement-sound syntheses could eventually be developed into a communicative system, the lure of pure play seems to be stronger.

Other tools developed by Kurenniemi included the "andromatic sequencer", the DICO [digitally-controlled oscillator], the DIMI-A 2-channel digital synthesizer, and the DIMI-O video-

controlled organ. The latter instrument was a keyboard with a 4-octave range and an attached video camera and video monitor. Images captured by the camera and visualized on the attached monitor could by 'played' once the image was stored into memory. A horizontally-moving vertical bar, appearing on the monitor screen, represented a time axis during playback of pre-drawn images. In a promotional image for the DIMI-O, circuit designer Hannu Viitasalo is shown sitting in front of the keyboard and cheerfully 'playing' a frozen image of his own face. For machines built in the tail end of the 1960s and the early 1970s, Kurenniemi's devices appear amazingly versatile in terms of their interfaces. Kurenniemi, no slouch when it came to tonal theory or computer science, also realized early on the ability of 3D computer graphics to represent musical notation: rather than merely porting the old system of staff-based sheet music over to the computer, Kurenniemi felt that "geometrical objects in the tonal space, like divisor lattices and cylinders... offer a natural way to classify musical chords and scales."[11]

Maybe it is the curse of the Finnish language, with its complex streams of harmonic vowels and its baffling morphology, which keeps Kurenniemi's work somewhat obscure while the synesthetic developments of a composer like Iannis Xenakis continue to gain traction and generate discussion in intellectual forums. Whatever the reason, it is a shame that Kurenniemi does not receive larger exposure, but at the same time it does not diminish the value of Xenakis' own discoveries. Principal among these is the development of the UPIC musical composition tool (finished in 1977), championed by synthesis wizard Jean-Claude Risset and others. UPIC's functioning is not all that different from Kurenniemi's DIMI-O equipment, or the waveform-shaping tool used in the seminal Fairlight Computer Music Instrument: patterns are drawn with an electromagnetic pencil on a table-top screen containing an x-axis (for a composition's duration) and a y-axis (pitch.) Like Kurenniemi's DIMI-O, a horizontal line moves across the screen containing the graphic score during playback. The UPIC system interprets this playback in real-time, allowing the composer / performer to make further manipulations and envelope changes to a score as the score's information is being processed by the computer. Xenakis, despite his academic pedigree, intended the UPIC system not to be used exclusively by professional musicians: to advertise the fact, a charming picture exists of the weathered composer smiling as three small children hover around the machine, one standing on tip-toes to reach its control panel.

During a residency at CCMIX Paris, the computer-savvy artists Russell Haswell & Florian Hecker used the UPIC device to initiate what they called 'diffusion sessions,' concerts in which massive volume, extended frequency range and the coordinated activity of sweeping light beams all come together in a sense-fusing spectacle. It is a demonstration of adventitious synesthesia on two levels, since it involves both converting graphics into sound on the UPIC machine, and then loosely syncing that sound output to the house lighting. Although fancy laser light shows have long been a mainstay of big-budget concerts, and a useful distraction from sub-par music, some observation of these diffusion sessions shows that the lighting is not behaving in a completely arbitrary manner. For example, as the UPIC tones glide from low rumble to keening highs, a column of blue light beams will rise from the floor to the ceiling, or fan-shaped swathes of green light will move with a dizzying speed that accompanies the complicated morphing of the UPIC sound signals. In many circumstances, the artists forego the typical stage setup and situate themselves in the center of a performance space for the diffusion sessions, letting the audience mill around them and try to find their bearings. Ironically, considering the colorful way in which these UPIC sessions proceed, a 2007 recording of Haswell and Hecker's UPIC-based compositions is called *Blackest Ever Black,* inspired by a special laboratory-engineered black paint which is used on optical devices to swallow up any light that strikes them. Also notable is the graphic information which the artists feed into the UPIC machine to be interpreted: photo documentation of Madrid train bombings, nuclear test sites, and so on – the uncomfortable shudders of atonality and spastic violence on *Blackest Ever Black* are all that we, as listeners, have to go by, but they would seem to sync all too well with visual information of this kind.

While Haswell & Hecker stun and disorient audiences with their UPIC-based diffusion

synthesis exhibitions, others are hard at work developing synesthetic software for home PC use. Digital age tools for producing synesthetic experience are becoming more and more commonplace, many of them available as shareware or freeware programs. Although they are both dated by several years now, the Metasynth program and the Coagula 'light organ' (a nod to Scriabin's innovation of the same name) still have the potential to surprise those who are new to ideas of sensory fusion: both programs allow an user to have an audio engine interpret on-screen brushstrokes or color gradients, resulting in sounds that would be described as glassy and luminous at best, hollow and anemic at worst. Slow firing of laser beams, monochromatic bursts of white noise and muted, peripatetic warbling are recurring motifs. The results rarely, if ever, are recognizable to the Western ear as melodic or harmonic, but careful looping and editing of the results can add the desired level of musicality while still retaining the alien timbres unique to the software. Some of the light-sound correspondences in a program like Metasynth are dead simple: a plain black patch signals an interlude of silence, while alternating strips of black and white color will create a crude rhythm using the aforementioned white noise bursts, with the tempo increasing or decreasing depending on how far apart the bars of color are spaced. When it comes to interpreting more complex visual information, though, we are left wondering what things would really sound like if a more sophisticated method of interpretation existed. Surely the glassy and static-laden sound output coming from these programs is too limited in comparison to the variety of visual input that can be fed into the software.

Then there is Argeiphontes' Lyre, a synthesis program developed by the magical realist and romanticist Akira Rabelais – this freely downloadable toolkit comprises many of the functions normally contained in academically-based synthesis software, such as the randomizing and convolution of sound files, and visibly sets itself apart from the vast majority of software applications by employing a translucent, cloud-like graphic user interface. No documentation or 'help' file exists to tell you what controller corresponds to what function; one tool named "The Lobster Quadrille" (which overrides the computer's buffering in order to make violently chopped and stuttering sound streams) can only be learned by regular practice since its control buttons are labeled with lines from a Lewis Carroll poem. While one manipulates the program's various parameters, random phrases and clusters of symbols appear across the bottom of the Lyre's screen, which in turn become the name of an user's saved output file. The Lyre is a distinctive meld of soft-edged Surrealism and cold, hard coding. It is something that would best be appreciated by those who are as enthralled by automatic writing as they are by Fibonacci chains and "floating point" arithmetic. It certainly points at one direction computer-based art may be heading as interfaces become much more 'organic', 'squishy' and ductile (Bruce Sterling refers to this trend as the rise of the "blobject.") And, naturally, it contains a synesthetic audio-to-video converting function. The user selects a sound file and then manipulates the size, resolution and playback speed of the video output file, also choosing a background color and dominant foreground color (subject to some deviation) for the resulting visuals. What one gets varies from flickering and fading flames of to an approximation of the chaotic whorls and scribbles in Harry Smith's hand-painted films. Like Metasynth or Coagula, the anticipation of a result is half the fun: the unlikely act of using a computer as an improvisational tool. Like the above programs, though, the parameters to be manipulated do not really contain enough variables to make a perfect 'translation' of a sound, even though startling synchronicities do crop up from time to time. Just as Metasynth produces an increasingly predictable palette of sounds from an infinite number of visuals, the reverse occurs with the visualizer in Argeiphontes' Lyre.

On The Crest of a Wave

It is somewhat interesting to note that, despite the admirable efforts of software and hardware designers to create new means of simulating the synesthetic experience, one quite successful method was discovered over a half-century ago, *without* the aid of any computer equipment. Dr. Hans Jenny, the father of this method, named it *cymatics* (from the Greek word for wave, "kyma".)

Jenny's studies in wave phenomena, their kinetics, and their dynamics are sadly overlooked or unknown by most practitioners of electronic music – only two volumes of Jenny's studies are currently in print – but the conclusions drawn by his research into phenomenology would be well worth looking at again, as we collectively lurch towards the discovery of more accurate light and sound machines.

Dr. Jenny's method seems almost laughably simple, a low-budget form of scientific rigour which fits nicely into this book's emphasis on such an ethic in the musical realm. Jenny would place substances such as sand or viscous fluids on a metal plate, which was in turn attached to an oscillator controlled by a frequency generator. The plate would amplify the vibrations of the oscillator, and, as the tones produced by the frequency generator were raised or lowered, different patterns would appear in the previously stationary materials: almost without fail, higher frequencies would produce more intricate and elegant patterns in the vibrating piles of sand, gelatin, or whatever other material Jenny was using. The current publisher of Jenny's studies admits to his awe when seeing a small pool of glycerin reveal a "snake" while under the influence of sound waves and some strategic lighting. In these experiments, the tendency of the higher frequencies to 'sculpt' forms with spiritual connotations, such as complex *mandalas* or *yantras,* eerily approached Arthur Schopenhauer's personal philosophy of frequency: namely, that higher tones corresponded to a striving toward superhuman greatness while the lower, almost inaudible tones corresponded to the inorganic: the planet's lifeless and will-less forms and masses. It is interesting to note that Scriabin reached roughly the same conclusion with visible light, insisting that the colors we understand to be the highest on the electromagnetic spectrum also correspond with the "higher" qualities of man: violet was the color representing the transformation of matter into spirit, or the color of 'will to creativity.' Schopenhauer quoted Aristotle on this matter as saying "how does it come about that rhythm and melodies, although only sounds, resemble states of the soul?" Answering this question, Schopenhauer wrote that "I recognize in the deepest tones of harmony, in the bass, the lowest grades of the will's objectification,"[12] and that "...in the high, singing, principal voice leading the whole and progressing with unrestrained freedom [...] I recognize the highest grade of the will's objectification, man's conscious life and endeavour."[13] To Jenny's line of thinking, density or heaviness, manifested in bass tones, represented physicality, while flights of thought and emotion were manifest in 'lighter', more evanescent, higher tones. The only key difference here is that Schopenhauer wrote explicitly of his era's *music* – lavish symphonies and concertos – while Jenny deals primarily with the simple, constant tones produced by standing waves.

At any rate, Jenny's own will was being crystallized by his cymatic experiments: his desire to display to others a 'unitary phenomenon,' a more holistic way of perceiving, bore more convincing results than his meager present-day fame lets on. His primary concern was with demonstrating nature as a "triadic phenomenon" of periodicity, shape and dynamics, not with simulating synesthetic experience – although the latter has seemingly come about as an unintended consequence of researching the former. Seeing that changes in the vibrational field were the fundamental cause of changes in natural phenomena, it was not difficult to at least try and detect some correlation between sound and visuals. Jenny was an enthusiastic polymath, both a musician who was "equally at ease improvising jazz as performing a piano sonata,"[14] and who was also a "tireless observer of the natural world."[15] He has had a few prominent acolytes within the fields of music and sound art: if nothing else, Jenny's work with standing waves was no small influence on Alvin Lucier's *Bird And Person Dyning* installation.

Younger proselytizers of Jenny-ism exist in the upper echelon of 21st century art, as well. One artist with both feet firmly planted in the cymatic, or at least synesthetic, mode of music creation is the ambitious and critically lauded Carsten Nicolai. Nicolai's most "Jenny-centric" work is *Milch* from 2000 – true to its title, the piece involves pools of milk being subjected to imperceptible audio frequencies from 10 to 150 Hz, causing the liquid to reconstitute itself into a number of different irregular patterns: concentric circles at the lowest frequencies and densely-packed masses of quivering goose bumps at the slightly higher ones (some of the visual results have

since been used as the cover artwork for one of Nicolai's CDs, *For,* recorded under his Alva Noto alias.) Cymatics are a motif that Nicolai has returned to time and time again in his work, including the 2001 piece *Wellenwannee* and the captivating *Snow Noise:* for the latter installation piece, gallery visitors approach a set of 3 glass cylinders aligned in a row and placed atop 3 identical white boxes containing cooling units. Almost instantaneously, snow crystals begin to form as random noise generators provide the soundtrack to this of transformation of matter. The congruence between the irregularities of the tiny crystals and the random attacks of audio "fuzz" is startling, even though we have been inundated with cultural references (white noise as "snow", etc.) pointing at this relationship before, and often took this relationship for granted.

In the East German town of Chemnitz ('"Karl-Marx-Stadt" prior to re-unification) in 1994, Nicolai founded one of the more unique electronic music labels to date, in terms of 'holistic' approach to packaging and aural content: the Noton *Arkhiv für Ton und Nichtton* [archive for sound and 'non-sound'], later consolidated as Raster/Noton in 1999 with partners Frank Bretschneider and Olaf Bender. Nicolai's abiding fascination with mathematics leaks into the design scheme of his releases: the characteristic static-proof bags and translucent clam-shell cases which house Raster/Noton CDs, overlaid with their unassuming and unobtrusive fonts, can seem at times like "crystallized mathematics," as can the deftly mastered music contained within. Ear-hugging stereo headphones are practically a must to experience the scalpel-sharp sounds of skittering static, depth-charge thump and needling ultra high frequencies encoded onto Raster/Noton discs. The label's name, coming as it does from the computer graphics term "raster imaging", has synesthetic connotations to it. As Nicolai explains:

"We were graphic designers... so we had a lot to do with raster points which we were working with on the screen every day, so for us it was a nice idea because the music we did also completely on the computer. And because you can divide the rhythm into rasters, you have units and you can measure."[16]

The Raster/Noton label attitude towards its roster of artists is, however, more flexible than the mathematical and digital façade would suggest – according to Ben Borthwick's 2003 exposé on the label,"... like Mego, it's an artist-run label without a fixed roster, rather, it has a fluctuating attendance around a core of artists who often release across a broad swath of likeminded labels."[17]

Carsten Nicolai's official press releases certainly paint him as being an emissary of synesthetic simulation: his *curriculum vitae* boasts that he is "part of an artist generation who works intensively in the transitional area between art and science,"[18] adding the following:

"As a visual artist Nicolai seeks to overcome the separation of the sensual perceptions of man by making scientific phenomenons [sic] like sound and light frequencies perceivable for both eyes and ears. His installations have a minimalistic aesthetic that by its elegance and consistency is highly intriguing."[19]

Nicolai's host of professional accolades, among them a couple of 'Golden Nica' awards from the Prix Ars Electronica festival, attest to his above-average skill in synchronizing sensory information, sculpting it into forms whose clarity and sense of purpose are not overwhelmed by their cold artificiality (he has occasionally been referred to as a "plastician," a suitable designation given his liberal use of manufactured plastics as contextual framing devices.) Among his more talked-about works are the 1998 installation *Bausatz Noto,* a row of four Technics turntables each adorned by a translucent sperm-white slab of vinyl containing a number of locked grooves. *Bausatz Noto* succeeded on multiple levels: as a merely visual artwork and as a participatory experience, in which anything from one to four patrons could enact a concert on the turntables, no two being exactly alike. The piece contains rhythm both in a musical sense, generated by the interlocking selected by the players, and an architectural rhythm as well, with its even spacing and forceful symmetry. It is the kind of piece that could would turn off fans of rococo eccentricity in an instant, but it can't be that it is beautiful in a sense: by Le Corbusier's definition (*"when a thing responds to a need, it is beautiful"*[20]), *Bausatz Noto* succeeds. If we understand the desire for restraint and clear definition to be a pressing need in a time of perplexing clutter and clatter, then the beauty of

Bausatz Noto follows.

If Nicolai and the Raster/Noton crew are successful in their multi-media ventures, perhaps it is because they place such a high value on phenomenology untainted by political grandstanding and prosaic proclamation of intent. One of Nicolai's stated goals is to erase his "signature" from his creations – paradoxically, the small number of people tilling this particular artistic field guarantees that certain pieces of his may be recognized as "a Nicolai" for some time to come. Still, the graphics, sounds, and even the tactile nature of Raster/Noton releases do not lend themselves to moralizing or politicizing, as Nicolai himself confirms:

"Something that is really important for us, coming from the East, is that we do not inscribe political meaning into the label. Basically, while we were growing up, everything was inscribed with meaning. This is also where these minimalist ideas come from: to prevent it from delivering pre-existing information – in the worst case you would say propaganda – or delivering any kind of existing opinion about the thing and what it is."[21]

Nicolai's statement rings truer the further one dives into the Raster/Noton back catalog: upon listening to a baker's dozen of the label's releases, it is striking how rarely – if at all – human vocals are employed. A personal survey of this label's work has shored up very little in the way of recorded verbiage; with the main exception being a brief monologue from the late John Balance on a track by Ivan Pavlov's project CoH. One could easily say that this is just an extension of a trend already begun by earlier manifestations of electronic dance music, but even the most robotic forms of Techno rely, from time to time, on sampled vocal snippets to 'inscribe meaning': bites of film dialogue permeate all varieties of club-friendly music, their content ranging from the self-consciously 'edgy' quoting of Tarantino movies, to mockery of the hysteria contained in vintage anti-drug documentaries, to amplification of low-budget kung-fu wisdom.

For Carsten Nicolai and his cohorts, though, raw electricity is the *lingua franca* of modern cultural development, and not vocal utterance, no matter how articulate. Although Nicolai is far more involved with computers than Jenny ever was, both Jenny and Nicolai rely on electricity to reach their conclusions about the unitary nature of perceptible phenomena: Jenny worked largely with piezo-electric amplifiers in his experiments, while Nicolai uses a full complement of electric equipment – from the voltage-controlled oscillators and filters on vintage analog instruments, to the now-omnipresent silver Powerbooks and MacBooks. Nicolai's use of electricity as an illuminator, in both the literal sense and a psycho-spiritual one, is evident in his appropriation of Thomas Edison's middle name for his alias, Alva Noto. Under the Noto banner (minus the Alva), one of Nicolai's most novel releases – and one most pertinent to synesthetic study – appeared under the name *Telefunken* in 2000.

Telefunken, a humble little tool for developing image-sound correspondence, embodies many of the more engrossing aspects of 21st century digital art: namely, the chance for a non-artist to complete the work on their own, the possibility for the perceived results to differ depending on variable factors like the quality of one's equipment (Nicolai personally recommends a Sony Black Trinitron TV for best results), and non-interference by the artist himself. The *Telefunken* CD is intended to be placed in a CD player which is hooked up to a television via its S-video and audio jacks; with the audible frequencies from the CD – sounding in a range from 50-8,000 Hz – determining the visual output on the television screen. Anyone who has experimented with video camera feedback by pointing it at its output monitor – creating undulating, vertiginous tunnels of white light and explosive bursts of white flak – will be intrigued by the results. Like said phenomenon, the results also bear similarities to the reality-deforming nature of Op art pieces, striving to escape the confines of the two-dimensional with their insistent 'hyper-visuality'. The micro-sized tracks on *Telefunken* (only a few seconds in length, and thusly to be treated like the digital equivalent of 'locked grooves') have more in common with shortwave radio noises than with anything noticeable to the average individual as "music". To be sure, they are a world removed from the ecstatic and overflowing symphonies of Scriabin (despite the 'Nicolai' which is shared between the two artists), but they do represent a fascinating step forward in the search for audio-visual

congruence. As with Jenny's cymatic experiments, the audible frequencies on *Telefunken* create rippling and strobing patterns rather than mere solid colors, and the work as a whole points at the larger role that machines will eventually play in determining the vocabulary of this language. The concept has caught on well enough that it has undergone several permutations as an installation, finally appearing on LCD flat-screen monitors in 2004. Nicolai encourages us that "the standards of the new technology permit new visual interpretations with the same set-up, expanding the acoustic and visual spectrum of the installation substantially."[22]

The Martian Solution: Kiki and Bouba

All of these tendencies of new electronic music to foster the synesthetic experience are thought-provoking, but they beg the question – where is all of this leading? Will those on the receiving end of these sensory revelations have some distinct advantage over those who cannot train their senses to work in a synchronous way? Would an ability to hear color, or smell sound, distributed among a wider section of the general populace, precipitate a positive change in our daily dealings with each other, owing to a newfound hypersensitivity to our surroundings? It is nice to fantasize about a new humanity whose higher-evolved sensory apparatus contributes to a deeper awareness of, and interaction with, the phenomenal world. With the studies in this field just now gaining recognition as being something more than pseudo-scientific, there is clearly a long way to go. The gulf between inherited and adventitious synesthesia is one problem to deal with; and even among these 'adventitious synesthetes' there is such a formidable difference in social backgrounds, education and preferred artistic style, that developing a normative aesthetics is no mean task. On the other hand, all is not total randomness in this area either. If that were the case, then there would be no international standard for things like warning signs. We could expect, upon traveling to another country, to encounter traffic signals where we "stop" on a brownish light and "go" on a purple one. In situations like these, which require the most urgent attention, some very rudimentary color-sound connections are already in place – televised warnings for incoming storms almost invariably pair high-pitched beeps or whines with flashing red or yellow graphics and text. Such examples suggest that there are already some 'cultural universals' in place, at least as far as the more primal human behaviors (the 'fight or flight reflex,' in the case of audio-visual warnings) are concerned. The challenge now is to apply these connections to far more nuanced forms of information.

Perhaps the easiest justification for further synesthetic study is not that a proliferation of synesthetic experience would change our deeply-ingrained belief systems, but that our abilities to express ourselves across cultures would be increased dramatically. As we progress further into the digital age, new subculture tribes with their own distinct linguistic patterns are popping up with alarming frequency, often bending the syntax of their 'parent' languages as far as it can possibly go without breaking: just the Internet-based subcultures alone, like the snarky and disruptive denizens of the 4chan bulletin board/image board, are so steeped in obscure in-jokes, deliberate misspellings, incorrect conjugations and puzzling neologisms so as to be totally incomprehensible to fluent speakers of 'proper' English (or any language.) All of this seems concocted merely as a means of self-amusement for people with desperately short attention spans and with large reserves of disposable time, side-stepping the usual reasons for a subculture's creation of linguistic deviations (outwitting or confusing the dominant culture, inventing coded terminology for illicit acts in order to avoid punishment.) The existence of such tribes certainly challenges the theory that a networked world will be one of increased understanding between cultures. In the meantime, there still exist spiritually-oriented and non-materialistic cultures like the Jamaican Rastafarians, who have comparatively little to do with computer networks. Although they speak a variant of English, they would no more understand a 4chan subscriber's frequent use of "lulz" to mean laughter than a 4chan subscriber would understand their habit of replacing disagreeable syllables with the letter "I" (e.g. removing the 'ban' from 'banana' and transforming it into "I-nana.") New communicative quirks are constantly arising in order to serve the highly specialized needs of increasingly smaller, non-assimilated culture cliques, and separatism/specialization seems to be the name of the game

rather than the finding of common ground. Having a steadily increasing number of planetary inhabitants who understand each other less and less seems like a surefire recipe for chaos.

When confronted with conundrums like these, we can always do worse than to go to the absolute source, mulling over the various theories of linguistic origins. Dr. Ramachandran is a proponent of what he calls the "synthetic bootstrapping theory of language," which is the notion that

"...language evolved as a result of fortuitous synergistic interactions between mechanisms—called exaptations—that evolved originally for other, completely unrelated functions. It's a striking illustration of the principle that evolution often involves the opportunistic co-opting of pre-existing mechanisms."[23]

Basically, Ramachandran is insisting that synesthesia had a role in shaping language from its earliest origins. To illustrate this hypothesis, he refers back to the now-notorious "Kiki and Bouba" test conducted in 1927 – in this scenario, subjects were shown pictures of a sharp-edged figure akin to a piece of broken glass, and a more soft-edged figure like a pool of spilled liquid. Test subjects were told that, in "Martian language," these two figures represented the words "kiki" and "bouba," and it was up to them to interpret which was which. There was an almost insignificant amount of deviance from the end result, with around 98% of all participants assigning the word "kiki" to the sharp figure and "bouba" to the rounded one. As the 'Kiki and Bouba' experiment suggests, shared perceptions of things lead inevitably to a shared descriptive vocabulary (e.g. a jagged piece of broken glass corresponding to a "ki-ki" sound.) If this theory is correct, then its implications are not hard to imagine: all of communication as we know it comes from making indisputable connections between visual and audible phenomena; of agreeing upon the fact that sharp spikes are equal to "k's" and formless pools of viscous fluid are equal to "b's". We may not all be synesthetes of the first order (until the cloning of genes is upon us in earnest), and not all of us will ever have a knack for Nabokov's inimitable fine-tuning of language. However, we have the tools now to make an astonishing array of art from with which we can re-assess and re-wire our communicative faculties, or just understand how we came to be in our present position. As far as *that* is concerned, it is, more often than not, an essential prerequisite to knowing where we are going.

11.
SILENCE IS SEXY:
THE OTHER 'EXTREME MUSIC'

Parental Advisory: Explicit Quiet

"Burn flutes and lutes, and plug Blind Kuang's ears, and then they'll really be able to hear again." (Chuang Tzu)

"..the lid fell like a feather falling on a mound of feathers..." (Samuel Delany, *Cage of Brass*)

In the summer of 2004, I found myself collaborating on a radio program with sound artist John Wanzel at Chicago's WLUW (on the University of Loyola campus.) I recall a discussion we were having at the time about radio broadcasting laws, and how it was technically illegal to broadcast a small amount of silence, or dead air, during normal operating hours – less than 20 seconds, if I recall. This bothered me, since, by that time, I had amassed a good number of sound recordings in which pieces contained stretches of silence longer than the FCC-allotted maximum amount. Would the intentional silences on these CD recordings really constitute 'dead air'? I figured that it would be difficult to make a case to an FCC agent if complaints really were lodged to the station, saying that the programmers were being negligent and continually, mischievously dropping the volume levels down to zero. It seemed like it would be futile, and a little comical, to try and explain the difference between long, deliberate silences used as an aesthetic element within sound works, and the long silences which resulted from a programmer's absence – fumbling to cue up the correct tracks, or falling asleep on the job. To someone in charge of upholding broadcast standards and practices, what would be the difference between inaction on the behalf of a pre-recorded artist, or inaction on behalf of a live disc jockey? The more I thought about such things, the less I was able to come up with an answer that would satisfy someone unfamiliar with the phenomenon of extremely quiet music. At the same time, I realized how much antipathy there was, in our modern society at large, towards moments of quiet – as if it the quiet individual were counter-productive, aloof, nihilistic, incompetent, or all of these things at once. If silence was viewed as a compositional element, then placing limitations on its use seemed as ludicrous as limiting the amount of distortion contained on the guitar tracks of a heavy metal song. Getting people to view it as a compositional element, though, is no less of a challenge today than it was when John Cage's landmark piece *4'33"* dared to break the non-sound barrier. In a way, it is *more* difficult since the number of sonic distractions in

metropolitan and suburban life have become manifold in the 50+ years since Cage's breakthrough.

One thing is certain, contemporary appreciation of silence is truly subjective, and those who do not appreciate it tend to absolutely, unequivocally *abhor* its presence, viewing it as an aggressive weapon or interrogative device when used in public, social situations. Tales abound of negotiations during the 1980s between Western business executives and their Japanese counterparts, the latter of which craftily used *Ma* (literally 'interval', meant here as an extended period of word-less silence) to fatigue their comparatively loquacious business partners, unfamiliar with anything but instantaneous response, into more compromising positions. More close to home, I recall a handful of instances in which, during moments of protracted silence during telephone conversations, the speaker on the other end would become audibly uncomfortable and would begin dishing out intimate details about other people within our immediate social circle. All it took, in some cases, was a pause of less than 20 seconds to spur on the disclosure of confidential, 'off-the-record' information relating to mutual friends' romantic lives, financial track records, and embarrassing quirks obscured from public sight. This was never actively sought out – yet I found this information was disclosed with disturbing regularity in situations where I was, owing to work-weariness or just brain-dead incoherence, unable to hold up my end of a conversation, yet was not allowed to hang up for reasons of communication etiquette. It was surprising, to say the least, how a raw fear of apparently blank audio space could drive certain individuals to desperation, and to fill this sonic void with whatever was immediately at their disposal. This phenomenon became much more evident to me when, a few years down the road, the explosion in the popularity of mobile phones annihilated moments of private contemplation or internalized dialogue while roaming in public.

It also goes without saying that there are a substantial number of situations in which some, *any*, external noise serves to soothe and comfort: when being jolted awake from sinister and portentous nightmares, it is a relief to have some utterly banal sound pierce the darkness that we lie in, and to jar us out of the hypnagogic terror that would convince us we are alone with the phantasms of our minds. Why, though, do we approach brightly illuminated and decently populated spaces with the same primal fear of silence as we do excursions into isolated, cavernous darkness? When the AIDS awareness group ACT UP chose *"silence = death"* as their rallying cry in 1987, "silence" referred to the mute indifference of communications media and the political class to the existence of a rapidly spreading, mortal disease – yet, twenty years later, this same rallying cry seems to apply to consumer culture's attitude towards *all* forms of silence. It is equated with all social evils from unproductivity to insolence; a nameless void only willfully inhabited by the anti-human.

Silence in the Digital Age

From the 1990s up to the present, there has been an unexpected, curiosity-provoking influx of electronically aided sound artists who make regular use of quiet as a compositional tool. Like much of the other music discussed in this book, pockets of such expression arose with such simultaneity that drafting up a linear chronology of actions would be pointless. The culture seeded by these musicians is, refreshingly, free of ego and of attempts to elbow one's way to the front of the 'public acceptance' line – and therefore no one is really brazen enough to claim they were "the first" to innovate or revolutionize any aspect of the music. Such claims would be met with skepticism and would be viewed as bad form within a culture that de-emphasizes the need for celebrity. Besides, for every musician that we know of through recorded evidence, there may be another who came to the same conclusions years before, and yet was content to keep such discoveries private.

The name of this music changes depending on where the form arises: in the metropolitan regions of Tokyo and Osaka it is referred to as *onkyo* [meaning loosely "sound reverberation"], in Western Europe it has been christened by the journalistic community with the label of New Berlin Minimalism. Others, like Steven Roden, have tried to draw attention to its tendency towards subtlety and near-imperceptibility by referring to it as 'lower case sound', going as far as to refuse the use of capital letters on the artwork accompanying his recordings. I myself would (for lack of anything more universally acceptable) use the term 'digital-age silence', which, unimaginative as it may be,

refs to a characteristic I find unique about this music: its genesis followed the rise of the CD as the dominant format for music storage, as well as all the formats like MiniDisc, MP3, and FLAC [Free Lossless Audio Codec] that followed on its heels. In any of these formats, the introduction of silence or near-silence into the recording can be sharply distinguished from doing the same on a cassette or a vinyl LP: the amount of 'system noise', or the sound being generated by the sound playback equipment itself, is infinitesimally small on a digital format. No form of interference or system noise, like tape hiss or vinyl crackle, is readily detectable, in many cases you would have to place your ear next to the playback device simply to be reminded that moving parts are at work, to hear the restless whirring of the disc or the liquid squelching sound of the laser navigating its way through the tiny indentations on its playable surface.

The makers of this music are spread all over the geographical space of the planet, and even the preponderance of Japanese musicians in the roster does not presuppose Japan as the epicenter of such activity (even though Western media bias occasionally points to it as such, lazily equating 'exotic' Japanese culture with 'exotic' new music.) The means of making the music are also 'all over the map': a wide variety of voicing and tonal color is to be found underneath whatever umbrella term we use for this music. Some use the feedback from audio and video devices as the *prima materia* from which to compose, some use electronically manipulated vocals (the idiosyncratic and occasionally frightening output of Ami Yoshida is a standout in this regard), some use output devices devoid of any conventionally 'playable' transducer (Toshimaru Nakamura's no-input mixer and Taku Sugimoto's manipulation of amplifier hiss), others play a form of computer-based acousmatic music that sounds like the scattering of sonic dust particles.

Flourishes of conceptual humor often surface to combat the misperceptions of po-faced seriousness within this culture. Before the coming of the digital age, there was a rich history of "anti-records" containing little or no sound on them, but acting as comical enlighteners in other regards: it's hard to stifle a laugh when being confronted with, say, The Haters' silent 7" vinyl platter entitled *Complete This Record By Scratching It, Before You Listen To It On Your Stereo,* or The Haters' other contribution to participatory art, the *Wind Licked Dirt* LP. The latter features no grooves at all on the record, but does compensate for this shortcoming by including a bag of dirt in the packaging, which the lucky owner can then use to create their very own Haters' 'performance', rubbing the dirt across the vinyl . Seeing as how contemporary Haters performances involved the band members watching mud dry and staring at blank TV screens, this activity may provide a decent substitute for their live appearances, for those whose hometowns are not included on the Haters' tour schedule. Another "anti"-album more relevant to the present era is the Argentian band Reynols' *Blank Tapes:* a compact disc release assembled solely from the noise produced by, yes, unused cassette tapes. One proud owner of *Blank Tapes* sees it as a multi-purpose object, at once a 'joke', an honestly intriguing listen, and also

"...a subtle attack on the medium of excess, the CD. How many albums need to be trimmed of their fat because the artist felt compelled to fill every millimetre of silver? Now, we're moving into the age of the Deluxe Edition! Not this one, sir. This is a wonderful tribute to the many minutes of negative space that haven't yet been violated by forgettable b-sides and studio flotsam."[1]

When it comes to instrumentation, the incorporation of silence into the music can be accomplished in a number of ways, as well: it could either done through literal inaction, such as not touching a hand to an instrument, or through an action which is borderline imperceptible, like playing constant electronic signals at such high frequencies that they teeter on the threshold of audibility and eventually vanish in the upper atmosphere...only to re-appear later in phantom form through the effects of mild tinnitus; a belated 'encore'. An artist like the Sydney-born guitarist and electronics manipulator Oren Ambarchi – also organizer of Australia's "What is Music" festival, host to many of this book's surveyed artists – reverses the polarity of this trend by using bass and sub-bass tones which can be felt but not always heard. Trente Oiseaux label boss Bernhard Günter shapes electro-acoustic sound clusters of satisfying variance, then mixes the results down so low that ferreting them out becomes more of a personal quest on the behalf of the listener than a mere

receipt of audio information. Günter's more intriguing creations could also be an audio herald of nano-technology to come – the sound of impossibly tiny machines at work, as they float through the bloodstream.

To further complicate things, some artists operating within this silence-enhanced realm will refer to their music as 'improvisation', while others consider it a form of 'composition'. Such partitions can be dismantled very easily, though. Taku Sugimoto, whose work since the dawn of the new millennium has relied more and more on intensified emptiness, suggests that it can be seen as both: "[music] *means neither 'theme and variations'...nor 'chained and dancing'... listen to the sound as it is... there is almost no distinction between improvisation and composition... to accept all the space."* [2]

Returning to the World

Whatever we choose to call this variety of sound that relies on low volume/perceptibility, intense concentration, and reflective pauses, it has to be admitted that it is followed by – at present – a loyal coterie as limited as that which enjoys other ill-defined pursuits like "noise". Those who are hostile to it assume that its motives are purely intellectual ones: like certain minimalist forms of visual artwork, it is assumed to be a cynical, oppositional gesture on the behalf of an incomprehensible intellectual clique, a small cadre of people with such a distaste for the shared human experience that they deliberately cocoon themselves in alienating expressive forms. Others will insist that such sound should be reserved as the plaything of ascetic religious brotherhoods, for those who live deeply internalized lives, wishing for no place in a vibrant social universe and preparing themselves for the ultimate silence of biological death by maintaining strict regimens of wordlessness. Some brave souls, like the Berlin-based guitarist Annette Krebs, have submitted to severe ascetic routines as the inspiration for recording, but such cases are still the exception rather than the norm.

Silence has been used just as much in scenarios of seduction than in occasions where one intended to alienate, to repel, or to make others cower before a display of dominant intellect or spiritual awareness. Although Hollywood films, with their habit of cueing up swells of lush romantic music to heighten cinematic representations of love-making, have increased the appetite for having a musical backdrop to these moments of intimacy, silence still wields an incredible power as a seducer and consequently as an amplifier of emotions. Its ability to create an illusion of time's cessation makes for some of the most intoxicating, intimate moments in the romantic ritual, as does its ability to yank certain bodily processes (e.g. the beating of the heart, and the rhythm of exhalation and inhalation) to the forefront of consciousness. Such things are normally taken for granted or buried beneath the incoming tide of daily distractions. Even the titles of pop songs – see "Don't Talk (Put Your Head On My Shoulder)" and "Hush", for starters – seem to acknowledge the fact that silence carries as much of an erotic force with it as poetic wordplay and gushing verbal confessions. You could always propose maudlin, introspective titles like Simon & Garfunkel's classic "The Sounds of Silence," written in the wake of America's grief over the Kennedy assassination, to rain on this particular parade – but even a song such as this confirms the role of silence in deeply stirring, communal experiences rather than its role as a denier of such experiences.

Interestingly, silence does not end with the music produced by these artists: a certain silence is also evident in the artists' self-promotion (or lack thereof), and in the advanced degree of self-restraint or inaction that accompanies CD releases, concerts, and other supplemental activities. Secondary literature and biographical information becomes an unessential adjunct to the act of recording and performing, especially when there is no stated goal beyond merely transmitting sound and observing as it assumes its place in the daily flux of energy and sensation. Photographs of artists are rarely used in promotional materials (when such materials even exist at all.) Magazine features on the artists and interviews with the artists, when they appear, tend to ignore quirky anecdotes and gossip, going straight for the jugular: the ideas driving the music. There is a greater-than-average desire to *not* see the performer as the 'center' of the music, as Steve Roden illustrates with

these comments:

"The whole thing is not about me as the artist, as the focus. It's about making these things that don't necessarily point back to me as being more important than the work. The art and sound culture right now is so much about the artist, the persona of the artist. I talked to someone recently who said he wanted to be 'the first superstar of noise', without thinking that Kenny G is the first superstar of jazz! I mean, it's not a good place to be!"[3]

With such limited attempts at promotion and outward projection of personae, music of this genre survives mainly thanks to a famished niche audience willing to discover it on their own, and to make old-fashioned, unadorned word of mouth or Internet bulletin board notification act as a highly effective means of information dispersal. This situation is encouraged by some artists, such as the Tokyo duo Astro Twin (Ami Yoshida and Utah Kawasaki) who humbly and humorously describe their music as "...boring sounds/un-evolving sounds/unproductive sounds/lazy sounds/garbage-like sounds,"[4] adding the caveat "each sound is junk, but some may be important. They are for you to seek. We want you to find them...that is Astro Twin's request."[5] When they are found, the surprises are plentiful, and present plenty of challenges to those who expect relatively "quieter" music to be a serene shortcut into easy narcosis: Ami Yoshida's vocal repertoire is a pastiche of drawn-out wheezes, glottal aberrations, focused bird-of-prey shrieks, reptilian slurps and occasional sung notes, all of which are then combined with smooth washes of electronic tones (her other partners in electronic sound have included Christoff Kurzman, Günter Müller and Sachiko M.) for devastating effect. With many of these sonic elements regularly employed within the same short audio piece, the unique 'push-pull' effect of the music – a continuous alternating between erotic attraction and outright alienation – is not something you experience regularly in any art form.

The more well known record labels dealing with digital age silence and the musical micro-gesture, like Bernhard Günter's Trente Oiseaux, rely on a simple design template that is applied to all of their releases: in the case of this label, each new release up until a point in the early 2000's featured no more than the artist's name and title on a textured paper background (the color of the paper changed with each individual release.) The CD *Warzsawa Restaurant* by Francisco López (who relies on a similarly reduced graphic design template for his own releases), bears only minor dissimilarities when placed alongside Marc Behrens' *Advanced Environmental Control* or Hervé Castellani's *Flamme*. The end effect of this common design scheme mirrors, appropriately enough, the aesthetics of the sound contained within. In a desperate panic to find some 'hidden' substance within this sparse packaging, the listener's tactile sense is engaged by the coarse paper of the CD booklets, and – as with the music – the lack of a familiar framing device, the refusal on the artists' behalf to lead the listener by the nose into a world where all is explained, uncovers those perceptible facts which were 'always there'. This extends to how a listener perceives the compact disc itself: in such a context, the bold spectra of color dancing about on the reflective surface of the aluminum-coated polycarbonate plastic disc become all the more vibrant, and the transparent center hole by the larger ring of seems to take on greater significance. These mundane little items become as close as they will get to being perceived as living organisms, rebelling against their status as mere objects. This brings us to the other half of the Chuang Tzu quote which opened this chapter: *destroy decorations, mix the Five Colors, paste Li Chu's eyes shut, and in All-Under-Heaven, they'll begin to see the light again.* My careless play with Taoist ideals here may upset some readers who wonder how a state-of-the-art, technological form of expression can mesh with this largely organic way of life, but closer inspection reveals that the use of digital-age expressive tools is not an automatic disqualification from such a lifestyle. On this subject, I can only defer to Taoist and Zen scholar Alan Watts, who reminds us that

"...the Taoist attitude is not opposed to technology per se. Indeed, the Chuang Tzu writings are full of references to crafts and skills perfected by this very principle of 'going with the grain.' The point is therefore that technology is only destructive in the hands of people who do not realize that they are one and the same process as the universe. Our over-specialization in conscious attention and linear thinking has led to neglect, or ignorance, of the basic principles and rhythms

of this process, of which the foremost is polarity."[6]

Watts goes on to relate the concept of electricity itself – without which very little of the music mentioned herein could be reproduced – to the Tao, noting that neither force can be explained on their own, both are fundamentals only comprehensible in terms of the phenomena which manifest them.

The concept of 'emptiness' in Taoism also takes on a special meaning far from a concept of 'the void' as purgatory or hell. Quite the contrary: Chuang Tzu refers to the "Tao of Heaven" as "empty and formless," a sentiment Fritjof Capra expands upon in his book *The Tao of Physics*: "[Lao Tzu] often compares the Tao to a hollow valley, or to a vessel which is forever empty and thus has the potential of containing an infinity of things."[7] Put this way, we can see "emptiness" not as a terminus point, but as a starting point: we can see silence not as a capitulation on the behalf of the artist, but as an invitation to go beyond sound itself and to experience all available aspects of the phenomenal world. "Empty audio space" has the potential to severely irritate those who expect sound to "explain" something, but for those who go beyond this, the apparent absurdity of making "music" from nothingness takes on the same role as a Zen riddle: illustrating that nature is a unitary phenomenon, a deeply intertwined organism in which every part contains every other part within itself.

Mutual Sacrifice

Like the more violent, droning, high-decibel creations that occupy another wing of the same sonic mansion, this form has not met with blanket critical acceptance. It has its obvious champions in music scribes like *Oceans of Sound/Haunted Weather* author David Toop, but it has also generated a host of skeptics who wonder how, if at all, this music differs from the kind of ersatz 'easy listening' experiences meant to be played in the bath by suburban housewives. Take, for example, this Stefan Jaworzyn review of Steve Roden's first 1993 outing as in be tween noise, *so delicate and strangely made:*

"...hardcore Art it most definitely is – with all the trimmings – the title being a dead give-away, perfectly encapsulating Roden's prissy self-image and tedious modus operandi – fussy, neo-minimalist puffing, blowing, scraping, tweaking and tinkling... ugh... 'experimental' pabulum for New Age sissies. In fact, the more I think about it and the more I listen to it, the more I hate it."[8]

Jaworzyn's impatience with Roden is indicative of a larger public view that digital-age silence is something created by, and for, meek souls: a pandering form of 'relaxation music' camouflaged in the Emperor's New Clothes of inscrutable, 'difficult' avant-garde experimentation. It is sometimes difficult to build a case against such naysayers, when positive reviews of this music make constant allegorical reference to the delicate, transient seasonal phenomena of nature, likening the character of the sounds to that of falling snowflakes, autumn leaves and wisps of summer breeze. Such reviews, unfortunately, do the makers of *onkyo*, 'Berlin Minimalism' et al., no favors when they fail to mention the intense *concentration* of energy necessary for making convincing exemplars of this music. This is something that easily equals the intense *release* of energy inherent in louder musical genres, and cannot be said, on a whole, to be the collective mewling of effete "pussies".

Jaworzyn's dismissals also do little to explain away the fact that some of this book's noisiest players also have close ties with the ever-expanding constellation of 'quiet' artists. John Duncan, though much of his catalog comprises sound of the white-hot, speaker-destroying variety, can still find time to share a collaborative CD with Bernhard Günter. The often demonic Portland noise artist Daniel Menche can also boast of a kinship with Günter by way of a Trente Oiseaux release. The late Koji Tano, who recorded teeth-grinding tectonic noise under the name MSBR, helped to co-organize improvisational performances of an intensely quiet character, when not organizing noise concerts, and penned reviews of such artists for his encylopedic *Denshi Zatsuon* ['Electronic Noise'] magazine. Individuals like Sachiko M, Otomo Yoshihide, Annette Krebs, Ralf Wehowsky, Kevin Drumm and Keiji

Haino (see *Black Blues: Soft Version,* his penultimate expression of strange evanescence, for a striking example) easily bridge the gap between trumpeting loudness and apparent stillness, giving them a special status as sonic omnivores. Even Taku Sugimoto and Steve Roden began their respective musical journeys in punk rock bands, the latter after chancing upon a performance by notorious L.A. synth-punks The Screamers. Like it or not, the number of such people is increasing in the 21st century along with the expansion of the globe's overall population; and those who would criticize them as being 'confused' for playing in more than one mode are sounding increasingly reactionary when they mistake resilience for weakness. In discussion with the cellist and record store owner Mark Wastell, David Toop reveals a valid counterpoint to the 'silence is weak' argument:

"Wastell once favoured Reductionism as a way to describe [his music], although now rejects that. He also rejects terms such as sparse, barely audible, quiet, and fragile, all of which suggest a weakness belied by the powerful impact the music can have on those that hear it. [...] 'A musician is defenceless in this genre,' says Wastell. 'He or she has nowhere to hide. His/her material is delivered with such care and diligence that it cannot be destroyed in ill-conceived collaborations. As Morton Feldman said, 'now that things are so simple, there's so much to do.'"[9]

Terms like 'reductionism' are still a thorn in the side of the new breed of musicians who dare to commune with quiet, since they imply the creators are cantankerous sorts with a hatred of 'busy' music rather than people who merely have a love of building something out of nothing: Taku Sugimoto faces this conundrum by stating that he is an "additionist" rather than a reductionist, starting with a white canvas every time he sits down to play. In his case, this music *is* being set up as an alternative to something – namely superficiality and 'cool' transience – but not for reasons of mere cynicism:

"The most important thing for me is to make something really vertical, something spiritual, like a tower. The whole of the culture is very horizontal, it's surface. We don't really need it, it's just for amusement. Art has become like TV, there's nothing to believe in. We need something spiritual, real culture."[10]

At any rate, you don't need to have achieved the Tao mindset to understand the veracity of Sugimoto's or Wastell's statements: all you have to do is attend a performance of such music to witness the strength this music possesses when done correctly. In Japan I was lucky enough to have access to venues like OffSite and the Uplink Factory, where international showcases of such music were regularly held. Presentation of this music almost requires an unspoken compact between performer and audience, a mutual willingness to let the long periods of silence unfold and ring in the ears without losing nerve or patience – the audience's struggle to impose restraint on their mouths, bodies and portable electronic devices becomes an appendage to the 'main' performance, and in many cases the feeling of sacrifice is also reciprocated between performer and audience: both parties must give up some freedom of movement or communication in order to more effectively immerse themselves in the silences.

While the filling in of blank spaces by feisty audience disruption may have been the intended effect of the famous endurance-testing Warhol films, it does not seem to be the case with this music. Bodily processes that would be completely ignored while grooving to the 120-decibel sounds of a modern rock combo suddenly re-assert themselves in a most intrusive way: a full complement of coughs, sneezes, wheezes, sniffles and general shifting of body parts can arise from the audience and wreck the sonic construction process – and heaven help you if you need to fart or belch in such a scenario. In such a setting, it is almost refreshing to see the 'extensions of man' being checked at the door as well, since the audacious nagging of a mobile phone ringtone will most certainly get you escorted from the performance venue and/or personally lambasted by the performers.

One such scenario is as follows: it is a hushed evening at Tokyo's Uplink Factory, where the Dutch label Staalplaat is hosting a characteristically eclectic evening of electronic music, split evenly between the Netherlanders and locals like the young psychoacoustic maestro Kozo Inada. A wall-to-wall crowd of inquisitive listeners sits cross-legged on the floor of the space, which resembles a well-tended artist's loft: white track lighting shining down onto naked white walls and parquet

floorboards. A couple of lanky Goths in leather accoutrements stand pinned against a far wall, looking on with healthy curiosity, and Staalplaat label boss Frans de Waard is sunk into a leather armchair in the same far corner of the room, trying not to look incongruous as he puffs on a wooden pipe. Smoke from the more conventional cigarettes rises from the floor-sitters' lips and nostrils like a thick swamp fog.

For the current performance, Roel Meelkop's calm presence graces one of the many tables strewn with electronic equipment, the now all-too-familiar silver laptop and portable mixing unit perched in front of him. Formerly of the electro-acoustic trio THU20 and also in the group GOEM, who are to perform later that evening, Meelkop has an above-average talent for warping naturally occurring sound phenomena into electronic particle streams of varying density and vibrance. Like most artists on the bill tonight, there's a dearth of literature available to explain his exact sound construction methods. The unknown origins of this material, and its lack of any desire to clarify such things, make it all the more seductive. Meelkop's performance, while not nearly as challenging to the distraction-starved consumer as Taku Sugimoto's music, is loaded with seductively quiet and ephemeral sound events; distant breezes and clean hovering tones acting as the bridges between portions with a greater 'presence' to them. Just as interesting as Meelkop's computer-generated sounds, though, are the choreographed and humorously self-conscious actions of the audience (which can be seen more easily than usual since the house lights remain on.) People tiptoe across the room and maneuver with exaggerated caution around the patrons still sitting on the floor, while the Uplink bartender delivers drinks to his thirsty customers in hesitant, slow motions, wincing while placing glasses down on the countertop and hoping that this action does not disrupt the show by coinciding with another dive into the depths of silence. Sign language is improvised on the spot, some people even going so far as to draw Chinese characters in the air with their fingertips in order to get a point across. Not every extraneous sound can be suppressed for the good of the performance, though: the air conditioning unit abruptly lurches and rattles to life, or the recurring sound of cigarette smoke being exhaled through pursed lips. Given the airy nature of the sounds Meelkop produces himself, though, these intrusions are actually complementary to the performance – this time, at least, the balance seems to be right. This is not always the case.

Walking Into Midnight

If the audience for the Meelkop show seems appreciative – and they are, as their sincere, beaming faces attest – it is because this is the kind of thing that can be experienced very rarely in one of the world's commercial epicenters. Just a few blocks away from the hermetically sealed environment of the Uplink Factory, the incessant burbling of voices rising from the 'Hachiko' exit of Shibuya Station melts into a cacophony of looped advertisements emanating from loudspeakers and the rhythmic growls and pukings of assorted motor vehicles. The noise itself is too blurred to be instantaneously irritating, unless we consider the unspoken message behind much of it: a fusillade of incoming commands and directives urging lockstep uniformity and punctuality, or at the very least a heightened rate of consumption.

Like Francisco López and his "restless pursuit of nothingness," there is a sense among the Asian 'quiet music' audiences of searching after something that will function as a pause button for their hectic lives and give them more time to discover the multitudinous, exquisite details which normally glide right by them. With life screaming by at Shibuya speed, there really is no time to put it into context, to determine where one fits into the larger scheme of things (or even if 'fitting in to the larger scheme of things' is necessary at all.) It is a quest that expands beyond the world of the audible, as can be discovered in an offbeat travel guide entitled *Yami ni Aruku* [Walking in Darkness]. The author of this 2001 volume, "night hiker" Jun Nakano, dedicates chapters to listening for the 'voice of stones' while on his solitary mountain treks, as well as penning a chapter entitled "The Pleasure of Being Buried in Darkness", and even one dedicated to finding web pages which are no more than darkened screens. A resurgence of archaic values is slowly, but surely, sneaking into the subculture of the hyper-modern citadels of Asia, and I can attest personally that Taku Sugimoto

is not alone as he wearies of "horizontal" culture. Despite its being at, or near, the forefront of global commerce and having a pronounced desire for the transient and gimmicky, Japan still has the world's largest population of citizens aged 60 and over (it also has the world's highest median age), those who might be more inclined towards a less turbulent way of life. There are many others, and not just in the musical realm, who seek a reprieve from modern relentlessness: a reprieve from being nearly blinded by the banks of halogen lights installed in Japanese electronics stores and supermarkets, and from other staples of an "always on" society. Quieting the mind has been the goal of Eastern mystical traditions for thousands of years, but only recently has 'congestion culture' – Asian or otherwise – provided the impetus for non-mystical rationalists to attempt this. While massage parlors and public baths provide adequate stress release for the average work-a-day businessman, other more radical forms of escape are part of the urban landscape, for those who look hard enough: hermetically sealed flotation tanks (or "isolation tanks") filled with warm water and Epsom salts can be found in Manhattan, Chicago, and elsewhere (a website named "float finder" lists a scattered number in the U.S. and along the Eastern coastline of Australia, but no Japanese entries as of yet.) Such methods, largely associated with the hallucinogen-based experimentation of John C. Lilly, have not exactly become popular after decades of public availability – but the time may yet come where congestion culture leads to a resurgence in demand for them.

As could be guessed for a musical culture which is so diversified in terms of its tools, approaches, and geographic bases, not everyone is "of one mind" about how to attempt this either. Different treatments of time provide the most dramatic differences in the quest for mental silence: like Taku Sugimoto, one could simply not play or act where an action is normally expected. On the other hand, you could fill the space around you with some simplistic, yet constant sound element, in order to prevent the mind from wandering off on its endless digressions. *Touching Extremes* editor Massimo Ricci has chosen the latter method, saying

"I used to play Klaus Wiese's Tibetan bowl loops day in, day out at high volume to fight the extreme noise that my neighbors made. It was like living in an aquarium, yet those external noises were somehow silenced and I managed to reach some moment of calmness amidst total mayhem. Now that my surroundings are definitely more tranquil, if I hear birds and wind, or my overall favorite sound – the distant moan of airplanes, which I often quote while writing about certain kinds of music – I can imagine walking a path that could hypothetically lead to a sort of inner quietness, but silence? No way."[11]

Ricci elaborates on his distinction between 'quiet' vs. 'silence' as follows, while explaining his fondness for the drone as an ideal vessel of the former concept:

"What I can say is that static music – the really deep one, not the shit coming from the 'dark ambient' market – is the best symbol of silence. It represents it better than music that includes 'silent' segments, as long as they could be. When I listen to Phill Niblock, god bless his soul, or to something like Mirror's *Front Row Centre* – dozen of tracks, a single majestic drone – that sounds like REAL silence to me. The silence of the mind. When the mind isn't wandering around looking for popcorn reflections about evolution, netherworld, big doors and presumed meditations, but is only blessed by the essential purity of sound, then you've reached what's the nearest thing to silence. All the rest is bullshit – including *4'33"*."[12]

Sensory Overload, Or Information Deprivation?

It might seem odd to be profiling this style of music in a book that also lauds the abrasive, engulfing, sensory overload of Industrial culture – but after scratching the surface, we can come to realize that one animating spark behind both sonic subcultures – a zeal for 'awakening' dormant perceptual faculties in the listener – is quite similar, although the production processes and ideological subtexts may differ wildly. Proper, concentrated use of both noise and silence takes music beyond the realm of mere sound, making it a total awakener of the senses: 'active' rather than 'passive' listening occasionally forces us to fill the moments of vague perceptibility with other kinds of information, be it visual, olfactory, or tactile. Naturally, 'vague perceptibility' could apply to high-volume showers

of white noise in which – like white light – all audible frequencies are contained, as well as to the musical nano-technology of someone like Bernhard Günter; rhapsodies of tiny mechanical anomalies that require close attention to discover.

To illustrate this concept, consider an anecdote from Samuel R. Delany's titanic "city book" *Dhalgren*. In this extended prose poem of penultimate strangeness, characters inhabit a city, Bellona, which seems to be a living entity owing to its mysterious spatial and temporal distortions: twin moons and other celestial anomalies appear in the sky, never to be seen again, or landmarks shift location from day to day. Against this idiosyncratic backdrop, the story's main protagonist, Kid, encounters a former astronaut named Kamp, who relays to him the following about a 'sensory overload' experiment he once encountered:

"They had spherical rear-projection rooms, practically as big as this place here. They could cover it with colors and shapes and flashes They put earphones on me and blasted in beeps and clicks and oscillating frequencies [...] After two hours of fillips and curlicues of light and noise, when I went outside into the real world, I was astounded at how... *rich* and complicated everything suddenly looked and sounded: the textures of concrete, tree bark, grass, the shadings from sky to cloud. But rich in comparison to the sensory overload chamber... *rich*... and I suddenly realized what the kids had been calling a sensory overload was really information deprivation."[13]

Those who have undergone the same experiment as Kamp are meant to sift out specific pre-set patterns from the barrage of incoming sights and sounds, although there is a catch: the test group that Kamp belongs to the 'control group' in the experiment, which did not receive any such patterns, even though they were told this would be the case. Any patterns that Kamp creates are the result of imposing his own will onto this heavily random mass of sensory information. In Kamp's case, it was over-saturation of noise and light that led him to once again see the external world in all its fullness, but this same 'experiment' could be carried out very easily with music of incredible quiet or austerity. Straining our minds to seek out information with which to 'fill the gap,' we are re-introduced to the textures and () which had long been as extraneous information. Kamp seems to confirm the possibility of this by using a visual example:

"Take any view in front of you, and cut off the top and bottom till you've only got an inch-wide strip, and you'll still be amazed at all the information you can get from just running your eye along that."[14]

It is, in the end, just a matter of willfully deciding to do this "cutting" in the first place: we can rise to a newer and more exciting level of contact with the most quotidian occurrences and the most menial objects, but only as active participants, and not as people who expect all incoming information to be presented to us with the simple nakedness of an instruction manual. It will take definite work to overcome years of being inundated with of pop culture trivia and the loud-yet-insubstantial blather of talk show pundits. Thankfully, though, there is music that makes this process seem not so much like 'work' at all. Once the hostile attitude towards it is shed, silence moves from being a yawning void to being a voluptuous substance. Silence, as employed by the artists mentioned here – and many more like them – is not death, but an essential component in the process of revitalization.

12.
FASTER THAN LIGHT (AND CHEAPER):
THE GREAT IMMATERIAL MUSIC DEBATE

The Hafler Trio's Andrew McKenzie is, like William Bennett of Whitehouse, something of a polarizing figure in an underground sound world that the general public is already a little wary of approaching. At least part of this polarization comes from McKenzie's high level of articulation, which some view as sheer artistic pretension designed to establish the 'artiste' as markedly superior to his listening audience (although the practice of artists expecting some input and intellectual consideration on behalf of their audience is hardly anything new, nor should it be discouraged.) Another barrage of criticism comes from alleged cases of McKenzie being a difficult person to share creative space with – the author has heard him referred to by various individuals on the periphery of the 'scene' as disagreeable and callous, a poor person to trust with money issues, and, amusingly enough, a person who once wielded tour co-organizer Jim O'Rourke as a human shield to protect him in a bar fight. While there's no way to attest to the validity of any of this information (which has come to the author entirely by word-of-mouth), the passionate delivery of these hair-raising "Andrew McKenzie stories" does attest to McKenzie's larger-than-life presence and influence. One has to watch their tongue within a community as incestuous and admittedly small as the international sound art community, given the dramatically heightened possibility that hastily spoken words may come back to bite you later. The fact that a considerable number of people on the edges of this culture even bother with these harsh criticisms is something unusual within such a tightly-knit milieu.

All accusations and apocryphal tales of O'Rourke abuse aside, McKenzie is himself an outspoken character, with as much of a talent for vitriolic attacks on his chosen targets as for elucidation on the nature of his sound work. On his website, some personal correspondence with former Hafler Trio/Cabaret Voltaire member Chris Watson is posted in order to lay to rest a rumored non-payment made to Watson from over 20 years ago. And, while commenting on a weblog entry from none other than William Bennett, which was written in regards to a critical panning of Whitehouse by *The Wire* magazine, McKenzie lets loose with barbs such as "[*The Wire*] started out being written by people passionate about a particular form of music, for people who felt likewise. Nowadays, it's hard to imagine a hard-on or even an increased temperature or pulse-rate within miles of any of the writers.[1]" So, perhaps it should come as no surprise that McKenzie weighs in with a particularly passionate NO in response to one of the burning questions of the day: if online sharing and distribution of copyrighted material, specifically Hafler Trio material, is acceptable. Addressing visitors to the Hafler Trio's website in June of 2006, he writes:

"Audio components of all [Hafler Trio] releases are worked on meticulously. More than a quarter of a century of personal experience is involved, as well as that of many years on the part of collaborators and mastering engineers that are used because of an understanding of areas APART and EXTRA from the prodigious technical skills they have. Taking the audio components and reducing them by compression to other formats is first and foremost an unacceptable degradation of the work in question. Not only is the quality of the experience in measurable terms such as frequencies present, spectral characteristics and so on, diminished and irrevocably altered, but the construction of a 'place' where 'something' can happen as was intended is denied. There is no worth in this in any way whatsoever. It is comparable to those who have opinions about world events based on what they read in the newspaper.[2]"

Francisco López has amassed a huge discography over a number of different formats – but he, too, is skeptical of the potential for 'pure' audio to act as an adequate replacement for audio encoded on traditional media. López may not share the exact sonic approach favored by Andrew McKenzie, but he agrees that sound quality is irrevocably compromised by being transferred to the compressed soundfile formats so popular in the file-sharing world:

"To me, 'disembodied' audio files have that potential advantage of detachment from artwork and packaging, which I certainly welcome, not for aesthetic but for perceptive reasons. Currently, however, the new standards of audio quality (mp3s and the like) are a greater disadvantage. Non-melodic, non-rhythmic audio material (like that of most so-called 'experimental' music) is particularly sensitive to the lowered standards. In that sense, the effectiveness of marketing campaigns is astonishing: after a whole century of refreshing sales and enlarging the market by the ceaselessly repeated principle of increased audio quality (from the phonograph to the CD), it has taken just a few years to convince everyone that speed and portability are even more relevant.[3]"

The arguments advanced by McKenzie and López are at least more sophisticated than the alarmist one employed by major record companies: that the illicit copying and sharing of recorded material will eventually bankrupt the companies providing the invaluable, irreplaceable distribution network for this music, thus leaving the artists with no way to ever make a profit off of it, and also with limited capabilities with which to continue making new creative works. However, not content to simply peg Hafler Trio bootleggers, file-sharers and the like as having a poor sense of aesthetics and a limited understanding of the arduous process of making a unique sound work, Andrew McKenzie decides to play the following card as well:

"By 'sharing' fragments of h3o [Hafler Trio] material with others through computer networks and the like, you are denying yourself the possibility of something that can never be obtained through such *reduction of effort to mere data* [italics mine], and you are ruining the chances of such possibilities for others. This is not a 'victim-less crime'"[4].

Continuing along these lines, he says:

"I ask you, the reader of this text, to understand that it is my express wish that you do not copy my work to any other medium, and that you understand that if you do, you are not seeing the intent of the work, as by doing so, you are removing the possibility of the attention needed to 'get' it. You may then, just as well, NOT buy my work. You are wasting your money.[5]"

McKenzie elucidates on this for a few paragraphs before delivering the emotional *coup de grace*, at which point you can practically hear his eyes rolling in disgust when coming across the words enclosed in quotation marks:

"Lastly, you are of course 'free' to ignore all of this, or dismiss it in any way you 'see' fit, rather than actually dealing with some of the rather 'difficult' things outlined above. This, I would pertinently suggest, is your loss, and this saddens me greatly. And only you have the means to perceive what it is that I am saying, to you. I honestly hope you can hear. I wish it with all my being.[6]"

As McKenzie's invective should make clear, the issue of freely trading and downloading copyrighted materials is a sensitive and passionate one within both the mainstream music world and its corresponding underground. Having worked at his craft for well over two decades now, it would

be hard to deny McKenzie his right to speak his mind in this defensive, choleric manner. McKenzie's opinion may also be colored by a string of severe misfortunes that have befallen him in recent years. In 2002, a desperate entreaty for help was made on the Internet after he was diagnosed with hepatitis B and auto-immune hepatitis, and things have not gotten much easier in the intervening years. McKenzie left Iceland in disgust after 12 years of calling that country his base of operations, partially owing to a regulation making it difficult for foreign-born citizens to affordably buy medicines. It's also easy to see where those who struggled for years to financially sustain themselves with their art don't wish to see the returns on that art diminishing exponentially. There *are* definite artistic advantages to not having a day job, to not being so fatigued throughout the majority of the work week that creative work becomes an impossibility – or, at the very least, a 'rush job' which leaves no room for any kind of subtlety or natural evolution of ideas. And yet, having said all this, McKenzie does not speak for the sound art world as a whole. Norwegian noisemaker, graphic designer and label boss Lasse Marhaug, for one, has remained as open to the possibility of online file sharing as he has to most other new developments within the subculture. He has personally posted gigabytes' worth of live performances and other material online – and while an artist without a back catalog as immense as Marhaug's might not do the same, it still stands as a quite generous gesture. Marhaug had this to say about the file-sharing phenomenon:

"It's fantastic – sharing is good, I think. I wish I had had that when I was interested in this stuff in '89-'90 – I had to tape trade with people, and spent a lot of money on postage. Just having more people interested in music, that's got to be good, right? Like, I'll go to Argentina, where people are very poor, but they know all your music – they don't own anything, but have heard everything through downloading. It's great. And I've never made any money selling records. I could make some money doing shows and things like that, but not selling records.[7]"

Marhaug, as with many people who favor some online distribution of sound works, places the onus for this problem squarely on the record company infrastructure itself. Many avid downloaders and file-sharing peers see their activity as a blatant form of revenge on an industry that has inundated a public against its will with, to quote CM von Hausswolff, "their boring pre-fabricated trademarks." Meanwhile, Marhaug maintains that, in addition to the opportunity that this method grants to underprivileged and poverty-stricken music fans, truly resourceful artists will always find ways to recoup their losses:

"The thing is, this is a problem for the record *industry* – this is not really a problem of musicians and composers. But the industry has convinced artists/musicians that this is a problem for *them*. The music industry itself is very young, you know – the music industry as we know it has only been around for 50 years or something like that, while music has been around for thousands of years and is doing just fine. It's the industry which has a problem now – and they had it coming, because if they didn't want people to share files, they should have never gone digital. Artists have many other ways to make their money, it's really no problem. You can also make money from playing shows, t-shirt sales or whatever.[8]"

Marhaug's optimism can be infectious, and it is invigorating for some to even ponder tearing down the corporate record industry while simultaneously supporting the more worthy independent artists. Many who engage in the downloading and sharing of music files are selective in their practices, taking 'for free' only those recordings which they see as being easily replaced, or created by artists whose execrable personalities make the proposition of paying them for their work unbearable. At the same time, these listeners may make a point to reward the effort of their favored artists by buying a physical copy of their work – even if a downloaded version already resides on their local hard drive.

That listeners now have the ability to fully evaluate a product from beginning to end, without having to pay for an inferior offering that doesn't suit their needs, may seem like a novel idea – but in this respect the music industry is just being forced to catch up to something that is already an accepted standard for other industries. Car dealerships, for example, have consented to test drives of their vehicles before buyers commit to purchasing them. And while it is unheard of

for modern record stores to allow customers uninterrupted listening of whatever music they choose from the racks, this *has* been common practice for the more popular bookstore chains. Since the advent of book chains like Barnes & Noble and Borders, comfortable furniture (and, more importantly for their sales, complimentary products like caffeinated drinks) has regularly been on hand to encourage customers' enjoyment of a thorough book browsing. Since the 1980s, regular trips to coin-operated video arcades in Japan have often preceded investment in home console adaptations of the 'coin-op' machines. And, lest we forget, certain U.S. radio stations were also once labeled as 'album rock' stations, 'previewing' much larger portions of new records than record companies' blatant 'payola' schemes would allow for today. Now the 'album rock' station is as much a thing of the past as 8-track cassettes, thanks to the solidification of Clear Channel's sickeningly homogenous radio empire (1,200 + stations and counting.)

Perhaps the rise of 'monoculture' transmitters like Clear Channel provides yet another justification for resorting to music downloading as the ideal method for discovering new sounds – among other controversies regarding its pro-war (pro-'foreign intervention' at the very least), rightist political bias, Clear Channel instituted a ludicrous blacklist of songs after the 9/11 terror attacks. In addition to banning songs questioning the use of righteous military violence as the solution to everything, there was also the inexplicable inclusion of uplifting fare like Louis Armstrong's *What A Wonderful World* and Frank Sinatra's *New York, New York* (not to mention just about anything mentioning the sky, aircraft, flames, and any sort of heightened human emotion whatsoever.) With no proper access to more radical forms of sound, with no radio/television outlets patient enough to deliver the longer tracks characterizing genres of sound art/'extreme music', and without even access to large chunks of the recorded music canon from past decades, downloading and file sharing practically becomes an inevitable course for the hungrier, more discerning music consumer to take.

Peter "Pita" Rehberg, who has not only his own works to be concerned about, but also oversees the Editions Mego record label, understandably wants to protect his investments, regardless of what the political implications are of accessing music for no charge. It appears that Rehberg doesn't take the same tack as Andrew McKenzie (that any form of separating the end product from its intended format will degrade the quality of the work), since a good amount of material in the Mego back catalog has been made available to well-known online outlets such as Bleep.com and iTunes. So, obviously, he is not restricted to a particular medium for releasing his works – but the avid music collector inside of him keeps him from totally embracing the concept of a non-physical form of music distribution. Acquiescing just a little, Rehberg says:

"Well [file-sharing] is an inevitable development, so we have to sort of accept that. But I don't think it's the end of it all. I still like physical products. And as a label, I'm still interested in maintaining physical products. But at the same time, you have to be aware that there are people who don't want to deal with that, and just want to download things.[9]"

Following down this path, Rehberg ends up echoing McKenzie's sentiment that a greater degree of free access to art will eventually erode away at its quality:

"If there's this kind of culture where everything is given away for free, sooner or later there will be no one making music anymore, because artists have to live – I'm not saying they should make loads of money, I know [file sharing] is happening to the main industry because they charge a hell of a lot – and that's why such things as free downloads have happened. And of course, the music industry was caught with its trousers down – the film industry were a little more clever and made it a little more difficult to distribute their product. But with music, as soon as CD-R came out, then one thing just led to another.[10]"

Rehberg also brings up another valid point, that attitudes towards file-sharing and non-physical music distribution vary from one generation to another. As the so-called 'Generation X' comes of an age where it can affect public policy and remake (or destroy) the existing infrastructure around it, the generation on *their* heels already has its own unique methods of music acquisition, which may not be what traditional music consumers expect:

"I'm 38 this year so [purchasing physical products is] what I'm used to. But I know people who are into their 20s or teens, just getting into music, who can't even *comprehend* buying something on a CD. I asked some kid once, a 15 year old, about how he found all the music he listens to on his iPod – he said he found it through computer games. It's become an exclusive thing. That's what kids listen to, the music on their Playstations. Maybe I'm stuck in this old-school way of thinking, that you find out about music by listening to the radio.[11]"

Rehberg is not alone in his observation that music and digital gaming cultures are becoming more and more intertwined. As mass media outlets such as MTV (remember that the 'M' does stand for 'music', after all) de-emphasize actual music content in favor of broadcasting quasi-moralistic social dramas and turgid consumerist fantasies, younger music consumers wisely flock to media that will give them a much better signal-to-noise ratio of music vs. glorified advertising and random distractive blather. Sony Playstations and other home gaming consoles have, since their inception, featured soundtracks composed of songs by popular or emerging artists in the pop, rock, rap and electronica fields. This phenomenon is common enough now to supercede the amount of incidental/background music being scored specifically for use in video games, although the high variance of imaginary environments contained within the games can still provide an ideal arena for promulgating the alien essence of experimental music. Since the more domesticated Industrial acts like Nine Inch Nails began contributing to deep-space shoot-'em-ups like *Quake* in the mid-1990s, video game designers have seen a correlation between the 'reality disconnects' of the games' narratives and imagery, and certain futurist tendencies within experimental electronic music (if only futurist tendencies with a marked dystopian character.)

Online gaming communities provide another choice opportunity for record companies and individual artists to have some product placement: *Second Life*, a 3-D virtual gaming environment developed by Linden Labs in 2003, has become a prime advertising source for, among others, mega-corporations like Sony BMG Music and Universal Motown Records Group. With the game's 'virtual currency' of Linden dollars corresponding to the values attached to real-life currency, these cornerstones of major record label hegemony have not been alone in exploiting the trend of using 'virtual' exposure to sell physical products or services: Dell Computers has a considerable presence in the online world of *Second Life*, as do Disney, BBC Radio, and even some scattered political parties here and there. Live performance has been included in the equation as well as broadcast of pre-recorded music – this can be seen by music performances given by the somewhat unconvincing, polygon-rendered avatars of real-life musicians such as Suzanne Vega. And, with *imaginary* cars being sold for real-life credit within the *Second Life* environment, a phenomenon like this more or less confirms that the Internet has a long way to go before separating itself completely from the materialist mindset.

Second Life has, at the time, of writing, only a little over a million subscribers. This is just over the amount needed to certify a record with the 'platinum' prize for sales, in a recording industry whose cash cow albums usually go double or triple platinum before sales begin to fizzle. But with the fall of major sales outlets like Tower Records (who declared bankruptcy in 2004, and just recently began closing the doors of their most successful stores) the industry has been less cautious when exploring *terra incognita* such as *Second Life*, and all its attendant possibilities for generating some extra profit. And with physical music CDs being consistently reported as a "high risk" or frequently stolen item in the stores that still carry them, record companies can ill afford to ignore an alternative method of conducting business.

Second Life, although it is generating more and more press and steadily securing more subscribers, while seeing everything from educational institutions to pornographers setting up shop within its limitless territory, is still not nearly the music industry breakthrough that the Apple iPod has been. The omnipresent white 'ear buds' and austere design of Apple's digital media player have been taken up by more than 70 million music consumers, and the iPod accessory industry accounts for a few *thousand* third-party companies. The complete iPod package, unlike the now-antiquated portable cassette and CD players that it has vanquished, is an integrated combination of Apple's

iTunes software and the iPod playback device. Individual music tracks are either loaded into an user's iTunes library when ripped off of CDs placed into a computer's CD drive, or added after being downloaded (Apple would obviously prefer that you use their iTunes Store for this purpose, but tracks can just as easily be added after being downloaded from peer-to-peer file sharing networks, or anywhere else in cyberspace.) It's certainly convenient to bypass record stores, not having to waste fuel or public transport money to access them – but the iTunes Store is not without other drawbacks, according to Peter Rehberg:

"I don't think iTunes is the solution, either – it's great that somebody would be looking for my track and they could find it amongst all these other billions of tracks that are on there. But at the same time, I don't like the way that iTunes treats the customers – you can only play [music you've downloaded] on 5 computers, and you're *forced* to buy an iPod; you're forced to buy certain hardware. I like the idea that, when you bought a record, of course you had to buy a record player, but you could at least choose what you wanted to play it on – you could buy a cheap one or a snazzy Bang & Olufsen one. You weren't obliged to buy a certain piece of hardware. Now they're selling you the playback device *as well as* the music, and I think that's kind of scary. I also like the idea of being able to download a file and cut it up or throw it away – with iTunes files you can't do this. You should be able to do what you want with it. Likewise, if you buy a vinyl record or a CD, you should be able to break it if you want. You bought it, you should be able to destroy it! So now we're getting into this whole thing about consumer rights – are we being sold what we want, or what they want us to want?[12]"

Of course, iTunes is just one option for the playback of purely digital media, and, as stated above, no real deterrent to music piracy. Virtually every personal computer sold these days comes with a free media player that can play back soundfile formats like MP3 or Ogg Vorbis. Anyone with an Internet connection and computer speakers or headphones can, if they are resourceful and adventurous enough, experience a broader array of music than any previous generation of humanity has experienced – limited only by the capacity of their hard drives, or the cost of porting soundfiles back into physical form on recordable CDs and DVDs. The truly impoverished may be happy enough just to have this option, and, as Lasse Marhaug has stated above, they show no lack of ability to find the underground streams that flow beneath the overcrowded realms of popular music. It could be argued that these new, much more anarchic methods of music distribution have sprung up not only in response to the avaricious "whatever the traffic will bear" pricing policies of major media conglomerates, but also in response to the failure of these same conglomerates to endorse and encourage radical new ideas in sound. Peter Rehberg agrees that, as stylistic innovations in mainstream music dwindle, technological innovations for accessing music increase:

"I think there's not going to be a revolution in the style of the music, but how people have access to it – that's something which is going to happen soon, or is happening now.[13]"

However, Rehberg stops short of expecting an unprecedented creative revolution in the developing world:

"In the long term, in the overall picture of geopolitics, the music side of it is just a drop in the ocean. People in Sudan or wherever don't give a shit about whether you buy things on an iPod or not, they just want to get some food. So, basically, it's just a Western thing.[14]"

File sharing, regardless of where the files originate and ultimately end up, is an anarchic enterprise, and legislation regarding proper use of this service is difficult to enact. The much-maligned Record Industry Association of America, for example, has little power to control how the products of American record labels are distributed in the Netherlands. This is to say nothing of the fact that, on the R.I.A.A.'s home turf, the number of file-sharers has *doubled* since they first mobilized their legal forces against individual downloaders (some of their litigations were famously unsuccessful, like the court case against an 83-year old grandmother who didn't even *use* a computer.) And even if file-sharing networks weren't being used to erode the profit margins of major record labels – which they most assuredly are – they are still becoming more successful in creating an autonomous, international community than any of the previous musical subcultures

were. The Soulseek file-sharing network claims that its distribution software was solely developed so that independent or unsigned artists could share their recordings with each other without having to pay for web server space, padded mailing envelopes or recordable compact discs. Many do use the client software for that purpose, although a quick scan of certain users' downloadable files can also reveal a decided emphasis on raiding the archives of established record labels.

Although he is an outspoken analog recording purist who, like Andrew McKenzie, sees immaterial, digital distribution as an inferior means of preserving music, recording engineer Steve Albini is no friend of the major record labels and their bureaucratic operating procedures. While addressing recording students at a 2007 lecture at Middle Tennessee State University, Albini was asked his thoughts on both the R.I.A.A. and on file-sharing networks. He began his characteristically damning response as follows:

"The R.I.A.A. is an industry lobby group, and it's almost exactly the same as the toxic waste industry or whatever... the lobbying interests of that group go contrary to public policy for the rest of the world. So, the interesting thing about the file-sharing debate is that it has parallels in every single technological era. When the printing press was invented, and musical scores didn't have to be copied by hand by monks, there was a fear that this was going to cheapen and dilute music, and that the investment that had been made in the musical class would disappear, and the music industry of the day (which was court musicians) would be destroyed. And, of course that didn't happen. Sheet music getting out into the world made it possible for common people to hear music now and again, and broadened and whetted their appetite for music, and it made possible things like sitting orchestras. When the player piano was invented, the exact same argument was used – this is going to allow people to hear music in their *homes*, they're never going to come to a concert hall again. It's going to ruin music."[15]

Albini then applies the same argument to more recent technological developments – the phonograph, radio, and the example of the cassette (which ended up increasing record sales when 'mix tapes' became a promotional tool for generating interest in full-length albums.) Finally coming to the issue of downloadable music itself, he says

"People are being exposed to music that they wouldn't hear otherwise. And it's developing a taste for it, and it's enlarging that audience. I don't know any working band that is opposed to file-sharing on principle, in fact they all think it's great."[16]

Albini makes a joking aside about 'not [personally] knowing Metallica' (one of the most vociferous opponents of file-sharing in the music community), which segues into an exposé of the hypocrisy inherent in that particular band's defensive stance:

"The Metallica position is a really perverse one, because in the early '80s the heavy metal underground had no support... there were no radio programs for it, there were very few fanzines for it, it didn't even have a club circuit like the punk underground did. So metal was deep underground in the '80s, and the first time I heard Metallica was on a copied cassette. So, Metallica's entire early audience was developed by this free trading that they are now so adamantly opposed to."[17]

Albini may be onto something when he slams the major label attitude towards music's production and consumption, and when he suggests that this is a feeble attempt at halting future musical developments. While file-sharing networks do help to reinforce the collective obsession with nostalgia (thanks to the newfound ability to download entire huge out-of-print catalogs of songs ripped from long-since-deleted vinyl records, cassettes and CDs), they have far more potential to develop future culture than mere re-packaged, re-released media hand-picked by a few small planning committees. On the same networks that distribute music, there are also vast archives of transcribed texts and visual data displayed as search results along with musical items that share the same keyword. So there is the potential for unanticipated educational flourishes and minor epiphanies, which neatly dovetail into whatever one is downloading as entertainment on any given keyword search. The "why not... it's free!" justification for downloading, regardless of its shifting legality or its financial impact on copyright holders, does have potential to lead to greater curiosity and experimentation. Add to this the much-touted anonymity of cyberspace (in which people don't

have to sheepishly explain themselves and make awkward rationales for the wild, conflicting diversity of their consumer choices) and there is the occasional possibility that raw ideas will spread like a wind-driven wildfire on bone-dry plains.

Here are just a few illustrative examples of the above: someone seeking out a budget compilation of derivative techno entitled "The Electronic Revolution" might inadvertently download a text file of William Burroughs' seminal text of the same name. Perhaps someone looking for a rising Spanish pop idol named Francisco López (not exactly an uncommon name) will end up downloading huge swaths of 'absolutist', dissipated ambience from the Madrid-based sound artist instead. The same could just as easily apply to John Duncan, Whitehouse or any number of artists whose challenging intentions are camouflaged by unassuming names. What these people do with their new additions is ultimately up to them – and there isn't enough hard empirical data available to determine how many of these accidental epiphanies will lead to further inquiries into the creative spirit. One thing is certain, though – this means of relaying pure ideas has a far greater efficacy than sending out unsolicited emails. Those artists concerned with the institutionalization of their art, and the inability to do anything with it beyond preaching to the converted, would be wise to make a small portion of their catalog – be it text, visuals, or audio data – available for such 'chance consumption.'

Francisco López takes a more guarded view of this, though, insisting that inflated access to information itself is not enough to truly enough to make for better, more attentive listeners – in fact, he believes that just the opposite holds true:

"Today, the rate at which information can be gathered (music, for example) is much higher than the rate at which it can be even just superficially examined. In essence, this is the outcome of the persistence of an obsolete strategy of 'checking out all that is available' at a time when this is by far no longer possible.[18]"

López is often quoted as saying "the act of collecting is one of my worst nightmares," although he has produced a staggering number of recordings. He is, sadly, a minority voice within a wilderness of information addicts, and, having seen a good deal more of the inhabitable Earth than most, he is not entirely unjustified in his criticism of musical completists' naïve assertion that they can successfully take in "everything" and still enjoy it – let alone make a halfway intelligent assessment of it.

It is too early, at this stage in the game, to predict whether or not physical music media will become obsolete. The advent of the iPod, along with the growth in popularity of immaterial music sharing networks and net-labels, has won a decisive battle in favor of the immaterial, but has hardly won the war. As long as any culture exists which prizes the accumulation of material objects as 'status indicators', it's fair to assume that physical copies of sound recordings will also continue to exist. They may do so only to satisfy a need for demonstrating that one's status is demonstrably better than the next person's, rather than because of any audiophile notion of 'preserving integrity,' such as Andrew McKenzie has laid out. Physical sound recordings may be reduced to a role as 'conversation pieces' shown to invited houseguests, or purely decorative/ornamental declarations of one's musical taste – ironically, having the same function as something like a t-shirt with a band's logo emblazoned on it. Even in the age of *Second Life*, with people putting imaginary cars on their credit cards, there is still a deeply ingrained connection between accumulating material goods and being seen as a 'respectable' member of society. And even if this is out of the question, there are still plenty of social networking websites, such as the Rupert Murdoch-owned MySpace, which satisfy this innate desire for hoarding by allowing users to linking to the profiles of as many 'friends' as possible. Seeing users with 'friend collections' upwards of several thousand people, it's tempting to believe that the materialistic 'collector' urge has, like so many other things in the 21st century, reached the absolute saturation point – and that revolt against it can only intensify from this point on. And what will follow that revolt, exactly? CM von Hausswolff has one interesting proposition:

"In the long run, it looks like people will come down with a [music] distribution system that dwells within themselves – the *'aum'* in meditation or the *'iiiiiiiii'* in a tinnitus defect.[19]"

13.
TECHNOMADISM:
TAKING ELECTRONIC SOUND BEYOND THE MASS MEDIA CENTERS

Midway through 2006, I was living north of Tokyo when unforeseen negative circumstances forced me to relocate to a comparatively quiet and isolated sector of the United States. As the reader can probably surmise, the feeling of 'culture shock' was all-pervasive, and led to a sensation not unlike the 'phantom limb' phenomena experienced by those who have lived through the trauma of sudden amputation – I literally began filling in the 'blank' audio-visual spaces of my new living environment with the ephemera of my former one. In more extreme situations, usually before going to sleep, I began relying on various white noise generators in order to mimic the constant mechanized droning of the city: whirring fans placed close to my head, or small portable humidifiers. The most pressing concern, though, was that my geographic isolation relative to Tokyo was going to undo years' worth of 'pavement-pounding' social networking and musical collaboration that took place there. I feared that, even though the Internet offered me the chance to continue functioning as a 'telepresent' member of the electronic music milieu, my limited amount of real face time before friends and collaborators would quickly render me a non-entity.

However, my creative production did *not* come to a grinding halt, and in fact it accelerated significantly due to the changes in certain external factors. It was good, for one, to be in an environment where I could breathe clean air and observe the functioning of nature, while not struggling for a tiny patch of space among 35 million other citizens. A certain degree of loneliness and agitation was inevitable after leaving an environment of near-total stimulation, but this could be alleviated somewhat with email, instant messaging, online exchange of videos and an Internet telephony system which allowed me to have free conversations with any other user around the globe – on certain occasions a friend and I would sync up a film and watch it together in real time, commenting on it to each other and bursting spontaneously into laughter together as if we were sharing the same living room. Things could have been far worse as far as 'isolation' goes, and as far as the promotion and distribution of my music went, there was little difference between Tokyo and my remote corner of the U.S.: downloading of music software applications, delivery of artwork to a CD pressing plant, solicitation of CD copies to radio stations, free public distribution of selected CD

tracks, a PayPal account to receive money instantaneously for CD orders – all of these things were carried out online at no cost (with the exception of the PayPal fee charged for receiving a payment.) Luckily for electronic music of my genre, live performances are not crucial in order to build a base of interested listeners (this kind of music has its roots in the globally scattered cassette trading underground), so there were few, if any, occasions were my physical presence was required. Positive reviews, college radio airplay and other niceties began to flow my way shortly after all these preparations, and for once it seemed like I was receiving a reward in direct proportion to the amount of work I put in. The Internet, for all its myriad flaws and failures, had kept my creativity afloat in what was an otherwise uncertain period in time for me. If it were not for occasional computer and hardware malfunctions, I would have been in a situation where the only limits placed on creativity were meager financial ones (having enough money to continue paying for broadband Internet service) and the limited number of hours in the day. Geographical distance, however, was not the limitation it would have been a little over a decade ago.

It can probably be guessed that my personal relationship with the Internet is, for the most part, a positive one. This could all change in an instant, if some legislation comes along to restrict my access (such as the failed Communications Decency Act of 1996), or if some form of "tiered" Internet comes into existence where a higher income or social standing will allow one access to better information – a kind of Internet 'business class' and 'coach'. Even now, the supposed omnipresence of the Internet is still somewhat illusory, given the vast numbers that do not yet have or want access to it, and the skewed ratio of Internet use in first world countries as compared with 'developing' ones. Ray Kurzweil, the perennial techno-optimist, claims that this is only a temporary trend, and tries to assuage fears that such technologies will be forever subject to a rich/poor divide. Kurzweil writes:

"Such inequality would, of course, be nothing new, but with regard to this issue, the law of accelerating returns has an important and beneficial impact. Because of the ongoing exponential growth of price-performance, all of these technologies quickly become so inexpensive as to become almost free. [...] And if one wants to point out that only a fraction of the world today has Web access, keep in mind that the Web is still in its infancy, and access is growing exponentially."[1]

Kurzweil encourages us that it would take a global totalitarian state to stem Internet advances, and uses the example of embryonic stem cell research as a field where strict government regulation has only served to spur innovation in related areas of research.

In spite of the encouragements of people like Kurzweil, though, Internet use has not completely gained social acceptability in the most modernized regions of the world, nor has it erased the more common social divisions (take inter-generational conflict as one example) with its promise of anonymity, and its ability to absorb the ideas and postures of oppositional cultures without forcing one to come into direct contact with them. The de-centralization and morally relative outlook offered by the Internet are not going to be universally accepted anytime soon, except in the event of an unprecedented homogeneity of human activity offline. If anything, the digital terrain has magnified tensions between the myriad sub-cultural tribes, who have distinctly different strategies for carving out a space of their own within the dominant culture.

The Internet as Squaresville?

The well-heeled socialite and urban hipster, weaned on a sensual, direct, "now or never" ethos inherited from Beat poetry and rock 'n roll, has no stomach for so-called radicals choosing to transmit their manifestoes over a screen and swapping digital audio files of their post-Industrial noise aberrations. The multi-disciplinary artist Vito Acconci is certainly no slouch 'hipster', and has an unassailable track record of production in fields from body art to sculpture – yet he echoes the romanticist sentiments of the rank-and-file Bohemian cynic when he states that

"...the city loses its importance when any person, wherever that person might be, can gather all the information of the city on a computer terminal...The electronic age, while supposedly eliminating boundaries, enforces the image of a person alone at a computer – it enforces images of

single units and separation. The electronic age makes for an easy escape from the mixed crowds of the city; instead of having to go *outside*, a person only has to go *within*, in between headphones and inside an automobile capsule. This resort to privacy is a withdrawal from the peopled places that lead to discussions, that lead to arguments, that lead to reconsiderations, that lead potentially to a revolution."[2]

To be fair, Acconci's comments were printed in 1988, some 7 years before the Internet would (in my humble opinion) reach a satisfactory level of usefulness. He would surely realize that the Internet is now filled with more than its fair share of 'discussions', 'arguments' and occasionally even 'reconsiderations' – just look at the 'user comments' section on any politically-related news dispatch – even if the 'revolution' is conspicuously absent. Although Acconci's remarks do not refer directly to the Internet, they do make clear the limits to the utilitarianism adopted by certain critics of the digital age: something only contributes to the 'greater good' when people are being *visibly, collectively* improved by that 'something' – isolated individuals enjoying a temporary increase in fulfillment of their goals (be they safety from external dangers, or ideological freedom and diversification) is somehow 'bad' because it provides no tactile example with which to win converts to a revolutionary ideal.

Some people will go to great pains to remind the public of the Internet's ignominious beginnings as a refuge for socially awkward and untenable 'geeks'; people who used to hang out in digital netherworlds called "Multi-User Dungeons" or MUDS for short (note that "Multi-User Domain" is an alternate term used by those hoping to avoid the 'geek' stigma.) Anything called a MUD is clearly not, for the 'real world' rebel, "where it's at," and the word 'dungeon' in particular hearkens back to the popular mid-1980s role-playing game Dungeons & Dragons, a sword-and-sorcery paragon of escapist geek subculture. But did this stereotype – that the online community is sheepish and safely ensconced in a middle-class lifestyle – necessarily hold true, even in the days of MUDs? MIT professor Sherry Turkle, in a discussion on MUD politics, thinks otherwise. In relating the stories of three separate MUD users from the early 1990s, she states that her case studies Josh, Thomas, and Tanya

"belong to a generation whose college years were marked by economic recession and a deadly sexually-transmitted disease. They scramble for work; finances force them to live in neighborhoods they don't consider safe, they may end up back home living with their parents. These young people are looking for a way back into the middle class. MUDs provide them with the sense of a middle-class peer group. So it is really not surprising that in virtual social life they feel most like themselves."[3]

One can, like Acconci, call this an easy escape done solely for the sake of convenience, or one can see it for what it truly is: a temporary reprieve from very real threats, which will in all likelihood be phased out in favor of 'real life' when the threat level is diminished.

No New York

Many people feel that, in order to make electronic art that has a reasonable shelf life, and that seeks to comment on man's relationship with machines, computers, etc., they must be as close as possible to a gigantic urban center: some place that is electrified 24 hours a day, where there is never *not* some superlative form of automated or mechanical activity happening. More ironically though, for people hoping to make art with some futuristic or techno-utopian tint to it, is the desire to become fused to the grid of a geographical region's cultural history – to carry on the artistic 'lineage' of that environment. This would explain why the migration of young artists to New York City has hardly abated in the new millennium, despite the anxiety over the city's central position in the 'global war on terror' and the American surveillance state. A recent documentary film, *Kill Your Idols*, details the cultural fascination with New York in particular, and the sensuous, Gothic novel mystique projected onto it by several generations of musicians. The latter half of the film features some truly sobering footage of New York's more recent musical ambassadors: Yeah Yeah Yeahs frontwoman Karen O., in particular, peppers her monologue with so many 'like's, 'um's, and 'you know's that to edit them out

of the film would remove more than half of her spoken part. There is much ground to cover before we arrive at this non-event, though, and much of the anecdotal footage comes from NYC's old guard in the industrial rock and 'no wave' movements: Jim 'Foetus' Thirlwell, Arto Lindsay of DNA, Lydia Lunch and Jim Sclavunos of Teenage Jesus & The Jerks, and Michael Gira of Swans. For Lydia Lunch, New York's magnetizing effect came not from the promise of glamour, fame, or a chance meeting with a television camera, but for the therapeutic effects of finding just a handful of people of a like mind. Lunch regularly admits that the decision to come to New York was a last-ditch defense against some terrible fate such as insanity or suicide, as was her decision to play uncompromising music upon settling there. All was not well, in her reckoning, but it was enough to finally have a forum from which to project her apocalyptic scream:

"It was [sic] desperate, dirty, impoverished times. There was nothing pleasant about the circumstances, other than the fact that for some freak reason, all these freaks had come to New York in order to purge themselves of their specific sickness in a very sick and impoverished environment – and it *worked*."[4]

If there was any 'up' side to this situation, the cost of living in the city – as desperate and dirty as it may have been – was minimal compared to the exorbitant rents being charged in the 21st century. Bob Ostertag, who formed part of the 'downtown' art scene with John Zorn, Eugene Chadbourne and others, recollects that

"When I moved to New York, I rented a pair of storefronts in the East Village for $275 a month – for the *pair*. John Zorn is still living in the building that he and a bunch of his friends bought from the city for a *dollar*. Back then, there were a lot of burned out buildings in the East Village – the city had a program where, if you agreed to take over an abandoned building and 'bring it up to code', they'd sell it to you for a dollar or something like that. And so, people would literally homestead in these buildings."[5]

Ostertag insists that the economic factor, in New York's case, was just as important as the guarantee that 'like minds' would be present there. For those who wanted them, there were employment options available – such as bike messenger jobs – that allowed workers to show up for work at hours and days of their choosing, rather than remaining on a rigidly fixed schedule. More important than this, though, there was the housing issue:

"The crucial ingredient to a vibrant cultural scene is cheap rent. It's not grants, it's not gigs that pay you a lot of money, it's cheap rent. Because if you have cheap rent, you don't have to work very hard to pay your bills, and people can make venues that can just afford to put on crazy stuff, where nobody knows if it's going to be interesting, or good, or whatever."[6]

Lydia Lunch, later in *Kill Your Idols*, goes on to contrast what made that particular idyll 'work' while its successor movements have failed. For the latter, she has plenty of venom to spare:

"It's just so la-de-da, happy-go-lucky, spoiled little brats from the suburbs coming in to start a band *because they can*, which tells me absolutely nothing, shows me nothing new, is not visionary, and is by its very nature and attitude redundant. I think its very sad that, in referencing something that happened 25 years ago, it's not as if there's a revival of the intellectual concepts, the visions, or the diversity, or the extremity of that music – but it's a homogenization, it's a gentrification, and...it's a softening. It just feels soft. It feels... mushy. There's nothing *important* that they're doing."[7]

If the characteristically acerbic appraisal from Lydia Lunch is not enough, there are also the cautionary fables of Swans frontman Michael Gira to act as a further deterrent:

"I literally had cardboard in my shoes for the first couple winters, and I had no money whatsoever. I would do construction work and things if I could find it. One colorful moment was, I was tearing down a ceiling and, um, there was about... a pile about a foot high of dried rat shit on the ceiling, and when I pulled the ceiling down at all came down on me (laughs.) It just seemed like the whole aspect of what I was interested in [about] New York kind of wasn't there anymore and had become something else, uh, pretty quickly. And then I got fed up with that and started Swans."[8]

Of course, the distinct possibility exists that even the hardships mentioned by Lydia Lunch

and Michael Gira now form part of the aspiring artist's romantic fantasy scenario – that 'purification by fire' will provide journeyman artists with the authenticity necessary to truly propel them into the upper echelons of critical acceptance. Herein lies the crucial difference between the impoverished New York of Gira and that of the musicians derided by Lunch: namely, the suffering of the latter was taken on by people who, with their hierarchy of basic needs (food, shelter) already taken care of, could afford to take a gamble on "suffering as journalistic experience" – in the event of failure, they could return to their home communities and regroup until the next strategy for success could be hatched. There would be a certain degree of suffering, but it was suffering with pre-conceived limitations, not suffering compounded by a true fear of not knowing when – or if – it would end.

This suffering is not entirely necessary, as it was in Lydia Lunch's time, merely to find a place where one can perfect one's musical skill. As we've seen already, electric guitars and amplifiers have long since stopped being the only means of blasting out intense and cathartic music, with electronic equipment being compact enough to fit comfortably into even the most squalid mega-city apartment, and versatile enough to lessen or nullify the costs of rehearsal and recording studios. The question of the social factor still remains, though. Erich Fromm wrote in 1941 that "to feel completely alone and isolated leads to mental disintegration just as physical starvation leads to death,"[9] but clarifies with the following:

"This relatedness to others is not identical with physical contact. An individual may be alone in a physical sense for many years and yet he may be related to ideas, values, or at least social patterns that give him a feeling of communion or 'belonging.' On the other hand, he may live among people and yet be overcome with a feeling of utter isolation, the outcome of which, if it transcends a natural limit, is the state of insanity which schizophrenic disturbances represent."[10]

Fromm states that 'moral aloneness' is the condition most to be feared by those hoping to have some connection with humanity – but, as stated above, there is no guarantee that an increase in the population of one's habitat, or its centrality, will also bring about an increase in the population of 'like minds'. In Tokyo, for example, alienation from the city's teeming millions of inhabitants has produced a form of extreme shut-in known as the *hikikomori*, who shuns virtually all social contact and spends an inordinate amount of time sleeping or inactive. Luckily for the afflicted *hikikomori*, the rich variety of Tokyo's vending machines and automats makes it possible to buy sustenance, toiletries and even certain items of clothing without even having to *encounter* another human being. It goes without saying, most people would like to avoid such a profound disconnect, but not all are able to: physical deformity and cognitive disabilities do exist, regardless of their being airbrushed out of the mass media picture. The Internet, although ill-equipped to wipe out deep-seated psychological problems, can at least offer a temporary reprieve: one interesting example of this is autism sufferer Amanda Baggs, whose film *In My Language* depicts the use of telecommunications to 're-humanize' such terminal outsiders.

It should really come as no surprise that certain residents of the mythologized mega-city would rise up in its defense, to counter the Internet's threat to its cultural monopoly. Given the fact that he is a long time New York City resident, rock guitarist/music writer Alan Licht leaps at the opportunity to deride the Internet as an insufficient alternative to direct face-to-face networking. In his mini-book *An Emotional Memoir of Martha Quinn*, Licht writes

"Okay, obviously you're connected to more people, potentially, than ever before, thanks to the Internet. And equally obviously, you're just sitting alone looking into your monitor while you do it. [...] Now that entertainment threatens to be virtually downloadable through a computer, and that literally any kind of shopping can be done on a computer, will there be any reason to go out? Of course there will, but consider this analogy: at one time there was just one town movie theater, which had to cater to a lot of different tastes. At one time commercial TV and radio was the same way. Years ago I saw Martin Scorsese introduce a screening of Jacques' Tati's *Playtime* at the Museum of Modern Art, and he marveled that when he was a kid a Tati film was shown on local television and the next day all the kids were talking about it. Can you imagine a foreign film shown on TV in prime time now?"[11]

There is much to refute in Licht's mournfully nostalgic statement, which is prefaced by silly theorizing about how the introduction of stereo recording was the "beginning of the end" for recorded music, and that "stereo separation, best appreciated in solitude on headphones, was symbolic of The Man's efforts to disperse the 'hippie' movement and helped usher in the Me Decade."[12] This is all part of a larger discourse on how a perceived lack of communalism has destroyed the vitality of recorded music: Licht is also careful to note how many songs in the 1960s counter-culture featured the word "together" on their titles, regardless of whether those songs' content referred to a single romantic coupling or a more politicized, socially organized form of "togetherness".

First of all, it would be interesting to know the net reaction to the Tati film mentioned by Martin Scorsese. Of course "all the kids were talking about it", but did that necessarily imply a desire to further explore Tati's work? The talking in question could very well have been mindless put-downs and derision. Having something simply *available* in a major public forum does not preclude appreciation of it, or even understanding of it, by the masses. It's hard to say without Scorsese's own testimony to back this up, but there is no guarantee that the film performed some socially useful function for its young viewers. Licht mirrors his example of the Tati film with a musing on (of course) the eclecticism of 1960s radio, sighing that back then "a hit was a hit" regardless of what musical genre that hit represented. For a book which spends its first half discussing Licht's impressions of pop music in the 1980s (it is, after all, named after the most popular of the original MTV video jockeys), it's telling that Licht doesn't see the commercial radio of that time as eclectic in its own right. I remember top 40 radio playlists from my own youth, circa 1987, which might feature the lean hip-hop stylings of Run DMC, followed by the confessional synthesizer drama of the Pet Shop Boys, topped off by the laughably dumb heavy metal pep rally music of Twisted Sister. Whether any of this is 'good' music is beside the point – it is music produced by people from a variety of different socio-cultural backgrounds, with an acceptable variety of sounds as a result.

Now, when Licht states that "I generally don't count on broadcast media for entertainment, but I wish I could,"[13] he reveals himself as a nostalgic *and* an advocate of centralism – rather than simply ignoring the dictates of the 'old media' in their entirety and being happy that he can listen to an online podcast of his favorite music, Licht would prefer to live in a world where the podcast was unnecessary, and where monolithic media was just a little more hip (but still monolithic.) Licht is like an atheist who wishes he could believe in God, rather than an anti-theist who rejoices in the fact of God's non-existence (his political opinions in this book also betray a sense of settling for the 'lesser of two evils'.) His thinly-veiled wish for central authority to better reflect his own aesthetics, rather than for central authority to be diminished to the point of uselessness, makes it logical that he would favor a physical mass communications hub like New York City over the fragmented realm of the Internet. But a defensive bunker mentality can arise even a culturally diverse media capital like New York, to the point where 'carrying the torch' of the city's artistic tradition supercedes the need to create in accordance with one's one whims and intuitions. Certainly New York is not a 'closed system', thanks to a continual flow of migration to the city – but when all of the artistically-inclined migrants begin to arrive with the intention of replicating a common 'New York style,' then the result paradoxically becomes a stifling homogeneity – one greater than what may have existed in the smaller communities abandoned for the city. The nostalgic adulation of aesthetics from the recent past – aesthetics which, in the case of New York 'no wave' and other alternative movements, were born out of desperation and alienation unparalleled in recent years – will slowly destroy the allure of the media mega-centers for the true seeker after creativity.

This seems to be happening already, to a small but still significant degree. Urbanism has, after all, never been *totally* synonymous with 'avant-garde'. One has only to look at the 1980s avant-garde's fascination with drawing on the vital creative energies of pre-industrial cultures, synthesizing them with the urban landscape in an attempt to re-animate the duller aspects of metropolitan life: see the "modern primitives" movement and festivals with titles like "Urban Aborigines" (a festival which featured Merzbow and Zbigniew Karkowski among others.) Relocation

and de-urbanization is becoming more common also: even in as 'wired' a field as electronic music, musicians like Coil and John Duncan moved their studios to remote, less populous areas (in the English and Italian countrysides, respectively.) On other occasions, those remote areas have become temporary staging grounds for international summits of new music. One reply form Bob Ostertag on this subject is worth quoting at length:

"There's a town in Italy, Maldova – there's these four guys there who are very into adventurous music. What goes on there is so un-American... it's this tiny little town, and the four guys are from that town, and their number one priority in life is not moving away from their town; they like this little town. There's very little in the way of work there, and there's very little in the way of urban sophisticated culture there. So they decided they would get whatever jobs that would allow them to stay in their town, and they wouldn't define themselves by their jobs – and they'd do creative stuff. One of them's a barber, one of them works in a canning factory, one is the Italian equivalent of an OSHA inspector, and they run this international music festival there. Their 'office' is a desk in the corner of a local boxing club, they have very little money and they think through very carefully who they're going to invite. And, you know, in *America,* if you're from a little town like that, when you turn 35 and you're still there and you're working in a canning factory – that means you're a *loser.* That means you should sit around and drink Budweiser and watch TV all day. A person from a little town like that, who worked in a canning factory, would not imagine himself as capable of organizing an international music festival."[14]

Moreso than providing an example of 'tech-nomadism', Ostertag's anecdote shows how, when armed with just some simple access to e-mail and web browsing, individuals can hold their ground in smaller, more comfortable enclaves, letting the culture typically associated with 'the city' come to them. This can initiate a kind of artistic exchange between the metropolis and the countryside, a creative 'circuit' rather than a one-way flow of creativity to a monolithic, magnetizing urban center.

Antisocial Networking?

By the time Alan Licht had migrated to New York City in the 1990s, there was already something of a cultural safety net in place for him: there was a firmly established audience for the myriad types of music that he performs. Those who are developing completely new forms – like the musicians who comprised the post-industrial tape-trading network in the early 1980s – cannot safely assume that there is *any* local audience for their music in the early stages, even in large cities with an above-average number of novelty seekers. So, all forms of sustenance (financial, emotional, or otherwise) are more easily gained through promotion from a distance – digitally reaching out to the four corners of the world. Even an artist as synonymous with his particular style as Merzbow *still* has a larger media presence overseas than he does within the confines of Japan, and this is after decades of recording and performing within the same Tokyo environs. Creating art that wildly differs from the current vogue is an insurgent undertaking – and just like partisan fighters who use methods of so-called "asymmetrical warfare" to repel a much better-equipped invasion force, artists working with radically new materials (or materials suppressed for long enough a time as to appear totally new) must engage their own "hostile forces" (in this case, a skeptical audience and critical community) using only the minimal means at their disposal. Insisting that artists must rely solely on a "meet and greet" strategy of making themselves visible in the flesh fails to take many factors into account, some of which could intensify the alienation of the artist from any type of artistic community and cease their production altogether. This strategy also implies that an artist's work is only validated by the degree to which that artist chooses to be a social creature, which dangerously conflates the two roles of 'artist' and 'entertainer' in situations where this should not be the case.

To use just one example of this, observe how many music venues worldwide revolve around steady sales of alcohol in order to turn a profit. What happens when an individual or small group doesn't have the disposable income required for several over-priced drinks, the 'fuel' of music club socialization in the 1st world? Maybe the artist *can* part with this kind of money, but prefers not to

drink for reasons of health or moral conviction – or falls asleep from the effects of too much drink just as everyone else's inhibitions drop and the conversation begins to flow more freely, with phone numbers, personal invitations and various expressions of *bonhomie* being exchanged. Any of these situations are enough to destroy one's standing in any given city's artistic community – and still there are other considerations, like not having the 'right' clothes or hairstyle for an evening of socializing. A medium like the Internet allows one to at least transmit music, manifestoes and other digitally-encoded items of relevance before these other irrelevancies come into play, inverting the previous ritual – wherein you are a social creature *first* and *then* an artist. In other words, the ever-important 'first impression' can now be made with the cultural product itself – less time needs to be spent on courting prospective allies and collaborators within the 'scene', and paying one's way into their corridors of power.

No one should be immediately disparaged simply because they choose to convene in a pub or club, and to have that as the salon for their creative development. But by the same token, no one should have to weather storms of ridicule for connecting with their peers via cyberspace, since there are so many reasons for doing this other than mere social ineptitude or misanthropic tendencies. A hybrid solution encompassing both approaches would be ideal, but this will not always be an option available to everyone. Although the tide may eventually turn, the conventional wisdom is that those who 'get out' to 'real world' social forums with high concentrations of people are vastly healthier, more well-rounded, more likable. But is this really the case, or is this a prejudice foisted upon us by journalists and tastemakers who still prefer 1960s-style methods of social organization, whose sympathies lie with the 'New Left' of that day rather than anything applicable to current battles for survival and evolution?

Guardian and *Idler* writer Tom Hodgkinson, in writing a withering critical piece on the Internet social network Facebook, seems to think this is really the case. Given the staunch anti-capitalist tone of the screed that this quote is extracted from, it's interesting to see what institution Hodgkinson defends while assailing the Internet:

"I despise Facebook. This enormously successful American business describes itself as 'a social utility that connects you with the people around you'. But hang on. Why on God's earth would I need a computer to connect with the people around me? Why should my relationships be mediated through the imagination of a bunch of supergeeks in California? What was wrong with the pub?"[15]

At the end of the day, even an aesthetically unpleasing and advertisement-encrusted Internet social network like MySpace or Facebook is 'what you make of it', and although MySpace may be a major component in the neo-conservative media empire of Rupert Murdoch, one really promotes Murdoch's social agenda by having a MySpace account as much as they would be promoting corporatism by merely wandering through the skyscraper district of Tokyo. Obnoxious advertisements and links to other dubious sites abound, but such things have always had their analogs in the urban landscape: in either environment, it is the individual's imperative whether or not to give these intrusions any real power. There is also a huge number of people already signed onto these social networking sites – the story might be different if there were just a few thousand souls trafficking these networks rather than tens of millions. A large number of the musicians profiled in this book, from Throbbing Gristle to Russell Haswell to Negativland, have even set up accounts at one or more of the major online social networks with no loss in the integrity or quality of their artistic product, nor with any neutering or 'dumbing down' of their critiques. A number of artists and individuals with anti-State, anti-corporate agendas have also chosen to 'squat' these social networks, despite the possibility that information on their insurgent activities will be very easy for the authorities to document and track. With the preponderance of electronic surveillance equipment at physical sites which are targets for protest and insurgent action, is a statement of defiance really *that* much more dangerous online?

In saying "*why on God's earth would I need a computer to connect with the people around me*"?, Hodgkinson is missing one of the main points of Internet networking in the first place – that it is to establish connections with people *beyond* your immediate geographical confines – not just

'around you' – given that you should find local people's company unsatisfying or impossible to maintain, for whatever reason. Hodgkinson's full wrath, though, remains focused on the potential of Internet social networks to accelerate the full-spectrum dominance of advertising culture:

"Sign up to Facebook and you become a free walking, talking advert for Blockbuster or Coke, extolling the virtues of these brands to your friends. We are seeing the commodification of human relationships, the extraction of capitalistic value from friendships."[16]

Unfortunately for Hodgkinson, advertising culture has long since been entrenched in his beloved pubs, and suggesting that advertisement saturation of 'virtual space' is more intense or threatening than that in the 'real world' is, at the very least, debatable. Bars, night clubs and other adult social spots – even those geared towards more minority or alternative predilections – are rife with advertising detritus, from drink coasters to signage above toilet stalls to the messages which pop up on the 'Internet jukebox' when patrons are downloading their favorite tunes. In fact, the type of 'viral advertising' I have encountered in drinking establishments over recent years has been more insidious, and for products more harmful to my health, than the annoying yet easily dismissed advertisements on the Internet social networks. I can recall at least one occasion in an urban American bar where an attractive woman would sidle up next to me at the bar and pretend to be showing genuine interest in me, as a potential 'date' for the evening, before using some tacky phrase like ("you know what would make this evening truly special...") that revealed herself to be a pitch woman for vodka or cigarettes. This type of intrusive and parasitic advertising has been phased out in more recent years – perhaps after being lampooned on an episode of *The Simpsons* – but it is still more ingeniously rude than anything I've yet encountered on the Internet (save for unsolicited, atrociously spelled spam emails warning me that I must increase my cock size, but those have little connection to the world of Facebook.)

Hodgkinson's unimaginative solution to all this is merely to pull the plug, to "ignore it and it will go away" – but making a statement about how authentic one is by not participating in an online social network can be a very drab, Puritanical gesture: that is to say, *not acting* when some kind of action is encouraged (and, in the case of the major online social networks, when the action is completely free of charge.) This kind of gesture reveals far more about the self-righteous vanity of the 'refuser', who cannot pull the plug without turning it into a grand proclamation of individual sovereignty, than it does about the inherent flaws of the corporate culture they seek to criticize. The opportunities for critiquing are actually far richer when working within 'the system' itself. Which is more memorable: a musician's refusal to receive a music prize on a TV award show, on the grounds that accepting the award shows complicity with the agenda of the award show's corporate sponsors? Or that same musician staging a piece of guerrilla theater during the award acceptance, culminating in a live, uncensored condemnation of those sponsors' unethical practices? Given the fact that the media would likely not even report on the non-appearance of the musician, but would have a considerably harder time editing their performance out of a live broadcast without raising some eyebrows, I would go with the latter.

As in the previous discussion of the cheap rents in 1980s New York, the issues of artistic promotion and survival cannot be separated from economic reality. It is a sad feature of post-Industrial culture, and music in particular, that the owners of more expensive equipment, or those who employ more expensive/time-consuming networking and promotion strategies, claim to have an exclusive right to cultural legitimacy. As the logic goes, you deserve to have more renown if you have invested more capital into the culture, or into 'supporting the scene' as it were. This hierarchy is seen at every stage of production and consumption: large-grooved vinyl LPs are necessarily 'better' than CD-recordable releases and downloadable net-releases, a keyboard synthesizer has a 'fatter sound' than a cheaper software emulator of the same synth engine, etc. This sets up a false equation of "capital investment = creative effort," which has become especially dominant in electronic music, but becomes less and less relevant as technology becomes more open source and accessible. Still, this has created another rift between those who use the Internet as their main communicative mode, and those who 'pound the pavement'. As the logic goes, the Internet

networkers, owners of net labels, and the like have not "paid their dues" and are taking an unfair shortcut to cultural recognition. This is also false, since many net-based artists have been active in the 'real world' for decades and are merely using the Internet to consolidate previous gains, or to clarify positions that have been held since their debuts as artists. The Zero Moon net label, for example, collects long-unavailable releases from stalwarts of the tape-trading underground and re-releases them through their own site and through the archive.org portal. The somewhat more intense and transgressive Radical Matters net label from Italy does the same, while also using the free releases as a supplement to more painstakingly hand-crafted 'art edition' physical manifests. It is an interesting business strategy, which combines both the immediate gratification of downloadable music with the "from me to you" directness and honesty of small-scale artisanship.

The "Internet vs. consensus reality" dichotomy is rapidly becoming an annoyance, not the least because it is an emotional wedge issue diverting energy from much more pressing matters. Especially amusing is the number of pundits who use Internet message boards as a pulpit from which to preach the merits of 'real life': Andrew Keen, author of an alarmist screed entitled *Cult of the Amateur,* rails against 'blogs' and the omnipresence 'user-generated' media while himself being an avid blogger, with a digital version of this book published for use on Amazon.com's 'Kindle' digital reader in spite of Keen's pronounced digi-phobia. Among other things, Keen represents an elitist faction who believes that the only acceptable content being generated is coming from those who receive payment for their efforts; he repeatedly demeans those who do otherwise as "monkeys." At the time of writing, Amazon customer reviewers have given the print edition of Keen's book a whopping 36 "one star" reviews and 18 "two star" reviews, out of a total 97. Keen's frequent appeals for more government regulation are telling, and all hopes of his journalistic neutrality are dashed when we learn that he is also a regular contributor to *The Weekly Standard* (the house organ of neo-conservative overlord William Kristol, co-founder of the unabashedly imperialistic Project For a New American Century.)

Like Alan Licht and his desire for better commercial radio, Keen mourns the fall of another paragon of centralized culture: in this case, it is the music supermarket Tower Records. Once touted as an exemplar of "cool capitalism," pundits like Keen point to Tower's demise as the inevitable result of file-sharing networks and random online noodling. Never mind the fact that, in a worldwide economic slowdown, people did not have upward of $20 on new CDs. But for those of us not ensconced in privileged positions like Keen, this loss is hardly worth shedding tears over. As one reviewer of Keen's book notes:

"Keen laments the passing of specialist record and book shops like Tower, whose 'unparalleled' and 'remarkably diverse selection' will be lost to us for ever. Clearly he's no online shopper then, since dear old Amazon would lick all of them put together – but Amazon, he says, lacks the dedicated expertise of sales assistants that could have stepped out of Nick Hornby's *Hi Fidelity.* Except that it doesn't, since it has literally millions of them – people like you and me – who can offer our tuppence worth, gladly and without thought of recompense."[17]

In lamenting the loss of Tower, Keen also betrays his metropolitan bias, glossing over the fact that some 50% of humanity – the amount not living in areas recognized as officially urban – have *never* had access to shops like Tower, and so are hardly going to be lamenting the passing of music supermarkets when the Internet suddenly connects them to shops with vast archives of downloadable music, to say nothing of peer-to-peer file sharing networks or the aforementioned net labels. Even with access to slow, patience-testing, dial-up connections, residents of suburbia and rural regions can not only seek out an unprecedented variety of recorded music, but can digest it in an environment not yet corrupted by a hierarchy of commodity fetishist "hipsters". Once again, it seems like nothing more than pure jealousy fuels the ire of people like Keen: the "paid my dues" syndrome is clearly at work within *Cult of the Amateur* and its many sister publications, a bitter reluctance to share one's cultural playthings with others who might put them to a creative use not intended by those currently holding the monopoly on their interpretation.

Keen, the well-groomed British society man, perhaps just doesn't understand the concept of

working with whatever tools are available, and that citizens of troubled, struggling territories will use them without a 2nd thought for their 'authenticity', exploiting the anonymity of the Internet in much the same way that illegal carbon-paper *samizdat* reproductions of banned literature were created when 'authentic' mass-market editions could not be obtained. The type of radical electronic music discussed in this book has already infiltrated the city centers of countries that were previously barred access to it, whether for reasons of poor economy, oppressive regimes, or both. From the Baltic countries to Turkey, festivals and symposiums of electronic music – and not just glorified disco parties – are appearing at a surprising rate (Istanbul's 'ctrl/alt/del' festival being one fine example of such.) The 'AudioTong' organization in Krakow shows a remarkable capacity for putting on concert events despite receiving only the occasional PayPal donation for their online releases, while mainland China sees an explosion in low-key soirees of electronic music and even local production of novel instruments, such as the Beijing duo FM3's tiny "Buddha Machine" – a walkie-talkie sized sound looping device championed by, among others, Brian Eno. FM3's Christiaan Virant also claims that

"since [2004], the number of electronic musicians and bands [in China] has doubled, or tripled, and there are just hundreds of kids out there playing all kinds of weird stuff. Noise is a big influence of many electronic musicians, as is breakcore, which has a strong representation in Beijing. It's just such a big country and so much is happening now that it's hard to give an overall picture."[18]

Clearly new cultural flashpoints are now appearing at a rate too quickly to be collectively extinguished, with the need for simple creation and communication trumping the need for institutional acceptance and monetary gain – by the time something with an extinguishing power *does* come along, we will assuredly have much greater problems to worry about than trivial bickering over whether or not the typical suburbanite or 'developed world' citizen values 'high culture' as well as a metropolitan 1st-world dandy does.

Interstitial Insurrection

The cutting edge of art, for at least a few decades now, has been far more concerned with exploring the 'interstices' between dualistic forces rather than wholeheartedly embracing dualistic concepts – so a return to misleading, contestable concepts of 'inside' and 'outside' seems like an unnecessary retreat, disregarding just how ductile machines and computer interfaces have become. Not to mention that people who construct such dualities reveal themselves to be slightly hypocritical when damning the binary zeroes and ones of the digital terrain.

All of this points, sadly, to the savage competition that can exist in a milieu such as electronic music, in which thousands of creators jockey for only a handful of financially rewarding positions and hard-won, ego-gratifying media coverage. The culture of electronic music is one in which there is a much higher ratio of producers to consumers than in other artistic fields, and when these producers fail to innovate or make some lasting contribution to the collective body of sub-cultural works, then it is tempting to run to "authenticity" for refuge, insisting to all who will listen that "real life" experience distinguishes music project 'x' from the plebeian horde of shut-in laptop jockeys. As Sherry Turkle says, though, "the virtual and the real may provide different things – why make them compete?"[19] Elisa Rose, of the Austrian net-media collective and pleasantly hallucinogenic techno band Station Rose, echoes this sentiment, suggesting a symbiotic relationship rather than one that parasitizes an individual's ability to interface with life at a flesh-and-blood level:

"...the more [Station Rose] did on the net, the more invitations we got from the real world. The time we spend out on the road equals the time we spend indoors, now. We couldn't have expected such a development 3 years ago. All that can coexist simultaneously. I believe that cyberspace and the real world relate to each other in jealousy and love."[20]

Last but not least, cultural theorist Jean Baudrillard also rejects the division between the two polarities of real and virtual, while going a step further and proposing that "'the real' has only ever

been a form of simulation."[21]

Baudrillard is correct to suggest that a supposed consensus form of reality is no less deceitful than what we experience in the "virtual reality" of cyberspace. Reality, just like the Internet, gives the creative mind the opportunity to retreat into a controlled social environment, providing an illusory sense of one's one worth in the grand scheme of things. Referring back to my own artistic development, I would regard my college writing studies in Chicago as one of the most unproductive periods in my creative life. Being constantly encouraged and reinforced by like minds, and by an implicit "any output is good" approach from most of the teaching staff, the result was, predictably, reams of turgid and self-indulgent garbage. In such a coddling environment, a single negative review could be enough to shatter one's nerves for weeks and to shut down the production line for an unspecified period of time. Compared to this, the unmediated nature of the Internet – which is a raging inferno of contradicting opinions compared to the incubating environment mentioned above – provides a much wider scope of criticism and challenge to the strength of one's ideas, for those willing to accept it. No one is risking loss of salary or professorial tenure by telling you that your music is a poor 3rd-generation facsimile of some superior production. Nor do advertisers' or other intermediaries' feelings need to be taken into consideration before a critique is made – such freedom from academic or corporate censorship is becoming increasingly scarce, and any opportunities to circumvent it should be pounced upon.

Conclusion

"At the stage we are at, we do not know whether technology, having reached a point of extreme sophistication, will liberate us from technology itself – the optimistic viewpoint – or whether in fact we are heading for catastrophe. Even though catastrophes, in the dramaturgical sense of the word – that is to say, endings – may, depending on the protagonists, assume happy or unhappy forms."[22] (Jean Baudrillard)

It may seem odd to conclude this book, after exhibiting serious skepticism of utopian ideals, with a resounding vote of approval for something like the Internet – itself often used as irrefutable evidence that 'human nature' is changing, and that we are on the royal road to a final phase of history in which we will all be free, by virtue of our newfound cultural dissolution. In reality, I do not harbor any illusions that the Internet, or any technological apparatus waiting in the wings, will 'remake' or 'revolutionize' humanity to the point where it will no longer be recognized as such. Nor do I have the same adamant conviction as someone like Ray Kurzweil – who believes technology will alleviate all human wants before the mid-point of this century – or Extropian high priest Mark Dery, who believes that technology will provide an "ejector seat" catapulting us far away from ecological concerns. Personally, I feel that the musicians and artists who use such tools as the Internet do so not for utopian ends, but primarily for the survival of their ideas in a hostile or indifferent climate. They seem much more concerned with securing a relatively autonomous space for themselves than with using the Internet to lay the groundwork for any revolutionary "takeover" of orthodox societies. There is now an intense privatization of public space, and increasingly complex security screening systems designed to keep populations homogenized even within malls or shopping centers. With the cards stacked against them as such, telling counter-culture dissidents to avoid online networking and to embrace only physical space would be like telling water not to seek its own level.

When we read Utopia as a condition of finally getting what we really want, it is likely to also be the end of what we collectively were before this singular revelatory moment: something noted by an author as familiar with the culture of the 'virtual' and 'posthuman' as Bruce Sterling, who rejected technological Utopia as "a synonym for Oblivion."[23] We finally obliterate those qualities in ourselves which we sought to destroy, but in the process become creatures with whole new sets of problems which, even though unpredictable, could just as easily recycle the discontent and boredom of previous incarnations. Another perspective suggests that technological advancements of any kind

are not an automatic precursor to the dramatic re-wiring of a culture's deeply entrenched beliefs, especially those of a religious character. Anti-Utopian political philosopher John Gray also noticed a curious fact:

"According to the standard, social-scientific theory of advanced, knowledge-based societies, America should be following Europe in becoming steadily more secular; but there is not the slightest evidence for any such trend. Quite to the contrary, America's peculiar religiosity is becoming ever more strikingly pronounced."[24]

Communications advances like the Internet, in Gray's reckoning, do not produce a "convergence of values",[25] and in fact cause societies to drift further apart from any kind of universal ideal – even if the visual homogeneity of characters in virtual environments like Second Life may make it seem otherwise. I suppose that even my "tech-nomadic" use of the Internet as a tool for music promotion has not really earned me any converts, as such, but it has revealed me to a wide body of people already predisposed towards this kind of music, yet previously unable to access it. The Internet has certainly 'globalized' the culture of the outsider or the marginalized, and makers of radical forms of electronic music are nothing if not marginalized for their creation of something too 'weird' to fit into the more mainstream teleological narratives of the day. I do not see this global linking of entrenched outsider cells as the forming of a revolutionary army, but at the same time I have difficulty dismissing it as *not* a good thing. This culture more often than not accepts the eclecticism, and even the chaos, of both human and natural life as the raw material for its ongoing creativity, simultaneously rejecting totalitarian concepts of 'The One' (be that a single deity, race etc.) that have brought about so many of humanity's most nefarious disasters. There no longer needs to be one imperial hub of activity towards which all the earth's artists migrate, one self-contained 'scene,' or one culture guru who rests atop a pyramid of subordinates. Such a pervasive "multiple choice" creative environment may give new cultures the opportunity to develop at a speed beyond many people's ability to readily comprehend their meaning or motives, but at the same time this speed of development may finally outpace the ability of heavy-handed militaries and secretive governments to fully destroy and subdue these efforts.

The emphasis on "exchange of ideas" within this culture also seems to suggest a rare phenomenon: people who are willing to occasionally have their own minds changed rather than to rely on certain beliefs of theirs as irrevocably fixed and universally applicable. The more people who get caught up in this cultural flux, the greater the number of people involved in such 'socially useless' enterprises as trying to engineer more palpable, fluid or mysterious sounds. This in turn means a greater number of people who have diverted their time and energy away from empire building, suicidal fundamentalism, solipsistic materialism, and other regrettable by-products of our common era. To date, even the most violent exponents of the sonic underground – Whitehouse, for example – have caused little in the way of real terror to put them on a scale with the ideologues whose columns fill the most widely-distributed newspapers, magazines and weblogs in the world, and who have routinely maintained that the world's elite power players must win 'hearts and minds' by exportation of brute force or by corporate hegemony. In a climate such as this, withdrawal to contemplate the unknown (often without any care as to whether that 'unknown' becomes more comprehensible or not) is the new radicalism in a world where spectacular missions and crusades more often than not end in mass alienation and the expansion of divisive hatreds. Pure enjoyment of the creative process, or the 'power of play' is another such radical act, recalling William Gibson's famous quip about the Internet: namely that it is "a waste of time, and that's exactly what's right about it."

It would seem that the electronic music culture's embrace of the Internet is just the solidification of tendencies which have incubated within it for the last 25 years or so: the developments within both electronic music and virtual life finally blur to the point where it becomes difficult to tell which is animating and inspiring which. The hallmarks of both cultures are essentially the same: resistance to inherited modes of social stratification, subversion of the uniform, 'one size fits all' nature of machines and technology in order to make unique comments about one's own

individuality or relationship with the biosphere, refusal to see something as without value because it was obtained "for free" or without lavish packaging. Both cultures have also refused to seek or implement consensus on a large scale, and have advanced by exploring an inexhaustible range of uncertainty and doubts, rather than believing in the possession of elite knowledge that must be shouted down to the unenlightened rabble below. If all of this interest in individual, 'lone wolf' creative activity, experimentation informed by skepticism, and rugged self-sufficiency does end up dramatically changing the media landscape in the end – dealing a grievous blow to the culture of the fake – it will have done so because of a superior dynamism and resilience. Such qualities have been used in the past, to astonishing effect, against vastly superior mobilizations of human and financial resources, and they can be used again. The 'micro-bionic' creative approach may not survive an uncontainable plague, or a horrific inter-continental exchange of weapons of mass destruction. In most other scenarios, though, it will flourish to a mature state: no techno-utopian 'Singularity' or New Jerusalem, but a riot of beautiful, continuously morphing, and dendritic sound to light our days.

NOTES

1. RESISTANCE OF THE CELL

1 Genesis P. Orridge, "Re: AOL." email to Ashley Crawford, January 18, 2000.
2 Genesis P. Orridge quoted in *Wreckers of Civilisation* by Simon Ford, p. 9.6. Black Dog Publishing Ltd., London, 1999.
3 Genesis P. Orridge, review of *Resisting the Digital Life. Amok Fifth Dispatch,* ed. Stuart Sweezey, p. 16. Amok Books, Los Angeles, 1999.
4 *Ibid.*
5 Genesis P. Orridge, interview with *Budapest Pod,* 1998 – unpublished.
6 Marc Almond quoted in *Tape Delay* ed. Charles Neal, SAF Publishing, Middlesex 1987.
7 Klaus Maeck quoted in *Naked Lens – Beat Cinema,* ed. Jack Sargeant, p. 204. Creation Books, London, 1997.
8 William S. Burroughs, *The Electronic Revolution* cassette. Aloctone, Lisbon, 2002.
9 *Ibid.*
10 John Balance interviewed on VPRO Radio, Amsterdam, June 18, 2001.
11 Francisco López, *Towards the Blur.* Reproduced online at:
 http://www.franciscolopez.net/aphorisms.html
12 interviewed by the author, December 2007.
13 Genesis P. Orrdige, *Answering a Question: TG and Punk,* unpublished essay, 2000.
14 Guy DeBord, *Theory of the Dérive.* Reproduced online at:
 http://library.nothingness.org/articles/all/all/display/314
15 Moritz R quoted in *Verschwende deine Jugend,* Jürgen Tiepel, p. 87. Suhrkamp Verlag, Frankfurt am Main, 2001. Translated from the German by the author.
16 Steven Grant and Ira Robbins, Throbbing Gristle entry in *Trouser Press Record Guide* 4th edition, ed. Ira A. Robbins, p. 677. Collier Books, New York, 1991.
17 refer to 13 above
18 transcript of Laibach *TV Tednik* interview, reproduced at:
 http://www.nskstate.com/laibach/interviews/laibach-interviews.php
19 Alexei Monroe, *XY Unsolved: NSK And Encrypted Culture,* reproduced at:
 http://www.nskstate.com/appendix/articles/xy_unsolved.php
20 Alexie Monroe, *Interrogation Machine: Laibach and NSK,* p. 244. MIT Press, Cambridge MA., 2005.
21 *Ibid.*
22 Laibach quoted in *Interrogation Machine: Laibach and NSK,* p. 256. MIT Press, Cambridge MA., 2005.
23 Laibach quoted at: http://www.nskstate.com/laibach/interviews/excerpts-86-90.php
24 refer to 22 above, p. 53.
25 Genesis P. Orridge, interviewed by MOJO magazine 2001.
26 Andrea Juno quoted in *Pranks!,* ed. Andrea Juno and V. Vale, p. 34. Re/Search, San Francisco, 1987.
27 interviewed by the author, February 2007.

2. LIBERTINES OR ASCETICISTS?

1 The New Blockaders, liner notes, *Epater Les Bourgeois* 7" single, NOP Records Japan, 1992
2 *Ibid.*
3 *Ibid.*
4 Otto Mühl quoted in *Atlas Arkhive Documents of the Avant-Garde 7: Writings of the Viennese Aktionists,* p. 101 – Atlas Press, London, 1999
5 Luigi Russolo, *The Art Of Noise,* p. 6. Ubu Classics, New York NY, 2004.
6 Genesis P. Orridge quoted in *Wreckers of Civilisation* p. 11.16, Simon Ford, Black Dog Press, London UK 1999.
7 interviewed by the author, December 2007.
8 *Ibid.*
9 Charles Manson interviewed on KALX radio, Berkeley CA (date unknown)
10 interviewed by the author, January 2008.
11 interviewed by the author, February 2008.
12 Interviewed by the author, March 2006.

13 *Ibid.*
14 *Ibid.*
15 Francisco López quoted at: http://www.franciscolopez.net/int_revue.html
16 William Bennett quoted : http://williambennett.blogspot.com/2007/07/nostalgie-de-la-boue.html
17 William Bennett interview on Resonance FM, London, July 27 2003.
18 *Ibid.*
19 William Bennett interview with Judith Howard, available online at:
 http://www.susanlawly.freeuk.com/textfiles/wbinterview02.htm
20 Marquis De Sade, *Justine, Philosophy In The Bedroom and Other Writings,* comp. and trans. Richard
 Seaver and Austryn Wainhouse, p. 253. Arrow Books, New York 1965.
21 Camille Paglia, *Sexual Personae,* p. 247. Vintage Books, New York, 1990.
22 Stewart Home, "The Sound of Sadism: Whitehouse and The New British Art",
 available online at http://www.stewarthomesociety.org/white.htm
23 Georges Bataille, *Eroticism,* p. 188. Penguin Classics, London, 2001.
24 *Ibid.,* p. 190
25 refer to 13 above
26 William Bennett quoted :
 http://williambennett.blogspot.com/2007/11/fine-art-of-profanity.html
27 refer to 13 above
28 William Bennett quoted in *Vice* magazine, October 2006. Reproduced online :
 http://www.susanlawly.freeuk.com/textfiles/wbinterview04.html
29 refer to 13 above

3. RE-LAUNCHING THE DREAM WEAPON

1 Z'ev, liner notes, *One Foot in the Grave* CD booklet. Touch, London, 1991.
2 Jacques Attali, *Noise: The Political Economy of Music,* p. 12. University of Minnesota Press,
 Minneapolis, 2003.
3 Hakim Bey, perf. *Temporary Autonomous Zone: A Night of Ontological Anarchy and Poetic Terrorism.*
 Videocassette, Sound Photosynthesis, 1994.
4 interviewed by the author, November 2007.
5 William Burroughs, *GYSIN/BURROUGHS/P-ORRIDGE – "Interviews & Readings"* cassette, Cold Spring,
 1989.
6 Brion Gysin quoted in *Re/Search #4/5,* p. 40. Re/Search Publications, San Francisco, 1982.
7 Brion Gysin quoted in *Literary Outlaw,* Ted Morgan, p. 301. Avon Books, New York, 1988.
8 Refer to 4 above
9 *Ibid.*
10 Stephen L. Harris & Gloria Platzner, *Classical Mythology,* 2nd edition, p. 140. Mayfield Publishing Co.,
 London/Toronto, 1995.
11 Coil, liner notes, *Scatology* LP. Force and Form, 1984.
12 Gilbert & George in conversation with Simon Dwyer, *Rapid Eye Vol.3,* ed. Simon Dwyer, p. 117.
 Creation Books, London, 1995.
13 Ian Penman, "England's Dreaming." *The Wire* #194, April 2000, p.30.
14 Stanislav Grof, *The Holotropic Mind,* p.15. Harper Collins, 1990, New York NY
15 John Balance interviewed on VPRO radio, Amsterdam, April 17, 1991
16 Peter Christopherson interviewed on VPRO radio, Amsterdam, April 17, 1991
17 John Balance quoted in *Tyr #2,* ed. Joshua Buckley and Michael Moynihan, p. 374. Ultra Publishing,
 Atlanta, 2004.
18 *Ibid.,* p. 375
19 refer to 4 above
20 LaMonte Young, "Ruminations on Radio." *Radiotext(e),* ed. Neil Strauss and Dave Mandl, p.183.
 Semiotext(e), New York, 1993
21 Peter Christopherson quoted at Heathen Harvest website:
 http://www.heathenharvest.com/article.php?story=20060901042847499
22 refer to 4 above
23 *Ibid.*

4. ELECTROVEGETARIANISM

1 Jiro Yoshizawa, *The Gutai Manifesto*. Reprinted at:
 http://www.ashiya-web.or.jp/museum/10us/103education/nyumon_us/manifest_us.htm
2 Malise Ruthven, *A Fury for God: The Islamist Attack on America*, p. 80-81. Granta Books, London, 2004.
3 John F. Szwed, *Space Is The Place: the Lives And Times of Sun Ra*, p.229. Da Capo Press, New York 1998
4 "Japan's Pornography Laws: Fleshing it Out", author uncredited. *The Economist* February 23rd-29th 2008, p. 60.
5 Masami Akita quoted at: http://www.esoterra.org/merzbow.htm
6 Aniela Jaffe, "Symbolism in the Visual Arts." Man And His Symbols, ed. C.G. Jung, p. 291. Aldus Books Ltd., London, 1964
7 http://www2.sbbs.se/hp/eerie/rcar.html
8 Clive Bell, review of *Rectal Anarchy* by Merzbow and Gore Beyond Necropsy. *The Wire* issue 163, September 1997, p.59.
9 *Ibid.,* p. 67
10 John Gray, *Straw Dogs*, p. 8. Granta Books, London, 2002
11 *Ibid.*
12 interviewed by the author, June 2007
13 Clive Wynne quoted in *Animal Minds* by Virginia Morell. *National Geographic*, March 2008, p. 54.
14 Frans de Waal, *Chimpanzee Politics*, p. 18. Johns Hopkins Press, Baltimore, 2000.
15 Leopold von Sacher-Masoch ,*Venus in Furs*, p. 39. Belmont Books, New York, 1965.

5. MASH COMMUNICATION

1 H.L. Mencken, *The American Scene: A Reader,* ed. Huntington Cairns, p. 11. Vintage Books, New York, 1982.
2 author uncredited, "Hold Your Wee for a Wii Lawsuit" at:
 http://www.thesmokinggun.com/archive/years/2007/0125073wii1.html
3 Peter Christopherson quoted at: http://brainwashed.com/coil/writings/jwint.html
4 Kalle Lasn, *Culture Jam*, p. 186-187. Quill, New York, 2000.
5 Lloyd Dunn quoted in *Sonic Outlaws*, dir. Craig Baldwin. Other Cinema, 1995
6 Mark E. Cory, *Soundplay: The Polyphonous Tradition of German Radio Art.* From *Wireless Imagination: Sound, Radio and the Avant-Garde*, p.363. Ed. Douglas Kahn & Gregory Whitehead. MIT Press, Cambridge MA, 1992.
7 Uncredited actor, *Suite (242)*, dir. Douglas Davis & Nam Jun Paik. Electronic Arts Intermix, 1974
8 Negativland, "Teletours in Negativland". *Radiotext(e)*, ed. Neil Strauss, p. 310-311. Semiotext(e), New York, 1993
9 Aniko Bodroghkozy, *Groove Tube: Sixties Television and the Youth Rebellion*, p. 126. Duke University Press, Durham/London 2001
10 *Ibid.,* p. 238
11 *Ibid.,* p. 240
12 Mark Hosler quoted in *Sonic Outlaws* – see 5 above
13 Timothy E. Moore, "Scientific Consensus and Expert Testimony: Lessons From The Judas Priest Trial," reproduced at: http://csicop.org/si/9611/judas_priest.html
14 *Ibid.*
15 Don Joyce quoted in *Sonic Outlaws* – see 5 above
16 Roger Ebert, review of *Passion of The Christ*. Reproduced at:
 http://rogerebert.suntimes.com/apps/pbcs.dll/article?AID=/20040224/REVIEWS/402240301/1023
17 Don Joyce quoted at: http://www.negativland.com/edge.html
18 Prof. Lawrence Lessig, *Willful Infringement: Mickey & Me*, dir. Greg Hittelman. Fiat Lucre, 2007.
19 John Oswald interviewed on 'Radio Radio', date/location unknown.
20 Jacques Attali, *Noise*, p.119. University of Minnesota Press, 2003.
21 Mark Hosler quoted at: http://www.negativland.com/reviews/trip.html
22 Nathan Rabin, review of *Epic Movie*. Online at http://www.avclub.com/content/node/57935
23 Charlie Brooker, "Supposing...Subversive Genius Banksy Really is Rubbish", *The Guardian*, September 22 2006. Reproduced at: http://www.guardian.co.uk/commentisfree/story/0,,1878555,00.html

24 Julian Baratt perf. *Nathan Barley*. Dir. Charlie Brooker and Chris Morris. Talk Back Productions, 2005.

25 Banksy quoted in "Banksy, The Joker" by Paul Vallely: *The Independent* online, reproduced at: http://www.independent.co.uk/news/people/banksy-the-joker-417144.html

26 comment by 'Barrymarshall', Sept. 26 2006 – see 19 above

27 refer to 15 above

28 Philip Sherburne, "Donna Summer: He's a Rebel." *The Wire* April 2003, p. 14.

29 *Ibid.*, Jason Forrest.

30 interviewed by the author, February 2008.

31 Genesis P. Orridge, "Thee Splinter Test." Unedited manuscript, 1995.

32 *Ibid.*

33 Ken Sitz quoted in *Incredibly Strange Music Vol. II*, p. 95-96. Re/Search, San Francisco, 1994.

34 Jasper Johns, "Marcel Duchamp (1887-1968), An Appreciation." Pierre Cabanne, *Dialogues with Marcel Duchamp*, p. 110. Da Capo, London, 1971.

6. BEYOND THE VALLEY OF THE *FALSCH*

1 Jim Green and Ira Robbins, Falco entry in *Trouser Press Record Guide,* 4th Edition, ed. Ira A. Robbins, p. 243. Collier Books, New York NY, 1991.

2 Genesis P. Orridge, review of *Atlas Arkhiv Documents of the Avant-Garde 7: Writings of the Viennese Aktionists.* Unpublished essay, 2000.

3 Hermann Nitsch quoted in *Atlas Arkhiv Documents of the Avant-Garde 7: Writings of the Vienna Aktionists*, ed. Malcolm Green, p. 129. Atlas press, London, 1999.

4 refer to 2 above

5 Max V. Mathews quoted in *The C-Sound Book*, ed. Richard Boulanger, p. xxxi. MIT Press, Cambridge, 2000.

6 Bob Ostertag, *Why Computer Music Sucks*. Available online at: http://www.earlabs.org/rss/text.asp?textID=24

7 *Ibid.*

8 John Duncan quoted in liner notes to *Our Telluric Conversation* CD by John Duncan and Carl Michael von Hausswolff, p. 6. 23five, San Francisco, 2006.

9 Mark Harwood, review of "What is Music?" festival. *Wire* #194, April 2000, p. 85.

10 interviewed by the author, February 2008.

11 Alois Bitterdorf quoted at: http://www.mego.at/mego032.html
interviewed by the author, April 2006

12 interviewed by the author, July 2008

13 Kenneth Goldsmith quoted at: http://www.wfmu.org/~kennyg/popular/articles/glitchwerks.html

14 Kim Cascone, *The Aesthetics of Failure*. Available online at: http://hz-journal.org/n3/cascone.html

15 *Ibid.*

16 Zbigniew Karkowski quoted in *Substantials* #1, ed. Akiko Miyake, p. 8. CCA Kitakyushu, 2003.

17 Nicholas Negroponte, *Being Digital* p. 229, Alfred A Knopf, New York, 1995.

18 User 'tine' quoted at http://www.discogs.com/release/97472, July 12, 2006

19 Alku/Imbecil, "E+", p. 1. Available online at: http://personal.ilimit.es/principio/pmwiki/pmwiki.php/Main/Essays

20 Bob Ostertag, *Are Two Screens Enough? The Networked Screen and The Human Imagination*, p. 10, unpublished manuscript, 2008.

21 *Ibid.*, p. 7.

22 Kim Ryrie quoted in *Vintage Synthesizers*, p. 190. Miller Freeman, San Francisco, 1993.

23 *Ibid.*, p. 196.

24 Mel Gordon, "Songs From the Museum of the Future: Russian Sound Creation (1910-1930)", in *Wireless Imagination: Sound, Radio, and the Avant Garde*, p. 212. Ed. Douglas Kahn and Gregory Whitehead, MIT Press, Cambridge MA., 1992.

7. TO KICK A KING

1 Paul Virilio, *Unknown Quantity*, p. 132. Thames & Hudson, New York, 2003.

2 *Ibid.*, p. 133

3 Håkan Nilsson, *What is the State of Elgaland-Vargaland?* Reproduced at: http://www.elgaland-vargaland.org/about/index.html

4 Critical Art Ensemble, *Electronic Civil Disobedience and Other Unpopular Ideas*, p. 36. Autonomedia, New York, 1996.

5 Nicholas Negroponte, *Being Digital* p. 157. Alfred A Knopf., New York, 1995.

6 *Ibid.*, p. 158.

7 interview with the author, March 2006

8 Carl Michael von Hausswolff, *Curriculum Vitae.* Reproduced at: http://www.cmvonhausswolff.net/curriculum_vitae.html

9 See #7 above.

10 *Ibid.*

11 Torsten Ekborn quoted in booklet accompanying *Åke Hodell: Verbal Brainwash and Other Works* 3xCD, p. 8 – Fylkingen Records, Stockholm, 2000.

12 http://web.comhem.se/elggren/experiment.html

13 http://web.comhem.se/elggren/bardot.html

14 Leif Elggren, *Experiment with Dreams.* Available online at: http://web.comhem.se/elggren/experiment.html.

15 *Ibid.*

16 Leif Elggren, liner notes, *Virulent Images/Virulent Sound* CD. Firework Edition, Stockholm, 2004.

17 *Ibid.*

18 http://www.wfmu.org/~kennyg/popular/reviews/elggren.html

19 http://epc.buffalo.edu/authors/goldsmith/goldsmith_boring.html

20 Leif Elggren, *Genealogy*, p. 41. Firework Edition, Stockholm 2005.

21 *Ibid.*

22 *Ibid.*, p. 29.

23 Robert L. Heinbroner, *The Worldly Philosophers*, p. 125. Touchstone, New York, 1992.

24 http://www.nskstate.com/philosophy/interviews/satanic_technocrat.php

25 Alexei Monroe, *Interrogation Machine: Laibach And Nsk*, p. 250, MIT Press, Cambridge MA 2005

26 *Ibid.*, p.227.

27 Dror Feiler, *Music, Noise & Politics.* Liner notes, *Sounds 99* triple CD. Blue Tower Records, Stockholm, 2000.

28 *Ibid.*

29 Refer to 20 above (p. 67.)

30 *Ibid.* (p. 68.)

31 Hakim Bey, *Immediatism*, p. 2. AK Press, San Francisco, 1994.

32 *Ibid.*

8. FRANCESCO LOPEZ

1 Brandon LaBelle, *Site Specific Sound*, p.62. Errant Bodies Press, New York, 2004.

2 Raymond Williams, *The Politics of Modernism: Against the New Conformists*, p. 52. Verso, London/New York, 2007.

3 F.T. Marinetti quoted in *Futurist Manifestos*, ed. U. Apollonio, p. 23. London, 1973.

4 refer to 2 above

5 Jean Baudrillard, *Impossible Exchange*, p. 44. Verso, London/New York, 2001.

6 interviewed by the author, March 2006.

7 *Ibid.*

8 Lionel Marchetti, *The Microphone and the Hand,* trans. Patrick McGinley & Matthew Marble. Reproduced in *Fo(a)rm* #5, ed. Seth Nehil, Matthew Marble, Bethany Wright, p. 115.

9 *Ibid.*, p. 109.

10 Francisco López quoted at http://www.franciscolopez.net/cage.html

11 refer to 6 above.

12 *Ibid.*

13 Francisco López, *Towards the Blur.* Reproduced online at: http://www.franciscolopez.net/aphorisms.html

14 Francisco López quoted in "Francisco López: Belle Confusion" by Gregory Gangemi. *Sound Projector* #11, 2003, p. 32.

15 *Ibid.*

16 refer to 6 above

17 Francisco López quoted in *Substantials #1*, ed. Akiko Miyake, p. 140. CCA Kita-Kyushu, 2003

18	refer to 6 above
19	Daniel Gasman quoted in *Ecofascism: Lessons from the German Experience*, ed. Janet Biehl & Peter Staudenmaier, p. 60. AK Press, San Francisco, 1995.
20	*Ibid.*
21	refer to 17 above – p. 114
22	Adam Kadmon, "Oskorei." *Lords of Chaos: The Bloody Rise of the Satanic Metal Underground,* by Michael Moynihan and Didrik Soderlind, p. 339. Feral House, Los Angeles, 1998.
23	*Ibid.*
24	*Ibid.,* p. 340
25	Francisco López quoted at http://www.franciscolopez.net/int_revue.html
26	Discogs.com user 'Peshehod', review of *Untitled #104* by Francisco López, March 8, 2005. Available online at http://www.discogs.com/release/123683.
27	Francisco López quoted at http://www.franciscolopez.net/int_loop.html
28	*Ibid.*

9. VOX STIMULI

1	Ed Pinsent, review of *Our Telluric Conversation* by John Duncan & CM von Hausswolff. *The Sound Projector* #15, p. 92. London, 2007.
2	Mike Kelley, "John Duncan: Los Angeles, Late 1970s/Early 1980s." *John Duncan: Works 1975-2005,* p. 14. Errant Bodies Press, Copenhagen 2006
3	Takuya Sakaguchi, "Woofer, Choir, Radio, Religion and DumDum Boys". *John Duncan: Works 1975-2005,* p. 21. Errant Bodies Press, Copenhagen 2006
4	Interviewed by the author, May 2006
5	John Duncan, booklet accompanying *Our Telluric Conversation* CD by John Duncan & CM von Hausswolff, p. 15. 23five, San Francisco, 2006.
6	*Ibid.*
7	Jerzy Grotowsky, *Towards a Poor Theater,* p. 16. Simon & Schuster, New York, 1969.
8	*Ibid.*
9	John Duncan quoted in interview by Carl Abrahamsson for *Flashback,* April 2002 – reproduced online at: http://www.johnduncan.org/abrahamsson.html
10	*Ibid.*
11	John Duncan, "Happy Homes". *Creed* 7", AQM, Los Angeles, 1981.
12	Interviewed by the author, May 2006
13	*Ibid.*
14	*Ibid.*
15	John Duncan interviewed by Takashi Asai, reproduced at: http://www.johnduncan.org/interview.jp.html – translated from the Japanese by the author
16	refer to 12 above
17	*Ibid.*
18	*Ibid.*
19	John Duncan interviewed by Boris Wlassoff for *Revue & Corrigée* (numéro 51, Mars 2002), reproduced online at: http://www.johnduncan.org/wlassoff.rc1.htmlp translated from the Italian by Thierry Bokhobzka
20	John Duncan, *Toshiji Mikawa – Radio Code* cassette side A, AQM, Amsterdam, 1989.
21	*Ibid.*
22	Arthur Zich, "Japan's Sun Rises Over the Pacific". *National Geographic,* November 1991, p.41. National Geographic Society, Washington DC.
23	Refer to 3 above
24	Refer to 12 above
25	Michael Prime, "Explorations in Bioelectronics." *Resonance* Vol. 9 No. 2, p. 17. London Musicians' Collective, London, 2002.
26	*Ibid.*
27	Erik Hobijn quoted in *Pranks!,* p. 207. Re/Search, San Francisco, 1987.
28	Willem de Ridder, *This Glass is a Bicycle* promotional cassette. Unreleased/no label.
29	*Ibid.*
30	Carl Michael von Hausswolff, "A Palace in a Stack of Needles." *John Duncan: Works 1975-2005,* p. 20. Errant Bodies Press, Copenhagen 2006

31 interviewed by the author, February 2008
32 refer to 25 above
33 refer to 12 above

10. UNCOMMON SENSE(S)

1 Arthur Schopenhauer, *The World as Will and Idea*, p. 170-171. Tuttle Publishing, North Clarendon, 1995.
2 Erik Davis, *TechGnosis: Myth, Magic and Mysticism in the Age of Information*, p. 291. Three Rivers Press, New York, 1999
3 Dr. Vilayanur S. Ramachandran quoted in *The Mind's Eye: Neuroscience, Synesthesia and Art.* Available online at http://www.neurologyreviews.com/jul02/nr_jul02_mindseye.html
4 Patrick Martin, *Synesthesia, Metaphor and Right-Brain Functioning.* Reproduced online at: http://barneygrant.tripod.com/synaes.htm
5 György Ligeti, *Ligeti in Conversation*, p. 58. Eulenburg Books, London, 1983.
6 Duke Ellington quoted in *Sweet Man: The Real Duke Ellington* by Don George, p. 191. G.P. Putnam's Sons, New York, 1981.
7 interviewed by the author, December 2007.
8 Z'ev quoted in *Acoustic Phenomenae* by Dmitry Koselnick. *The Egg and We #1*, March-June 1999 (unedited MS Word manuscript.)
9 Errki Kurenniemi quoted in *The Future Is Not What It Used To Be*, dir. Mika Taanila. Kinotar, 2002.
10 *Ibid.*
11 *Ibid.*
12 Refer to 1 above (p. 165.)
13 *Ibid.*, p. 166.
14 Christiaan Stuten quoted in *Cymatics: A Study of Wave Phenomena and Vibration*, Hans Jenny, p. 14. Macromedia Press, 2001.
15 *Ibid.*
16 Carsten Nicolai quoted in "The Perfect Strom" by Ben Borthwick. *The Wire* #283, December 2003, p. 42.
17 *Ibid.* (Ben Borthwick.)
18 Carsten Nicolai, *curriculum vitae*, available online at: http://www.carstennicolai.de/?c=biography
19 *Ibid.*
20 Le Corbusier, *Towards a New Architecture*, p. 110. Dover Publications, New York, 1986.
21 refer to 16 above.
22 Carsten Nicolai, *telefunken* [wtc version]. Available online at: http://www.carstennicolai.de/?c=works&w=telefunken_wtc_version.
23 refer to 3 above.

11. SILENCE IS SEXY

1 User "Namakemono," review of *Blank Tapes* by Reynols, June 16, 2008. Available online at: http://www.discogs.com/release/325745.
2 Taku Sugimoto, liner notes, *Off Site Composed Music Series In 2001.* A Bruit Secret, Paris, 2002.
3 Steve Roden quoted in "Case Sensitive" by Christoph Cox, *The Wire*, # 229 March 2003, p. 30.
4 Astro Twin quoted at http://www.japanimprov.com/astrotwin/profile.html
5 *Ibid.*
6 Alan Watts, Tao: *The Watercourse Way* p. 21. Pantheon Books, New York, 1975.
7 Fritjof Capra, *The Tao of Physics*, p. 212. Shambala, Boston, 1991.
8 Stefan Jaworzyn, review of "so delicate and strangely made" by in be tween noise. *Music From The Empty Quarter*, August/September 1995, p. 90.
9 David Toop, *Haunted Weather: Music, Silence, and Memory*, p. 253. Serpents' Tail, London, 2004.
10 Taku Sugimoto quoted in "Understatement of Intent" by Clive Bell, *The Wire*, # 237 November 2003, p. 30.
11 Interviewed by the author, April 2008
12 *Ibid.*
13 Samuel R. Delany, *Dhalgren*, p. 610. Vintage Books, New York, 2001.
14 *Ibid.*

12. FASTER THAN LIGHT (AND CHEAPER)

1 Andrew McKenzie quoted at http://williambennett.blogspot.com/2006/09/witchfinder-pencil.html
2 Andrew McKenzie quoted at http://www.brainwashed.com/h3o/whatis.html#copyright
3 interviewed by the author, March 2006
4 refer to 2 above
5 *Ibid.*
6 *Ibid.*
7 interviewed by the author, March 2006
8 *Ibid.*
9 interviewed by the author, March 2006
10 *Ibid.*
11 *Ibid.*
12 *Ibid.*
13 *Ibid.*
14 *Ibid.*
15 Steve Albini lecture at MTSU, video posted at:
 http://www.mtsu.edu/~nadam/downloads/Stevealbiniweb.html
16 *Ibid.*
17 *Ibid.*
18 refer to 3 above
19 interviewed by the author, April 2006

13. TECHNOMADISM

1 Ray Kurzweil, *The Singularity is Near*, p. 469- Viking Penguin, New York NY, 2005
2 Vito Acconci quoted in *Vito Acconci*, by Kate Linker, p. 178. Rizzoli, New York NY, 1994.
3 Sherry Turkle, *Life on the Screen- Identity in the Age of the Internet*, p. 240. Simon & Schuster, New York, 1995.
4 Lydia Lunch quoted in *Kill Your Idols*, dir. Scott Crary. Palm Films, 2004.
5 interviewed by the author, January 2008
6 *Ibid.*
7 refer to 4 above
8 refer to 4 above (Michael Gira.)
9 Erich Fromm, *Escape from Freedom* p.17. Owl Books, New York 1994
10 *Ibid.*
11 Alan Licht, *An Emotional Memoir of Martha Quinn*, p.66-7. Drag City, Chicago, 2002.
12 *Ibid.*, p. 65.
13 *Ibid.*, p. 67-68.
14 refer to 5 above
15 Tom Hodgkinson, *With Friends Like These...*, reproduced at:
 http://www.guardian.co.uk/technology/2008/jan/14/facebook
16 Ibid.
17 reviewer "Olly Buxton" quoted at: http://www.amazon.com/review/product/0385520808/
 ref=cm_cr_pr_link_1?%5Fencoding=UTF8&filterBy=addOneStar
18 Christiaan Virant quoted at in *Buddha Machine: Batteries Included* by Adam Park, available online
 at: http://www.boomkat.com/article.cfm?id=3
19 refer to 2 above- p. 236
20 Elisa Rose, *private://public*, p. 99. Ed. Station Rose. Editions Selene, Vienna, 2000.
21 Jean Baudrillard, *Passwords*, p. 39. Translated by Chris Turner. Verso, New York, 2003.
22 *Ibid*, p. 42.
23 Bruce Sterling, *Tomorrow Now: Envisioning the Next Fifty Years*,p. 292. Random House, New York, 2002.
24 John Gray, *Al Qaeda and What It Means to Be Modern*, p. 23. New Press, New York NY 2003.
25 *Ibid.*, p. 42

RECOMMENDED LISTENING

The following is a list of titles which figure into this text, in one way or another. Many of these are no longer available under the catalog numbers given; and may now be re-released on completely different record labels than the ones listed here. As a rule of thumb, the *original* labels and catalog numbers under which these releases appeared have been printed, for the sake of historical accuracy. While hopelessly unavailable "collectors' items" do populate this list, have no fear: the vast majority of this music is digitized and available to those with the patience to seek it out.

Akita, Masami/Haswell, Russell, *Satanstornade*, Warp Records WARP CD666.

Alva Noto, *Prototypes*, Mille Plateaux MP 082 CD.

Ambarchi/Fennesz/Pimmon/Rehberg/Rowe, *Afternoon Tea*, Ritornell RIT014.

Burroughs, William S., *Nothing Here Now but the Recordings*, Industrial IR 0016.

Burroughs, William S., *The Best of William Burroughs from Giorno Poetry Systems*, Mercury 314 536 701-2.

Cabaret Voltaire, *The Voice of America*, Rough Trade ROUGH 11.

Cascone, Kim, *Blue Cube []*, Raster/Noton cdr014.

Cascone, Kim, *Cathode Flower*, Ritornell RIT 006 CD.

Cascone, Kim, *Dust Theories*, c74 c74-004.

Cazazza, Monte – *The Worst of Monte Cazazza*, The Grey Area MONTECD1.

Chopin, Henri, *Audiopoems*, Tangent Records TGS 106.

Chopin, Henri, *Poésie Sonore*, Igloo Records, IGL 013.

COH, *0397 Post Pop*, Mego MEGO 076.

COH, *Iron*, Wavetrap WAV02.

Coil, *Scatology*, Force and Form FFK1.

Coil, *Horse Rotorvator*, Force and Form ROTA 1.

Coil, *Love's Secret Domain*, WaxTrax! WAXCD 7143.

Coil, *Constant Shallowness Leads to Evil*, Eskaton ESKATON 024.

Coil, *Musick To Play in The Dark Vol. 2*, Chalice GRAAL 005CD.

Coil, *ANS*, Eskaton ESKATON 034.

Cosmos, *Tears*, Erstwhile Records erstwhile 024.

Cyclo., *Cyclo*, Raster-Noton cdr041.Duncan, John/Günter, Bernhard, *Home, Unspeakable*, Trente Oiseaux TOC 964.

Duncan, John, *Riot*, All Questions Music AQM204

Duncan, John, *River in Flames*, Anckärstrom R9.

Duncan, John, *Send*, Touch TO:20.

Duncan, John, *Palace of Mind*, All Questions Music AQ-01.

Duncan, John/López, Francisco, *Nav, .Absolute.[Osaka]/All Questions .a.[o] 004-01, AQ-02*.

Duncan, John/Von Hausswolff, Carl Michael, *Our Telluric Conversation*, 23five 008.

Duncan, John/Springer, Max, *The Crackling*, Trente Oiseaux TOC 961.

Elggren, Leif, *Talking To a Dead Queen*, Fylkingen FYCD 1008.

Elggren, Leif and Liljenberg, Thomas, *9.11*, Firework Edition FER 1015.

Elggren, Leif, *The Cobblestone is the Weapon of the Proleteriat*, Firework Edition FER 1051.

Elggren, Leif, *Cunt 69*, Firework Edition , FER 1063.

Elggren, Leif, *Flown Over By An Old King*, Radium 226.05 RAFE 044-61.

ELPH, *Worship The Glitch*, Eskaton ESKATON 007.

ELPH, *Zwölf/20' To 2000.December*, Raster/Noton 20TO200012.

EVOL, *Punani Quatre*, Alku alku 61.

Farmers Manual, *Fsck*, Tray TRAY 2.

Farmers Manual, *Explorers_We*, OR SQUISH 4.

Fennesz/Harding/Rehberg, *Di-n*, Ash International ASH 4.8.

Fennesz, *Hotel Paral.lel*, Mego MEGO 016.

Fennesz, *Endless Summer*, Mego MEGO 035.

Fennesz, *Live in Japan*, Headz HEADZ 10.

Filament, *Filament 1*, Extreme XCD 045.

Furudate, Tetsuo/Karkowski, Zbigniew, *The World as Will II*, 23five 003.

Ground Zero, *Ground Zero Revolutionary Pekinese Opera (Ver 1.28)*, ReR Megacorp ReR GZ1.

Günter, Bernhard, *Un Peu de Neige Salie*, Selektion SCD 012.

Günter, Bernhard/Wehowsky, Ralf, *Un Ocean de Certitude*, V2 Archief V222.

Gysin, Brion, *Poem of Poems*, Alga Marghen 8vocson021.

Gysin, Brion, *Self-Portrait Jumping*, Made to Measure MTM 33 CD.

Haswell, Russell, *Live Salvage*, Mego MEGO 012.

Haswell & Hecker, *Blackest Ever Black (Electroacoustic UPIC Recordings)*, Warner Classics & Jazz 2564 64321-2.

Hecker, *Sun Pandämonium*, Mego MEGO 044.

Hijokaidan, *King of Noise*, Alchemy Records ARLP-006.

Hijokaidan, *Modern*, Alchemy Records ARCD-004.

Hodell, Åke, *Verbal Brainwash and Other Works*, Fylkingen FYCD 1018.

In Be Tween Noise, *so delicate and strangely made*, New Plastic Music NPIB-1.

Incapacitants, *Repo*, Alchemy Records ARLP-027.

Incapacitants, *No Progress*, Alchemy Records ARCD-070.

Karkowski, Zbigniew, *Uexkull*, Anckärstrom K4.

Karkowski, Zbigniew/López, Francisco, *Whint*, .Absolute.[London] .a.[l] 003-01.

Kurenniemi, Erkki, *Äänityksiä/Recordings 1963-1973*, Love Records LXCD 637.

Laibach, *Nova Akropola*, Cherry Red BRED 67.

Laibach, *Opus Dei*, Mute Records STUMM 44.

López, Francisco, *Paris Hiss*, Banned Production BP-81.

López, Francisco, *Belle Confusion 969*, Sonoris SON-05.

López, Francisco, *La Selva*, V2 Archief V228.

López, Francisco, *Untitled #104*, Alien8 ALIENCD 020.

López, Francisco/Arford, Scott, *Solid State Flesh/Solid State Sex*, Low Impedance Recordings LoZ 04.

López, Francisco, *Warszawa Restaurant*, Trente Oiseaux TOC 951.

Lucier, Alvin, *Bird and Person Dyning*, Cramps Records CRSLP 6111.

M., Sachiko, *Sine Wave Solo*, Amoebic AMO SAT 01.

MacLise, Angus, *Astral Collapse*, Locust Music LOCUST 17.

MacLise, Angus, *The Cloud Doctrine*, Sub Rosa SR 182.

Marchetti, Lionel, *Sirrus*, Auscultare Research Aus 014.

Marclay, Christian, *Record Without a Cover*, Recycled Records (no catalog number).

Marclay, Christian, *More Encores*, ReR Megaccorp ReR CM1.

Merzbow, *Pornoise 1KG*, ZSF Produkt (no catalog number).

Merzbow, *Batzoutai with Material Gadgets*, RRRecords RRR005.

Merzbow, *Ecobondage*, ZSF Produkt, SH62-01.

Merzbow, *Live in Khabarovsk CCCP 'I'm Proud By Rank of the Workers'*, ZSF Produkt SH63-01.

Merzbow, *Rainbow Electronics*, Alchemy Records ARCD-017.

Merzbow, *Great American Nude/Crash for Hi-Fi*, ARCD-035.

Merzbow, *Music for Bondage Performance*, Extreme, XCD 008.

Merzbow, *Metalvelodrome*, Alchemy Records ARCD061-064.

Merzbow, *Pulse Demon*, Release Entertainment RR 6937-2.

Merzbow, *Scumtron*, Blast First BFFP 138 CD.

Merzbow, *24 Hours – Day of Seals*, Dirter Promotions DPROMCD 50.

Merzbow, *Timehunter*, Ant-Zen act 146.

Mühl, Otto, *Ein Schreckliche Gedanke*, no label.

Mumma, Gordon, *Dresden/Venezia, Megaton*, Lovely Music Ltd. VR 1091.

Nakamura, Toshimaru, *No-Input Mixing Board*, Zero Gravity ZGV-026.

Nakamura, Toshimaru, *Vehicle*, Cubic Music CUBIC MUSIC 08.

Nakamura, Toshimaru and M., Sachiko, *Do*, Erstwhile Records erstwhile 013.

Negativland, *Escape from Noise*, SST Records SST 133.

Negativland, *Helter Stupid*, SST Records SST 252.

Negativland, *U2*, SST Records SST 272.

Negativland, *Dispepsi*, SEELAND CD 017.

Neumann, Andrea/Krebs, Annette, *Rotophormen*, Charhizma cha009.

New Blockaders, *Symphonie in X Major*, Hypnagogia GOG01.

NON, *Pagan Muzak*, Graybeat Records GB 3301.
NON, *Physical Evidence*, Mute Records STUMM 10.
Noto, *Telefunken*, Raster/Noton cdr032.
Noto, Alva, *Transspray*, Raster/Noton R-N 63.
Noto, Alva, *Xerrox Vol. 1*, Raster/Noton R-N 78.
Okura, Masahiko/Müller, Günter/Yoshida, Ami, *Tanker*, For 4 Ears CD 1759.
Ostertag, Bob, *Sooner or Later*, ReR Megacorp ReR B01.
Ostertag, Bob, *Burns Like Fire*, RecRec Music, RecDec 53.
Ostertag, Bob, *DJ of the Month*, Seeland SEELAND 526 CD.
Oswald, John, *Discosphere*, ReR Megacorp ReR JO CD.
Oswald, John, *69 Plunderphonics 96*, Seeland/fony 515 CD/69 96.
Pade, Else Marie, *Face It*, DaCapo Records 8.224233.
Pan Sonic, *Kulma*, Blast First BFFP 132 CD.
Pan Sonic, *A*, Mute Corporation Mute 9078-2.
Pita, *Seven Tons for Free*, Mego MEGO 009.
Pita, *Get Out*, Mego MEGO 029.
Pita, *Get Off*, Häpna H.19.
Prime, Michael, *L-Fields*, Sonoris SON-08.
Rabelais, Akira, *Spellewauerynsherde*, Samadhisound SOUND-CD ss003.
Reynols, *Blank Tapes*, Trente Oiseaux TOC 002.
Rice, Boyd, *self-titled*. No label.
Roden, Steve, *Forms of Paper*, Line Line 007.
Roden, Steve, *Light Forms (Music For Light Bulbs and Churches)*, Semishigure semi 003.
Schwitters, Kurt, *Ursonate – Sonate in Urlauten*, Hat Hut Records, ART CD 6109.
SPK (as 'System Planning Korporation'), *Information Overload Unit*, Side Effects SER01.
SPK, *Auto-Da-Fé*, Walter Ulbricht Schallfolien, WULP002.
Sugimoto, Taku, *Periodic Drift*, Corpus Hermeticum.
Sugimoto, Taku/Krebs, Annette, *Eine Gitarre Ist Eine Gitarre Ist Keine Gitarre Ist Eine Gitarre...*, Rossbin RSS005.
Throbbing Gristle, *Second Annual Report*, Industrial IR 0002.
Throbbing Gristle, *D.o.A. – The Third and Final Report*, Industrial IR 0004.
Throbbing Gristle, *20 Jazz Funk Greats*, Industrial 0008.
Throbbing Gristle, *Heathen Earth*, Industrial IR 0009.
Tone, Yasunao, *Wounded Man'Yo #38-9/2001*, Alku hajime39.
Tone, Yasunao/Hecker, *Palimpsest*, Mego MEGO 060.
Tujiko, Noriko, *Haado ni Sasete (Make Me Hard)*, Mego MEGO 062.
Van der Heide, Edwin/Karkowski, Zbigniew, *Datastream*, OR ORCDR001.
Von Hausswolff, Carl Michael, *Operations of Spirit Communications*, Die Stadt DS 31.
Von Hausswolff, Carl Michael, *The Wonderful World of Male Intuition*, Oral CD10.
Von Hausswolff, Carl Michael, *Three Overpopulated Cities Built By Short-sighted Planners, An Unbalanced And Quite Dangerous Airport And An Abandoned Church*, Sub Rosa SR 217.
V/VM, *Sick Love*, V/Vm Test Records OFFAL 003.
V/VM, *The Green Door*, V/Vm Test Records OFFAL 004.
Wehowsky, Ralf/Marchetti, Lionel, *Vier Vorspeile/L'Oeil Retourné*, Selektion SCD 026.
Wehowsky, Ralf, *Pullover*, Table of the Elements Ge 32.
Whitehouse, *Birthdeath Experience*, Come Organisation WDC 881004.
Whitehouse, *Erector*, Come Organisation WDC 881007.
Whitehouse, *Right to Kill*, Come Organisation WDC 881033.
Whitehouse, *Great White Death*, Come Organisation WDC 881069.
Whitehouse, *Halogen*, Susan Lawly SLCD007.
Whitehouse, *Cruise*, Susan Lawly SLCD024.
Whitehouse, *Racket*, Susan Lawly SLCD029.
Yoshida, Ami, *Tiger Thrush*, Improvised Music From Japan IMJ-504.
Yoshida, Ami/Kurzmann, Christof, *Aso*, Erstwhile Records erstwhile 047.
Yoshihide, Otomo, *The Night Before the Death of the Sampling Virus*, Extreme XCD 024.
Z'ev, *1968-1990: One Foot in the Grave*, Touch TO:13.
Z'ev, *My Favorite Things*, Subterranean Records SUB 33.

TABLE OF ILLUSTRATIONS